THE ART
OF SEEING

1	2	3	4	5	6	7	8
9	10	11	12	13	14	15	16
17	18	19	20	21	22	23	24
25	26	27	28	29	30	31	32
33	34	35	36	37	38	39	40
41	42	43	44	45	46	47	48
49	50	51	52	53	54	55	56
57	58	59	60	61	62	63	64

The Brueghel Series (A Vanitas of Style) was inspired by a still-life by the sixteenth-century painter Jan Brueghel. Each of Pat Steir's panels pays homage to a great artist. The work represents her personal summation of the art of seeing as practiced by a great community of artists through time.

THE ART OF SEEING

Paul Zelanski

Mary Pat Fisher

Prentice-Hall, Inc., Englewood Cliffs, N.J.

North and South American edition first published 1988 by
Prentice-Hall Inc., Englewood Cliffs, NJ 07632

ISBN 0-13-046905-X

This book was designed and produced by
JOHN CALMANN AND KING LTD, LONDON

Designer Karen Osborne
Typeset by Rowland Phototypesetting Ltd, England
Printed in Hong Kong by Mandarin Offset

Cover: PAT STEIR, *The Brueghel Series (A Vanitas of Style)*, 1981–83.
Oil on canvas, 20 × 16ft (6.1 × 4.9m).
The back cover shows one of the 64 canvases that make up the work;
each measures 28 × 23ins (71 × 58cm). (See endpapers.)

Frontispiece: HENRI MATISSE, *Venus*, 1952. Paper pasted on canvas, 39⅞ × 30½ins
(100 × 76cm). The National Gallery of Art, Washington D.C.

CONTENTS

PREFACE

Great art affects people in different ways. Some of us are moved to tears by it; some of us are struck speechless. Such responses are, to a certain extent, natural human reactions to the extremes of experience, be they beauty, truth, or anguish. But responding to art is also an acquired sensitivity, based on exposure and expanded knowledge. The purpose of this book, then, is to expose you to a wide range of great artworks, beautifully reproduced, and to provide information that will increase your awareness of and responsiveness to what you are seeing.

The nature and organization of this book

We have made a great effort in *The Art of Seeing* to make art come to life through the text. Unfamiliar words are carefully defined when they are first used and also in an extensive glossary at the end of the book. The language we use is vigorous and down-to-earth, with numerous quotations from the artists themselves to help explain in their own words what they were trying to do. We have also included anecdotal material about art and artists and interesting pieces of information because these things are memorable in themselves and because they add the vital human dimension to art. The illustrations for each concept are conscientiously described and clearly related to the text.

Perhaps even more important than the writing in *The Art of Seeing* is the art. There are some 520 illustrations, 210 of them in color, and many of these are reproduced at full-page size. Some may be familiar to you, for they are deservedly famous; many others are new or less well-known works of outstanding quality that clearly illustrate points made in the text. They are taken from all the visual arts, from painting and sculpture to clothing and industrial design. Many cultures are represented, as is the work of many women artists. A number of the works chosen refer explicitly to art or artists—most notably the painting on the cover by Pat Steir. As well as being good references for the explanations in the text, the illustrations provide a stimulating, exciting visual gallery.

The Art of Seeing begins with a chapter laying the foundations for all that follows. In Chapter 1 we develop an initial vocabulary and an intellectual framework for considering artworks: the basic forms of art, the functions of art for the artist and the viewer, and the ways in which art can be appreciated. Chapter 2 is devoted to extensive analyses of the

visual elements with which the artist works: line, shape, form, space, texture, light, color, and time. Chapter 3 covers the subtle organizing principles behind the ways these elements are used in a work of art.

The next two chapters approach art from the point of view of materials and techniques. By revealing the difficulties associated with each method, we hope to enhance appreciation of the results artists have managed to create despite the intractabilities of their media. Chapter 4 covers two-dimensional media: drawing, painting, mosaic, printmaking, graphic design, photography, film, television, video, and computer graphics. Chapter 5 covers three-dimensional media: sculpture, crafts, industrial design, clothing design, architecture, interior design, environmental design, and the performing arts.

Chapter 6 takes a succinct and intelligible approach to historical styles in Western art. Some 39 major movements, from prehistoric to contemporary, are concisely covered. The flow of change is kept in the foreground, rather than garbled by extraneous details. The illustrated Timeline on pages 380 and 381 further helps you to understand how the distinctively different styles of different periods are related in time.

Chapter 7 is unique. It approximates the actual experience of encountering a work of art, drawing on all levels of appreciation developed in the book to analyze and respond to three special works: a round stone barn built by a Utopian community, Picasso's *Guernica*, and Rodin's *The Gates of Hell*.

Acknowledgements

Many people have contributed to the preparation of this text and we are very grateful for their help. We want to pay special tribute to our superb editor, Peter Zombory-Moldovan, for his creativity, brilliance, and hard work. All the people at John Calmann and King have been a delight to work with, including Laurence King, who has been ever gracious. Dominica Blenkinsopp and Annabel Hood have carried out an extraordinary international hunt for the images we wanted to use, with great success. Karen Osborne is responsible for the book's elegant design and has done a beautiful job of the complexities of putting everything together visually. Bud Therien of Prentice-Hall has contributed many thoughtful suggestions that have helped to shape the book.

A number of people have helped us to track down images and factual information, including John Gregoropoulos, John Fawcett, Katharine Farina, Harold Spencer, Richard Swibold, Bette Talvacchia, Richard Schindler, John Craig, Richard Thornton, Beverly Dickinson, Sharen Baker, Billi Gifford, Roger Crossgrove, and Jerry Rojo. We are also very grateful to the artists whom we interviewed—Stephen Alcorn, Katharine Alling, William Bailey, Frank Ballard, Russell Connor, Juan Gonzalez, Peter Good, Glenn Gregg, Arthur Hoener, Richard Lytle, Norma Minkowitz—and especially Ruth Bernhard, whose enthusiasm

for life and for the art of seeing sets the tone for the book. Michelle Fisher and Victoria DeWitt were of great help in the tasks of preparing our extensive picture list. And, of course, we want to thank Annette Zelanski, whose editorial help and moral support have been unfailing throughout our years of writing art books together.

We also feel great gratitude to artists in general, for the beauty and truth they have shared. May the world of art they have created increasingly enrich your own life.

Paul Zelanski Mary Pat Fisher
Storrs, Connecticut

An Instructor's Manual by Jack Breckenridge of Arizona State University, as well as museum quality slides from Sandak, Inc., are available from the Publisher.

CHAPTER ONE
ART APPRECIATION

Art is life intensely experienced. For those with eyes to see, an encounter with a work of art can be deeply moving. From the sensual pleasures of using a handcrafted bowl to the transcendent awe of standing within a Gothic cathedral, art touches us on many levels.

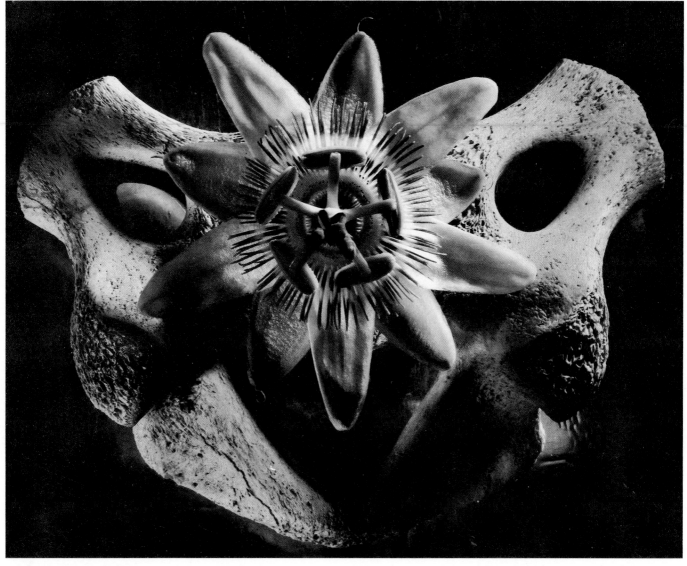

1.1 RUTH BERNHARD, *Bone and Passion Flower*, not dated. Photograph.

Art appreciation is a skill that has to be learned. But it begins with simply looking with full awareness. We usually screen out most of the impressions our senses bring us, to avoid over-stimulation by the complexities of modern life. When we are reading a book, we don't notice the refrigerator humming or cars passing; when we walk through a room, we don't notice most of its furnishings; when we are driving a car, our attention may be so focused on the road and the other cars, or on some problem with which we are struggling, that we are unable to pay attention to the beauty of the sunset. Psychologists call this screening of sensations a DEFENSIVE GRID. Although it is a useful survival tool in our industrialized, cluttered existence, we must learn to abandon it when looking at art. If we want to really see a work of art, we must open ourselves to all the sensations it evokes.

To begin this journey into the great richness of the visual arts, take several minutes simply to look at Ruth Bernhard's photograph *Bone and Passion Flower* (**1.1**). Allow it to fill your awareness; explore its textures and forms, and the play of light and shadow. Bernhard herself experiences life intensely. She said in 1979:

> Living is a matter of passion. I feel intensely about every single day. Here I am, seventy-three years old, and still possessed with the curiosity of my childhood. . . . If we are aware that everything around us is constantly changing, then we can't ever become bored or lose our zest for living.[1]

In 1987, her outlook had not changed:

12

I think that every day is like no other in the world. Every day is remarkable and extraordinary. I know that the shadows come and go, and that they are only the shadows of this moment and not of the next moment.[2]

We can participate in Bernhard's rich experience of life and bring to it something of ourselves by exploring what we see and feel in her photograph, if we give it our complete attentiveness and the curiosity we all had as children.

In addition to the intense act of looking, the learned art of seeing also depends on exposure to many kinds of art. A negative response to something unfamiliar may block our awareness of its worthwhile qualities. While "I like it" and "I don't like it" are basic and valid reactions to any work of art, we can expand our personal tastes by exploring unfamiliar styles and forms of art. Indifference and even hostility may have been our first reaction to something we come to understand and appreciate. Today's communication technologies give us the unprecedented opportunity to expose ourselves to an enormous range of artworks. Art of all times, all places, all disciplines is now available in photographic reproduction as well as in museum shows. In this chapter, we will begin by sampling this diversity while exploring the general forms of art, their functions, and the levels of appreciation that we can cultivate, broadening and deepening the "I like it" reaction.

Our seeing is also informed by our knowledge. Throughout this book, we will be building up a body of knowledge about what specific artists have tried to do, the AESTHETIC and mechanical means they have used to achieve their goals, and their relationship to the historical progression of art movements. In many cases, knowing something about the artists as individuals will further enrich our appreciation of the works they have brought forth.

FORMS OF ART

To many Westerners, the word "art" usually suggests paintings hanging in a museum, but of course paintings are just one of many types of art. The world of art includes three-dimensional as well as two-dimensional pieces; both applied and fine arts; and

1.2 IVAN LE LORRAINE ALBRIGHT, *Into the World There Came a Soul Called Ida*, 1929–30. Oil on canvas, 56⅛ × 47ins (142.5 × 119.4cm). © The Art Institute of Chicago. All Rights Reserved.

works not just for public, but also for private display.

Two- and three-dimensional art

There is a major conventional distinction between two- and three-dimensional artworks. THREE-DIMENSIONAL works have spatial depth as well as height and width. TWO-DIMENSIONAL works, by contrast, are developed on a flat PLANE without depth (though the surface may be somewhat built up with gobs of paint or gesso). Many two-dimensional pieces are nevertheless representations of the three-dimensional world. With *Into the World There Came a Soul Called Ida* (**1.2**), Ivan Le Lorraine Albright makes us feel that we are looking at a fully three-dimensional woman whose body is giving way to the decay of the flesh. If we are sensitive to the grotesque light-exaggerated lumpiness of her form and her expression on examining herself in the mirror, we may

13

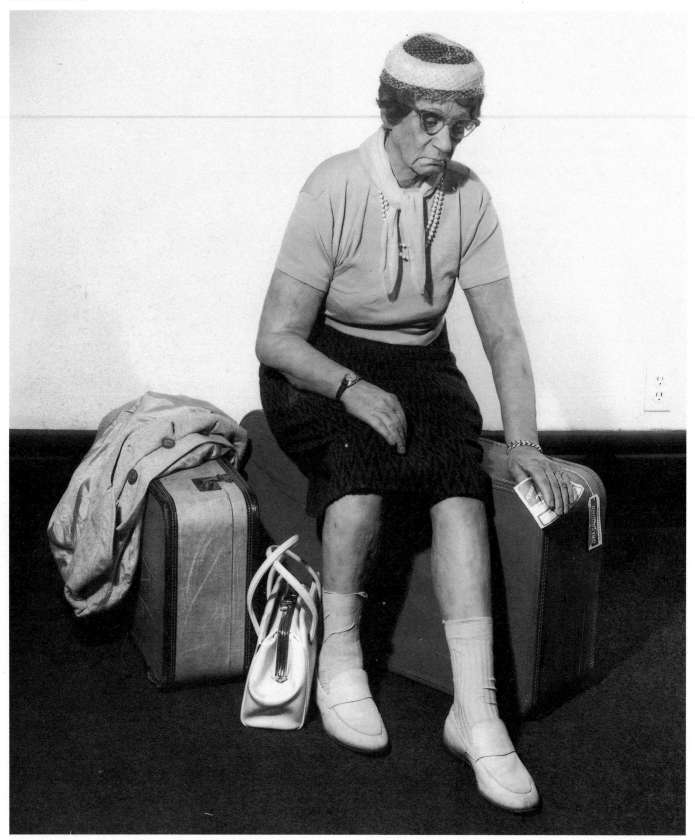

1.3 DUANE HANSON, *Woman with Suitcases*, 1973. Polyester resin and Fiberglas, life size. Collection Mr and Mrs Morton G. Newmann, Chicago.

even feel something of her emotion. The artist has drawn us into this illusion by skillful use of the elements of design, such as form, texture, space, and light, which we will be exploring in Chapter 2.

Since two-dimensional works are often framed and hung on a wall or shown on a television screen or in the pages of a book or magazine, they exist on a plane other than the three-dimensional world of our experience. To assign meaning to them requires a sophisticated act of perception. Not so with three-dimensional works: if nothing else, they are barriers that we have to walk around. They exist in the same three-dimensional space that we ourselves occupy. Duane Hanson's sculptures, such as *Woman with Suitcases* (**1.3**), are often mistaken for, and responded to, as real people. Life-sized Fiberglas and polyester casts of actual human models, dressed in real clothing and equipped with the familiar trappings of our lives, they directly evoke the same kind of response we would have if we encountered their living prototype. In this case, depending on our personality, we may feel empathy for the woman's fatigue, curiosity about her story, depression over her unhappiness, or distaste at her lack of physical beauty. Then there comes the strangely unsettling recognition that the figure is not alive, but is instead a highly realistic work of art.

Within the category of three-dimensional art there are many degrees of three-dimensionality. The flattest works approach two-dimensionality. These are called RELIEFS: works in which an image is developed outward or inward from a two-dimensional ground. Such pieces are often categorized by the degree to which figures project from the background. In a LOW RELIEF (or "bas relief"), figures exist on nearly the same plane as the background, almost as in a drawing, but are sufficiently carved that shadows appear on surfaces where the light is blocked. Coins are familiar examples of low-relief pieces. In the low-relief Moon House post used to support a roof beam by the Kwashkan Tlingit of the north-west coast of North America (**1.4**), the shadows enhance the drama of the piece, drawing attention to the moon and wolf symbols of the family's membership in the wolf clan. Nevertheless, no area is entirely detached from the ground.

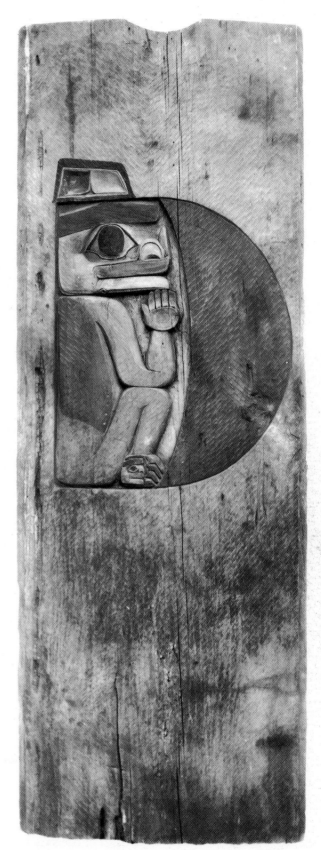

1.4 House Post from the Moon House, Port Mulgrave, Yakutat, c.1916–17. Wood with red, black, and green pigment and nails. Museum of the American Indian, Heye Foundation, New York.

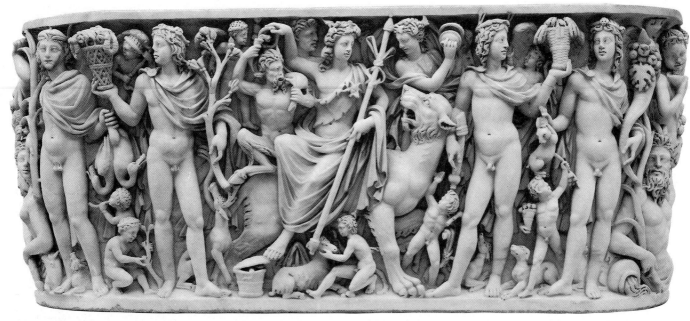

1.5 Sculptured sarcophagus representing Dionysos, the Seasons, and other figures, c. AD 220–230. Marble, 35½ × 87¾ × 36¾ins (90.2 × 222.9 × 93.3cm). The Metropolitan Museum of Art, New York, Purchase 1955 Joseph Pulitzer Bequest.

Technically, a work is considered a HIGH RELIEF only if at least half of the figures' natural spatial depth projects forward from the background. The fact that far more of the substrate is carved away than in a low relief creates a greater range of light and dark shadows that help to define the forms.

In the sculptured exterior of the Roman sarcophagus, or coffin (**1.5**), some limbs are completely undercut, lifting them away from the background entirely, while other more shallowly carved figures merge with the background. These variations in depth create a dynamic flow of values (modulations of darks and lights) and of projections toward and recesses from the viewer.

Some relief works, however, are not the result of carving into a block of wood or stone; rather, they are created by attaching materials to a closed backplane so that they project outward. Nevertheless, the basic orientation of a relief of any sort is the association of three-dimensional figures with a backing. Reliefs are principally designed to be seen straight-on; the farther to the side the viewer gets, the less sense the images make. The figures on the left of the sarcophagus in the photograph are hard to grasp because we see them at an extreme angle as the piece curves away from us; those on the right "work" because they are oriented in our direction.

Another form of three-dimensional art that is designed principally to be seen straight-on is called FRONTAL work. Although it is totally freestanding, allowing the viewer to walk all around it or turn it over if it is small, it does not invite viewing from more than one side. Necklaces are typically designed as frontal pieces; the interesting, worked side faces outward, while the back is often minimally worked and not designed to be seen. The decorative glass piece *Suzanne au Bain* (**1.6**) is not meant to be examined from the back or ends; its beauty lies totally in its frontal aspect. As one moves one's head ever so slightly from side to side, the opalescent glass seems to change colors, ranging from a milky blue to amber depending on the shifting relationship between the light source, the piece, and the angle of one's vision. It was designed in the late nineteenth-century flowing Art Nouveau style by René Lalique, whose creations included jewelry as well as glassware. We tend to "read" the piece as if it were a piece of jewelry, enjoying the sensual play of forms and colors across the front.

Three-dimensional art in the FULL ROUND is freestanding and designed to be seen from all sides. When a full-round piece is effective, it often makes people

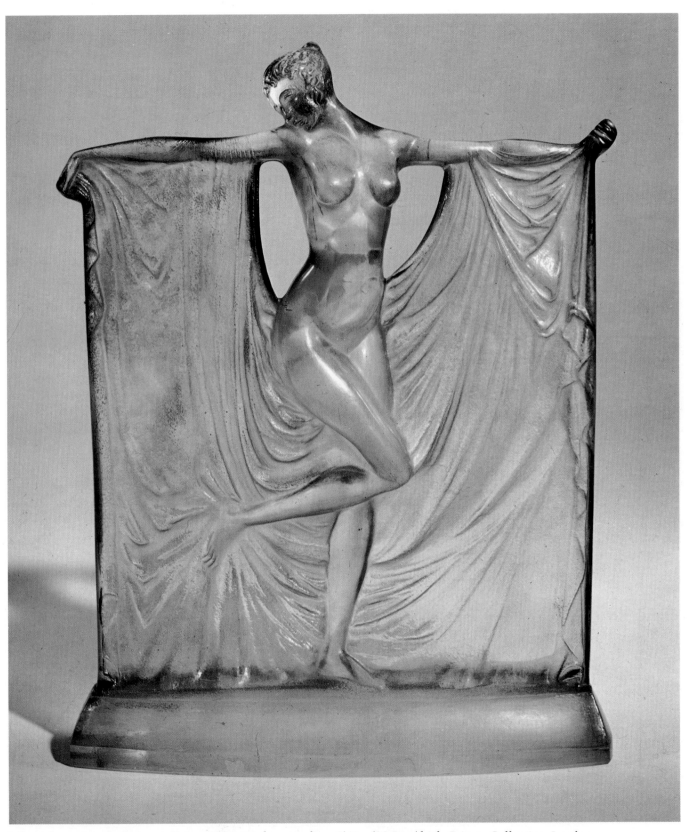

1.6 RENÉ LALIQUE, *Suzanne au Bain*, c.1925. Opalescent glass, 9¼ins (23.5cm) high. Private Collection, London.

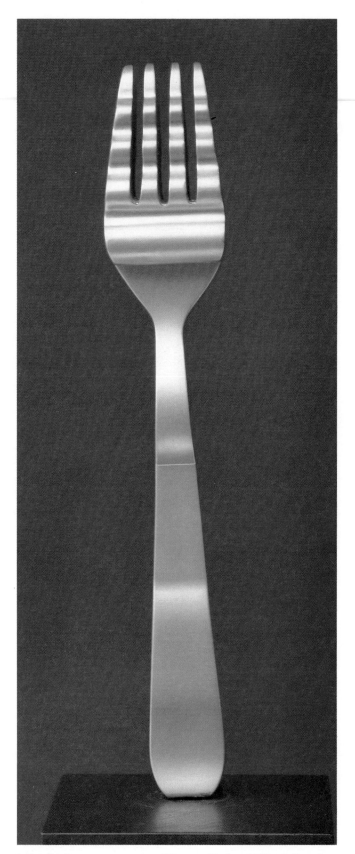 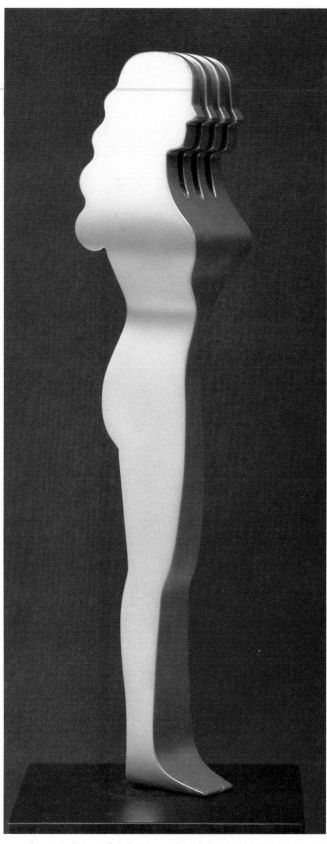

1.7 and **1.8** SHIGEO FUKUDA, *Woman/Fork*, c.1970–5. Gray lacquer on wood, c.9ins (23cm) high. Photos by Malcolm Kirk, New York.

want to walk all the way around it or turn it around in their hands to discover how it changes. A common lure artists use is to pique our curiosity to see what happens out of sight. If a leg disappears around a curve in the piece, we are likely to follow it to find the foot. Extreme examples of the changes possible in a full-round piece appear in the work of Japanese sculptor Shigeo Fukuda. In the playful sculpture shown here, what looks like a giant fork from one viewpoint (**1.7**) is transmuted into a woman when seen from another point of view (**1.8**).

The ever-changing quality of three-dimensional works in the full round can only be guessed at in the single two-dimensional photographs used to represent them. To fully appreciate a full-round piece, one must explore the real thing, from as many angles as possible, for each step and each movement of the head reveal new facets and new relationships among the parts of the piece.

An even fuller degree of three-dimensionality occurs in WALK-THROUGH works which become part of the environment through which we move. Landscape artists have long planned gardens as walk-through aesthetic experiences for us. A contemporary version of this experience is available to visitors to the Smithsonian Institution's central court, in Elyn Zimmerman's *Marabar* (**1.9**). We are invited to walk among the granite boulders, sensing and perhaps feeling their rough, organic strength and discovering the contrasting extremely smooth textures of the faces of those boulders that Zimmerman has cut and polished. These cut faces can only be seen

1.9 ELYN ZIMMERMAN, *Marabar*, 1984. Plaza and garden sculpture, National Geographic Society, Washington D.C. Five natural cleft and polished carnelian granite boulders, 36 to 120ins (91.4 to 305cm) high, surrounding a pool of polished carnelian granite.

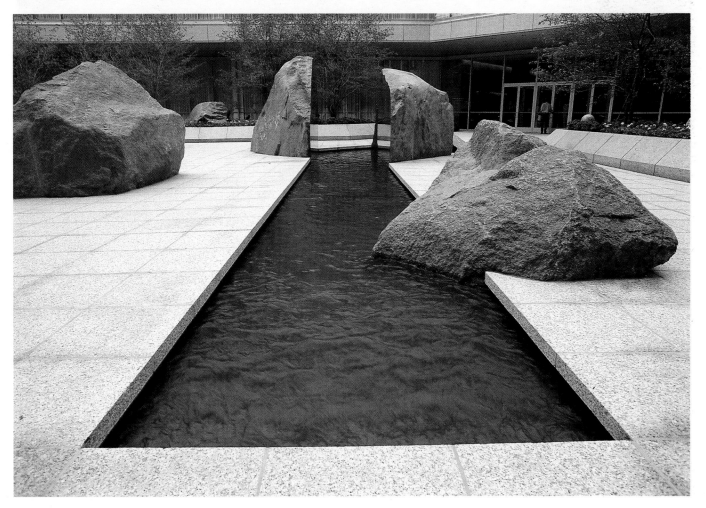

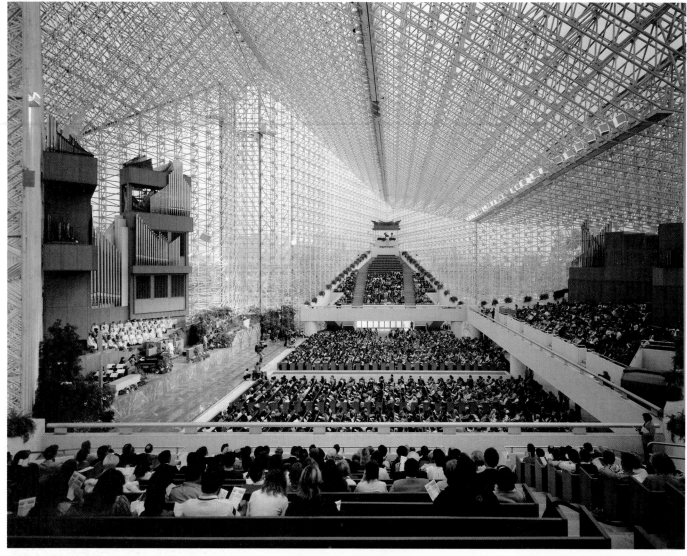

1.10 PHILIP JOHNSON and JOHN BURGEE, Garden Grove Community Church (Crystal Cathedral), Garden Grove, California, 1980.

from certain angles, so to experience the totality of the work we must walk varying paths through it, exploring what can be seen from many points.

All effective three-dimensional work subtly defines a certain area as "belonging" to it and to a certain extent influences our movements within this space. Work that surrounds the viewer – such as architecture – is the final step in this control, becoming not only an encompassing structure that we enter but also perhaps surrounding us with a certain psychological atmosphere. Architects Philip Johnson and John Burgee's Garden Grove Community Church (**1.10**), better known as the Crystal Cathedral, is designed to uplift local worshippers and television viewers with a multi-faceted experience of light,

drawn in through myriad panes of reflective glass and re-reflected off shiny interior surfaces. The 128-foot (39m)-high glass building is the setting for services by television evangelist Dr Robert Schuller, designed to emphasize the drama of his presentations with its vastness as well as its glittering lights, dancing fountains, marble pulpit, and energetic traceries of metal trusses holding the 10,900 panes of glass. Nearly 3000 people can be seated within its stretched four-pointed star form, with the longer dimension reaching 415 feet (127m) from point to point. Within this immense theatrical setting, one cannot maintain an everyday, humdrum attitude; whether or not one likes the theatrical approach to religion, one is inevitably touched by the drama of the architecture.

Fine and applied arts

Another kind of distinction that can be made among works of art is whether they were originally intended as objects purely to be looked at, or as objects to be used. The FINE ARTS, such as drawing, painting, printmaking, and sculpture, involve the production of works to be seen and experienced primarily on an abstract rather than practical level. Pieces of fine art may evoke emotional, intellectual, sensual, or spiritual responses in us. Those who love the fine arts feel that these responses are very valuable, and perhaps especially so in the midst of a highly materialistic world, for they expand our awareness of the great richness of life itself. The nineteenth-century sculptor Auguste Rodin, whose work *The Gates of Hell* (7.13—7.22) is the final piece we explore in this book, offered a passionate challenge to artists—and to those who are touched by their works: "The main thing is to be moved, to love, to hope, to tremble, to live."[3]

Constantin Brancusi's elegant *Bird in Space* (1.11) has no utilitarian function whatsoever. It is solely "art for art's sake," a highy refined suggestion of that ephemeral moment when a bird in flight catches the light. When it is displayed with lighting that brings out its highly polished surface, the impression is stunning. Indeed, it captured Brancusi's imagination, and between 1910 and the early 1950s he created a series of 28 similar birds in bronze and marble, explaining that "The Bird has fascinated me and will not release me."[4] It is based on the Rumanian legend of Maiastra, a magical golden bird whose feathers shone like the sun, illuminating the darkness. When struck by light, Brancusi's bronze birds become radiant light-giving sources, formless points of light in the immensity of space. Brancusi said,

> As a child, I used to dream that I was flying among trees and up into the sky. I have always remembered this dream and for 45 years I have made birds. It is not the bird that I want to express but the gift, the taking off, the *élan*. . . . God is everywhere. One is God when one forgets oneself and if one is humble and makes the gift of oneself, there is God in your work. . . . One lady in New York felt that and, kneeling, wept before one of my Birds.[5]

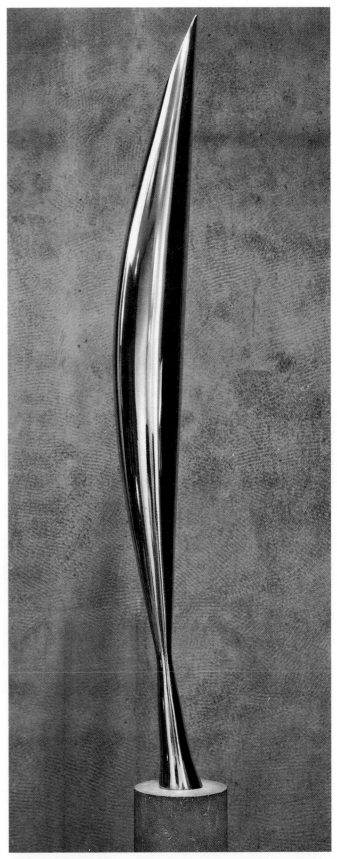

1.11 CONSTANTIN BRANCUSI, *Bird in Space*, 1928. Bronze (unique cast), 54ins (137cm) high. The Museum of Modern Art, New York.

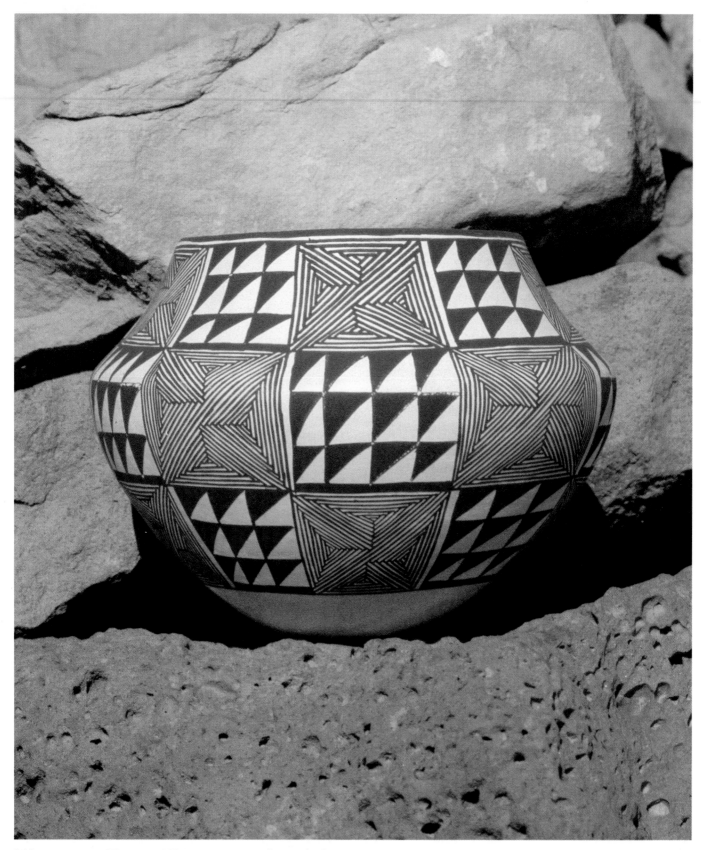

1.12 LUCY LEWIS, *Water jar*, 1979. Ceramic, 6ins (15cm) high.

In contrast to the nonfunctional appeals of the fine arts, the first purpose of the APPLIED ARTS is to serve some useful function. Lucy Lewis, a traditional potter from Acoma Pueblo in New Mexico, has applied a visually exciting surface decoration to her water jar (**1.12**), using the chewed end of a yucca spine to paint the fine lines, but the jar's main reason for being is to hold water. Some of the people of Acoma, which may be the oldest continually inhabited city in the United States, still follow the old ways, carrying water for drinking, cooking, and washing up to their adobe homes from natural rock cisterns on the cliff walls below. The forms of their water jars are therefore designed to prevent spilling and to balance readily on one's head. The pots must also be light in weight, so Acoma ware is some of the world's thinnest-walled pottery. Interestingly, the languages of most Native American peoples do not include a word that means "fine art." While they have traditionally created pottery, basketry, and weaving with a highly sophisticated sense of design, these pieces were part of their everyday lives.

The applied art of pottery-making, or CERAMICS, is one of the CRAFTS, the making of useful objects by hand. Other applied art disciplines are similarly functional. GRAPHIC DESIGNERS create advertisements, fabrics for interior decoration, layouts for books and magazines, logos for corporate identification, and so on; INDUSTRIAL DESIGNERS shape the mass-produced objects used by high-tech societies, from cars, telephones, and teapots, to one of the most famous visual images in the world: the Coca-Cola bottle (**1.13**). Other applied arts include clothing design, interior design, and environmental design.

Having made this traditional distinction between the fine and applied arts, we must note that the boundary between them is blurred. For one thing, certain works had functions when they were created that are now overlooked by those who consider them fine arts. The sculptures and stained glass windows of Gothic cathedrals were functional, designed to teach and inspire people of the Christian faith. Furthermore, many functional pieces have been made with the accent on their visual appeal rather than their functional qualities. The fine porcelain stemcup shown in Figure **1.14** is so beautifully designed that

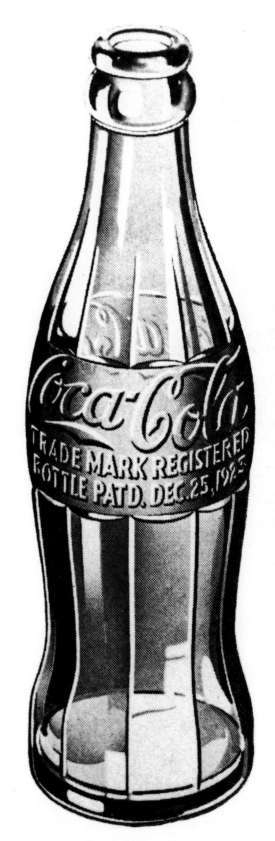

1.13 ALEX SAMUELSON, Coca-Cola bottle, designed 1913, patented (with minor modifications) 1915, 1923, 1937.

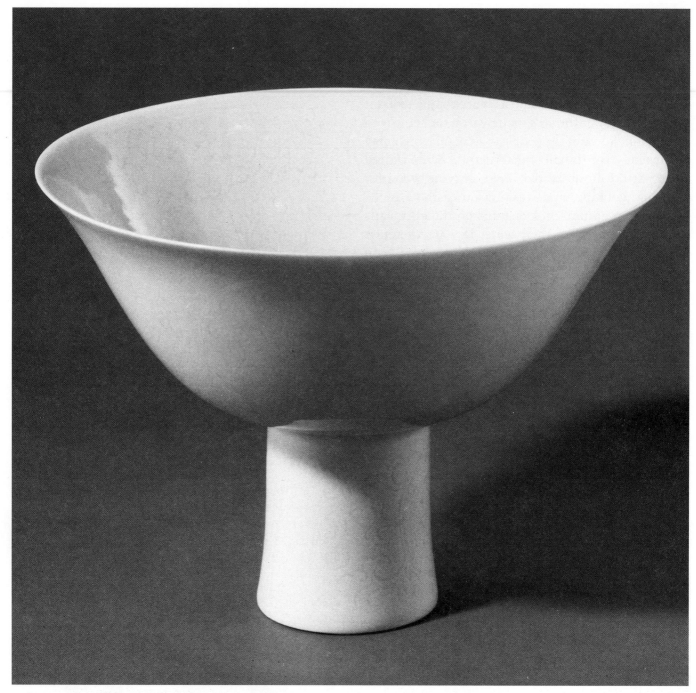

1.14 Stemcup, Ch'ing dynasty, Ch'ien Lung reign, 1736–39. Porcelain, 3⅞ins (9.8cm) high.

we cannot consider it simply a functional piece. It is equally a work of fine art, created for those who could afford to surround themselves with costly beauty, even in the functional furnishings of their homes. Another reason for the blurring of the distinction between fine and applied arts is our culture's increasing appreciation of the artistic sophistication of many functional pieces and for the time and skill involved in handmade crafts. Pueblo potters' works, along with all other kinds of applied design, are now included in the collections of many major museums, solely to be looked at.

Public and private art

An even less obvious distinction can be made between works designed to be displayed to the public at large and those intended chiefly for private use or enjoyment. Governments and public institutions have long commissioned art on a grand scale as public statements. Rome's Arch of Constantine (**1.15**) was designed to glorify Constantine's victory over his greatest rival, a victory that made him absolute ruler of the Roman Empire. Its surface is decorated with a series of reliefs used to honor the emperor (though some were actually plundered from monuments to earlier rulers); the massiveness of the arch is a symbol of the emperor's public stature.

In all cultures, religious institutions have been major patrons of artists, commissioning paintings and sculptures to help tell the story of their tradition to the masses and inspire the people with the same beliefs. Much of our greatest architecture has been created in the service of centralized governments and religious bodies, who had the power or commanded the devotion to raise the large sums of money needed for monumental projects. A dazzling contemporary display of this power is Japan's Science Expo 85, a high-tech world's fair in the newly created city of Tsukuba, with such showpieces as the neon cube that appears to float through what is actually a solid building, a dramatic illusion created by mirrored reflections (**1.16**).

1.15 Arch of Constantine, Rome, AD 312–315.

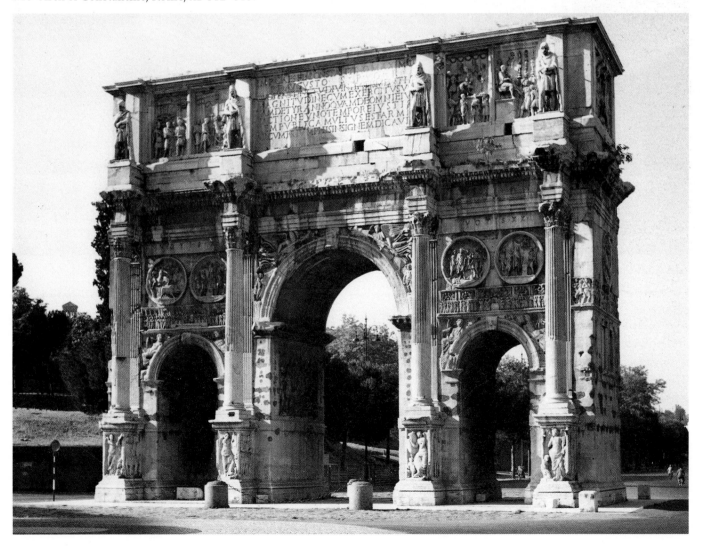

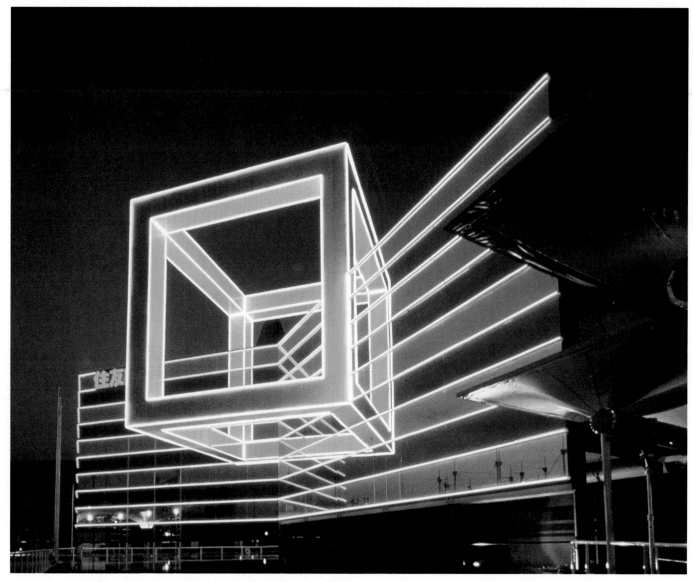

1.16 Sumitomo Building at Expo 85, Tsukuba Science City, Japan.

A relatively new form of concentration of wealth and power, business corporations and conglomerates are increasingly becoming patrons of the arts as well. They buy and display large paintings and sculptures, partly to impress their clients and partly as good investments, for the commercial gallery and auction-house system has fostered a vigorous market in art as a financial commodity.

By contrast, some works of art are of a scale and character that invite more intimate participation, though they may end up on public display at museums. Some Western paintings are "just the right size" to be hung over a sofa or mantel in a private home; magic fetishes may be intended for the use of only one person or family. In the traditional Japanese home, the *tokonoma* alcove, like the one shown in Figure **1.17**, is a quiet spot for private contemplation, usually decorated only by a single scroll painting and a vase with flowers, whose natural beauty is thought to humble anything created by humans. Originally set aside for worship of ancestors, the alcove still invites contemplation of the sacred in the midst of life.

1.17 *Tokonoma* alcove in a private home, Japan.

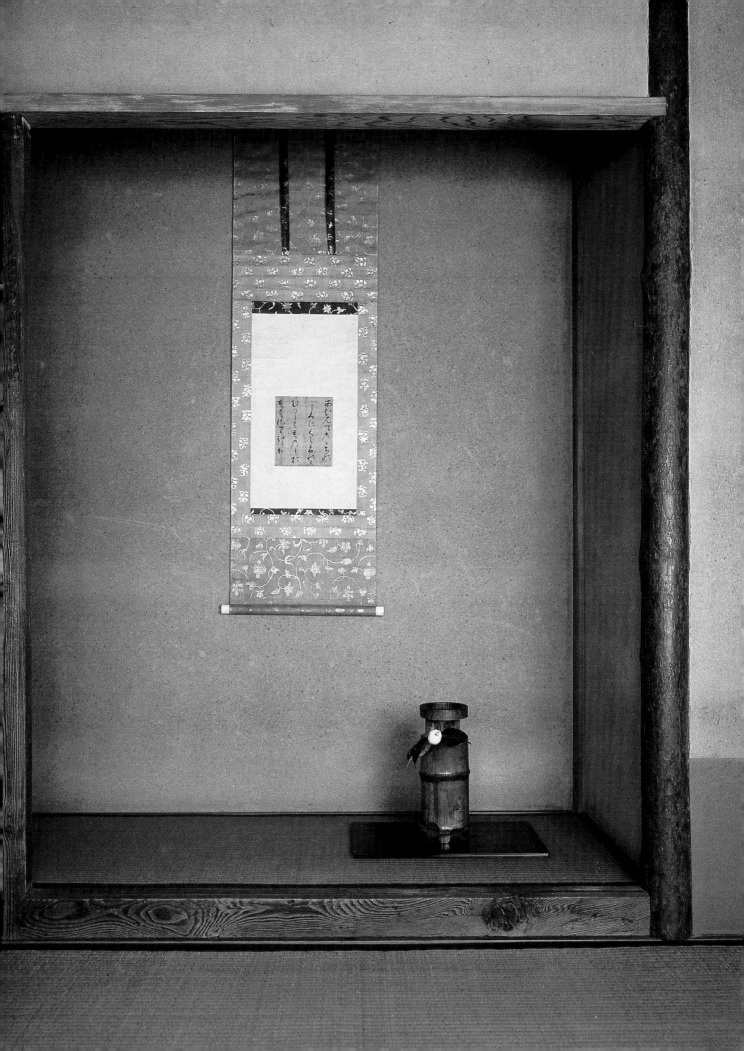

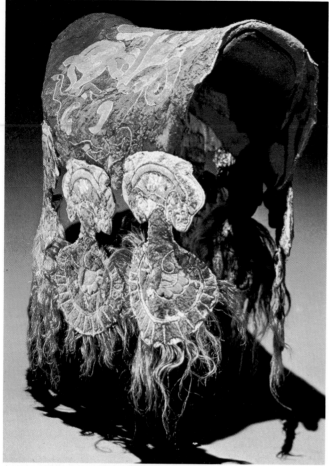

1.18 Saddle-cover from Pazyryk, Altai region, Russia, 5th century BC. Felt, leather, fur, hair, and gold, 46⅞ins (119cm) long. State Museum, Hermitage, Leningrad.

FUNCTIONS OF ART

In a sense, all art serves some purpose, whether it is strictly defined as fine or applied art. In fact, many pieces serve several purposes, both for the artist and for the viewer. In the following pages we will explore a number of the reasons why art is created, after first noting that the impulse for art may lie partly beyond our ability to explain our motives.

The creative impulse

The impulse to create art is so strong that artworks have appeared in all cultures, from the earliest days of our species. Perhaps as early as 70,000 years ago, our Paleolithic ancestors were apparently painting with red ocher, shaping ritual objects, and fashioning simple necklaces out of animal bones and teeth. Even weapons and sewing needles had decorations scratched onto them.

Artworks have been created and prized even by nomadic peoples whose belongings are limited to what they can physically carry as they follow the herds. Witness the beautifully detailed felt saddle cover (**1.18**) preserved in the permafrost of Siberia from the fifth-century BC Scythians, horse-riding nomads. The deep-frozen body of a Scythian reveals that the arts of these people included intricate body-tattooing, as well as sophisticated animal figures of gold, bronze, wood, and leather.

The question is not so much why people make art but why some people don't. As children, we humans begin trying to shape materials in our environment into artistic creations as soon as our hands are able. This effort usually continues unless it is stifled by those who try to teach us the "right" way to make art or who insist that we color within the lines of somebody else's drawing. We ourselves may compare our creations unfavorably with more skillful works and give up our attempts at making art.

On the other hand, training and practice are essential in the effort to make the hands create what the mind can imagine. Even the most seemingly uninhibited of modern artworks are created by highly trained artists who know very well what they are doing and struggle continually to perfect their skills.

The desire to create persists in some of us against all odds. Psychiatrist Oliver Sacks finds that some of his patients who cannot reach out to the world

1.19 JOSÉ, *Dandelion*. (From *The Man who Mistook his Wife for a Hat* by Oliver Sacks.)

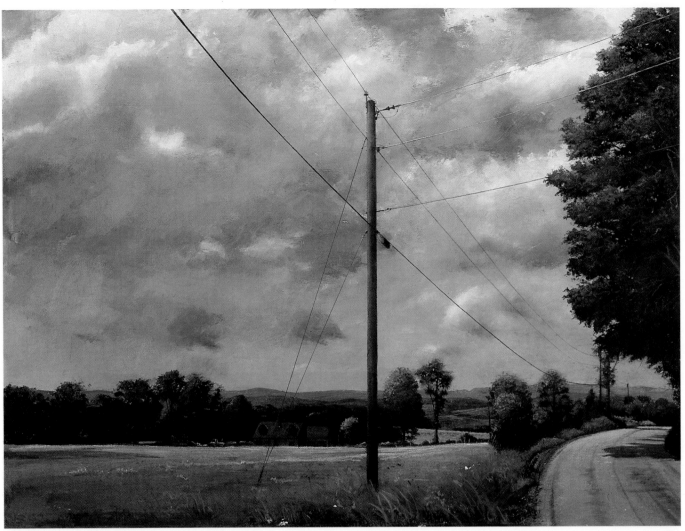

1.20 WILLIAM BECKMAN, *Power Lines*, 1982. Pastel on paper, 24⅜ × 33ins (61.9 × 83.8cm). San Francisco Museum of Art, The Glenn C. Janss Collection.

through any other means may communicate through artistic creations. He describes the case of José, a young man diagnosed as autistic and hopelessly retarded. Invited to draw, José responded with great concentration and joyful appreciation for his subjects, such as a dandelion (**1.19**). Sacks speculates that José has a direct link with reality, untouched by socially-learned ideas. When artists are working at their best, perhaps they, too, are in intense communion with life. The chance of experiencing this rare communion is at least part of what calls them to create—and us to share in the experience.

Representation of external realities

The drive to create is manifested in many ways. One is the effort to represent what we see in the world around us. Such art is called REPRESENTATIONAL or FIGURATIVE work. Within this category there are many degrees of realism.

William Beckman's *Power Lines* (**1.20**) illustrates the highest degree of realism. Rather than painting only the conventionally "pretty" aspects of this rural scene, he included what might be considered blots on the landscape—the road and power lines. Such work is often termed PHOTOREALISM, for it records external reality almost as accurately as a camera. Nevertheless, the artist carefully chooses what slice of life to represent, just as a photographer carefully selects views that work well aesthetically. In *Power Lines*, the road and power lines curve in flowing relationship and opposition to each other, creating a harmony of movement that is balanced by the staid quietness of the rural scene.

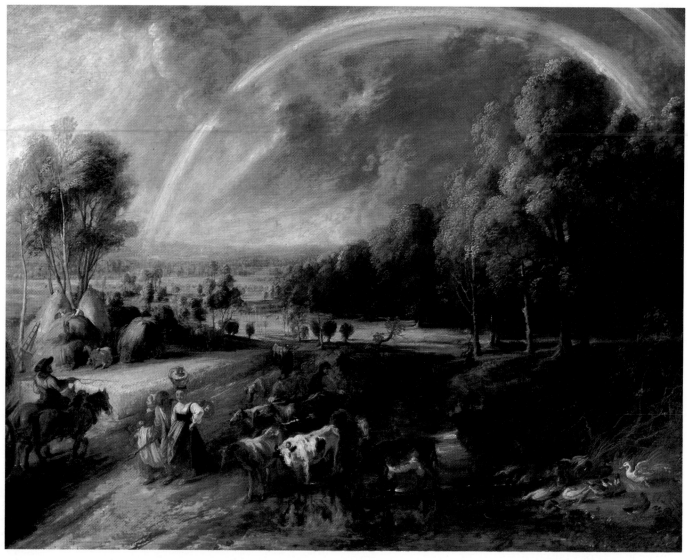

1.21 PETER PAUL RUBENS, *Landscape with Rainbow*, c.1635. Panel, 37¼ × 48½ins (94.6 × 123.2cm). Alte Pinakothek, Munich.

A step removed from photorealism is IDEALIZATION—transforming the real world into one that approximates one's ideas of perfection. Idealized paintings of the human form may be more beautiful than any of the flesh-and-blood models actually used. Peter Paul Rubens' *Landscape with Rainbow* (**1.21**) paints a glowing picture of country life. Everyone seems healthy and happy, even the animals, and the sun's appearance after a shower of rain floods the scene with light from over our shoulder to the left, bringing out a double rainbow in the sky. The pastoral idyll expresses Rubens' own apparent pleasure with life. The most celebrated artist of his times in Europe, he had recently married a woman much younger than himself and started fathering a second

family, and had bought an estate in the Flanders countryside which inspired paintings such as this one.

Another kind of shift from absolute realism is STYLIZATION—emphasizing principles of design rather than exact representation when working with natural forms. The wolf in the Tlingit house post (1.4) has the ears, jaws, and clawed feet of a wolf, but the wolf form has been highly stylized according to sophisticated Tlingit artistic conventions. Similarly, Ando Hiroshige, one of the great masters of the Japanese color woodcut, presents a highly stylized view of a rural landscape in *Maple Leaves at the Tekona Shrine, Mamma* (**1.22**). The forking trunk of the tree in the foreground is presented as a flattened

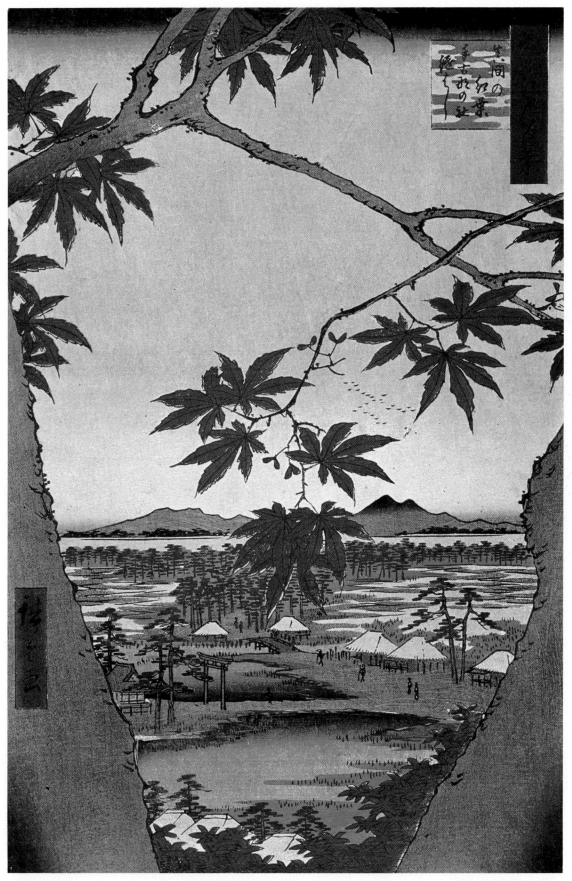

1.22 ANDO HIROSHIGE, *Maple Leaves at the Tekona Shrine, Mamma*, 1857. Polychrome woodblock print, 13¾ × 9⅗ins (35 × 24cm). The British Museum, London.

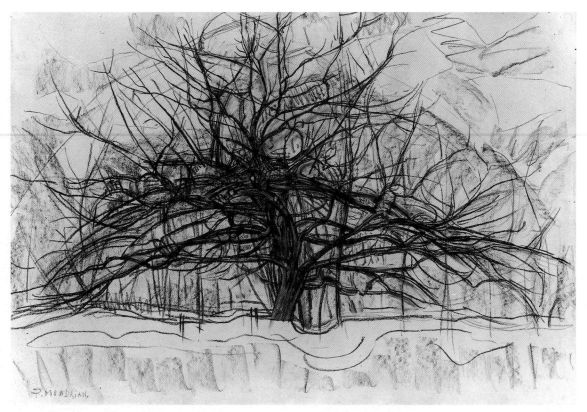

1.23 PIET MONDRIAN, *Tree II*, 1912. Black crayon on paper, 22¼ × 33¼ins (57 × 85cm). Haags Gemeente Museum, The Hague.

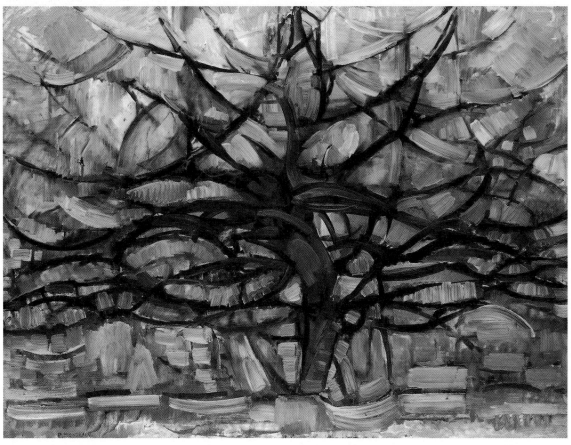

1.24 PIET MONDRIAN, *The Gray Tree*, 1912. Oil on canvas, 30½ × 42ins (78 × 107cm). Haags Gemeente Museum, The Hague, on loan from S. B. Slijpen.

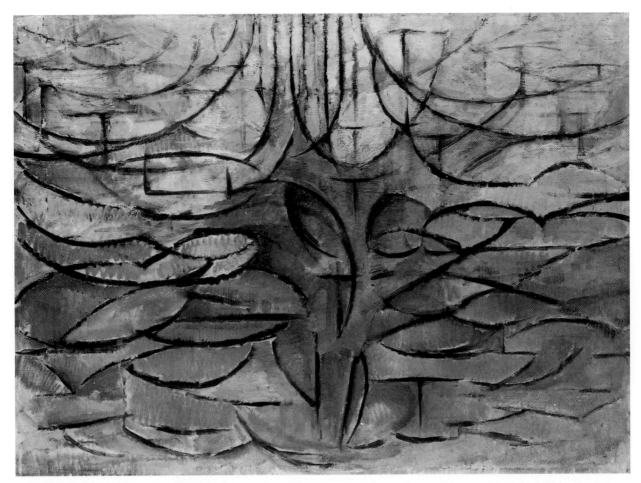

1.25 PIET MONDRIAN, *Flowering Apple Tree*, 1912. Oil on canvas, 27½ × 41¾ins (69.9 × 106cm). Haags Gemeente Museum, The Hague.

shape to frame what lies beyond. The changing colors of the sky are chosen more for their design interest and their contrast with the maple leaves than for their true-to-life quality. The houses and trees and even the human figures appear as lines, shapes, and colors, rather than as detailed representations of individually differing objects.

A somewhat different approach to figurative art is called ABSTRACTION: extracting the essence of real objects rather than representing their surface appearance faithfully. A series of trees by the Dutch artist Piet Mondrian illustrates the process of increasing abstraction. The first one shown (**1.23**) is a fairly representational depiction of what appears to be an old apple tree, with riotous interplay among the lines of the main branches and the secondary suckers that shoot upward from them. In the second (**1.24**), Mondrian has in effect pruned away the suckers, leaving only the branches that form a rhythmic series of arcs, echoing and counterbalancing the strong left-

ward arc of the main trunk. Mondrian also develops interest in the shapes of the spaces between the branches by painting them as if they had textures of their own. In the third, most abstract, tree image (**1.25**), the thickness of trunk and branches is also pared away, leaving only the interaction of arcing lines and the spaces between them. Here Mondrian has reduced the visual essence of a tree as lines in space to its bare bones.

The opposite extreme from photorealism is NONOBJECTIVE or NONREPRESENTATIONAL work— that which makes no reference at all to objects from the physical world. Richard Diebenkorn's *Ocean Park* series, of which #115 is shown in Figure **1.26**, is clearly nonobjective. The title of the series refers to the area of Santa Monica, California, where he has his studio, rather than to any physical imagery. He seems to be working instead with the pure elements and principles of design, particularly a counterplay between rigidly geometrical lines and shapes and a

1.26 RICHARD DIEBENKORN, *Ocean Park 115*, 1979. Oil on canvas, 104¼ × 59⅛ins (254.5 × 205.7cm). The Museum of Modern Art, New York, Mrs Charles G. Stachelberg Fund.

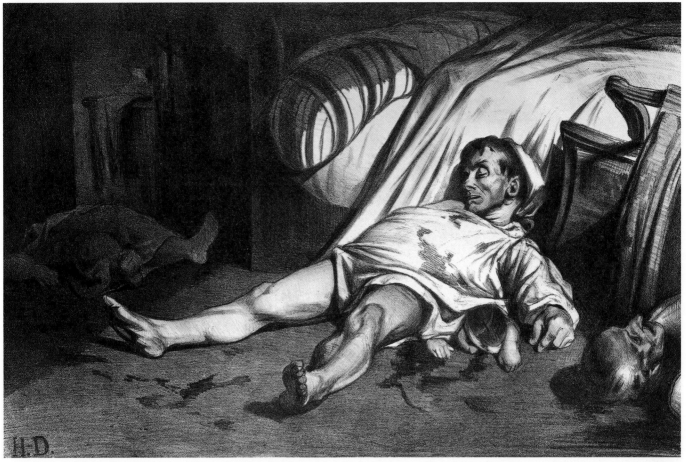

1.27 HONORÉ DAUMIER, *Rue Transnonain*, 1834. Lithograph, 11¼ × 17⅜ins (28.5 × 44cm). Victoria and Albert Museum, London.

more organic sense of weathered, light-and-color-filled spaciousness created by repeated SCUMBLING (dry-brush applications of thin layers of paint) and scraping of paint pigments. To strain to find figurative imagery in these paintings is to mistake the artist's intentions.

The less representational a work is, the more we must bring to it to appreciate it. In Mondrian's more abstract trees, we have to use our memories of trees to interpret the images. We are also asked to become intellectually involved in discovering relationships between lines and spaces. When all figurative imagery is deleted, as in Diebenkorn's work, our response no longer has any base in our experiences of the physical world. Instead, we can explore the work as one would explore virgin territory, with no familiar landmarks and only our own perceptual acuity and appreciation for design as our guide.

Recording one's times

Another outlet for the creative impulse is the creation of works intended to record something in the political or social rather than physical environment, to inform the public or to preserve an event for history. Today photography and television have largely taken over this function; in the past, other arts were used as means of recording. Honoré Daumier created thousands of lithographs documenting for satirical magazines the social and political ferment in industrializing Paris. His *Rue Transnonain* (**1.27**) was intended to bring to public view a massacre of sleeping civilians by soldiers; shot at by someone from this building in the working quarter, the soldiers stormed it and killed everyone inside.

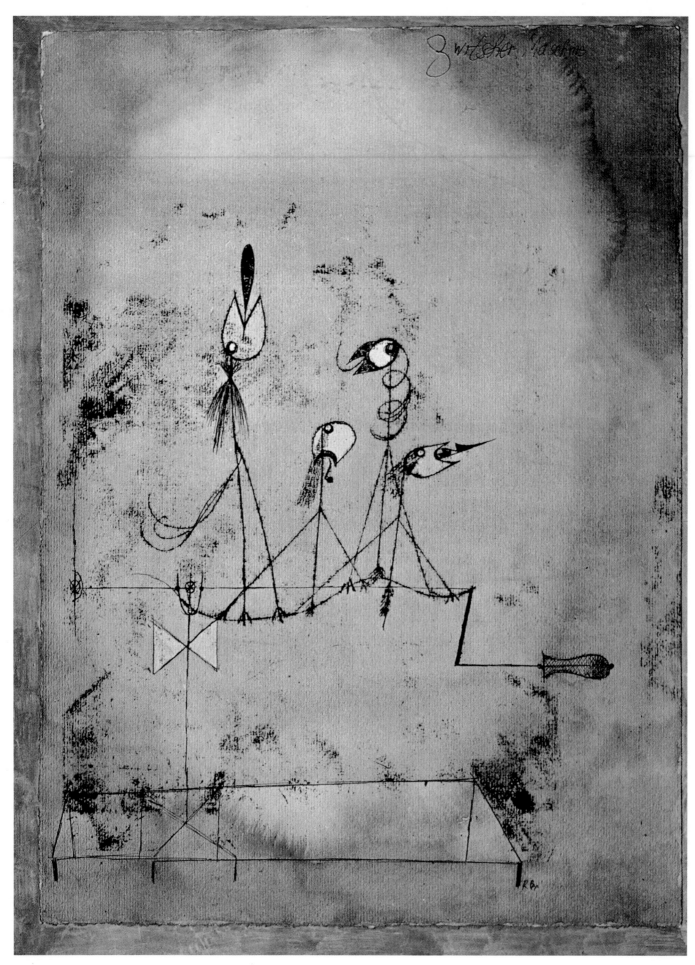

1.28 PAUL KLEE, *Twittering Machine*, 1922. Watercolor and pen and ink, 16¼ × 12ins (41.3 × 30.5cm). The Museum of Modern Art, New York.

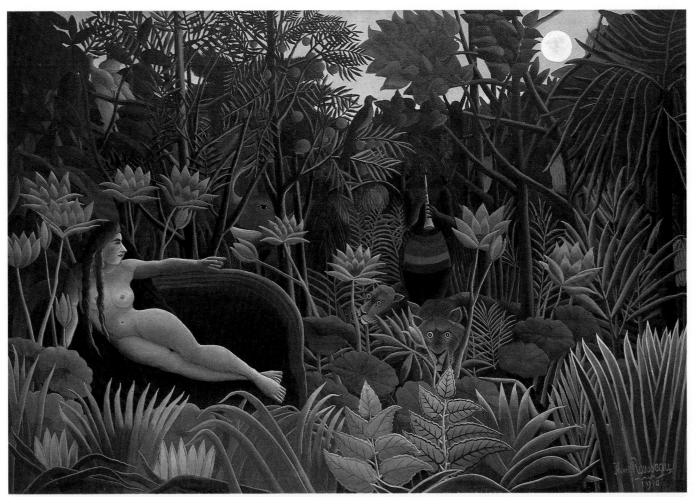

1.29 HENRI ROUSSEAU, *The Dream*, 1910. Oil on canvas, 80½ × 92½ins (205 × 299cm). The Museum of Modern Art, New York, Gift of Nelson A. Rockefeller.

Inner experiences

Rather than taking images or events outside themselves as their subjects, many artists have explored their own interior worlds. One aspect of this inner world is the capacity for FANTASY—for imagining things that have never been seen, such as Paul Klee's *Twittering Machine* (**1.28**). Despite the delicate playfulness of this painting, Klee spoke about the act of artistic creation very seriously, as having spiritual connotations. In his *Creative Credo* he asserted that "visible reality is merely an isolated phenomenon latently outnumbered by other realities." The method he used to gain access to other realms of possibility was to approach his materials with no preconceived subject matter, allowing unconscious

understandings to guide his hand. "My hand is entirely the implement of a distant sphere,"[6] he explained. "What artist does not yearn to dwell near the mind, or heart, of creation itself, that prime mover of events in time and space?"[7]

Another artist who dove into the unconscious to bring forth fantasy images was Henri Rousseau. A retired Parisian customs collector, he painted exotic landscapes and creatures that he had never seen, such as *The Dream* (**1.29**). The NARRATIVE, or "story," within the painting suggests the illogical happenings and inventive landscapes we experience in our dreams. Rousseau was a NAIVE ARTIST, one who had never been trained in the principles and techniques of art. For instance, the lighting in *The Dream* does not seem to come from the direction of the moon;

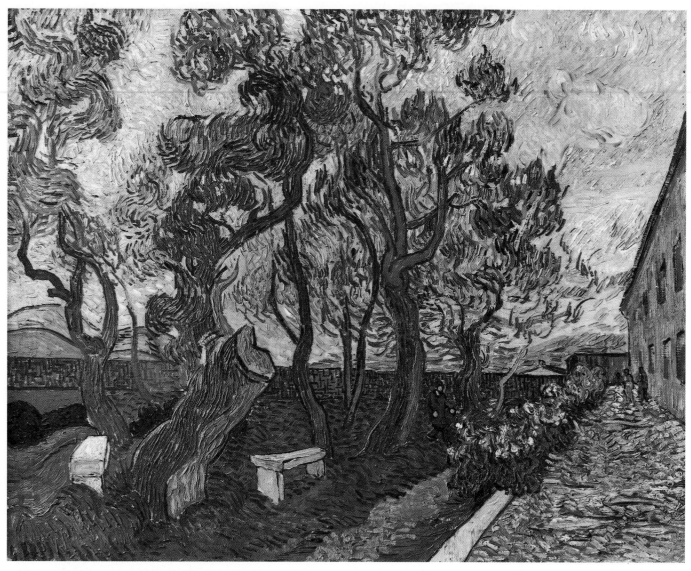

1.30 VINCENT VAN GOGH, *The Park of the Asylum, Saint Rémy de Provence*, 1889. Oil on canvas, 28¾ × 36¼ins (73 × 92cm). Folkwang Museum, Germany.

1.31 Photograph of the Park of the Asylum.

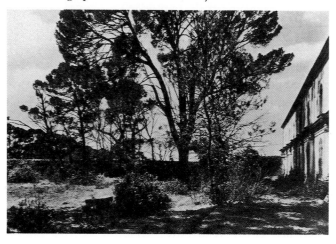

Rousseau placed highlights and shadows where he wanted them, rather than where they would logically fall. Unencumbered by ideas of how things "should" look or be represented, he was highly successful at tapping into a world of archetypal images that we respond to on some level beyond thought. His natural sense of design gives a haunting power to these land-scapes of the soul.

In some cases, artists draw their imagery from external realities but project their own state of mind onto them. Some quality inside the artist communi-cates with that quality in the outer world, revealing inner truths: intangibles within the tangible. One

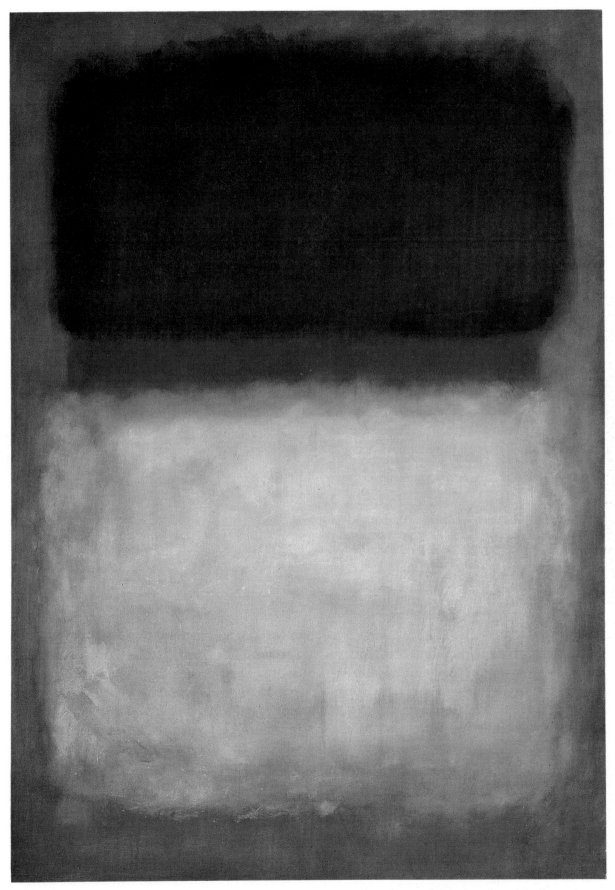

1.32 MARK ROTHKO, *Green on Blue*, 1956. Oil on canvas, 89¾ × 63¼ins (228 × 161cm). University of Arizona Museum of Art, Gift of Edward J. Gallagher, Jr.

who worked this way was Vincent van Gogh. His *The Park of the Asylum* (**1.30**) is either highly subjective or highly visionary, or both. An extremely sensitive patient in the insane asylum, he could sense the heat of the sun, the power of the wind, and the dynamic life-force of the trees, all blazing and writhing upward together. His painting of the asylum's park reveals a vibrant reality lying behind the surface that most people see. A photographer has recorded the same view more objectively (**1.31**); it seems altogether ordinary and docile in comparison with van Gogh's perceptions.

Inner experiences may also be depicted directly, as it were, without any imagery from the outer world. Sometimes their subject matter is sheer emotion, beyond form. Such is the case in the work of Mark Rothko, whose own emotions led him to commit suicide in 1970. His sublime nonobjective paintings, such as *Green on Blue* (**1.32**), offer large, hovering, soft-edged fields of color for quiet contemplation. People often respond to them with powerful emotion, and this was Rothko's intention. He said,

> I am interested only in expressing the basic human emotions—tragedy, ecstasy, doom and so on—and the fact that lots of people break down and cry when confronted with my pictures shows that I *communicate* with those basic human emotions. The people who weep before my pictures are having the same religious experience I had when I painted them. And if you . . . are moved only by their color relationships, then you miss the point.[8]

Spiritual expressions

As may already be apparent in the words of the artists quoted, much art is highly spiritual in its inspiration and its intentions. Spirituality is different things to different people. It ranges from interest in the mysteries of one's own psyche, to interest in the supernatural, to worship of the divine within the framework of one of the organized religions.

In many cultures, interest in the unseen aspects of life has led to attempts to control them. The magical figure from Kongo, Zaire (**1.33**), is designed to ward off evil presences. It is studded with power objects that have been added over time to build up a "force field" to protect its owners.

A tremendous amount of the world's art has been

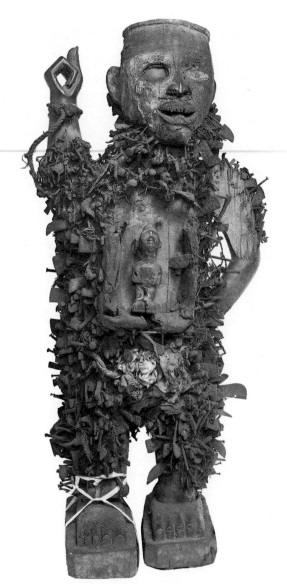

1.33 Magical figure, Kongo, Zaire, 53ins (135cm) high. The British Museum, London.

created as objects for devotion and inspiration. *The Ecstasy of St Teresa* (**1.34**) is the altarpiece of an entire chapel created by the great Baroque sculptor and architect Gianlorenzo Bernini. Its spiritual intent is to inflame the worshipper with the same sensuous ecstasy as Teresa of Avila experienced when in a vision she was speared by an angel, leaving her "completely afire with love of God."

Power and propaganda

Another way in which artists' talents and creativity have been engaged is in the creation of works that allow the person or group who paid for them to gain prestige. In addition to the spiritual intentions of the

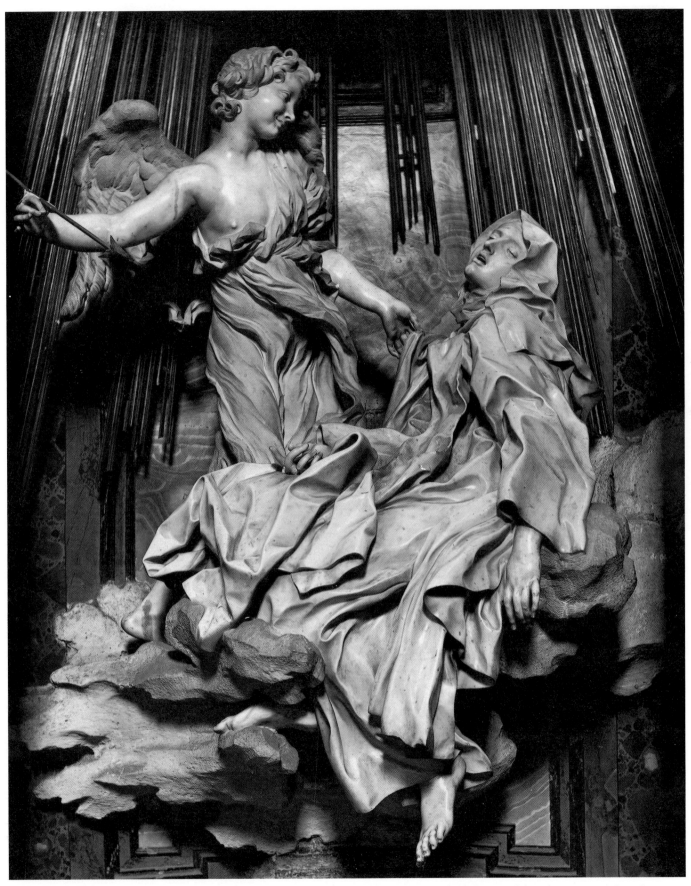

1.34 GIANLORENZO BERNINI, *The Ecstasy of St Teresa*, 1645–52. Marble, stucco, and gilt bronze, life size. Cornaro Chapel, Church of Santa Maria della Vittoria, Rome.

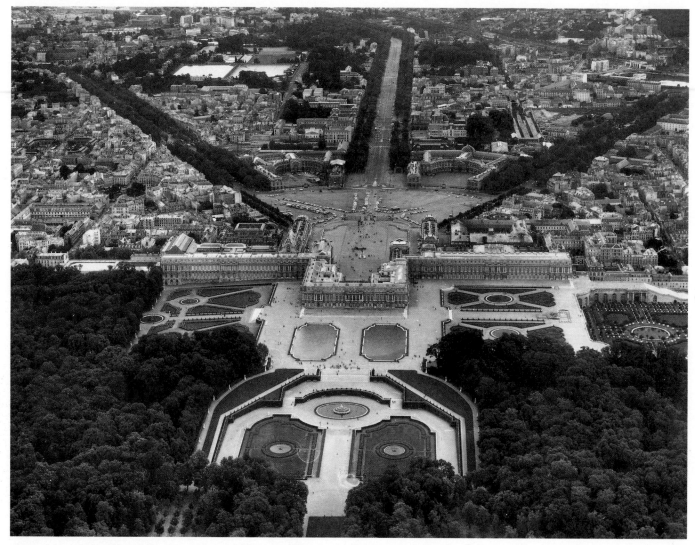

1.35 LOUIS LE VAU and JULES HARDOUIN-MANSART, Palace of Versailles, 1669–85.

Cornaro Chapel which houses *The Ecstasy of St Teresa*, it was intended as a place to celebrate the future remains of Cardinal Cornaro, who commissioned it, and to honor his family. The intimate chapel is ornamented with such splendor that it must have served as a statement not only about the Cardinal's devotion to St Teresa but also about his wealth. Certainly this was an intention behind the commissioning of many secular monumental pieces, such as Louis XIV's colossal palace at Versailles (**1.35**). A huge corps of architects, interior designers, sculptors, painters, and landscape artists worked for almost half a century to create not only the largest and grandest palace the world had ever seen, surrounded by an immense and elaborate park, but also an entire city for government officials, courtiers, servants, and the military. Their buildings radiate along avenues that intersect in the king's bedroom, symbolizing the vast wealth and power of the absolute monarch.

Mingled with a show of wealth is the desire to impress the public with one's good taste in art. Today corporations often choose for this purpose large nonobjective paintings and sculptures. These can suggest a sophisticated, contemporary corporate image and have no subject matter that would offend

1.36 ISAMU NOGUCHI, *Red Cube*, 1968. Marine Midland Plaza, New York.

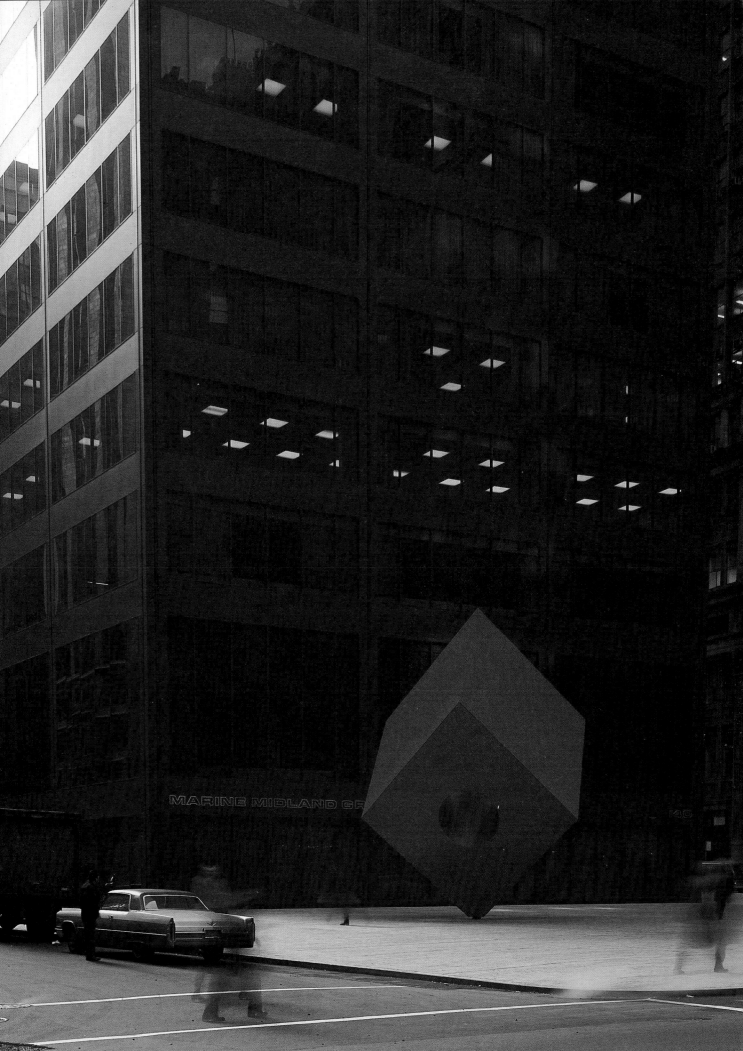

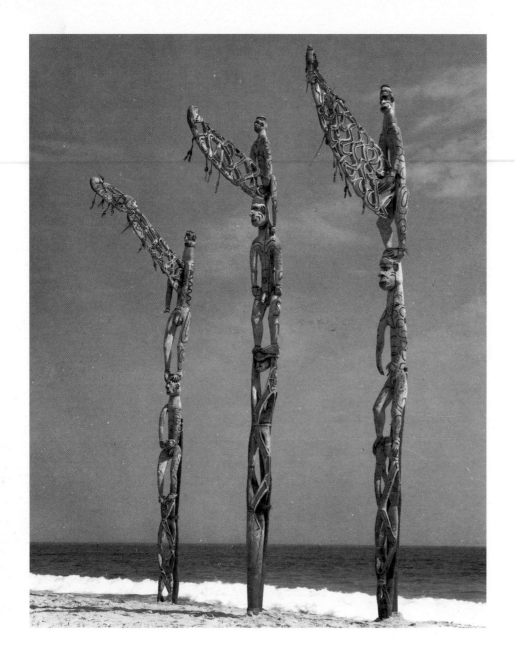

1.37 Ancestral poles, Asmat, New Guinea. Wood, paint, and sago palm leaves, c.18ft (5.5m) high.

anyone. But it takes wealth and a certain daring to commission monumental modern sculpture to occupy expensive urban real estate. The point of using valuable Manhattan ground-level space for a huge cube resting precariously on one corner (**1.36**) may escape the uninitiated, but this sculpture by Isamu Noguchi is a signal to those who know something about art that its owner, the Marine Midland Bank, is imaginative, forward-looking, and prestigious.

Some works are more blatantly assertions of power. Across the globe, a universally recognized symbol of power – and perhaps of aggression – is the form of the erect phallus. When getting ready to

avenge a member's death in war, the Asmat head-hunters of Melanesia topped poles representing their ancestors with highly exaggerated phallic symbols (**1.37**), as if to say, "Look how powerful we are! Not only do we have the strength of our ancestors behind us, but we are also men of colossal masculinity!"

Governments like to project positive self-concepts, presenting a proud image for local citizens and visitors. Such a monument to civic pride is the Jefferson National Expansion Memorial magnificently engineered by architect Eero Saarinen (**1.38**). Built in 1966, it is part of a federal project originally funded under Franklin D. Roosevelt to glorify the territorial expansion of the United States. The great arch pre-

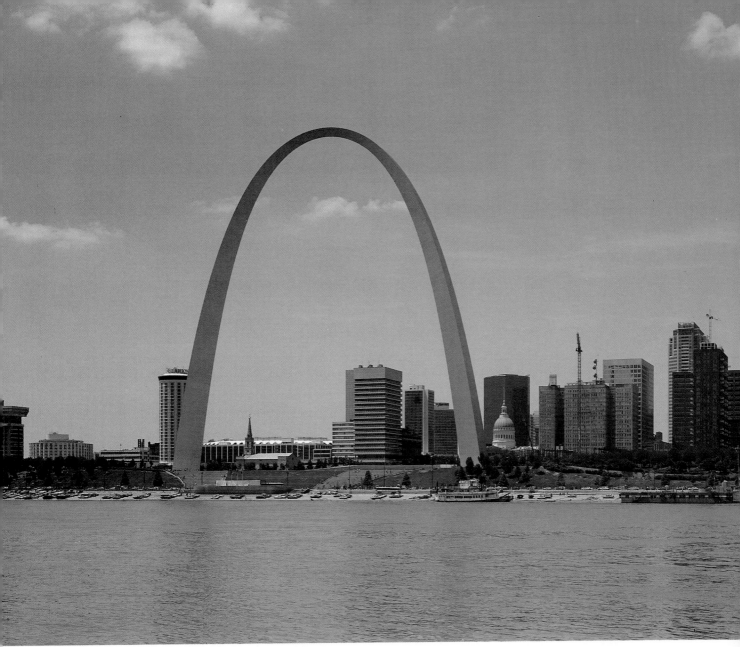

1.38 EERO SAARINEN, Jefferson National Expansion Memorial (*The Gateway to the West*), St Louis, Missouri, 1966.

sents a visible symbol of St Louis as "The Gateway to the West." From a distance, it appears as a line thrown against the sky. Up close, its girth becomes apparent: Its triangular form is 54 feet (16.2 meters) along each side at its bases, carrying stairways and elevators up to an observation room at the top. This soaring structure can be seen not only from the city but also from miles around.

The same artistic skills that can express civic pride can also be used coercively. Graphic designers are skillful at using consumers' interest in self-pride to convince them to buy products. Advertisements for expensive cars often speak to people's aspirations to wealth and good taste; ads for clothing often manipulate people by their desire for sex appeal. Tragically, Adolf Hitler had a clear sense of the tremendous impact of media propaganda and used it extensively to build popular support for his regime. Nazi propagandist Ludwig Hohlwein's poster (**1.39**) presents such a powerful visual image that the mere words "Und du?" ("And you?") convey the aggressive challenge to the civilian to become part of the war machine. We are shown only the storm trooper's masculine features, nothing of his individuality, making him an abstraction for the idea of The German Soldier: a superhumanly strong man with the

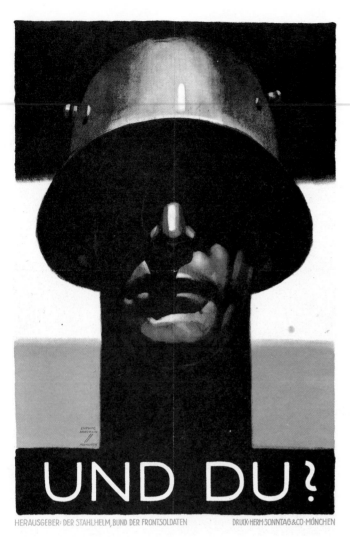

HERAUSGEBER: DER STAHLHELM, BUND DER FRONTSOLDATEN DRUCK·HERM·SONNTAG&CO·MÜNCHEN

1.39 LUDWIG HOHLWEIN, Poster, c.1943. Library of Congress, Washington D.C., Poster Collection.

power of the group and the group's history behind him. The angle from which he is shown makes us look up at him, and the deliberate mingling of hero-worship, intimidation, and brooding power are characteristic of the totalitarian values of the regime that commissioned the image.

Entertainment

In a lighter vein, many works of art are intended at least partially as entertainment by artists who are having fun. Certainly Shigeo Fukuda's woman-to-fork metamorphosis (1.7, 1.8) is more visual game than serious commentary. Designers Ivan

Chermayeff and Milton Glaser came up with the whimsical idea of adding appendages to toy boxes (**1.40**) to make them into mock animals, with fins and crests for lid handles and comically moving legs, tails, and bubbles for wheels. A more serious intent behind these pieces was to create marketable designs for The Golden Eye, a design center in India enabling Indian artisans to use their skills profitably without sacrificing aesthetic sophistication.

Many artists also like to play with visual puns and in-jokes. To those who are familiar with the originals, Russell Connor's *The Discovery of Venus* (**1.41**) is a hilarious pastiche of two romantic nineteenth-century paintings: Théodore Gericault's *Raft of the Medusa* (which appears in its original form as Figure 6.29) and Alexandre Cabanel's version of the birth of Venus. Connor, who paints portions of famous pictures with considerable fidelity to the originals, while making them appear to be logically unified, provides a tongue-in-cheek commentary:

> The desperate survivors in Gericault's huge, fact-based *Raft of the Medusa*, 1818, were originally waving to the distant French gunboat which rescued them. Who knows what fantasies filled the horizon until that moment? The ultimate barroom nude, *The Birth of Venus*, 1863, by Cabanel, presents itself as one possibility.[9]

The search for beauty

Although not all art is meant to be beautiful, satisfying the desire for beauty is one of the major functions of many works of art. Confronted by a physical world that often jars the senses, sensitive individuals have long sought refuge in beauty, both natural and manufactured. To surround ourselves with beautiful things soothes our spirits and brings a sense of the sublime into everyday life. Many artists have responded to this quest for the beautiful, but there are no absolute guidelines for them to follow.

Consider the changing ideas about the human figure, for example. To the ancient Greeks, the Warrior from Riace (**1.42**) represented the epitome of physical beauty in a male. Unadorned and highly toned, the figure is presented in a stance that accentuates the pleasing swell of buttocks and upraised arm to bring out the biceps. The bronze body is convincingly realistic and yet idealized to probably greater

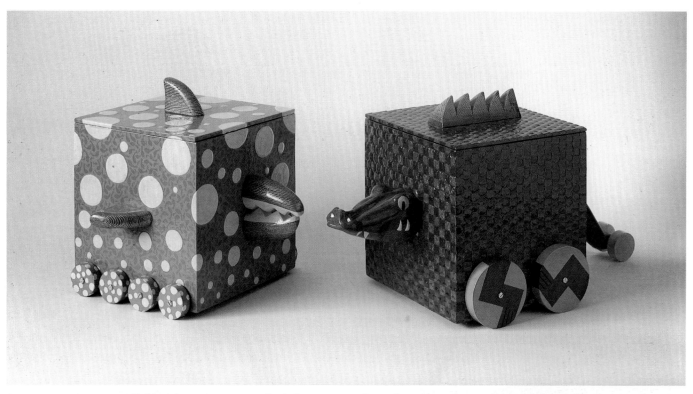

1.40 IVAN CHERMAYEFF (left) and MILTON GLASER (right), Papier-mâché and wood toy boxes, 1986, for the Golden Eye Project. Cooper-Hewitt Museum, New York.

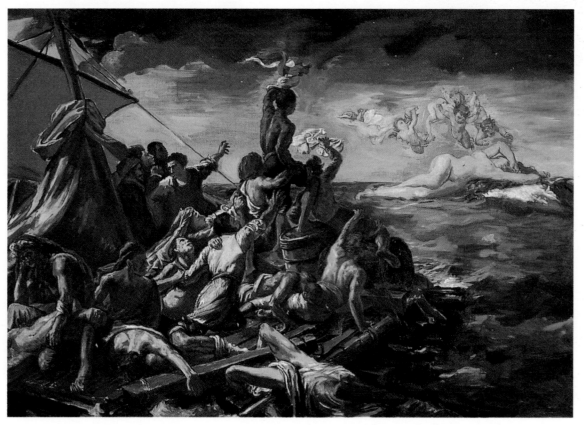

1.41 RUSSELL CONNOR, *The Discovery of Venus*, 1986. Oil on canvas, 36 × 52ins (91 × 132cm).

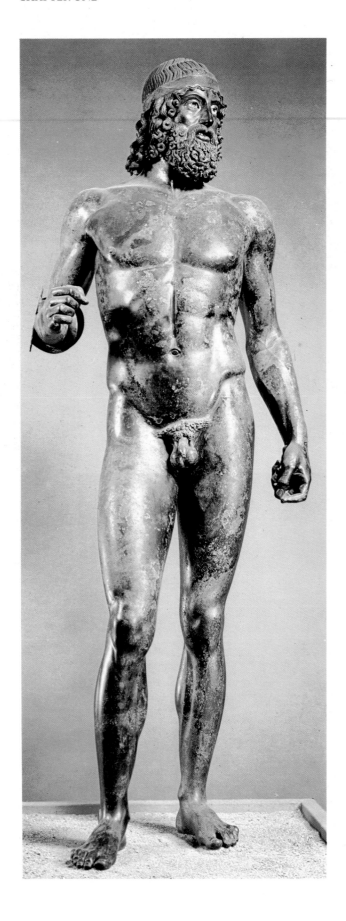
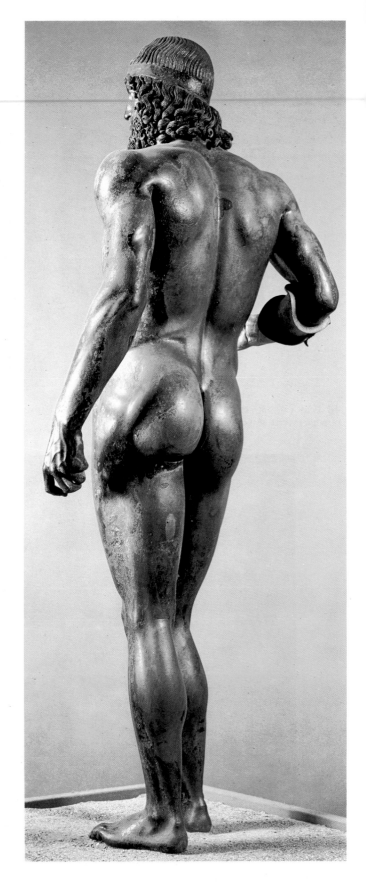

1.42 Warrior from Riace, 5th century BC. Bronze with bone, glass-paste, silver and copper inlaid, 79ins (200cm) high. Museo Nazionale, Reggio Calabria.

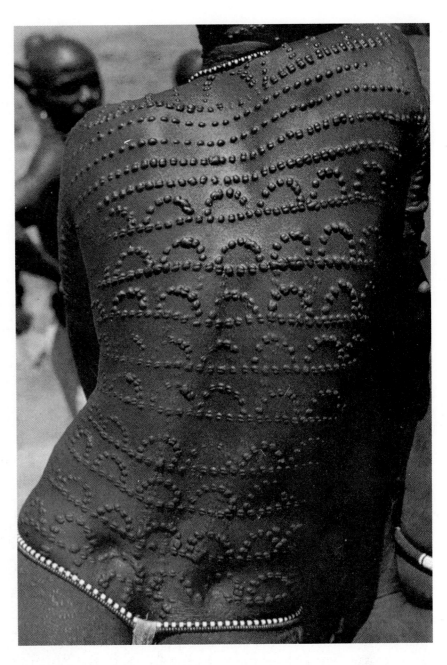

1.43 Scarification on a Nuba woman.

physical beauty than any Greek actually possessed. The nude human body—when in good shape—was contemplated as a beautiful image, perfect, with no connotations of shame.

Many cultures have felt that the human body is insufficiently beautiful in itself. To improve its appearance, some have incised, painted, or tattooed designs directly on the human skin. The Nuba of southern Sudan, for instance, practice SCARIFICATION (**1.43**), cutting the skin to create raised scars in patterns that complement the natural curves of the

body. Sandro Botticelli's *The Birth of Venus* (**1.44**) juxtaposes two different cultural ideals of female beauty: The nude Venus was modeled on a classical statue of Venus, suggesting in a mythological context the Roman and Greek appreciation for the natural body. To her right, the Early Renaissance ideal of clothed beauty is represented by the attendant nymph. She is dressed in contemporary fashion, with the high-waisted style that exaggerates the length of the legs. The flying figures at upper left are similarly elongated, reflecting current tastes in ideal physique.

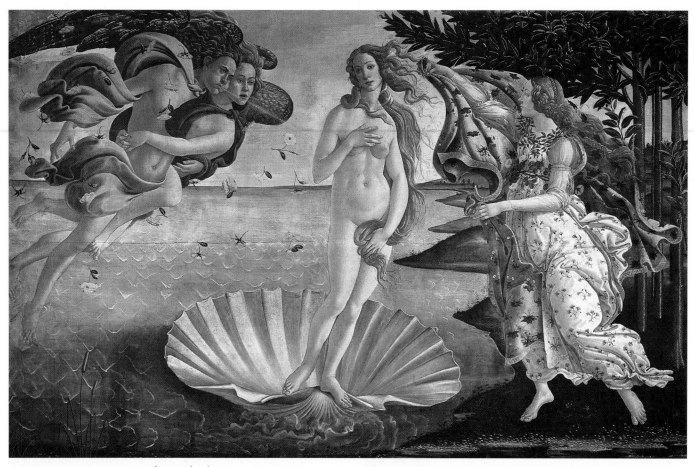

1.44 SANDRO BOTTICELLI, *The Birth of Venus*, c.1482. Tempera on canvas, 68 × 109ins (175 × 278cm). Galleria degli Uffizi, Florence.

To some, the ideal in human beauty is entirely a matter of artifice. An extreme example was Louis XIV, whose attention to dress set the style for high fashion in late seventeenth-century Europe. In Rigaud's portrait of the Sun King (**1.45**) everything considered beautiful is artificial. Surely his face is not particularly handsome by any standards. But the high-heeled shoes make the king appear taller and bring out his calf muscles for more shapely legs. The great bulk of the fine garments adds to the impressiveness of his appearance. The walking stick helps him stand straight and visually emphasizes the vertical in his carriage. And the immense wig gives his head a much larger-than-life importance, helping to balance the mass of his clothing. It was Louis who encouraged the elevation of the wig to an art form; his attendants at Versailles included 40 wigmakers.

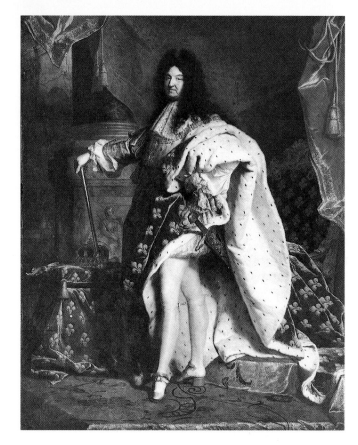

1.45 HYACINTHE RIGAUD. *Louis XIV*, 1701. Oil on canvas, 9½ × 6⅝ins (275 × 184cm). The Louvre, Paris.

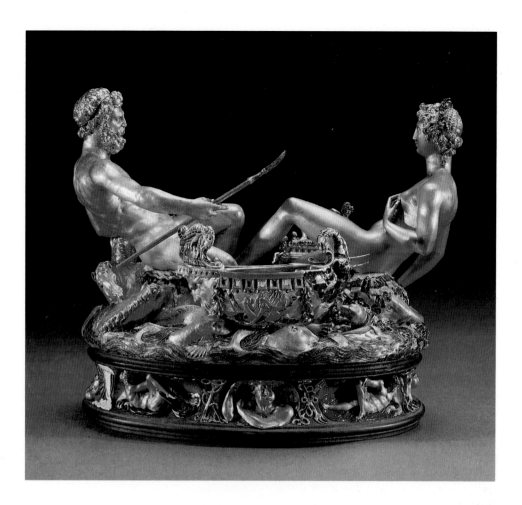

1.46 BENVENUTO CELLINI, *The Saltcellar of Francis I*, 1539–42. Gold and enamel, 10¼ × 13⅛ins (26 × 33cm). Kunsthistorisches Museum, Vienna.

Designing the utilitarian

A final function of some artistic creativity is to create aesthetically pleasing forms for the objects of our everyday existence. In many cultures, no distinction is made between functional objects and art; everything is created with an eye for aesthetics. In the West, art became the province of specialists whose offerings were available only to those with enough money to trade. Modern tastes in functional pieces often tend toward clean, uncluttered lines that reveal the elegance of the material. But in some times and places, highly ornamented works have been the aesthetic standard. Consider the saltcellar made for the sixteenth-century French king Francis I (**1.46**). Intricately modeled in gold, featuring the gods Neptune and Ceres (symbolizing the Sea and the Earth), it is worlds apart from the humble salt shakers found on most of our tables. At the time, salt was a sufficiently valuable commodity to deserve an expensive showcase—the masterpiece of the celebrated goldsmith and bronze sculptor Benvenuto Cellini.

1.47 Nineteenth-century corkscrews.

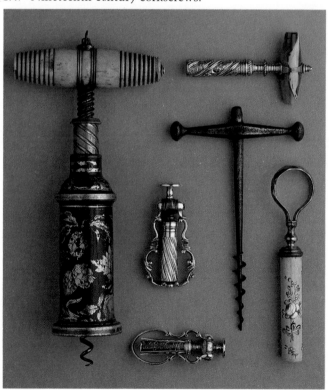

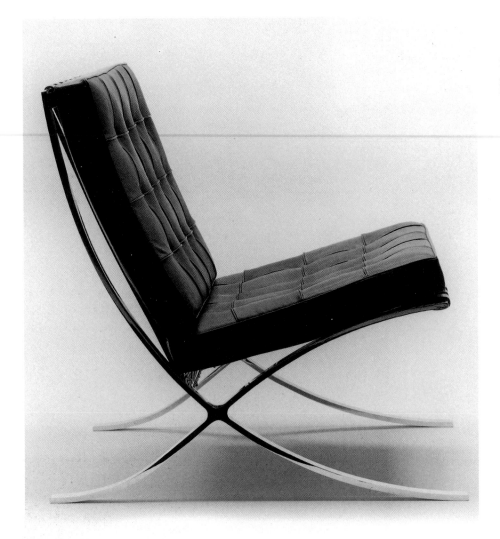

Early in the twentieth century, a group of industrial designers, architects, and craftsmen tried to merge their talents with those of sculptors and painters in a German school of applied art called the *Bauhaus*. Their aim was to bring aesthetics to mass production. One of the products of their intended marriage between form and function was the classic chair designed by Mies van der Rohe (**1.48**). Also executed in white kid leather as a modern throne for the king and queen of Spain, it is commonly known as the "Barcelona chair" because it was displayed at the innovative German Pavilion, which Mies also designed, at an international exhibition in Barcelona. Long after its 1929 debut, the chair is still in production and used in settings from hotel reception areas to private living rooms. It is highly esteemed for its elegant form and the high quality of its workman-

ship. In contrast to Cellini's ornamental approach, the Bauhaus designers worked with the demanding principle "less is more."

The requirements of functionality place some restrictions on design. For all its visual elegance, the Barcelona chair would not be so popular if it were not also comfortable to sit on. However, there are many possible aesthetic solutions to the same utilitarian function. Take the issue of removing a cork from a bottle of wine. So many types of corkscrew have been devised that they have become collectors' items and museum pieces, complete with a corkscrew collectors' society and a magazine about corkscrew collecting. Those shown in Figure **1.47** are only a sample of the variety, ingenuity, and visual elegance evoked by attempts to create a cork-pulling tool that is at once useful and beautiful.

LEVELS OF APPRECIATION

It has often been said that there are two aspects one can appreciate in a work of art: its form and its content. In this context, FORM refers to the physical qualities of a work—its elements and principles of design, techniques, and materials. CONTENT refers to the work's subject matter (what it is or represents), and the emotions, ideas, symbols, narratives, or spiritual connotations it suggests. Instead of making this traditional distinction here, however, we will focus instead on the realities of our personal reactions to a work. From this perspective, in encountering a work we may respond to it on several levels: how it affects our feelings; what the current critical opinion of the artist is; how well designed and crafted it is; what idea it suggests; and what we know of the history of its period and the artist.

Feeling

Many works engage our emotions on a subtle level that we may not even notice. Others, such as W. Eugene Smith's photograph *Tomoko in a Bath* (**1.49**), appeal quite directly to our feelings. The work is part of a series illustrating industrial pollution in Minimata, Japan. Tomoko is a victim of mercury poisoning; her mother is giving her a bath. The scene —dramatized by composition and lighting—is one of the most powerful photographs ever taken. It may evoke a strange mixture of feelings, from horror at Tomoko's deformed body and the effects of pollution, to compassion for the tenderness with which her mother is holding and looking at her. The pose and expression of great love in the midst of tragedy may remind some of Michelangelo's *Pietà* (6.18).

1.49 W. EUGENE SMITH, *Tomoko in a Bath*, 1972. Photograph. © 1972 Aileen & W. Eugene Smith.

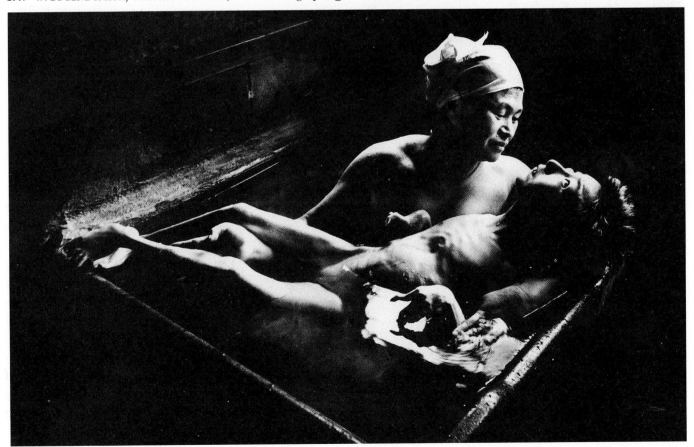

Sacred architecture has often been designed with consideration for its emotional impact on worshippers. The great Gothic cathedrals of Europe were intended to uplift people's emotions from the pettiness of the everyday to the heights of sublime adoration. They did so through their soaring vertical dimensions, making the devout feel individually insignificant in contrast with the grandeur of the divine. This attempt aspired to an unattainable peak at Beauvais, France, in what was to be the highest enclosed space ever—a stone structure rising 157 feet (48m) above the floor (**1.50**). But the choir vault collapsed during construction, leaving only the APSE (the domed altar projection) intact. The structure was eventually redesigned and gradually rebuilt but then a tower collapsed and there was not enough money to continue the impossible project. What survives is only a portion of the original grand dream, but it still has the intended self-transcending emotional effect.

Even humorous works may be intended to alter our habitual emotional patterns. Meret Oppenheim's *Object* (**1.51**) contradicts our usual reactions to both fur and cups. She provokes us visually into feeling what it would be like to drink from such an object, with the fur deliberately arranged thrusting toward where our mouth would go. Depending on our own psychological makeup, we may be amused by the expected sensation or filled with disgust at the Freudian associations.

1.51 MERET OPPENHEIM, *Object*, 1936. Fur-covered cup 4⅜ins (10.9cm) diameter, saucer 9⅜ins (23.7cm) diameter, spoon 8ins (20.2cm) long. The Museum of Modern Art, New York.

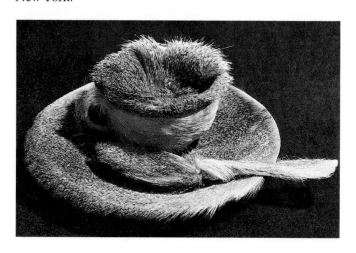

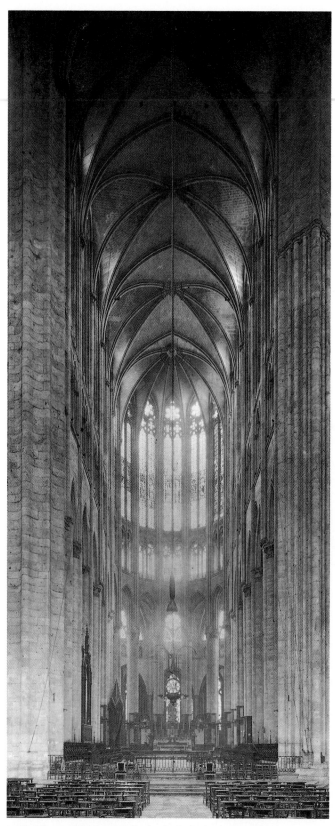

1.50 Choir of Beauvais Cathedral, France, c.1225.

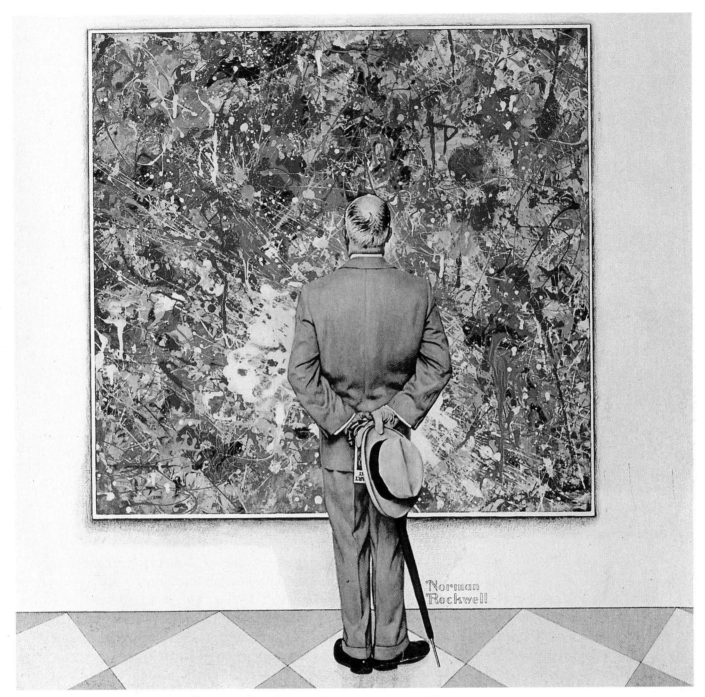

1.52 NORMAN ROCKWELL, cover illustration for *The Saturday Evening Post*, 1962.

Critical opinion

In addition to our personal emotional response, the opinions of art critics—and the mood of our times —may have considerable impact on how we respond to works of art. There are no absolute guidelines for judging quality in art. People tend to respond negatively to anything unfamiliar, but, over time, what was originally shocking and unprecedented may be-

come quite familiar and acceptable. In the early 1960s, the average person thought Jackson Pollock was a fraud or a trickster, pretending to present works done with flung paint as serious art. Norman Rockwell's version of a Pollock (**1.52**), painted for the cover of the mainstream family magazine *Saturday Evening Post*, places us looking over the shoulder of an apparently traditional, dignified gentleman who is trying to decide what to make of this seemingly

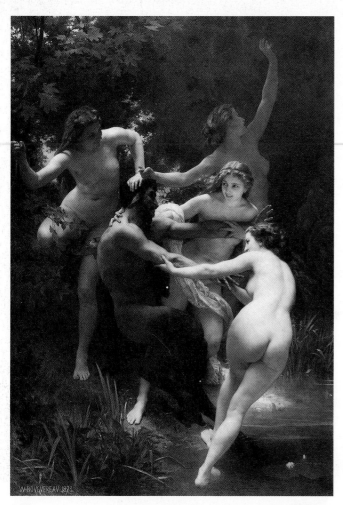

1.53 WILLIAM BOUGUEREAU, *Nymphs and Satyr*, 1873. Oil on canvas, 102 × 71ins (259 × 180cm). Sterling and Francine Clark Art Institute, Williamstown, Massachusetts.

1987, a van Gogh painting of sunflowers was sold at auction for $40 million to a Japanese insurance company.

While the Impressionists were struggling to survive, a member of the French Academy named William Bouguereau was the favorite of the critics. His romantic paintings, such as *Nymphs and Satyr* (**1.53**), achieved flowing groupings of figures through the application of traditional formulas for composition. But as Impressionism and later contemporary movements gradually took hold, accustoming viewers to more offbeat and abstract effects, Bouguereau's work lost favor. For a long time, it was considered too contrived and romanticized to be taken seriously. In recent years, however, some critics have reassessed this opinion; Bouguereau's work is being shown again at certain museums, and realistic figurative work is coming back into vogue.

Craftsmanship and design

Another level on which we can appreciate what we see is to admire the skill with which it was crafted or composed. By contemporary standards, the emotional content of François Girardon's *Apollo Attended by Nymphs* (**1.54**) is dismissed as a rather vacuous copy of classical Greek statues. Whether or not that critical opinion is valid, it allows us to focus more dispassionately on the physical form of the work, which was created for a grotto in the palace garden at Versailles to glorify Louis XIV. If nothing else, the work is a triumph of technique, of skillfulness in chipping away at recalcitrant stone to approximate the soft textures of skin and flowing cloth. Chapters 4 and 5 of this book will explore the many media and techniques artists use, increasing appreciation of their accomplishments by examining the physical requirements of each medium.

We can appreciate not only the way artists have handled their media but also their sense of design. This level of appreciation encompasses the ELEMENTS OF DESIGN, which are the visible characteristics of matter: line, shape and form, space, texture, lighting, color, and movement or change through time. Artists study these characteristics and use them quite consciously to achieve their ends, as we will see in

chaotic new stuff. Rockwell doesn't show us his face; what we read into his opinion is largely based on how we ourselves view Pollock, which in turn is now heavily influenced by the fact that the critics have declared Pollock a serious artist, worthy of being studied and collected. Nonobjective art is now "in," highly respectable and also highly priced.

Critical tastes have changed dramatically over time. When the French Impressionists such as Monet, Renoir, and Seurat began their experiments in seeing and in new ways of representing what they actually perceived, they were utterly rejected by the reigning French Academy. At one point, a bankrupt dealer tried to sell van Gogh's canvases in bundles of ten for 50 centimes to one franc per bundle. Today the works of the Impressionists are considered so valuable that only the very wealthiest can afford them; in

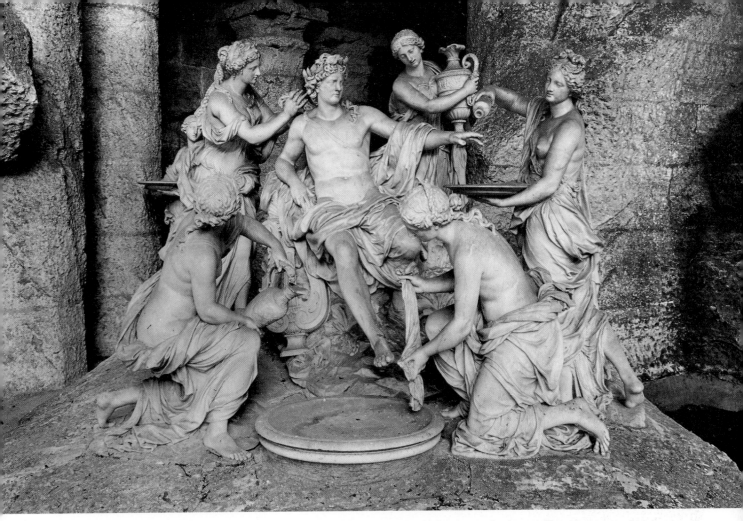

1.54 FRANÇOIS GIRARDON, *Apollo Attended by Nymphs*, c.1666–72. Marble, life size. Park of Versailles, France.

Chapter 2. It also involves an awareness of artists' use of the PRINCIPLES OF DESIGN—how a work is organized for a unified effect. The principles of design we will be studying in Chapter 3 include repetition, variety and contrast, rhythm, balance, compositional unity, emphasis, economy, proportion, and relationship to the environment. After studying these elements and principles of design, we might see in the black buck shown in Figure **1.55**, a page in an animal album created for the son of the emperor of Moslem India, the beautiful simplicity of the form of the buck, the sophisticated use of dark and light areas to complement the form, the use of calligraphy as a textural device, and the repetition and variety expressed in the floral border. Even without a formal awareness of the elements and principles at work, we may respond intuitively to their effects by recognizing the pleasing, aesthetically satisfying nature of the work.

Idea

Another aspect of our appreciation is our understanding of the idea behind a work. The IDEA of a work is not what it *is* but what it is *about*. Two different memorials have been built in Washington, D.C., to honor the soldiers who died in the Vietnam War. They differ tremendously in form but not so much in idea. A representational sculpture by Frederick Hart (**1.56**) demonstrates quite directly the youthfulness, ethnic mixture, individuality, friendships, and inglorious, mud-spattered attire of the American troops. That the war was unpopular and confusing can be seen in their expressions. This is not a monument to heroism and glorious victory; it is a way of honoring those who died trying and of encouraging the living to draw back together after years of bitter division in the United States between those for and against the war.

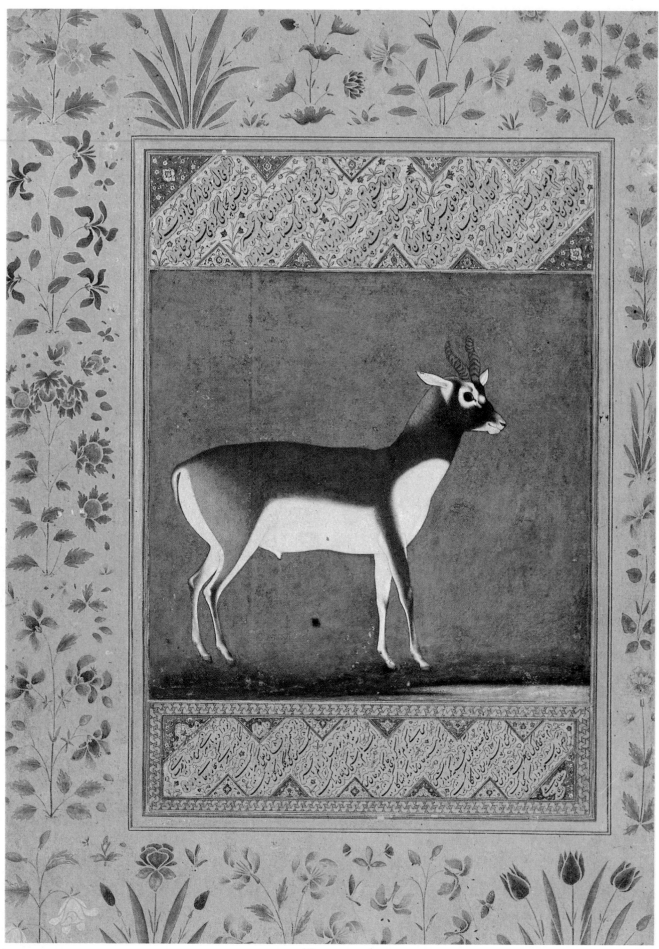

1.55 MANSUR, *A Black Buck*, Mughal, period of Jahangir 1605–28. Colors and gilt on paper, 15⅜ × 10¼ins (39 × 26cm). The Metropolitan Museum of Art, New York.

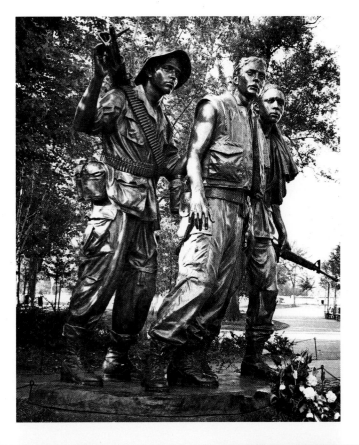

The more well-known of the two memorials, designed by art student Maya Lin (**1.57**), carries a similar message but in a highly abstract form. Elegantly and starkly simple, it consists of an angled wall of polished black granite, incised with the names of all Americans who died in the Vietnam War, and then tapering down to disappear into the earth. Lin explains,

> Many earlier war memorials were propagandized statements about the victor, the issues, the politics, and not about the people who served and died. I felt a memorial should be honest about the reality of war and be for the people who gave their lives. . . . I didn't want a static object that people would just look at, but something they could relate to as on a journey, or passage, that would bring each

1.56 FREDERICK HART, Vietnam Memorial, Washington D.C., 1984. Bronze, life size.

1.57 MAYA YING LIN, Vietnam Veterans' Memorial, Washington D.C., 1984.

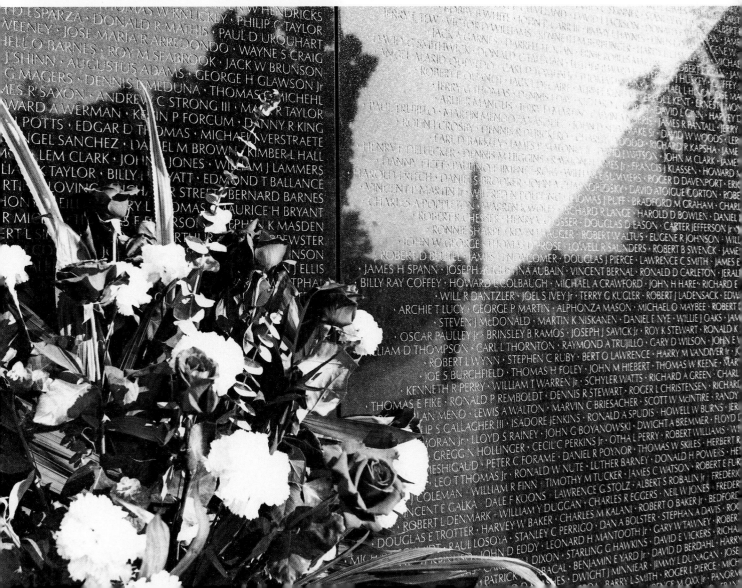

to his own conclusions. . . . I didn't visualize heavy physical objects implanted in the earth; instead it was as if the black-brown earth were polished and made into an interface between the sunny world and the quiet, dark world beyond, that we can't enter.[10]

Maya Lin's wall speaks to us as a symbol of recent and, for many, remembered history. Older works or works from other cultures may use symbolic language that we no longer understand. To fully appreciate Albrecht Dürer's *Melancolia I* (**1.58**), we need to be acquainted with the neo-Platonic symbols and concepts he presents. The central figure—Melancholy—is slumped in despondent contemplation of earthly knowledge that cannot create without divine inspiration. Strewn about her are symbols of the arts and sciences. For all his skill, Dürer may have identified quite personally with the recurrent frustration of unproductive dry spells and of trying to create the perfection that one can only imagine.

1.58 ALBRECHT DÜRER, *Melancolia I*, 1514. Engraving, 9½ × 7½ins (24 × 19cm). Victoria and Albert Museum, London.

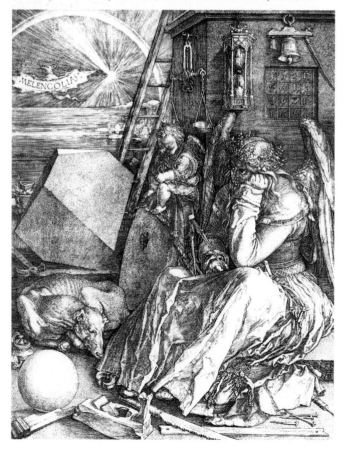

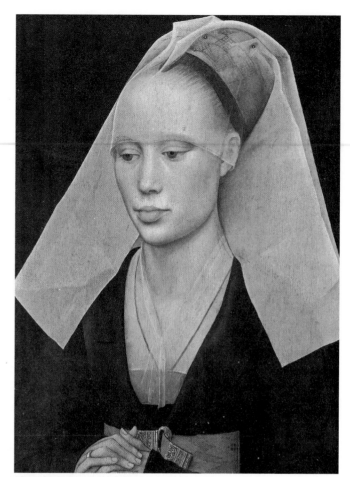

1.59 ROGIER VAN DER WEYDEN, *Portrait of a Lady*, c.1455. Oil on panel, 14½ × 10¾ins (36.8 × 27.3cm). The National Gallery of Art, Washington, Mellon Collection.

History

Finally, our appreciation of a work of art may be greatly enhanced through knowing something of the historical or personal context of the work. Some pieces are best understood within the framework of an established tradition; others are best understood as pioneering works that may have lost something of their original impact because the way they showed later became a familiar one.

Rogier van der Weyden's *Portrait of a Lady* (**1.59**) fits well into today's spare aesthetic. But at the time, Roger's minimization of detail in search of essence and expression was a departure from tradition. He and the other great Flemish masters of the fifteenth century were experimenting with the newly developing medium of oil and finding that it could be used to create fine details and subtle gradations of light and shadow that had been impossible with tempera. In

1.60 REMBRANDT VAN RIJN, *Self-Portrait*, c.1660. Oil on canvas, 33 × 26ins (84 × 66cm). The National Gallery of Art, Washington D.C., Mellon Collection.

Rogier's hands, oils also had a translucent quality, as though light were radiating outward through the model's fine skin. To help appreciate artists within their historical artistic context, in Chapter 6 we will review the major movements in Western art.

In some cases, it is also helpful to know something about artists' personal lives and inner motivations, as a framework for understanding what they were trying to do. As sensitive, imaginative individuals, artists have often lived unconventional lives, not always by their own choosing. Paul Gauguin, for instance, was led by events and his own inner search to abandon the life of a wealthy stockbroker in Paris (partly because business was failing), leaving behind a wife (who may have forced him out) and five children, and taking refuge finally in Tahiti. There his painting became more primitive, exploring the mysterious depths of the unconscious, as in *The Spirit of the Dead Watching* (**1.61**). This spiritual sensitivity, Gauguin felt, was being subverted by materialism in Western civilization. His life in the tropics was hardly idyllic, however. Deserted by his wife, heartbroken over the death of his daughter, impoverished, and physically tormented by syphilis, he tried to poison himself

1.61 PAUL GAUGUIN, *The Spirit of the Dead Watching*, 1892. Oil on canvas, 38¾ × 36¼ ins (98.4 × 92cm). Albright-Knox Art Gallery, Buffalo, A. Conger Goodyear Collection.

with arsenic but took so much that he threw it up and survived for a few more tortured years. His work can therefore be seen in the context of a determined search for truth in the face of physical and psychological torment.

Some works are so strong that we can respond to them directly, without knowing anything of the artist's personal life or of the historical context. We don't think of Rembrandt as a period artist; we know him as one of the greatest artists of all times. Hun-

dreds of years after the painting of his 1660 self-portrait (**1.60**), that face looks out at us from the darkness with such compelling truth, such strength in design, and such technical skill that its appeal seems timeless. Ultimately, time is the most telling test of quality in art. If a piece is so good that after hundreds of years people will still value it enough to keep and prize it, whether the artist is currently in favor or not, it is probably worthy of being considered great.

CHAPTER TWO
VISUAL ELEMENTS

Despite its rich diversity, all art is created from a few simple visual elements. Beginning with truly raw materials — an empty canvas, a block of stone, some plant fibers, or a vat of liquid plastic — the artist shapes them into lines, shapes, forms, spaces, and textures, enlivened with the effects of light, color, and perhaps time.

The elements of design with which artists work are the observable properties of matter: line, shape and form, space, texture, value (lights and darks) and lighting, color, and time. Although these elements are unified in effective works of art, we will isolate and deal with one at a time to train our eye to see them and to understand how artists use them.

LINE

A mark or area that is significantly longer than it is wide may be perceived as a line. There are lines all around us in the natural world. A tree bare of its leaves, for instance, can be perceived as a medley of lines, as Mondrian noted in his tree abstractions (1.23–1.25). The sections that follow will develop the ability to discern lines in artworks and to understand the aesthetic functions they serve.

Seeing lines

It is easiest to see lines in works that are primarily linear and two-dimensional, such as the lovely piece of calligraphy shown in Figure **2.1.** CALLIGRAPHY is the art of fine writing, so highly developed in Arabic cultures, Japan, and China that some pieces are meant first as art and only secondarily as figures to be read. (Most non-Arabs will see the lines in this piece as purely abstract anyway, because they don't know how to read them as words.) Arabic characters are usually set down in straight lines, but the master calligrapher Sami Efendi worked the strokes into a flowing circular pattern to enhance their beauty and the unity of the design. When lines are made with a flat-pointed instrument, such as the reed pen used here, their thickness grows and diminishes as the lines swing through curves. Note the careful attention paid to the ends of each stroke.

2.1 SAMI EFENDI, *Levha* in *Celi Sülüs*, 1872. Private collection, London.

2.2 JOHN ALCORN, *The Scarlet Letter*, 1980. Exxon Corporation, for Public Broadcasting Great Performances.

Lines may be seen in unworked as well as worked areas of a design. In John Alcorn's drawing to represent Hawthorne's novel *The Scarlet Letter* for television audiences (**2.2**) we can see not only black lines on white but also white lines defined by black-inked areas. Notice how gracefully Alcorn handles the rapid transitions from the white of the background to the white lines defining the hair, leading us to see the former as NEGATIVE, or unfilled, space, and the latter as POSITIVE, or filled, space.

Even more subtly, we perceive lines along EDGES where two areas treated differently meet. Along the left side of Hester Prynne's face, as we see it, there is a strong white line belonging to and describing her profile; the black of her hair shadows is pushed behind it in space. On the right side of her face there is a strong edge belonging to the black of her hair, with her face appearing to be behind it in space.

65

In three-dimensional works, we may find lines that are incised, raised, or applied to forms. On the Maori ancestor figure (**2.3**) rows of small lines are used to create textured effects and slow the eye. These occur within larger patterns of curving lines that define the figure in a highly stylized, dynamic fashion. This symphony of lines is set off and brought to our attention by contrast with the large unworked club in the center.

Edges may be "read," or interpreted, as lines in three-dimensional work as well as in two-dimensional works. Part of the effectiveness of Barnett Newman's *Broken Obelisk* (**2.4**) lies in the sharp edges where flat planes meet, creating visual lines that emphasize the form and define its three-dimensionality (**2.5**). If the top and bottom segments were rounded, without the lines of the edges, the effect would be quite different.

In some three-dimensional pieces, entire areas are so thin in relation to their length that they are seen as lines. The human figure is sometimes handled as abstract lines in space, a perception that is carried to an extreme in the attenuated figures of Alberto Giacometti, such as *Walking Man* (**2.6**). This reduction of a human to something less than a skeleton can be seen as a statement about the isolation and loneliness of the individual in modern civilization. Giacometti himself insisted that his focus lay not so much on the gaunt figure as on the vast, empty space that surrounds and presses in on it. It is hard to grasp this perspective when looking at a photograph, but in actuality, the small scale of the battered figure—only 27 inches (69cm) high—does make the space surrounding it seem even greater.

EARTHWORKS—large-scale environment-altering projects in which the surface of the earth becomes the artist's canvas—sometimes create immense lines that can best be seen from a distance. Up close, Christo's *Running Fence* (**2.7**) appeared as a great fabric curtain, 18 feet (5.5m) high. Its even more memorable aspect was the beautiful line it created over 24 miles (38km) of northern California countryside, ultimately disappearing into the Pacific Ocean. To erect this temporary structure for only two weeks in 1976, Christo and a large crew of engineers and lawyers spent three years threading their way

2.3 Ancestor Figure, c.1842. Wood, 55 × 25¼ins (140 × 64cm) high. National Museum of New Zealand.

2.4 BARNETT NEWMAN, *Broken Obelisk*, 1963–67. Steel, 25ft 1ins (7.65m) high. Institute of Religion and Human Development, Houston, Texas.

2.5 Lines formed by the edges of *Broken Obelisk*.

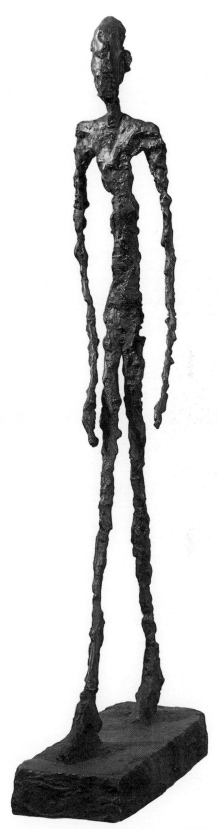

2.6 ALBERTO GIACOMETTI, *Walking Man*, c.1947–49. Bronze, 27ins (69cm) high. Hirshhorn Museum and Sculpture Garden, Smithsonian Institution, Washington D.C., Gift of Joseph H. Hirshhorn, 1966.

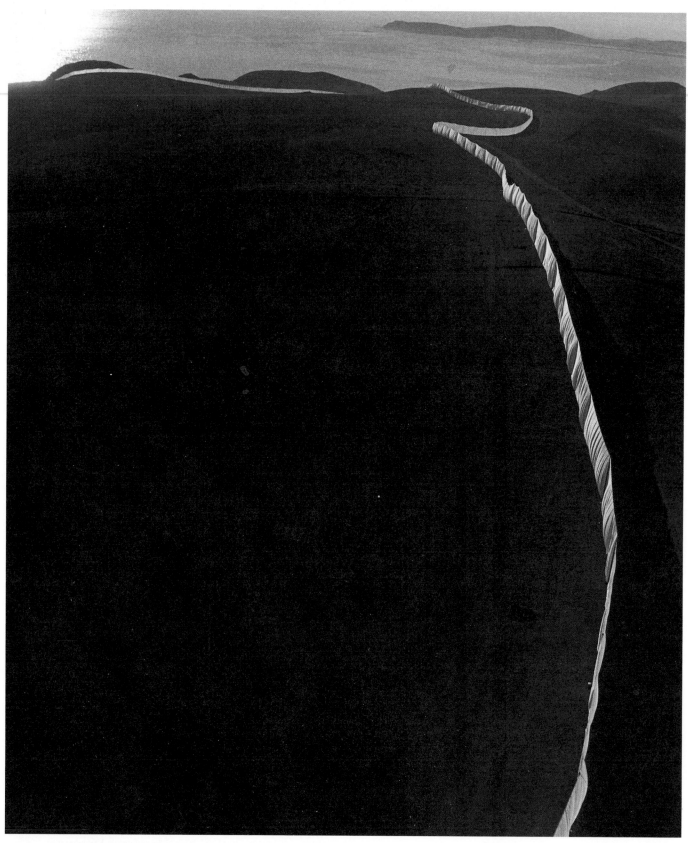

2.7 CHRISTO, *Running Fence. Sonoma and Marin Counties, California, 1972–76*, erected 1976. Nylon fabric, steel poles, cable, 18ft × 24 miles (5.5m × 38.4km).

through public hearings and legal battles, including a 265-page environmental impact statement they were required to produce. These struggles with a disbelieving society are part of Christo's art form; the temporary end product is not the only goal. Neither was the line of the fence the only visual element in the design; its existence also called attention to the contours and features of the land. Speaking of the ranchers who initially opposed the project but then were sorry when, as intended, it was taken down and all traces of it removed, Christo was pleased that "they can find that a part of *Running Fence* is their cows, and the sky, and the hills and the barns and the people."[1]

Implied line

Some lines are not physically created; they are merely suggested by the artist. Our mind, with its penchant for trying to read order into the messages from the senses, does the rest, perceiving lines where there are none. Part of the visual excitement of the ad for *Harper's Magazine* (2.8) by The Beggarstaffs (a farsighted but short-lived British design studio around the turn of the century) is the filling in of lines that have been left out. Just enough information is given for us to see the famous figure of a beefeater in his distinctive uniform. The illusion works particularly well along the right side of his lower tunic, where an edge is suggested by very slight upward swings of the dark bands.

2.9 PIET MONDRIAN, *Fox Trot A*, 1930. Canvas, diagonal 43¾ins (109.8cm). Yale University Art Gallery, New Haven, CT, Gift of the Société Anonyme.

In many two-dimensional works the artist asks us to make assumptions about what "happens" beyond the edges of the picture. To do so, we need to be given enough information for us to draw inferences based on our experiences of the physical world. Geometric figures are perhaps easiest to predict. Shown part of a square or a circle, we may automatically fill in the rest with our imagination. In *Fox Trot A* (**2.9**), Piet Mondrian shows us a cropped segment of a linear image that by implication extends beyond the picture area. The challenge he sets for us is to determine how much larger the uncropped "original" would be. We automatically assume that the left vertical and the horizontal will continue as straight lines and intersect just beyond the picture. But what about the two verticals? Will they be joined by a crosspiece above the top? The only clue that the cropped segment shown may be part of a hypothetical series of rectangles—like a multi-paned window—is the crossing of the two lines at lower right. The suggestion that the figure doesn't end here leads the mind outward to imagine a much larger series of lines that it cannot see at all.

In addition to drawing the viewer into participating

2.10 Thorn Puller (*Spinario*), 1st century BC. Bronze, 28¾ins (73cm) high. Capitoline Museums, Rome.

in a work, implied lines are often used for compositional ends. EYELINES—the implied lines along which a subject's eyes appear to be looking—are a common device for directing the viewer's eye or pulling a composition together. Usually eyelines occur between figures, as in Bouguereau's *Nymphs and Satyr* (1.53), in which each person in the circle is looking at someone who is looking at someone else, so tying them all together. But in the Hellenistic bronze *Thorn Puller* (**2.10**), we follow the "line" between the youth's eyes and his own foot, for his concentration is so clearly fixed on his foot that our eyes go in the same direction. His limbs are also arranged to form lines that lead our eye toward the foot. Our attention is often drawn to points where many lines intersect. If our eye then strays to examining the figure as a whole, the lines of the body carry us around in a circle

to arrive back at the same point.

Descriptive line

Line that is DESCRIPTIVE tells us the physical nature of the object we are seeing and how it exists in space. By contrast, DECORATIVE line is that which provides surface embellishments, such as the A on Hester Prynne's dress (2.2).

In *Narcissus* (**2.11**), the spare inked line is purely descriptive. Although the paper has the same tone everywhere, the line tells us to read certain unfilled areas as positive leaves and flowers and the rest as negative unfilled space. Not only do the outlines allow us to "see" the narcissus plant; they also describe the space around it. The plant has been carefully placed on the page in such a way that the negative areas become satisfying in themselves as a series of shapes that alternately curve softly outward (such as the large unfilled space at lower left) and

2.11 After CHU TA, *Narcissus*, 1625–1705. Ink on paper, 12⅛ × 10½ins (30.8 × 26.5cm). The British Museum, London.

2.12 ALBRECHT DÜRER, *Head of an Apostle*, 1508. Brush on paper, 12½ × 8⅓ins (31.7 × 21.2cm). Graphische Sammlung Albertina, Vienna.

2.13 ARNOLD BITTLEMAN, *Martyred Flowers*, c.1957. Pen and ink, 26 × 38¾ins (66 × 98cm). Fogg Art Museum, Harvard University, Cambridge MA.

plunge in pointed tips into the heart of the stem. The lines also describe two enclosed pointed spaces below the flowers.

Whereas the narcissus drawing is quite flat in space, lines are often used to describe three-dimensional form. *Head of an Apostle* by the great German artist Albrecht Dürer (**2.12**) appears to have continually varying contours and to be fully rounded in space. Dürer achieved this extremely detailed depiction of a venerable, beetle-browed head largely by highly skillful use of line. Drawn close together, dark parallel lines (HATCHING) and crossed parallel lines (CROSS-HATCHING) suggest shadows where contours curve away from the light. Where the lines seem to loop in visually incompleted ovals around an axis, a technique known as BRACELET MODELING, they

imply the contours of the unseen back side of the form.

Many small lines placed close together may also be used to suggest texture. In Arnold Bittleman's *Martyred Flowers* (**2.13**) we readily perceive textural effects even though we cannot be sure what forms are being described. The title refers to flowers; yet in places the textures appear feathery, wing-like. These are not hastily scribbled strokes; each line was placed with great care. Where many are juxtaposed, dark areas develop that create a mysterious undulation in and out in space.

Expressive qualities of line

By its character—its size, movement, and the way it is laid down—line may express certain emotional qualities. Sharply angled lines may suggest excitement, anger, danger, or chaos; a relatively flat line suggests calmness; a wide, fast line suggests bold strength, directness; a gently curving line may suggest unhurried pleasure (**2.14**). Such expressive qualities may set the tone for works of art.

The reclining rocking chair by the Austrian firm of Thonet (**2.15**) suggests, by its long, flowing lines, the restful feeling that one expects to experience when lying in the chair. As the lines flow through lengthened curves, it is difficult to follow a single line; rather, we are visually drawn into the abstract expressive quality of the lines: the sense of languid movement. In the mid-nineteenth century, Michael Thonet had perfected a process of steaming and bending wood that allowed the creation of these plant-like lines and greatly reduced the need for structural joints in furniture. The graceful bentwood furniture designs became so popular that many have continued

2.14 Lines with varying expressive qualities.

2.15 GEBRÜDER THONET, Reclining rocking chair with adjustable back, c.1880. Steam-bent beechwood and cane, 30½ × 27½ × 68½ins (77.5 × 70 × 174cm). The Museum of Modern Art, New York.

2.16 CY TWOMBLY, *Untitled 1964*, part of a triptych called *A Roma*, now dispersed. House paint, crayon, pencil on canvas, 78¾ × 82½ins (200 × 206.3cm). Saatchi Collection, London.

2.17 JOHN CROCKER, CBS album cover, 1968.

in production to this day.

Cy Twombly's lines in *Untitled 1964* (**2.16**) have a very different expressive quality. Erotic, impulsive, and as seemingly loose as doodling or graffiti, they are at the same time partially negated by being crossed out here, semi-erased there. There are words but they cannot be read. This fragmented, hidden, ambiguous line quality is an appropriate visual metaphor for social attitudes toward expressions of sexuality.

For another example of the expressive possibilities of pure line, consider John Crocker's album cover for Schubert's violin music (**2.17**). A blank set of staves goes through a gradual, comically plausible metamorphosis into a visual equivalent of Schubert's romantic music, with flourishes and embellishments. Such lines can quite literally be called *lyrical*, a term used in describing art that is the visual equivalent of melodies that express intimate emotions.

75

2.18 A. M. CASSANDRE, Poster, 1927. Colored lithograph, 41½ × 29½ins (105 × 75cm). Victoria and Albert Museum, London.

Directional line

Lines may be used in art to tell us which way to look. In the poster for a luxury train by the great French poster designer A. M. Cassandre (**2.18**), we are placed squarely on top of the rail that is perpendicular to the bottom edge of the poster. Our eye races along the rail to the point where all the rails converge and disappear on the horizon. The immediate impression is that of speed and elegance in covering great distances. These directional lines lead us effortlessly to our destination—and beyond, to a star.

SHAPE AND FORM

Throughout this book we will be using the word SHAPE to refer to defined two-dimensional areas. As we use the term, a shape is flat. We will reserve the word FORM for three-dimensional areas, also called "volume" or "mass." But flat shapes may appear on the surface of three-dimensional forms, and two-dimensional works may create on a flat surface the illusion of forms.

Actual three-dimensional forms

To understand the many ways in which three-dimensional forms work aesthetically, we can set up some overlapping categories of features. These include primary and secondary contours, exterior and interior contours, open versus closed forms, and static versus dynamic forms.

In many three-dimensional works, we can distinguish both outer, or PRIMARY, CONTOURS and SECONDARY CONTOURS developed within the primary contours. Often the primary contour is the outline that allows us to identify the subject of the work, if it is representational. In the marvelous ancient fish found in Germany (**2.19**) the primary contour is the familiar outline that we read as the shape of a fish. The secondary contours are the raised and incised areas across the body. Highly decorative, these secondary contours include not only scales, gills, eye, and mouth, but also the forms of a school of fish below the midline and land animals above the midline, with rams' heads forming the tail.

Some three-dimensional works have both EXTERIOR and INTERIOR CONTOURS that can be

2.19 Fish, from Vettersfelde, Germany, early 5th century BC. Alloy of gold and silver, 16¼ins (41cm) long. Antikensammlung Staatliche Museen Preussischer Kulturbesitz, Berlin.

2.20 *Senmut with Princess Nefrua*, Thebes, Egypt, c.1450 BC. Black stone, 40ins (102cm) high. Egyptian Museum, Berlin.

examined. In architecture, the exterior (generally convex) form of a building gives quite a different impression from its interior (generally concave) structure. In some works, we are invited to look at both exterior and interior contours simultaneously.

The lovely flask shown in Figure **2.22** is made of clear crystal, revealing the concave pear-shaped contour within a similar but convex exterior contour. The interior contour is emphasized and elaborated by the bubbles surrounding it.

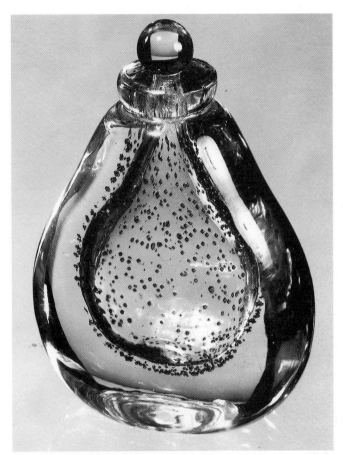

2.22 MAURICE MAINOT, *Flask*, 1931. Clear crystal glass with bubbles, 4⅞ins (12.4cm) high. Victoria and Albert Museum, London.

A more subtle kind of interior form can only be sensed, rather than seen. Barbara Hepworth, whose work is shown in Figure 2.24, had a highly refined awareness of unseen interior forms. In her auto-biography, published in 1970, she wrote:

> There is an inside and an outside to every form. When they are in special accord, as for instance a nut in its shell or a child in the womb, or in the structure of shells or crystals, or when one senses the architecture of bones in the human figure, then I am most drawn to the effect of light. Every shadow cast by the sun from an ever-varying angle reveals the harmony of the inside and outside.[2]

Many early Western sculptures were CLOSED FORMS that reflected the block from which they had been carved. The block of stone from which the early Egyptian sculpture of *Senmut with Princess Nefrua* (**2.20**) has been carved is drawn in only slightly at the base. To create the heads—particularly that of the child—far more of the original block has been re-

2.21 after POLYCLITUS, *Spear Bearer (Doryphorus)*, Roman copy after a Greek bronze original of c.450–400 BC. Marble, 78ins (198cm) high. National Museum, Naples.

2.24 BARBARA HEPWORTH, *Pendour*, 1947. Painted wood, 10⅜ × 27¼ × 9ins (26 × 69 × 23cm). Hirshhorn Museum and Sculpture Garden, Smithsonian Institution, Washington D.C., Gift of Joseph H. Hirshhorn.

moved, yet the overall impression is that of a solid mass. As stone carving evolved, sculptors learned how to open the forms without losing their structural strength. In the *Spear Bearer* (**2.21**), the legs are placed apart and the arms are lifted slightly away from the body. Yet to keep the limbs from breaking off—as they often did—several props have been maintained.

The development of bronze casting allowed fully OPEN FORMS, such as the equestrian statue of Marcus Aurelius (**2.23**). This piece almost seems to show off the ability to support long projections from a central mass, with the horse's leg raised and the emperor's arm outstretched. The space around the horse and between its legs is so opened that it invites walking all the way around to see how the form changes. The tensile strength of bronze allows it to be cast into elongated forms without bending or breaking.

In the twentieth century, a number of sculptors have gone even farther, opening voids through the center of their works. In Barbara Hepworth's *Pendour* (**2.24**) the holes piercing the center of the form draw the focus of attention. These ambiguous voids are accentuated by contrast with the solidity and simplicity of the outer form. Defined by wood painted white, in contrast with the darker exterior, they suggest a quality of tender, hidden purity protected from the outer world. They lure us into looking through the sculpture, exploring what can be seen in and through it instead of just walking around its periphery.

2.23 Equestrian Statue of Marcus Aurelius, C.AD 165. Bronze, over life size. Capitoline Hill, Rome.

Finally, we can draw a distinction between static and dynamic forms. STATIC forms appear to be still, unchanging. The pyramid is a supremely static form, for its broad base seems to guarantee an immovable stability. Michael Heizer's *City Complex One* (**2.25**) has an enduring, monumental effect. Like the surrounding mountains, it looks set to remain standing a very long time. Indeed, in contrast to the more temporary nature of many earthworks, this structure was built to last, with concrete and steel reinforcing packed earth. The sense of historical permanence that Heizer's structure evokes is increased by its reference to ancient structures: the mastabas of ancient Egypt, which were tombs with rectangular base and sloped sides, and framing derived from a ball court at the ancient Mayan city Chichén-Itzá.

DYNAMIC forms are those that appear lively, moving, and changing, even if they are really standing still. The Art Nouveau movement in applied art often worked with dynamic forms, such as Louis Comfort Tiffany's exquisite *Flower-form Vase* (**2.26**). From chairs to vases to stair railings, Art Nouveau designs appear to be growing as though they were organic forms. Tiffany's vase exposes the dynamic process by which the glass was blown, pulled, and shaped when in a molten state. Although the end result is hard and fixed, it appears still to be in fluid motion, like a bud in the process of reaching upward and growing outward.

2.26 LOUIS COMFORT TIFFANY, Flower-form vase, c.1900. Iridescent glass with internal decoration, 11 ins (28.5cm) high. Private Collection, London.

2.25 MICHAEL HEIZER, *City Complex One*, 1972–76, Garden Valley, Nevada. Cement, steel, and earth, 23½ × 140 × 110ft (7 × 43 × 34m). Collection: the artist and Virginia Dwan.

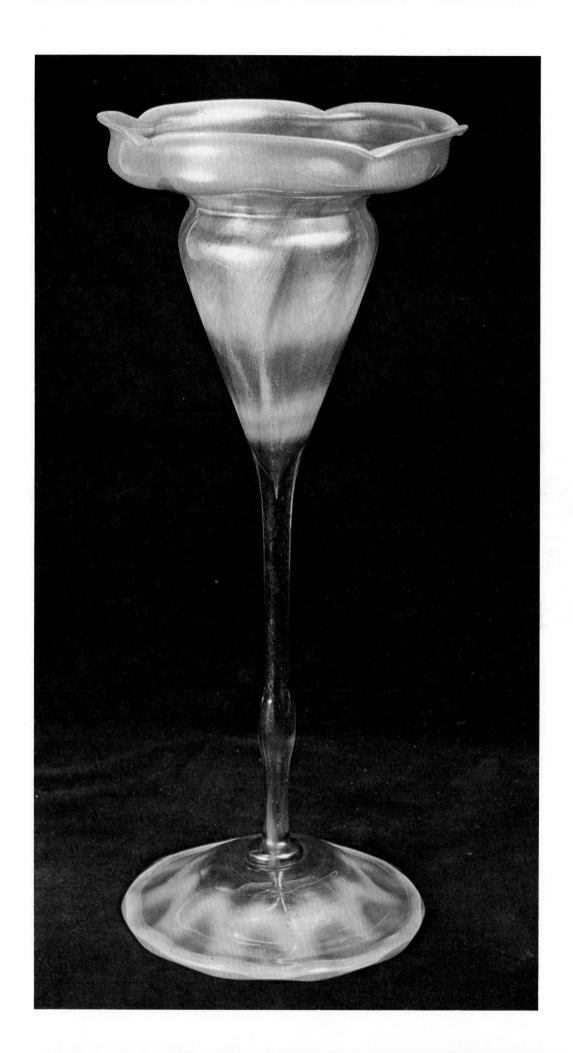

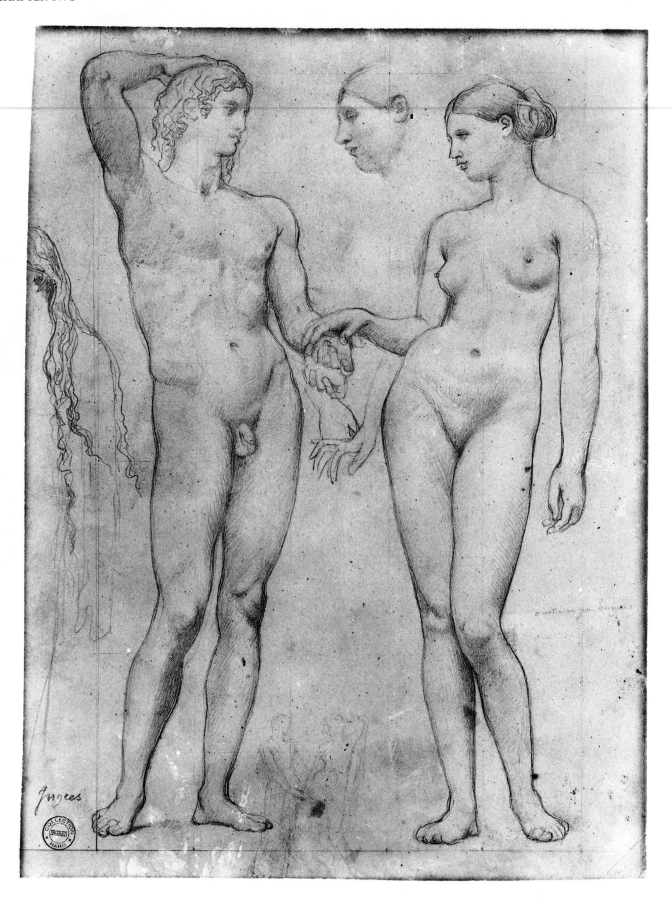

2.28 Banquet, from the tomb of Netamun, Thebes, c.1400 BC. Painted stucco, 25ins (63cm) high. The British Museum, London.

Two-dimensional illusion of form

Through the ages, artists of many cultures have developed ways of creating the illusion of three-dimensional form on a two-dimensional surface. One of the earliest devices is the use of OVERLAPPING: From our experience in a three-dimensional world, we know that if one thing covers another from our view, it must exist in front of it in space. In Ruth Bernhard's *Bone and Passion Flower* (1.1), we can readily interpret the flower and the bone as having volume, for the flower's exotic reproductive structures overlap each other in space, the petals lie behind them, the petals overlap the bone, and the forward surface of the bone overlaps farther parts glimpsed through a hole. Ancient Egyptian artists used this overlapping technique in painting images

on the walls of tombs, such as the one shown in Figure **2.28**. We can tell how the parts of the nearer dancing woman relate to each other in space because they overlap each other: Her left arm is in front of her head, which is in front of her right arm. In the seated musicians, we can perceive their arms as being in front of their bodies because they obscure parts of their dress.

The Egyptian figures nevertheless appear flat, like paper dolls in a shallow space. Another set of devices—SHADING and MODELING of contours—brings out a sense of spatial depth. In the elegantly understated Ingres figure study (**2.27**) just the slightest indication of shading within the primary contours develops a full-bodied illusion of form, for we interpret shaded areas as existing behind contours that block the light. Curving lines of bracelet modeling, such as those on the woman's left leg, suggest that the form is also fully rounded on the side we cannot see. In areas such as the heads, where bracelet modeling is not added, the figures read more like reliefs than like full-round forms.

2.27 JEAN AUGUSTE DOMINIQUE INGRES, *Two Nudes*, study for *The Golden Age*, 1842. Graphite on paper, 16⅜ × 12⅜ins (41.6 × 31.4cm). Fogg Art Museum, Harvard University, Cambridge MA.

2.29 PAUL CÉZANNE, *Mont Sainte-Victoire seen from Les Lauves*, 1902–4. Oil on canvas, 27½ × 35¼ins (69.8 × 89.5cm). Philadelphia Museum of Art, George W. Elkins Collection.

Another device for giving a two-dimensional surface the appearance of three-dimensional forms is to show more than one side of a form, indicating how it recedes into the distance. If we see only the front wall of a building, we have no idea of the building's depth in space. But if an artist depicts the building from an angle that allows us to see one of the sides as well as the front, we immediately grasp the idea of its form. Paul Cézanne studied nature—and human perceptions of natural objects—with great care to determine how we see them and therefore how a painter might truthfully represent the optical sensations. In *Mont Sainte-Victoire seen from Les Lauves* (**2.29**), a complex array of buildings, trees, and facets of the mountain he so often painted are reduced to abstract geometric structures. Some are painted in clear linear perspective, with sides angling back toward the horizon. (The topic of linear perspective is covered in depth later in this chapter in the discussion of Space.) Others are brush-stroked suggestions of geometric

form. In letters to an art student, Cézanne advised:

> To achieve progress nature alone counts, and the eye is trained through contact with her.... In an orange, an apple, a bowl, a head, there is a culminating point; and this point is always—in spite of the tremendous effect of light and shade and colorful sensations—the closest to our eye; the edges of the objects recede to a center on our horizon.... Treat nature by the cylinder, the sphere, the cone, everything in proper perspective so that each side of an object or a plane is directed towards a central point.[3]

Shapes

In the terminology we are using, SHAPES are relatively flat areas. In *The Snail* (**2.30**), for instance, Henri Matisse was working primarily with large shapes that had been painted and then cut and organized into a dynamic composition in which each painted shape touches and is related to the sequence forming the whole. Shapes are particularly noticeable here because they have been physically cut out with clearly

defined edges and then glued down. Note that the white shapes created between the colored shapes are active and interesting in themselves, and more varied in configuration than the colored patches.

There are a number of general kinds of shapes with which artists have worked. One is the distinctive results of tearing or cutting paper, as in the Matisse. Another is objects from the three-dimensional world flattened into two-dimensional shapes. In Gerald Murphy's *Wasp and Pear* (2.31), we see many forms in apparent cross-section: a pear, a honeycomb, a leaf, a magnification of the wasp's foot. The wasp itself is

painted in solid colors, with no value changes that would indicate rounding in space. Even the pear that is in the center of the composition is treated in such a stylized manner that the slight indication of shading appears more decorative than three-dimensional. The geometric shapes that complete the composition are also clearly very flat. We read the composition from shape to shape across a relatively flat surface in which the only indication of any depth is the continual overlapping of one shape by another.

Another approach is the use of purely imaginative shapes that have no clear connection with specific

2.30 HENRI MATISSE, *The Snail*, 1953. Painted, cut, and pasted paper, 112¾ × 113ins (286.4 × 287cm). The Tate Gallery, London.

2.31 GERALD MURPHY, *Wasp and Pear*, 1927. Oil on canvas, 36¾ × 38⅝ins (93.3 × 97.9cm). The Museum of Modern Art, New York.

objects in the real world. A pioneer in the use of invented shapes in both two- and three-dimensional art was Jean Arp. His *Automatic Drawing* (**2.32**) illustrates his attempts to release his hand from the constraints of the known world and let it be guided by the unconscious. After Arp filled in the outlines thus created, the resulting shapes often suggested dynamic life forms.

Geometric shapes have long been used as a design element in many cultures. The water jar by the pueblo potter Lucy Lewis (1.12) is decorated with black and white triangles within squares, alternating with diamond-like shapes created by lines, woven into squares of the same size. A Liberian gown (**2.34**) is composed largely of geometric shapes—circles, squares, rectangles, and triangles—whose symmetry is a striking counterpoint to the asymmetrical style

2.32 JEAN ARP, *Automatic Drawing*, 1916. Brush and ink and traces of pencil on paper, 16¾ × 21¼ins (42.6 × 54cm). The Museum of Modern Art, New York.

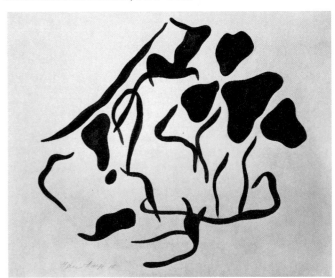

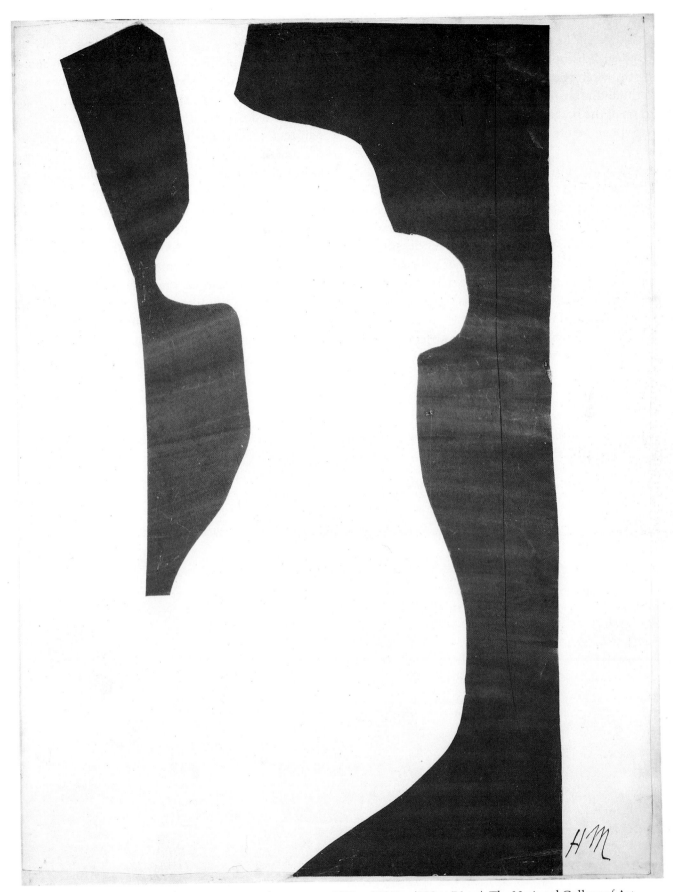

2.33 HENRI MATISSE, *Venus*, 1952. Paper pasted on canvas, 39⅞ × 30⅛ins (100 × 76cm). The National Gallery of Art, Washington D.C.

of the gown. Although the shapes are worked flat on the cloth, when the gown is worn they will become more three-dimensional as the cloth drapes over the contours of the body.

Shapes can be created in unfilled as well as filled areas of a design. We perceived unworked white shapes in Matisse's *The Snail* (2.30), but they were not the focus of the work. In Matisse's *Venus* (**2.33**), the white, relatively unworked area in the center becomes a positive shape: that of a female torso. It takes some visual sophistication to see it, for the outline is abstracted and distorted, but indications of breasts and swelling hips—plus the title of the work —are given as clues. Viewers are asked to fill in the rest from their own imagination.

The shapes shown thus far are HARD-EDGED, but some artists work with SOFT-EDGED shapes. When edges are not precisely delineated, it may be hard to pinpoint where one shape stops and another begins, but we may still get a sense of the presence of shapes. Odilon Redon, one of the foremost of the Symbolist painters of the late nineteenth century, created a dream-like atmosphere for *Orpheus* (**2.35**) through softly diffused lights and shadows and a barely defined outline for the severed head of Orpheus. The blue cloth is an even more soft-edged shape. Redon, who sought visible expression of the products of the unconscious, saw the mythical still-singing head of the dead Orpheus as a symbol of art's immortality.

Shapes may also be created to express a certain emotion. The life-like shapes of Arp's *Automatic Drawing* (2.32) express a playful, happy mood totally divorced from any subject matter. In E. McKnight Kauffer's poster for the *Daily Herald* (2.36), associa-

2.34 Gown, made by the Mandingo of Liberia. Dyed and woven cotton cloth, decorated with embroidery and appliqué, 36½ins (93cm) high. The British Museum, London.

2.35 ODILON REDON, *Orpheus*, after 1903. Pastel, 27½ × 22¼ins (70 × 56.5cm). Cleveland Museum of Art.

2.36 E. MCKNIGHT KAUFFER, Poster for the *Daily Herald*, 1918. Victoria and Albert Museum, London.

tions with a flock of flying birds add to the expressive quality of the shapes themselves. Full of long, pointed edges (including those of the white shapes), they carry a quick and busy impact that is entirely appropriate for the image of a successful newspaper. Together, the bird shapes form the larger IMPLIED SHAPE of a jetlike object flying from right to left across our field of vision. This implied shape is too subtle for most viewers to grasp consciously, but it nonetheless influences our emotional response to the advertisement.

SPACE

In art, as in life, space is an intangible element. Yet artists work quite consciously with spatial aspects of our existence to achieve the effects they desire. Those we will explore here are the ways in which three-dimensional art controls space, the differing ways space is handled in two-dimensional work, the concept of scale, and the mystery of spatial illusions.

Aesthetic distance

Perhaps the first way in which we are affected by space in a work of art is our own spatial relationship to it. Sometimes we stand far away to take in the whole thing or to see the work in relation to its surroundings; sometimes we move in very close to look at small details, examine how a piece was made, or feel its surface with our hands.

A miniature will draw us in, if it is successful, whereas many large paintings are best seen from a certain distance. People who are aware of this aspect of the art of seeing may move away from or closer to a painting in a gallery or museum until the work looks its best. In a representational painting, lines may come into familiar focus when we discover the best AESTHETIC DISTANCE; forms may gradually appear, whereas from close range all one could see was patches of color.

Some artists work consciously with aesthetic distance, manipulating the viewer in space to the optimal viewpoint. When the viewer's spatial position is relatively fixed, as in an advertisement meant to be

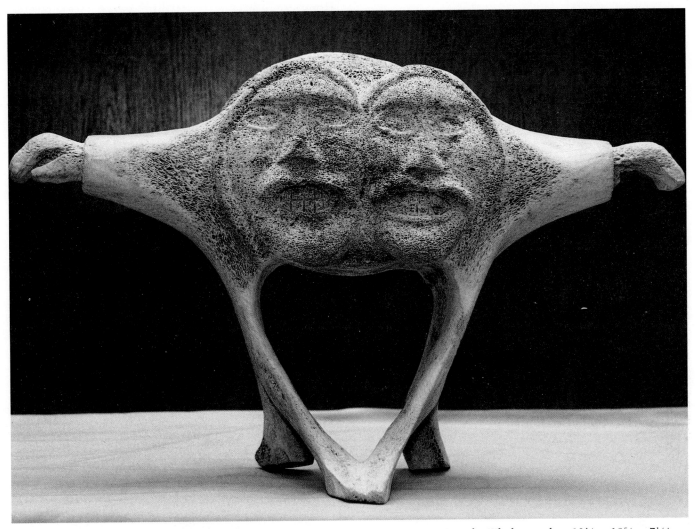

2.37 MANASIE MANAIPIK, *Good Spirit*, 1969, Pangnirtung, Northwest Territories, Canada. Whale vertebra, 12½ × 18⅝ × 7½ins (32 × 48 × 19cm). Macmillan-Bloedel Limited, Vancouver.

seen on a page in a magazine, the artist is challenged to make the work seem to fill the viewer's whole visual field, with everything beyond its bounds dropping out of focus even if the ad covers only a quarter of a page.

Three-dimensional art in space

On the most basic level, three-dimensional art physically occupies space. It has its own very obvious spatial reality—the volume of air it displaces. Less obvious are other ways in which certain works exist in space.

Some works delineate forms in space, shaping the intangible into contoured areas. In Manasie Manaipik's *Good Spirit* sculpture (**2.37**), the open area in a whale's vertebra that once housed the spinal cord is brought to our attention as an interesting form in itself. The hard edges of the opening and its regular contours help us to "see" the form of the unfilled

2.39 Model of the interior space of Hagia Sophia.

space. Certain architectural forms work the same way, defining a volume in space by enclosing it. In the great Byzantine church of Hagia Sophia (2.38), the central interior space is a vast domed square rising 183 feet (56m) above the floor. A model of the interior (2.39) reveals the form of this space as though it were a solid mass. This delineated space surrounds worshippers—originally restricted to the emperor, his court, and the clergy—with an awe-inspiring microcosm of the vastness of the universe and the greatness of its Creator.

Some sculptures carve out their own small world in a confined space. Joseph Cornell has done many works of this sort, defining an area by means of a glass case and then building up enigmatic compositions within it from FOUND OBJECTS. *Soap Bubble Set* (2.40) seems to carry allusions to the childhood fun of blowing soap bubbles—thus the doll's head, clay pipe, and perhaps the egg in the goblet. But the cylinders and the old map of the moon carry the meanings of the work into the realm of allegorical mysteries. Within this confined and compartmentalized space, everyday objects lose their usual identities and become whatever the artist and viewers' imaginations perceive them to be.

2.40 JOSEPH CORNELL, *Soap Bubble Set*, 1936. Glass case with map, goblet, egg, pipe, head, and four boxes, 15¾ins (40cm) high. Wadsworth Atheneum, Hartford, CT., Henry and Walter Keney Fund.

2.38 Hagia Sophia, Istanbul, AD 532–537. Dome 183ft (56m) high.

2.41 MARK DI SUVERO, *She*, 1976–79. Steel, 55ft (16 .6m) long. Collection: Eugene M. Klein.

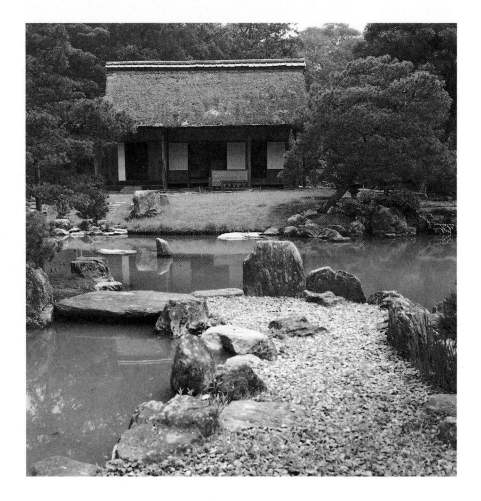

2.42 Garden of Katsura Palace, Kyoto, Japan, Edo Period, early 17th century.

It is possible for a three-dimensional work to "control" an area larger than it physically occupies. Sculptures with pointed linear projections may seem to activate the space around them, as if the lines continued for some distance into that space. The bold lines of Mark di Suvero's sculpture *She* (**2.41**) are so strong that their commanding presence is felt beyond the edges of the steel. Furthermore, it is a participatory sculpture with three movable parts to swing on. When these swinging members are in motion, the sculpture seems to command an even greater volume of space.

It is also possible for three-dimensional art to control us in space. Architecture provides defined rooms and halls and stairways that guide our movements. Gardens may also be planned to manipulate people's movements through space, using pathways and barriers. In the Japanese garden shown in Figure **2.42**, the way across the pond is defined by a path and then by stepping stones, all carefully arranged to imitate nature. The artistry of Japanese garden design leads us to step in specific places, at a specific pace, so that we are invited to enjoy artfully composed views of the landscape. When these devices work well, we are unaware of being manipulated.

Two-dimensional space

The two-dimensional surface is by definition a flat plane. But for artists to use it thus, without creating an illusion of three-dimensional space, is a relatively recent development in Western art. Stuart Davis's *Semé* (**2.43**) is a visual puzzle strewn ("*semé*") as flat cut-outs and writing across a flat surface. It invites us to try to piece together the meaning of its obscure clues. One possible interpretation is that in working with visual "eydeas" (lower left), "any" subject matter is of equal validity and importance. On the level of form, we read this flat composition across the surface of what is called the PICTURE PLANE, as flat objects on a flat background, a continually changing series of FIGURE-GROUND RELATIONSHIPS. In such a use of the picture plane, the figure is what we see as the positive shape; the ground is what appears to lie just behind it in space.

2.43 STUART DAVIS, *Semé*, 1953. Oil on canvas, 52 × 40ins (132 × 102cm). The Metropolitan Museum of Art, New York, George A. Hearn Fund, 1953.

If the figure and ground are approximately equal in size, artists can create another kind of visual puzzle: a FIGURE-GROUND REVERSAL. If you stare at the logo for a health maintenance group (**2.44**), your perception may keep flipping from a black butterfly on a white ground to two white people, with a heart between them, on a black ground.

2.44 ERIC MADSEN and KEVIN KUESTER, Trademark design for Physicians of Minnesota.

2.45 MU-CH'I, *Six Persimmons*, Southern Sung dynasty, China, late 13th century. Ink on paper, 14½ins (37cm) wide. Daitoku-ji, Kyoto, Japan.

Two-dimensional picture planes are often treated to create the impression of space that recedes from the viewer—or sometimes even extends forward. A number of devices have been developed that fool the eye into thinking it is looking into a space that has depth. As illustrations, we will use works that primarily use only one device, though many pieces of three-dimensional art use all of them at once.

One such device is the PLACEMENT of images on the picture plane. In general, we tend to interpret figures that are lower on the picture plane as being closer to us in space. In Mu-ch'i's *Six Persimmons* (**2.45**), we do not interpret the fruits as floating in the air. Even though there is no visible surface for them to be sitting on, we perceive them as resting on something because of their placement in relationship to each other. We see the one that is lowest as closest to us, implying a surface that extends at least as far forward as the fruit seems to come. The other persimmons

2.46 *Sudama Approaching the Golden City of Krishna*, c.1785, Northern India. Gouache on paper, 7¼ × 10½ins (18.5 × 26.5cm). Victoria and Albert Museum, London.

2.47 Painted buffalo skin with mythological scenes, c.1830. Andans Tribe, North American Plains, c.96ins (250cm) long. Musée de l'Homme, Paris.

line up behind it at slightly different depths in space, with the highest one in the center seeming farther away than the ones to either side. The artist tells us to look from object to object, observing the many subtle ways they differ, including their very slightly differing placement in space.

Similarly, the Native American painter of a buffalo skin (**2.47**) did not intend for the warriors and horses to be seen as flying in the sky. Though mythological, the horses are clearly standing on solid ground, and the two fallen warriors at upper left are obviously lying on something rather than floating. Each of the figures is drawn as if seen directly from the side and from exactly the same distance, a logical impossibility for an unmoving viewer albeit a "true" piece-by-piece depiction of reality. But their placement one above the other is a clue that they are all standing on

the same receding surface, rather as though we were looking down and across a large battlefield. Many cultures have used this convention, having figures apparently receding into the distance by presenting them in bands from the bottom to the top of the picture plane.

Another device giving the illusion of spatial depth is OVERLAPPING: the obscuring of images to be interpreted as farther away from us by objects designed to appear closer to us. In *Sudama Approaching the Golden City of Krishna* (**2.46**) the pilgrim Sudama seems closest to us not only because he is at the bottom of the painting but also because he obscures parts of the hills. The hills, in turn, overlap each other in tiers to be read as one behind the other in space.

A device which was not used consistently in any of these works but which adds a tremendous feeling

2.48 PIETER BRUEGEL the ELDER, *Hunters in the Snow*, 1565. Oil on canvas, 46 × 64ins (117 × 162cm). Kunsthistorisches Museum, Vienna.

2.49 ALBERT BIERSTADT, *The Rocky Mountains, Lander's Peak*, 1863. Oil on canvas, 73½ × 120¾ins (186.7 × 306.7cm). The Metropolitan Museum of Art, New York, Rogers Fund, 1907.

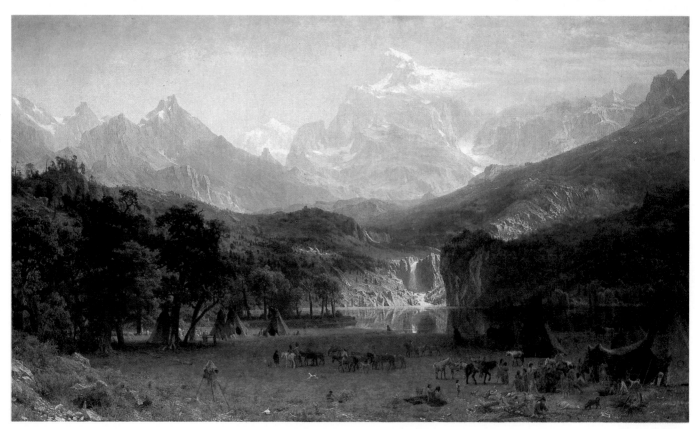

2.50 One-point linear perspective in *The Finding of the Body of St Mark*.

2.51 JACOPO TINTORETTO, *The Finding of the Body of St Mark*, 1562–66. Oil on canvas, 14 × 14ft (4.26 × 4.26m). Pinacoteca di Brera, Milan.

of depth to a two-dimensional painting is SCALE CHANGE. In art, the term "scale" refers to relative size. One of the most dramatic examples of the use of scale change is Bruegel's *Hunters in the Snow* (**2.48**). We perceive the large figures to the left as closest to us in space because they are by far the largest of the human figures. The people down on the frozen pond are pushed way back in space because they are so much smaller in comparison. The same kind of rapid scaling down can be traced in the houses and the trees from foreground to distant background. Bruegel makes us feel that we are looking across an immense distance, all the way to another village with a church spire and even beyond that.

Another device used to create the illusion of ex-

tremely deep space is LINEAR PERSPECTIVE. This technique was refined and translated into precise mathematical terms by Renaissance artists in the fifteenth century. It portrays all parallel horizontal lines of forms that recede from the viewer's position as converging diagonally toward the same VANISHING POINT in the distance (in simple "one-point" perspective), determining the changing scale of the forms. In Tintoretto's *The Finding of the Body of St Mark* (**2.51**), the vaulted crypt, elevated sarcophagi, and floor tiles all provide lines shown as diminishing along diagonals to a point precisely behind the open palm of the saint, as shown diagrammatically in Figure **2.50**. Even the cadaver on the floor is dramatically FORESHORTENED, or contracted in length, indicating that it

is receding from us in space. This dramatic use of linear perspective not only gives a sense of depth to the scene but also draws our eye compellingly toward the palm of St Mark's hand. He has appeared as a vision to his devotees, who are searching for his body in the crypt of a church in the captured city of Alexandria. His dramatic gesture halts them from opening any more graves, for he has revealed his own corpse. The perspective lines make his open hand the focal point of a complex composition in which the twisting figures tend to draw our eye away in many directions. We look from one group to another in the attempt to decipher what is going on. But the many lines angling toward the one vanishing point eventually bring us back to St Mark's hand, tying the composition together.

Artists may also use AERIAL (or ATMOSPHERIC) PERSPECTIVE, by representing the tendency of things in the distance to be less sharply defined in form and value contrast than forms that are closer to us, because of the effect of atmospheric haze. This device is used naturalistically to push areas back in space, especially when a truly vast scene is depicted, as in Albert Bierstadt's scene from the Rocky Mountains (2.49). In contrast with the details of the Shoshone Indian encampment in the foreground, the land gradually loses sharpness and value contrast to the point where the details of the mountains in the distant background are so faint as almost to blend with the sky.

In working two-dimensionally with illusions of

2.52 EDGAR DEGAS, *Dancer with a Bouquet*, c.1878. Pastel and wash over black chalk on paper, 12½ × 19¾ins (40 × 63cm). Museum of Art, Rhode Island School of Design, Providence.

2.53 ROBERT LAWSON, Illustration to Munro Leaf, *The Story of Ferdinand*, 1936.

three-dimensional space, artists also manipulate the POINT OF VIEW. By the angle from which they show us figures, they are telling us exactly where we are placed in spatial relationship to them. The invention of the camera encouraged artists to experiment freely with the points of view they used, rather than rely on conventional frontal views. Edgar Degas explored unusual points of view in many of his works. In *Dancer with a Bouquet* (**2.52**), we can barely see the bouquet. What we see instead is the fan of the woman whom Degas has placed between us and the ballerina, telling us exactly where we are sitting: behind and to the left of the woman with the fan, perhaps in a box slightly above the stage. Degas even makes it very

clear where we are looking: down and back across the stage. This precise and unexpected point of view brings us intimately into the scene, as though we were really sitting at the ballet rather than looking at a picture of a ballet.

Sometimes artists deliberately place us in very improbable points of view. Robert Lawson illustrates the sentence from Munro Leaf's book *Ferdinand*, "He didn't look where he was sitting and instead of sitting on the nice cool grass in the shade he sat on a bumble bee," with a picture that places us under the bull's rump, a bumble bee's eye view (**2.53**). This perspective emphasizes the great bulk of Ferdinand and actually shrinks our sense of our own size, for we

103

2.54 JANET CUMMINGS GOOD, *Floor Show*, 1983. Ink drawing, 30 × 40ins (76.2 × 101.6cm).

must be very small to fit where Lawson has placed us and to see the bumble bee as it is presented in the original, about three times life size.

Another relatively recent innovation in points of view is the AERIAL VIEW, perhaps suggested by the photographs taken from airplanes and satellites. It takes considerable visual sophistication to interpret such images as horizontal when they are hung on a vertical surface. Janet Good's *Floor Show* (**2.54**) may make sense to you if you are holding this book horizontally. But if you tip it to the vertical, as the picture would be if it were hanging on a wall, you

2.55 HIERONYMUS BOSCH, *The Carrying of the Cross*, c.1510. Oil on board, 30 × 32ins (76.2 × 81.3cm). Musée des Beaux-Arts, Ghent.

must make a strong mental adjustment to recognize that you are looking down on cats who are lying on a wooden floor instead of across at cats splayed against a wall. In such cases, artists require us to use our model of the world to interpret their creations. We just know from experience that cats sleep on the floor, not on the wall.

We can also examine two-dimensional use of space by considering the extent to which the artist has filled it or left it open. Hieronymus Bosch's *The Carrying of the Cross* (**2.55**) is so full of people that the canvas seems crowded with degenerate life

forms. For this crowd effect, Bosch packed more heads into the picture than could actually fit bodily into the space. Amid this leering and hateful mob, the serene, resigned face of Jesus is a striking counterpoint—the image of the divine unrecognized in the midst of human ugliness.

By contrast, leaving large areas of the picture plane unfilled may be used to create a quiet effect or to draw attention to an image isolated within this emptiness. Advertisements often use large unfilled spaces for effect, even though they have to pay for the "empty" space. In the *Daily Herald* ad shown in Figure 2.36, the large unfilled space beneath the birds emphasizes the heights to which the paper is soaring. In traditional Japanese painting, the areas left unfilled were considered just as important as the filled areas. The sixteenth-century Japanese artist Hasegawa Tohaku dares to leave two of the large panels of his painted screen (**2.56**) almost completely unfilled and provides only suggestions of form in the others to create the effect of trees fading into the mist. By a supremely subtle use of contrast, the unfilled areas and the barely-seen, washed-out tree forms heighten our appreciation of the darkest strokes.

Occasionally an artist will work with IMPLIED UNFILLED SPACE, giving enough information for our imagination to create unfilled spaces that are not actually shown. Consider *St Francis in Ecstasy* (**2.57**) by the Venetian painter Giovanni Bellini. In physical terms, all of the canvas has been worked. But in terms of content, the information given allows us easily to imagine an open area continuing around behind the rocky hilltop and down into the valley. The strong light coming from the left (both sunlight, and a manifestation of the presence of God) and St Francis's ecstatic communion with it clearly suggest that to our left stretches a vast area of open space, in which nothing obstructs the steady radiance.

Scale

We are accustomed to objects that are "life-sized." When an artist presents a familiar form in an unfamiliar size, our interest is often heightened, for the experience is immediately something out of the ordinary.

Claes Oldenburg presents mundane objects—such as a clothespin, a lipstick, a hamburger, a baked

2.56 HASEGAWA TOHAKU, *Pine Trees*, Momoyama Period, Japan, 1539–1610. Ink on paper, 61ins (155cm) high. National Museum, Tokyo.

2.57 GIOVANNI BELLINI, *St Francis in Ecstasy*, c.1480. Oil on panel, 49 × 56ins (124 × 142cm). Frick Collection, New York.

potato—as colossal monuments to the familiar banalities of our lives, greatly exaggerated in scale. By their great size, these inflated monuments to the ordinary make viewers feel dwarfed. Visitors to the Dallas Museum of Art discover that *Stake Hitch* (**2.58**) is so huge that the 20-inch-thick (51cm) rope runs all the way to the vaulted roof of the gallery and the point of the stake is "hammered through" the floor and can be seen in the basement. Oldenburg sketched and proposed far more monuments than municipalities have dared to build. Approaching the absurdities of modern civilization with humor as a survival tactic, Oldenburg explained his first inspiration:

2.58 CLAES OLDENBURG, *Stake Hitch*, 1984. Aluminum, steel, urethane foam, 53ft 6ins × 15ft 2ins × 44ft 6ins (16.3 × 4.6 × 13.6m). Dallas Museum of Art, commissioned to honor John Dabney Murchinson, Sr, for his arts and civic leadership, and presented by his family.

2.59 HANS HOLBEIN, *Jane Small*, c.1540. Watercolor on vellum, 2¹⁄₁₆ins (5.3cm) diameter. Victoria and Albert Museum, London.

> The first suggestion of a monument came some years ago as I was riding in from the airport. I thought: how nice it would be to have a large rabbit about the size of a skyscraper in midtown. It would cheer people up seeing its ears from the suburbs.[4]

Whereas *Stake Hitch* was commissioned and fabricated especially for the Dallas Museum of Art, the huge Buddha in Honan Province, China, (**2.60**) was carved directly out of the living rock. It, too, dwarfs visitors, in this case awing them with the greatness of the illuminated master. The people at the foot of the statue reveal its great scale in comparison to normal human size. The remains of the original rock still present as a ledge above the Buddha give some indication of the tremendous amount of rock that had to be chipped away to create this enormous stone figure.

At the other end of scale exaggerations are MINIATURES, artworks that draw us in because they are so much smaller than we would expect. We are accustomed to seeing paintings scaled down to sizes that fit conveniently onto book pages. But when we recognize that Hans Holbein's miniature portrait of a lady (recently identified as one Jane Small) (**2.59**) was actually painted in the same size as it is shown here, we can begin to appreciate the extreme delicacy and skill required for its creation. Imagine how small a brush Holbein must have used to paint the details on the cuffs and neckpiece. Despite the minuscule scale of this meticulous work, it is considered one of the world's great portraits. Precise miniature paintings were very popular as illustrations for medieval European and Persian manuscripts and as jewelry pieces for sixteenth- through eighteenth-century English aristocrats.

Scale may also be used to make a statement about the relative importance of forms within a work. In *Buddhist Temple in the Hills after Rain* (**2.61**), as in many early Chinese landscape paintings, the figures

2.60 Vairocana Buddha, AD 672–5. Natural rock, c.49ft (15m) high. Lung-mên, near Lo-yang, Honan Province, China.

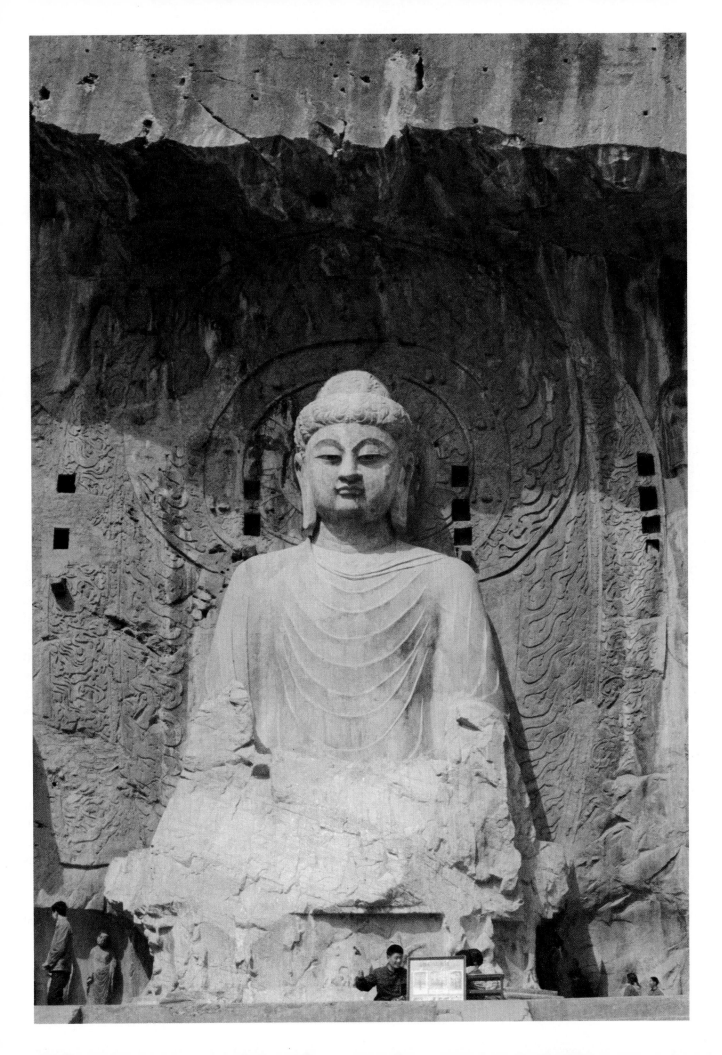

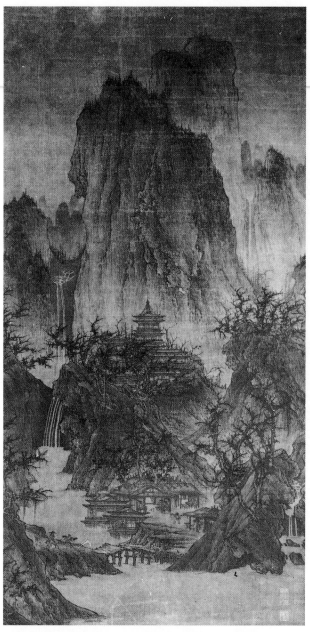

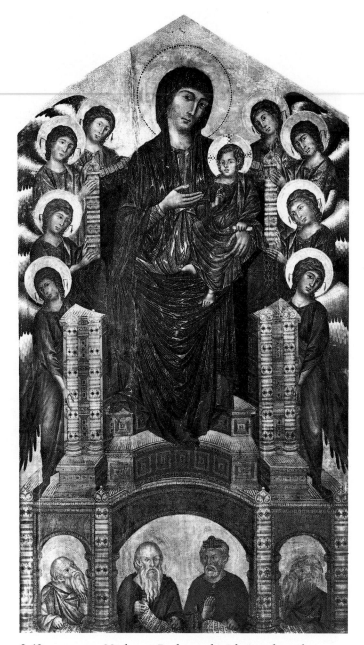

2.61 Attributed to LI CH'ENG, *Buddhist Temple in the Hills after Rain*, Northern Sung Dynasty, China, c.AD 940–967. Ink and slight color on silk, 44 × 22ins (111.8 × 55.8cm). William Rockhill Nelson Gallery of Art, Atkins Museum of Fine Arts, Kansas City.

2.62 CIMABUE, *Madonna Enthroned with Angels and Prophets*, c.1280–85. Tempera on wood, 12ft 6ins × 7ft 4ins (3.85 × 2.23m). Galleria degli Uffizi, Florence.

of pilgrims are tiny and unobtrusive in comparison with the impact of the mountains. In Taoist thought, this scale reflected the importance of humanity in the universe—a barely significant part of the totality, subordinate to nature. By contrast, religious works from the Christian tradition tend to emphasize hu-

man forms, especially those of holy figures. In the large altarpiece *Madonna Enthroned with Angels and Prophets* (**2.62**), the Madonna is larger than life and larger than the angels on either side and the prophets below, a spatial device that speaks of her importance on the throne of heaven.

2.63 WILLIAM HOGARTH, frontispiece to *Kirby's Perspective*, 1753. Engraving, 8¼ × 6¾ins (21 × 17.1cm). Victoria and Albert Museum, London.

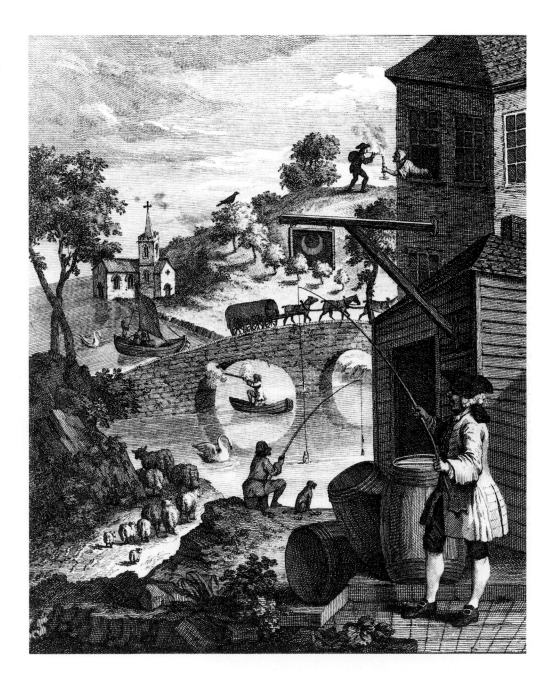

Spatial illusion

One intriguing way in which some artists work with space is to twist it into situations that seem at first glance to work but turn out on closer inspection to be quite impossible, given what we know of the three-dimensional world. William Hogarth's frontispiece for *Kirby's Perspective* (**2.63**) is a visual game with space as its subject. For instance, the fishing pole held by the man at the far right cannot possibly be long enough to reach all the way out to the pond, where it is shown neatly catching a fish. The scale of the sheep rounding the corner at the left is exactly backwards: Those farthest away are the largest. To introduce the study of perspective, Hogarth has humorously created a scene full of spatial "mistakes." It may look initially plausible, but the longer you examine it, the more spatial impossibilities you will discover.

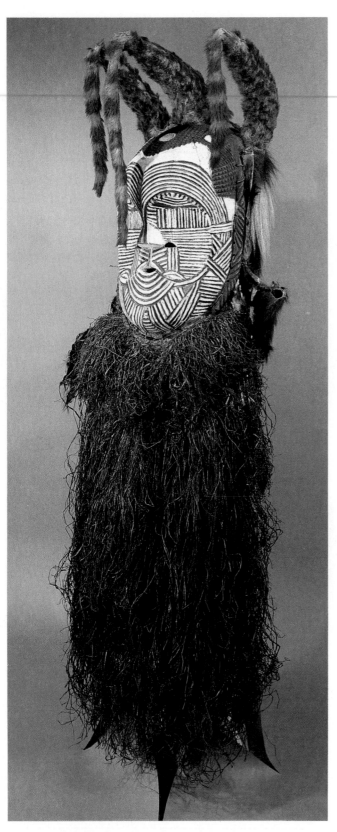

2.64 African Batetela mask. Wood, fur, and fiber, 16½ins (42cm) long. The British Museum, London.

TEXTURE

The TEXTURE of a work of art is its surface quality—how it would feel if we touched it. From our experiences in the world, we are quite familiar with a great range of textural qualities: coarse, slimy, bristly, smooth, furry, matted, scratchy, wrinkled, and so on. Our hands are equipped with sensitive nerves for distinguishing textures, and we find sensual joy in feeling certain surfaces. Artists know this, and often use textures as a major influence on our response to a piece.

The sculptor Henry Moore encouraged people to touch his works. His *Reclining Figure* (**2.65**) makes us want to do so. Its highly polished wood surface reminds us visually of the smoothness of taut skin and invites caressing. Despite the abstraction of the form, the prominent grain in the elm wood accentuates the visual similarity to a human body by suggesting the curves of muscles.

Some textures are much less inviting, but nonetheless enhance the intended visual impact of a piece. The Batetela mask shown here (**2.64**) was designed for a shaman's use in exciting crowds with fear of the spirit world, and must have done so rather effectively. Its several textures are in dramatic contrast to each other, from the hairy unkempt quality of the beard, to the geometrically precise incised lines defining the contours of the face, to the furry antennae flopping down over the face like the legs of a dangerous spider. Used in this context, all of these textures become alarming yet fascinating. The effect of the mask in motion must have been truly terrifying.

Textures may toy with our curiosity, using it to lure us into spending time with a piece. Lucas Samaras's *Book 4* (**2.66**) presents us with sharp found objects we know would hurt us if we touched them. What is more, Samaras has placed them in menacing projections. But rather than totally avoiding such dangerous things, we tend to come as close as we dare out of a sense of adventure. The combination of all these sharp materials with an open book increases their perception as textures. Since a book is something we usually hold in our hands, turning the pages, we can readily "feel" these textures.

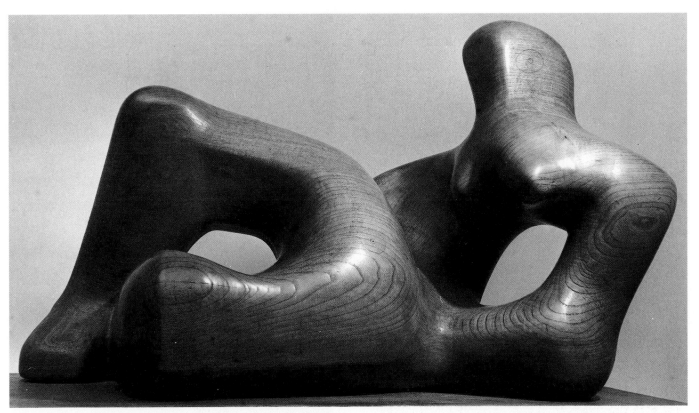

2.65 HENRY MOORE, *Reclining Figure*, 1935–36. Elm wood, 42ins (107cm) long. Wakefield Metropolitan District Council Art Gallery and Museums, Yorkshire.

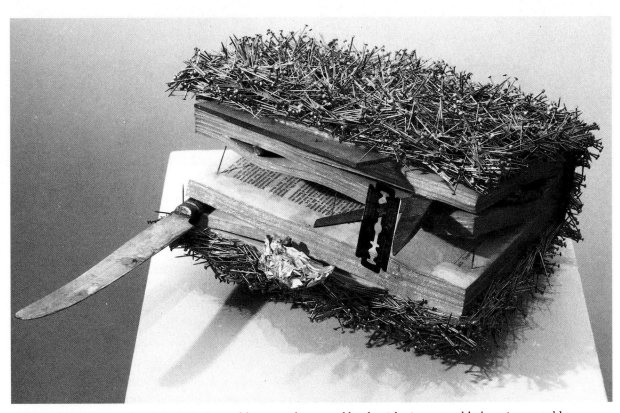

2.66 LUCAS SAMARAS, *Book 4*, 1962. Assemblage, partly opened book with pins, razor blade, scissors, table knife, metal foil, piece of glass, and plastic rod, $5\frac{1}{2} \times 8\frac{7}{8} \times 11\frac{1}{2}$ins ($14 \times 22.5 \times 29.2$cm). The Museum of Modern Art, New York, Gift of Philip Johnson.

Actual texture

The textures with which we are most familiar are those we can feel with our hands: ACTUAL TEXTURES. Everything has a surface texture, but some textures tend to stand out as such. The Danish rune stone (**2.67**) is carved as a low relief into rock so grainy that its roughness shows in the photograph. The over-and-under interlacing patterns that wrap around the Christ figure ask to be touched and followed with the fingers, almost bringing us into physical contact with the person who carved the stone.

To create an impressive, magical bust of the war-god Kukailimoku (**2.68**), a Hawaiian artist applied several materials with striking actual textures to a wicker frame. The feathers of tropical birds create a mysterious texture for the skin, pearl shells make a smooth and shining eye, and dogs' teeth make an impressive array of sharp teeth. These textural materials may have been used partly because they were plentiful, but to the eyes of those from other cultures, they give a strange, inexplicable quality to the piece.

The identity of actual textures may be transformed

2.67 Rune Stone, Jelling, Denmark, AD 965–986. Granite, 96ins (244cm) high.

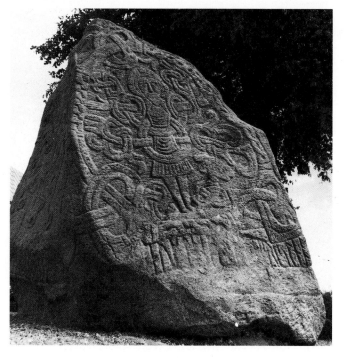

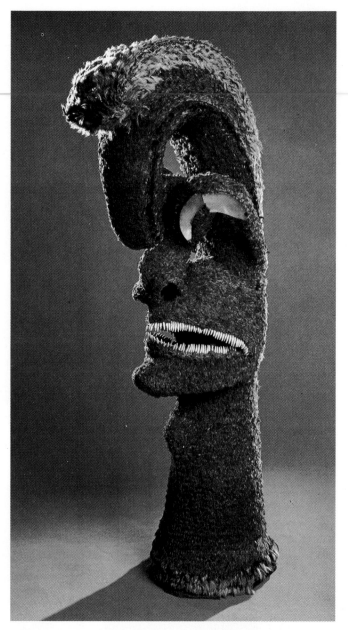

2.68 The war-god Kukailimoku, from Hawaii, before 1779. Feathers over wickerwork, pearl shells, and dog teeth, 40¾ins (103.5cm) high. The British Museum, London.

into other, very different textural qualities, depending on the context in which the artist places them. In Peter Good's *Wall Street* (**2.69**), the raised textures of soft fabric trims become architectural details on buildings, presumably quite hard, through the humorous device of vastly changing their scale.

Some actual textures are created rather than used just as they are found. In her *Rock Books*, such as the

2.69 PETER GOOD, *Wall Street*, 1980. Fabric appliqué, 16 × 21½ins (40.6 × 54.6cm). For Farm Credit annual report.

one shown in Figure **2.70**, Michelle Stuart captures the "story of a place" by gathering rocks and dirt there and pounding it into paper, rubbing its surface until it develops a gloss. A series of such "pages" made from diggings at the site are then bound into a "book." The book, in turn, is sealed with a found texture—a feather, a coarse-woven string, a bone. These assemblages bespeak touching the earth, but they do not invite much handling by the viewer because they appear fragile, precious, and even ancient.

Simulated texture

Two-dimensional works often create the visual sensations of textural qualities on a surface that would actually feel quite different if touched. If we touched a print of Mary Azarian's woodcut (**2.71**) from the alphabet she was commissioned to create for the Vermont public schools, we would feel only the slight coarseness of the paper and the ink across the surface. But visually, what we perceive is the relative smoothness of grass blades, the filmy deli-

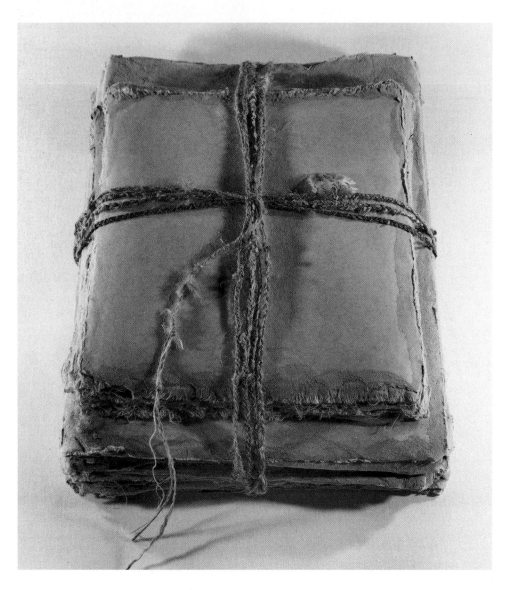

2.70 MICHELLE STUART, *The Pen Argyl Myth*, 1977. Earth and feather from Pen Argyl Quarry, Pennsylvania, rag paper, 13½ × 10½ × 3½ins (34.3 × 26.7 × 8.9cm).

MARY AZARIAN, *T is for Toad*, from *A Farmer's Alphabet*, 1981. Two-color woodcut, 12¼ × 7½ins (31.1 × 19cm).

cacy of dragonfly wings, and the bumpiness of the toad's skin. None of these textures is described utterly realistically. For instance, the bumpiness is more hard-edged than the smooth, moist lumps on a real toad. Instead, Azarian uses a visual shorthand that reminds us of these natural textures, if we are familiar with them. These shorthand simulated textures also provide an interesting series of visual contrasts.

In comparison, certain artists have gone to great lengths to capture the visual effects of textures. One of the masters in this respect is Ingres. In his *Portrait of the Princesse de Broglie* (**2.72**), the facial skin and hair are rather stylized and simplified, in dramatic contrast to the extreme attention to detail in rendering the textures of the fabrics. The lush satiny dress fabric is so realistically painted that we can guess exactly how it feels. One clue is the way it reflects the light, a characteristic of smooth and shiny surfaces. We can see that the lace and gold-trimmed throw have very different textures, though they share with the satin the suppleness of fabric. And the information given to our eyes about the chair allows our fingers to imagine the play of the smooth surface and raised brocade across its plump contours.

Such brilliant simulated textural effects have occasionally been achieved in three-dimensional works. One of the hardest of materials—marble—has been lovingly sculpted to suggest the feel of human skin in the *Venus de Milo* (**2.73**) from the Hellenistic period. Not only does it appear soft; it even looks as though it would feel warm to the touch.

When a visual effect is so realistic that it totally fools our perceptions, it is called TROMPE L'OEIL (literally, "deceive the eye"). We are fascinated with that which deceives us in art. There is probably little innate visual appeal in a golf bag. But the fact that

2.74 MARILYN LEVINE, *Two-Toned Golf Bag*, 1980. Stoneware with nylon reinforcement, 35 × 10½ × 7ins (89 × 27 × 18cm).

2.73 *Venus de Milo*, c.150 BC. Marble, 82ins (208cm) high. The Louvre, Paris.

2.72 JEAN AUGUSTE DOMINIQUE INGRES, *Portrait of the Princesse de Broglie*, 1853. Oil on canvas, 47¾ × 35¾ins (121.3 × 90.8cm). The Metropolitan Museum of Art, New York, Robert Lehmann Collection 1975.

Marilyn Levine has created a life-sized golf bag (**2.74**) from ceramics makes her piece utterly intriguing. She has carefully studied and captured precisely in the hardness of fired clay the look of pliable worn leather and of metal. If we touched it, the actual feeling of the surface would be shockingly and humorously different from what our mind expects.

Texture-like effects

Certain works create a visual texture by repetition of elements of design. Imagine a forest seen from a distance. It has an all-over visual texture created by the repetition of tree-forms that is quite different from the actual feeling of tree trunks and branches. But those of us who are familiar with trees and forests may not be aware of this all-over texture, for our familiarity with the particular blinds us to what we are actually perceiving. It is easier for us to perceive a texture-like effect in something unfamiliar, such as the Imperial Edict ("Firman") of Sultan Mustafa IV (**2.75**). Because most of us cannot read the Arabic scripts used for the Imperial Monogram and the edict that is written below it, we can see them as non-objective designs, each having its own distinct visual texture. Certainly the way that the calligrapher Mustafa Rakim presented the edict reflects his awareness that each line of characters forms a textured shape.

Sometimes even with familiar images the textural effect of repeated elements of design is so strong that we distinguish the individual elements only secondarily. In the ancient German fish (2.19) the school of fish and the deer-like forms appear first as textural effects, and then as identifiable forms in themselves. In the portrait of Mao Tse-tung (2.76), it is the revolutionary leader we see first; the figures used to create him are so numerous, similar, closely-packed, and small in relationship to the whole that it is difficult to read them as individuals. The visual texture the faceless multitudes create is again a sort of shorthand, with sufficient information given that we translate the image into known textures of hair, eyebrows, lips, ear, and "Mao jacket."

2.75 MUSTAFA RAKIM, *Firman*, early 19th century. 51 × 19⅝ins (129.5 × 50cm).

2.76 HANS-GEORG RAUCH, illustration for *En Masse*, Macmillan Publishing Co., Inc. © Rowoholt Verlag, 1974.

2.77 HENRI-EDMOND CROSS, *The Artist's Garden at St Clair*, c.1908. Watercolor, 10½ × 14ins (26.6 × 35.5cm). The Metropolitan Museum of Art, New York.

VALUE AND LIGHT

Another visual element that may escape our notice, but which is used quite consciously by artists, is VALUE, the relative lightness or darkness of an area. Values are most easily perceived when color hues are subtracted. Black and white photographs of colored artworks translate hues into a range of grays from very dark to very light, as in this reproduction of Henri-Edmond Cross's watercolor *The Artist's Garden at St Clair* (**2.77**). These value variations help us to understand the effects of lighting and distance despite the abstract quality of the painting. Here, the overhanging branches seem to create pools of

shadow, beyond which values become very light in what appears to be strong daylight, fading to near-white in the distance. In general, as we saw in the section on space, perceived value contrasts are strongest in areas closest to the viewer.

The gradations of value from very dark to very light can be represented by means of a VALUE SCALE. The one shown in Figure **2.78** breaks down the variations into ten equal steps, with black at one end and white at the other. In a work such as *The Artist's Garden at St Clair*, there are actually many more values than ten, but the value scale is a useful tool for seeing value gradations lined up sequentially.

In addition to giving spatial clues, values also help

2.78 A 10-step value scale.

2.79 GASTON LACHAISE, *Standing Woman*, 1932. Bronze, 88 × 41⅛ × 19⅛ins (224 × 104 × 48cm). The Museum of Modern Art, New York.

us to perceive the modeling of forms. As light falls on three-dimensional object, such as Gaston Lachaise's sculpture *Standing Woman* (**2.79**), the areas that light strikes most directly are the lightest, showing up as HIGHLIGHTS. As contours curve away from the light source in space, the light dims, making the surface appear darker, until it approaches a true black in areas where light is fully blocked. The strong value contrasts on *Standing Woman* help us to grasp the extent to which the form swells out and draws back in space. In this photograph, strong lighting accentuates these contrasts; in more diffuse light, such as an overcast day, the ins and outs of the form would not be so apparent.

Local and interpretive values

The actual lights and shadows we see on real surfaces are called LOCAL VALUES. Some photographers attempt through techniques of photographing and developing to capture on film the full range of local values, called a FULL TONAL RANGE in photography. Although Katharine Alling confines and twists feathers into interesting shapes in *Feathers #22* (**2.80**), she also emphasizes their visual reality, with all the local values created as they curve from light into shadow. She remarks,

> We generally don't look at a feather that carefully. We label it and that's it. One of the features of photography is that we examine an object more carefully as a visual thing. We don't just say "Feather" and let it go.[5]

With intents other than reproducing visual reali-

2.80 KATHARINE ALLING, *Feathers #22*, 1984. Toned silver print, 12 × 9ins (30.5 × 22.9cm).

ties, many artists have manipulated values. When they are not handled realistically, they may be called INTERPRETIVE VALUES. One technique is to reduce the degree to which values gradually change, presenting them as more dramatic contrasts. To turn the sculptor Rodin's famous profile into a massive sculptural form, as if the man himself were a monument chipped from black stone, photographer Edward Steichen arranged for both Rodin and his sculpture *Le Penseur* ("The Thinker") to be in shadow, making them appear similarly strong (**2.81**). Their intense confrontation is set off by the white plaster figure of *Victor Hugo* brooding in the background. There are mid-grays in this photograph, but the main focus is on the stark contrast of the black forms to the highlights on *Le Penseur* and the light values of the *Hugo*. The drama of this approach is like hitting chords on both ends of a piano keyboard at once, with none of the notes in between.

Another approach to interpretive value is to emphasize one area of the value scale: lights, darks, or mid-tones. Each carries a different emotional quality. Rembrandt used the dark end of the scale in his self-portrait (1.60), with the light of his face barely

2.81 EDWARD STEICHEN, *Rodin: The Thinker*, 1902. Photograph. Collection: The Gilman Paper Company.

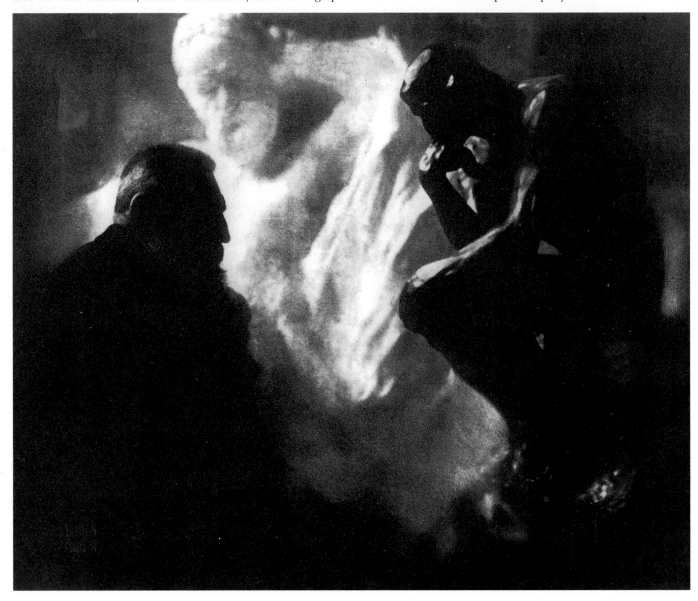

emerging from the shadows. Graphic designer Milton Glaser has chosen the light end of the scale to represent Monet on a poster (**2.82**). The choice is appropriate, for the artist emphasized the effects of light in his own work. Here he appears as if in midday light so strong that it has burned away all details except for those disappearing into the shadow under his hat. The fact that Glaser has added slight shadows to the right on Monet's hat and shoulder, an indication that the sun is slightly to the left of directly overhead, keeps the near-abstraction within the realm of the nearly-realistic.

In HIGH CONTRAST works, artists leave out all minor details, turning forms that usually include a range of grays into a dramatic contrast between black

2.82 MILTON GLASER, Poster for The Monet Museum, Giverny, 1981.

2.83 MALCOLM GREAR DESIGNERS, Poster for the Solomon R. Guggenheim Museum, 1970.

and white. The result may be an unrecognizable, seemingly nonobjective design. But in the case of the Guggenheim Museum poster (**2.83**), just enough information is left to allow us to fill in the missing edges of the building's famous spiraling form. Presented in high contrast, it is an intriguing abstraction that calls on us to bring our own knowledge to complete the picture.

Lighting

The way a subject is lit—by the sun or by artificial lighting—will affect how we perceive it. In the Persian miniature painting to illustrate *The Concourse of the Birds* (**2.84**), as in most Persian miniatures,

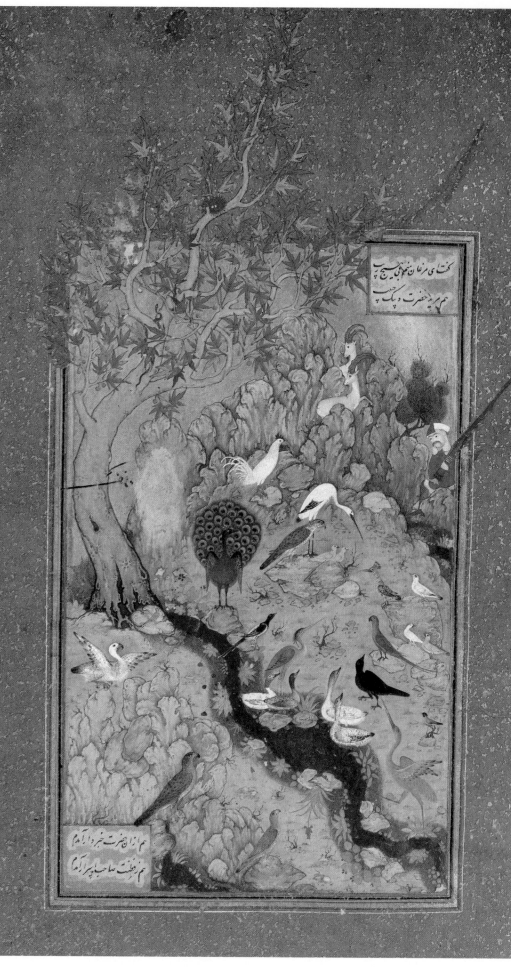

2.85 NANCY HOLT, *Sun Tunnels*, 1973–76. Total length 86ft (26.2m), tunnels each 18 × 9ft 4ins (54.8 × 28.4m). Great Basin, North West Utah Desert.

2.86 NANCY HOLT, *Sun Tunnels*, detail. Sunset on summer solstice.

Habib Allah presents a uniformly lit scene with no shadows. This lighting represents no particular time of day, removing it from the realm of the real into the ideal, mystical setting of the parable, which symbolically illustrates the unity of individual souls with the divine. In the *Mantiq at-Tayr* thirty birds undertake a difficult journey in search of the Simurgh, king of the birds, only to discover that they are themselves *sī murgh*, which means "thirty birds."

Many works do, however, contain some reference to the ever-changing reality of light. Three-dimensional pieces placed outside in a natural setting—as well as two-dimensional depictions of the natural world—will appear quite different when lit from the east at sunrise, overhead at noon, and from the west at sunset. The sun's angle changes during the year, also altering where the highlights and shadows fall. Moonlight brings a very different quality to a scene or piece of sculpture, softening edges and blurring distinctions between forms. And on cloudy days and during rain or snow the character of a piece or scene will be dramatically changed.

From antiquity, humans have used objects placed outside to track—and honor—the movements of the sun, moon, and stars. To do so reveals the predictabilities inherent in an otherwise uncertain existence. The sun will come up again tomorrow, though the point of its rising will have moved slightly. The solstices—the points on the horizon and calendar where this movement turns back on itself—have long had particular significance. A contemporary version of the ancient homage to the sun's apparent movements is Nancy Holt's *Sun Tunnels* (**2.85**). This consists of four enormous concrete tunnels placed on the Utah desert in such a way that the sun shines directly through two of them for ten days at the winter solstice and through the other two during the summer solstice. At other times, holes drilled into the pipes channel the light of sun, moon, or stars into their shaded centers to create the constellations Capricorn, Draco, Perseus, and Columba. Looking directly through the appropriate pipe during a solstice (**2.86**) one sees a shining circle around a circle whose center is the sun. At other times, one sees encircled darkness studded with starlike points of light, a circular sunwashed openness beyond, and the

2.84 HABIB ALLAH, *Concourse of the Birds*, 1609. Colors, gold, and silver on paper, 10 × 4½ins (25.4 × 11.4cm). The Metropolitan Museum of Art, New York, Fletcher Fund, 1963.

2.87 GEORGES DE LA TOUR, *The Penitent Magdalene*, c.1638–43. Oil on canvas, 52½ × 40ins (133.4 × 101.6cm). The Metropolitan Museum of Art, New York, Gift of Mr & Mrs Charles Wrightsman.

2.88 CHARLES W. MOORE and WILLIAM HERSEY, Piazza d'Italia, New Orleans, 1978.

dark circle of the opposite tunnel at its center.

The use of artificial lighting allows controlled rather than changing effects. Sculptors are very careful how their works are lit, for the shape, size, and position of shadows and highlights depend on the placement of lighting. During the Renaissance, European painters developed the technique of CHIARO-SCURO (Italian for "light and shade")—the depiction in a two-dimensional work of the effects of light and shadow. The direction from which light was coming was clearly stated, and sometimes the light source was incorporated as part of the picture. In Georges de la Tour's *The Penitent Magdalene* (**2.87**) the light of a single candle, amplified by its reflection in a mirror, is depicted as the source of the bright light washing out the values on the Magdalene's throat and left side, leaving the rest of the scene in relative darkness. The contrast in values between the illuminated and the shadowed areas is considerably exaggerated; true candlelight is a good deal weaker and more diffuse. But the artistic license the artist has taken with chiaro-scuro allows him to heighten the drama of the image.

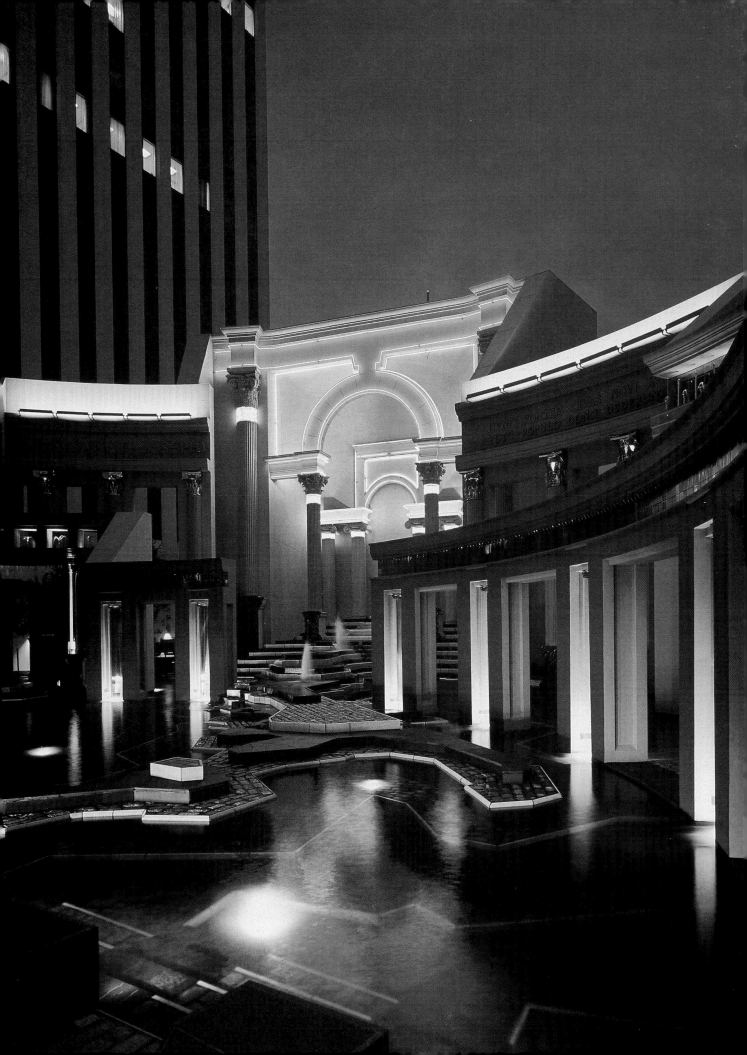

We are quite familiar with the use of artificial lighting to add drama to a city's skyline or friendly warmth and light to the interiors of our homes. Less familiar is the use of artificial colored lights to change the hues as well as the values in an area. A spectacularly theatrical use of colored neon lights appears at the *Piazza d'Italia* in New Orleans (**2.88**). A celebration of the contributions of Italian immigrants, it is like a stage setting for an opera. Flamboyantly sensual, eclectic and surprising in its architectural forms, it lures visitors to become part of the play. The neon lights throw a great range of colors across the fantastic architecture, for they mix where they overlap, enticing viewers to experience this multi-hued lighting playing across their own bodies.

2.89 LABBAR HOAGLAND, ALFONSO SOTO SORIA, and PEDRO LEITES, *Double-Wall Bowl*, 1985. Silver, 8 × 5½ins (20 × 16cm). Manufactured by Tane Orfebres, Mexico.

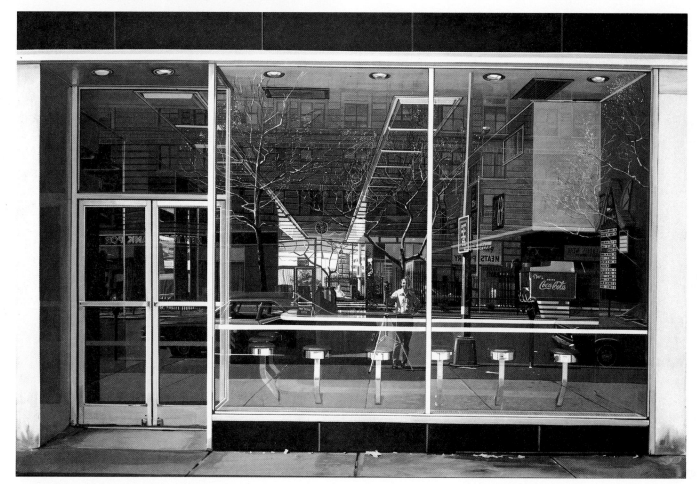

2.90 RICHARD ESTES, *Double Self-Portrait*, 1976. Oil on canvas, 24 × 36ins (60.8 × 91.6cm). The Museum of Modern Art, New York, Mr & Mrs Stuart M. Speiser Fund.

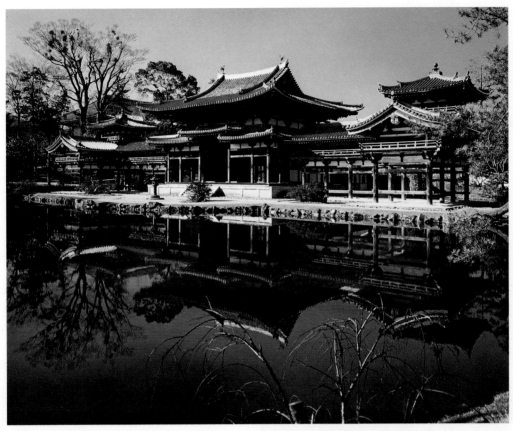

2.91 Hoodo (Phoenix Hall), Byodoi Temple, Uji, near Kyoto, Japan, 11th century.

Reflections

Another way in which light is used in art is by taking advantage of the fascinating effects of reflections off a smooth surface. Reflected light tends to capture our attention. The reflections of the surroundings on the highly-polished interior of the double-wall bowl (**2.89**) make us aware of this unfilled area. The reflections make this area surprisingly active and the high gloss adds to its sense of preciousness.

To depict reflections convincingly in two-dimensional works takes great skill. Richard Estes has perfected the art of painting the reflections in artificial surfaces such as chrome and glass so realistically that they appear to be photographs. His *Double Self-Portrait* (**2.90**) is a complex tour de force, photorealistically displaying both the reflections in a restaurant's glass wall of the view across the street —including the artist, who is seen taking the photograph from which this painting was done—and the

intermingled details of the interior of the restaurant seen through the same glass. In certain lighting situations, some glass will seem to hold reflections on its surface, but this glass allows both inside and reflected outside to be seen at once, as if the outer world were penetrating the interior. To add to the visual puzzle of figuring out what is inside and what is outside, there is a mirrored surface inside the restaurant, in which a second reflected image of the artist appears.

When we see an object reflected in water, it may seem to lose its grounded position on the earth and instead appear to be floating in space. Such reflections hold great fascination for us, for they draw us into a different world of spatial possibilities. When the water outside the Byodoi Temple (**2.91**) is as smooth as it is in this photograph, the temple and its reversed image become a totality apparently floating without support in space. The reversed image is visually exciting in itself as a symmetrical completion of the actual temple.

Light as a medium

Light itself may be captured and controlled as an element of design. Since light is energy that tends to diffuse through space, it must be controlled in different ways from corporeal matter. From the familiarity of neon signs—such as the word *EAT* floating in the dark before a restaurant—contemporary artists have derived the idea of using neon tubes to create lines of light in space, such as Stephen Antonakos's *Green Neon from Wall to Floor* (**2.92**). The invention of lasers suggested another art form: laser projections thrown against the night sky or a dark wall (**2.93**). Here no structure is needed to confine the light; it is shaped as a needle-thin beam.

Windows provide another way of controlling light for aesthetic purposes. The elaborate use of stone arches allowed great openings to be made in the walls of Gothic cathedrals for stained glass windows that told Biblical stories and created a mystical atmosphere for worshippers within, like the breath of the

2.92 STEPHEN ANTONAKOS, *Green Neon from Wall to Floor*, 1969–70. Neon tubing, 8 × 24 × 5ft (2.4 × 7.3 × 1.5m).

2.93 Laser deflection images, produced by Video/Laser III, 1987. Operated by Professor Lowell Cross at The University of Iowa.

2.94 Sainte-Chapelle, Paris, 1243–48.

2.95 LE CORBUSIER, Interior of the chapel of Notre-Dame-du-Haut, Ronchamp, France, 1950–55.

divine. At Sainte-Chapelle (**2.94**), a chapel for the French kings, the interior is suffused with many jewel tones that color the sunlight coming through the intricate stained glass panes, more brilliant than any flat-painted color could be. The architect Le Corbusier translated this effect into contemporary terms at his *Notre-Dame-du-Haut* (**2.95**), placing bits of stained glass within continually varying window openings. As the light bursts through each of these recesses in the thick walls, it creates a series of focal points in complex mathematical relationships to each other. Within the safe thickness of the walls, the light of God breaks through to touch each person physically.

COLOR

Color is an immediately obvious aspect of a work of art that clearly impresses itself on our consciousness. In describing any work that strikes a particular color note, we inevitably speak of it as "that red cube" or "one of Picasso's blue paintings." Less obvious are the subtle effects of colors on our visual receptors, emotional state, and our perceptions of space, though these effects are under study by scientists and used consciously by many artists. Color may even affect us spiritually, as the Russian nonobjective painter Vassily Kandinsky wrote:

> Color is a power which directly influences the soul. Color is the keyboard, the eyes are the hammers, the soul is the piano with many strings. The artist is the hand which plays, touching one key or another, to cause vibrations in the soul.[6]

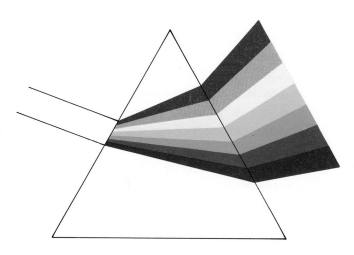

2.96 The visible spectrum.

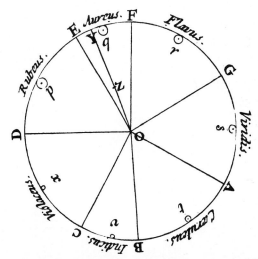

2.97 Newton's Color Wheel, from Isaac Newton, *Optice*, 1706. The British Library, London.

A vocabulary of color

From Kandinsky's sublime perception we descend to the need to establish a vocabulary for speaking about differences between the colors we perceive. The first understanding necessary is that what we perceive as the color of an object is actually the reflection of light of a certain wavelength off the surface, as this reflection is received by the retina of the eye and perceived by the brain. It does not "belong" to the object itself. The wavelengths that humans can see (only a tiny fraction of the great spectrum of electromagnetic radiation) are collectively referred to as the VISIBLE SPECTRUM. As shown schematically in Figure **2.96**,

the visible spectrum is the rainbow of colors we see when the white light of the sun passes through a prism that breaks up the wavelengths into seven graduating bands of color.

Centuries ago, Sir Isaac Newton proposed that the ends of this band of hues were so similar that they could be joined, pulling the band into a circular model of color relationships that we now call the COLOR WHEEL. Newton's original proposal is shown in Figure **2.97**. The color wheel demonstrates theoretical relationships among HUES, the wavelength properties by which we give colors names such as "red," "blue," and so on. In REFRACTED (light or "additive") colors, there are theoretically three basic

2.98 Primary and secondary hues in refracted lights.

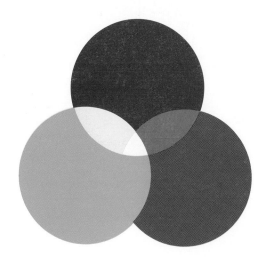

2.99 Primary and secondary hues in reflected pigments.

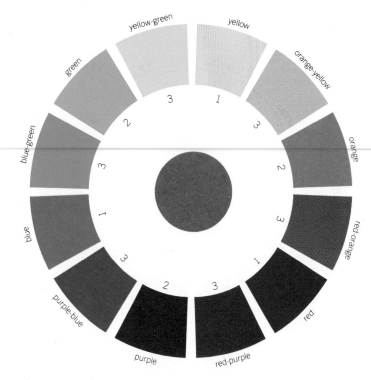

2.100 The traditional color wheel of pigment mixtures.

hues, from which all other hues can be mixed (**2.98**). These basic hues are called PRIMARY COLORS. In refracted colors, the primaries are red, green, and blue-violet. If you examine a color television picture very closely, you will see that it is composed entirely of dots of these three hues. There is no yellow in television transmission. Yellow is one of the SECONDARY hues in refracted light mixtures; it is created by mixing red and green light.

This information is hard for many of us to grasp, since the color wheel with which we are more familiar (**2.100**) shows the relationships between RE-FLECTED hues. Also called "pigment" or "subtractive" hues, reflected hues are those that result when light is reflected from a pigmented surface that absorbs all wavelengths except those that we see. In this case, the primary hues according to traditional color theory are red, blue, and yellow; the secondaries that can be mixed from them are orange, green, and purple (**2.99**). If primary and secondary hues lying next to each other on the color wheel are mixed, they form another level of mixtures: TERTIARY HUES, as shown in Figure 2.100. Note that there is a circle of gray in the center of the color wheel. If pigments of hues lying opposite each other on the wheel—which are called COMPLEMENTARY HUES—are mixed in

equal amounts, they will theoretically produce a neutral gray. Purple and yellow, for instance, are complementary to each other, as are blue-green and red-orange.

The problem with Newton's model of color relationships—in addition to the open question of whether the two ends of the spectrum can really be joined—is that it accounts for only one characteristic of color: hue. The colors we perceive also differ in two other ways: VALUE and what is called SATURATION (also known as "chroma," or "intensity"). Value, as we have seen, is a measure of the relative lightness or darkness of a color. It can be conceived as a vertical pole with white at the top and black at the bottom, in terms of grays. Value variations in reds, blues, and so on run a similar course from near-white to near-black, with middle-value reds or blues lying at the middle of the pole. These value variations are shown as a three-dimensional model in Figure **2.101**. To illustrate the effects of value changes in a hue, Georgia O'Keeffe's *Abstraction Blue* (**2.102**) can be seen as a beautiful study in value changes in several hues. At their darkest, the hues of the cloudlike forms are almost black, graduating to pastels that are almost as light as the shape dividing the center of the canvas. At either end of the value scale, different hues are almost indistinguishable from each other.

2.101 Relationships in hue, saturation, and value, according to the color theorist Albert Munsell.

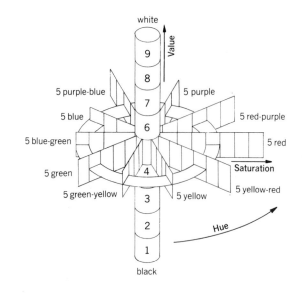

136

2.102 GEORGIA O'KEEFFE, *Abstraction Blue*, 1927. Oil on canvas, 40¼ × 30ins (102.1 × 76cm). The Museum of Modern Art, New York, The Helen Acheson Bequest.

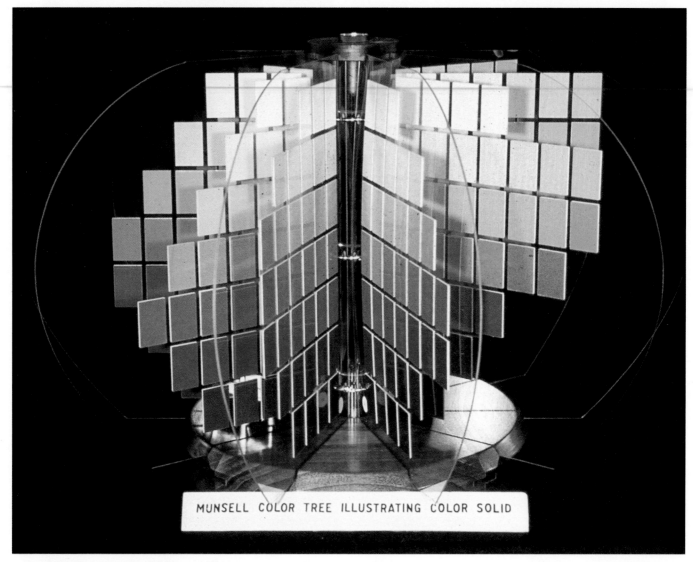

MUNSELL COLOR TREE ILLUSTRATING COLOR SOLID

2.103 The Munsell Color Tree

The three-dimensional model of color relationships (2.101) also illustrates differences in saturation, which is a measure of the relative brightness and purity of a color. The most highly saturated colors are those that are the pure hue with none of its complementary added. As more and more of its complementary is added—for instance, as we mix yellow with purple—the color becomes more and more subdued, until, at the center of the vertical axis on this model, it appears as a gray value. O'Keeffe worked with highly saturated, pure hues, though many are shown only in their lighter values to minimize jarring contrasts.

The three-dimensional models shown in Figure 2.101 and in Figure **2.103** were developed by the color theorist Albert Munsell. Munsell found that color relationships could best be explained with a system of five primaries, so his complementary colors do not exactly match those of the traditional color wheel shown in Figure 2.100. Munsell's sytem is now used as a commercial standard for naming and mixing pigments. His models show that the number of equal steps in saturation, from gray to most saturated, varies from one hue to another, with red having the most possible steps and yellow the least. The Munsell "Color Tree" is therefore asymmetrical.

Natural and applied color

We are surrounded by color in the natural world. Our awareness of its subtleties depends partly on how open our eyes are and partly on where we live. Those who live in snowy areas may become sensitive to the varied hues that can be seen in the "whiteness" of snow, from blue and even green in its shadows to the grayness of "white" flakes seen falling against a pale sky.

Many artists doing three-dimensional work have featured the natural colors in materials rather than covering them with another color. The many hues that lie beneath the bark of wood are often prized by woodworkers. In Ed Moulthrop's wooden vessels (**2.104**), the surprising red flashes in tulipwood play

against the yellow values (brown being a dark value of yellow). Semi-precious stones may be cut and polished to bring out their colors, and amethyst and citrine quartz crystal clusters are presented as art objects not only because of their unusual crystalline forms but also because of the natural beauty of their translucent colors. Isamu Noguchi dwells on the natural colors of marble in many of his marble sculptures (**2.105**). The orderly juxtaposition of bands of two natural marble colors clearly draws our attention to each kind by isolation and contrast within a simplified form.

In diametric contrast to Noguchi's restrained use of natural colors, the opposite attitude is that color applied to materials intensifies the significance of a work. Many classical Greek and Roman marble

2.104 ED MOULTHROP, Wood Bowls, from left to right: orangewood, 9ins (22.8cm) diameter; figured tulipwood, 25ins (63.5cm) diameter; wild cherry, 9ins (22.8cm) diameter; figured tulipwood, 14ins (35.6cm) diameter.

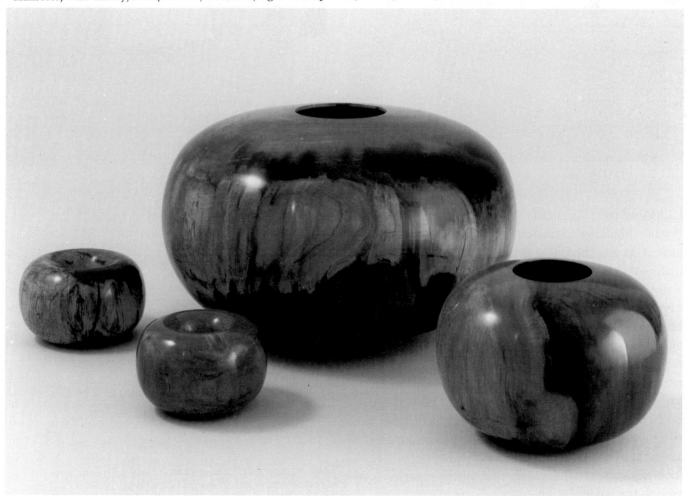

sculptures were originally painted to bring out the details. Medieval wooden sculptures were also painted, as was the Chinese statue of the Bodhisattva Kuan-yin (**2.106**). Kuan-yin, like other Chinese divinities, had both male and female qualities, and was at various times considered the Bodhisattva of Mercy and the traditional Chinese mother goddess. The gold suggests a rich and spiritual presence; the red and green excite the eye, in addition to carrying connotations of life, fertility, and good fortune. When colors that are complementary to one another, such as red and green, are juxtaposed, they intensify each other's brilliance. Here this effect is used only sparingly, for the garment is chiefly red trimmed with gold, with a green sash draped here and there like a pathway through the red and gold.

2.105 ISAMU NOGUCHI, clockwise from left: *Heart of Darkness*, 1974; *Infant*, 1971; *The Opening*, 1970; *Noodle*, 1943–44; *Sun at Midnight*, 1973; *Ding Dong Bat*, 1968. Marbles. Isamu Noguchi Garden Museum, Long Island City, New York.

2.106 *Kuan-yin*, Chinese, 11th to early 12th century. Polychromed wood, 95ins (241.3cm) high. Nelson Gallery, Atkins Museum, Kansas City.

Local, impressionistic, and interpretive color

Many of us are taught as children that objects in our world "are" predictable colors: An apple is red, an orange is orange, a tree has a brown trunk and green leaves, the sky is blue, and so on. These perceptions are called LOCAL COLORS. They are the color an object appears if seen from nearby under normal lighting. Often these ideas of what color an object "is" are used to guide color choices in painting. In Gerard David's *The Resurrection* (**2.107**), boulders are gray, dirt is brown, and grass is green. Although the values of forms in the distance are generally painted lighter than those in the foreground, the hues are still largely local colors. Christ risen from the tomb clearly dominates the composition, not only because of his central position and upright, frontal stance but also because of the intense red of his cloak, heightened by contrast with the greens that surround it.

A fixed mental model of the world can blind us to its subtle and shifting realities, however. The French Impressionists met with tremendous opposition when they trained their minds to perceive the actual colors and forms their eyes were seeing. When Monet painted haystacks, as in Figure **2.108**, he discarded the idea that hay is yellow and presented what he actually saw in the red light of late afternoon. The surprising, scintillating color impressions tend to dematerialize the form. To capture visual truth as nearly as possible, Monet took his canvases outside to paint in natural lighting, from nature, rather than making sketches with color notations and then working inside. He returned again and again to the same field near his home, from summer into winter, painting the ever-changing effects of lighting on the same haystacks.

An INTERPRETIVE use of color is different from either local or impressionistic color: Here color choices are guided by the artist's intent rather than by any external reality. Color is often used interpretively to set the emotional tone for a work. Picasso's *The*

2.107 GERARD DAVID, *The Resurrection*, c.1500. Oil on wood, 34 × 11ins (86.4 × 27.9cm). The Metropolitan Museum of Art, New York, Robert Lehmann Collection, 1975.

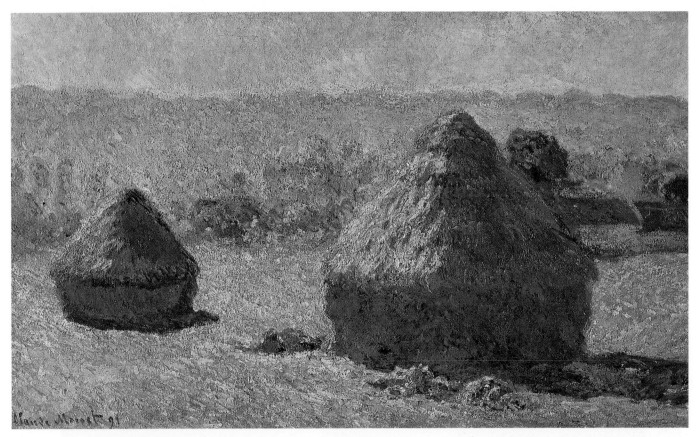

2.108 CLAUDE MONET, *The Haystack*, 1891. Oil on canvas, 23⅞ × 39½ins (60.5 × 100.5cm). The Louvre, Paris.

Old Guitarist (**2.109**) was painted during his "Blue Period" (1901–1904). During these years, he used blues as the predominant colors in his paintings to express the pathos of poverty. In the West, blue is often associated with a feeling of melancholy. If Picasso had used other colors—such as the pinks of his "Pink Period" that followed—the tone of the painting would have been more jovial, but that was not his intent.

Emotional effects of color

Colors affect our moods, and we tend to surround ourselves with the psychological atmosphere we want through our choices of colors in clothing and interior design. Research into the effects of colors suggests that a certain pink has a calming effect on us, for instance, whereas red is stimulating. In addition to these physiological effects, we respond to our culture's color associations. In Northern European cultures, white is a symbol of purity. But to the Sioux Indians, white symbolized wisdom and health; and in the Far East white is a symbol of death. As we saw in Picasso's *The Old Guitarist* (2.109), blue is associated with sadness in Western cultures; it is also linked with serenity and humanity and is therefore the color often used symbolically for the robes of the Virgin Mary (see Figures 6.14, 6.19, and 6.25).

While such knowledge is interesting and useful, it does not totally explain the ways colors are used

143

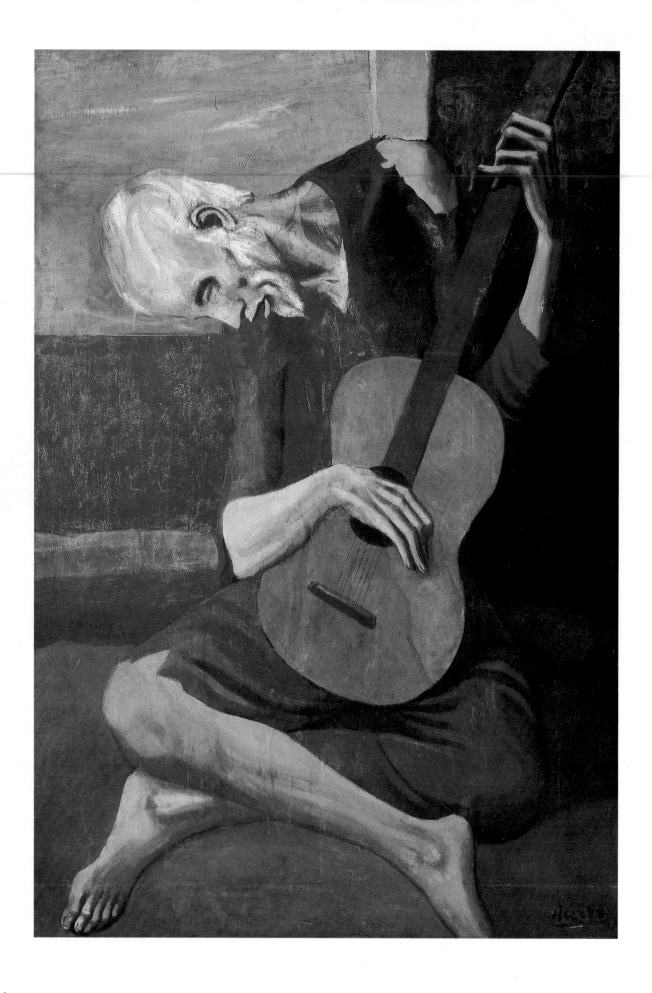

144

2.109 PABLO PICASSO, *The Old Guitarist*, 1903. Oil on panel, 47¾ × 32½ins (121.3 × 82.5cm). The Art Institute of Chicago, Helen Birch Bartlett Memorial Collection.

2.110 HENRI MATISSE, *The Red Studio*, 1911. Oil on canvas, 71¼ × 86¼ins (181 × 219cm). The Museum of Modern Art, New York, Mrs Simon Guggenheim Fund.

expressively in art, for color is only one aspect of the totality to which we respond in a work of art. As an illustration, consider three works, all of which feature red as their dominant color. Considered sensitively, each has a different emotional content. In Matisse's *The Red Studio* (**2.110**), the red is joyous and noisy; the slight accents of other colors make the red seem boisterous. Matisse intentionally subordinated realism to expression in his use of color, explaining, "What I am after, above all, is expression. . . . I am unable to distinguish between the feeling I have for life and my way of expressing it."[7] In

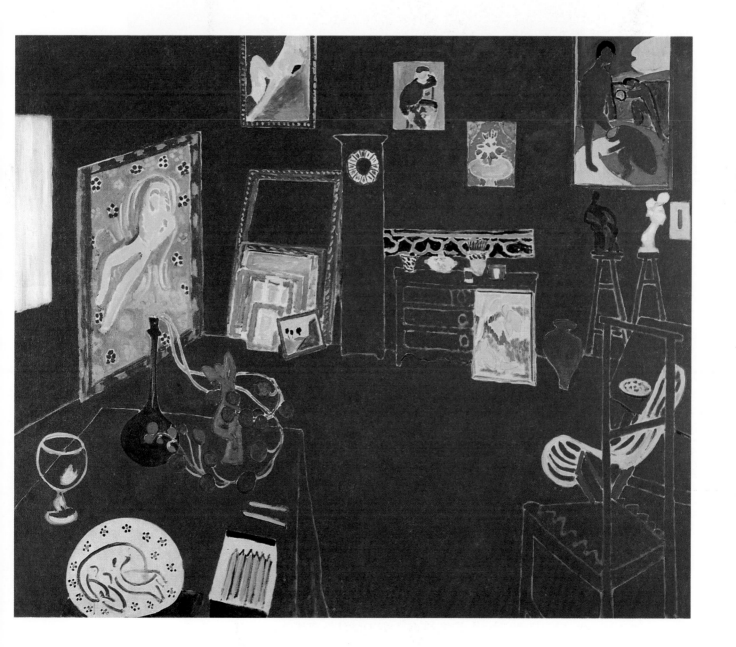

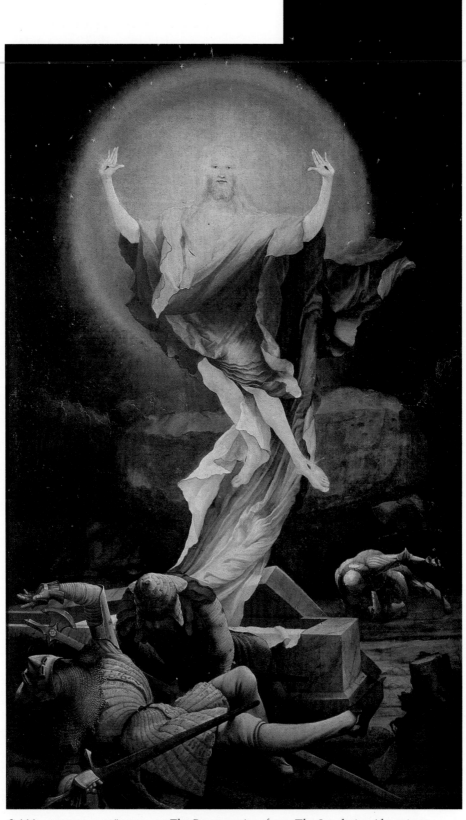

2.111 MATTHIAS GRÜNEWALD, *The Resurrection*, from *The Isenheim Altarpiece*, c.1510–15. Oil on panel, 8ft 10ins × 4ft 8 ins (2.7 × 1.4m). Musée Unterlinden, Colmar, France.

2.112 JOSEF ALBERS, *Homage to the Square: Board Call*, 1967. Oil on composition board, 48 × 48ins (122 × 122cm). The Museum of Modern Art, New York, The Sidney and Harriet Janis Collection.

Grünewald's *The Resurrection* (**2.111**), a panel from the Isenheim Altarpiece, red has a highly spiritual quality, for it appears as the light radiating from the risen Christ. And in Josef Albers' *Homage to the Square: Board Call* (**2.112**), red has an almost cold and intellectual quality. Albers presents reds in such precisely geometrical gradations, with edges softened by the minimizing of contrast, that his work suggests itself as an object for quiet contemplation. These very different ways of handling the same hue attest to the genius of the artists: that they can make red do whatever they ask, by the way that they use it.

Warm and cool colors

In addition to—and perhaps linked with—our perceptions of colors as having certain emotional qualities, we also tend to associate degrees of heat or cold with them. Reds and yellows are generally considered WARM colors, like those of fire; blues and greens are considered COLD, like icy water. Consider the visual "temperature" of three interiors.

The silvery-blue paleness of Jim and Sandy Howell's living room (**2.113**) has a feeling so cool and airy that even the red of the woodstove does not seem

147

2.114 Willa Cather's attic bedroom, Red Cloud, Nebraska.

to give off much warmth. Built on 45 acres of land overlooking the sea on an island off the coast of Washington state, the house is designed to draw in a tremendous amount of outside light through broad glass walls and a skylit core. This light is of great importance to Jim, for he is a painter who works with very subtle variations of color and light (one of his paintings hangs on the wall). The warmth and brilliance of the light that floods the house is balanced by the quiet coolness of the blues inside.

By contrast, in author Willa Cather's childhood home in Red Cloud, Nebraska, an emphasis was placed on cozy warmth to help the family get through

2.113 Interior of Jim and Sandy Howell's home, Washington.

the cold, hard winters. Willa's bedroom under the eaves in the attic (**2.114**) is full of reds and oranges that must have been comforting during winter's chill. But when such colors are used in small amounts, as accents rather than whole environments, they may not create a sense of warmth. We have already noted the strange coolness of the small fire seen in the woodstove in Jim and Sandy Howell's living room. And the red-purple of the chair and ottoman in Judy and Pat Coady's townhouse (**2.115**) does not change the overall coolness of the room. Rather, the pale pastel green of the door draws our attention to the cool qualities in the focal point: Marni Bakst's stained glass panels. The amounts in which colors are used, and the areas where our attention is focused, have a strong effect on our response.

149

2.115 Interior of Judy and Pat Coady's townhouse, with Marni Bakst stained glass doors, column by Trent Whitington.

Advancing and receding colors

Because of the ways our eyes see colors, warm colors tend to expand visually, seeming to come toward the viewer in space, while cool colors contract, seeming to draw back in space. But these effects do not exist in isolation. Look carefully at Ellsworth Kelly's *Spectrum, III* (**2.116**). Because the same amount of color appears in each band, careful observation of our own reactions will give us some clues as to which colors seem visually larger and closer. Does the strip of colors seem to bow in or out at any point? Is this effect continuous, or does it change direction on any of the bands? Now try blocking out the white of the page by placing four strips of some other color around the edges of the reproduction. Does the spatial effect of the colored bands change?

The only rule that is always true in dealing with the elusive subject of color effects is this: *All colors are affected by the colors around them.* Our perception of certain colors as closer or farther depends to a large extent on the colors to either side of them. Colors that are closer to the hue and value of the background will seem to lie on the same plane as the background; the more that colors differ in value and hue from the background, the more they will appear to come off or recede into it in space, with the direction depending on other spatial clues. The effect of contrast between individual colors and the background is complicated in the Ellsworth Kelly painting by the interactions between adjacent colored bands. If you look closely and for some time, you will begin to see that along many edges where colors meet, the light one appears lighter and the dark one appears darker. Colors affect each other optically by "subtracting" their own hue and value from that of their neighbor.

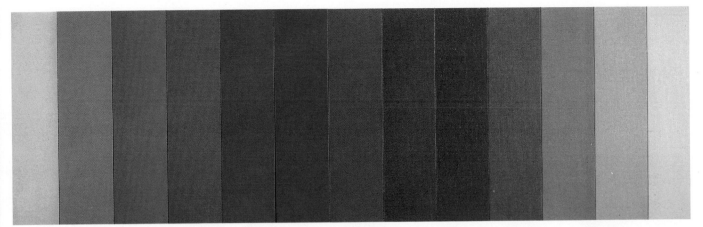

2.116 ELLSWORTH KELLY, *Spectrum, III*, 1967. Oil on canvas in thirteen parts, overall 33¼ × 9⅝ins (84.3 × 24.1cm). The Museum of Modern Art, New York, The Sidney and Harriet Janis Collection.

Color combinations

Because colors affect each other, in our perceptual apparatus, theorists have noted that the distance between colors on a color wheel has a predictable effect on how harmonious they will be if placed together. Using the traditional color wheel, they have distinguished several common patterns of color combinations, as shown in Figure **2.117**. These patterns apply to any sets of colors, and not just the ones shown as illustrations in the figure and the examples that follow. Such orderly relationships do not exhaust the possibilities but provide a basic framework for some designers' color choices.

2.117 Color combinations.

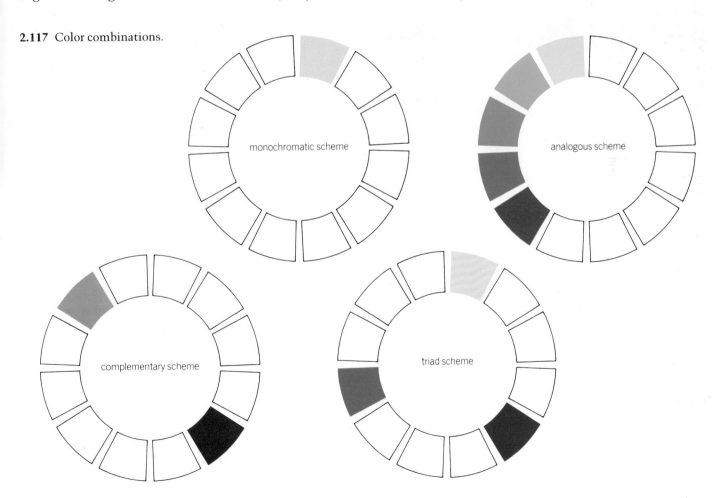

2.118 FRANKLIN D. ISRAEL, Interior of New York loft of Francis R. Gillette.

When only one hue is used, perhaps in different values and saturations and perhaps with small amounts of other colors as accents, the color combination is said to be MONOCHROMATIC. For example, the area shown of Francis Gillette's apartment (**2.118**) is done chiefly in values of yellow, from pale yellow to dark brown, with one red wall to the left that appears yellow-orange itself when awash with sunlight. Values of one hue harmonize very closely with each other.

Another kind of close harmony occurs when ANALOGOUS colors—hues lying next to each other on the color wheel—are used. Blue and green are analogous colors, with minimal contrasts. In Jennifer Bartlett's *In the Garden* (**2.119**), one of a series of nearly two hundred works devoted to the garden of a French villa where she lived for a time, a broader range of analogous colors is presented. The freely stroked colors in this DIPTYCH (two-panel work) vary from blue-violet to yellow-green, with all the steps through blues and greens linking them. The colors harmonize easily not only because they are analogous but also because Bartlett has used light values extensively—for, as we have seen, colors become

similar at either end of the value scale.

In contrast with the peaceful coexistence possible between closely related hues, hues that lie opposite each other on the color wheel have a jarring or at least exciting effect on the eye when they are juxtaposed. These high-contrast combinations are called COMPLEMENTARY color schemes. In the Chinese statue of Kuan-yin (2.106), the juxtaposition of red and green, which are complementary to each other, creates a sensation of vibrant life. Redon gave his *Orpheus* (2.35) an enhanced atmosphere of mystical space by juxtaposing purple and yellow where mountains meet sky, creating a sense of vibration between them. It is possible to capture the visual excitement of a complementary color combination without overstimulating the eye, if this is the artist's intent. Anni Albers' weaving, *Pasture* (**2.120**), combines a series of green values and red most effectively by using very small amounts of red to bring the greens to life.

A similarly stimulating combination is a TRIAD color scheme, in which three colors equally spaced around the color wheel are used together. The yellow, blue, and red of the lovely Ottoman embroidered envelope (**2.121**)—a container for royal gifts, messages, and documents—are far enough apart on the color wheel to provide vigorous contrast for each other, but not so far apart that their hues clash.

2.119 JENNIFER BARTLETT, *In the Garden #56*, 1980. Gouache on paper, 19½ × 26ins (49.5 × 66cm). Paula Cooper Gallery, New York.

2.120 ANNI ALBERS, *Pasture*, 1958. Mercerized cotton weaving, 14 × 15½ins (35.6 × 39.4cm). The Metropolitan Museum of Art, New York.

2.121 Embroidered envelope, Ottoman, 16th century. Velvet with silk, gold and silver wire, 7½ × 16⅛ins (19 × 41cm). Topkapi Sarayi Museum, Istanbul.

2.122 RICHARD ANUSZKIEWICZ, *Splendor of Red*, 1965. Acrylic on canvas, 72 × 72ins (183 × 183cm). Yale University Art Gallery, New Haven CT, Gift of Seymour H. Knox.

Interaction of color

The highly contrasting effects of complementary colors juxtaposed may be exactly what an artist desires. When highly saturated complementaries are used in the right amounts next to each other, the interaction between the color sensations in our brain may create some extraordinary optical phenomena. The complementaries may seem to enhance each other's brilliance, the edges between them seem to vibrate, and ghost colors may appear where they meet. Op Art, a movement of the 1960s, used these phenomena ex-

tensively in nonobjective, hard-edged, geometrical works that create fascinating illusions in our perceptual apparatus. In Op Artist Richard Anuszkiewicz's *Splendor of Red* (**2.122**), the juxtaposition of green and blue lines, and then blue lines alone, with a uniform red ground creates vivid optical illusions that transcend what has actually been painted. The red is the same throughout, but what we perceive is a diamond of very intense red popping forward from a less brilliant red diamond against an even less brilliant red. That blue halo around the center diamond occurs solely in our perceptions; it has not been

155

2.123 LARRY POONS, *Orange Crush*, 1963. Acrylic on canvas, 80 × 80ins (203 × 203cm). Albright-Knox Art Gallery, Buffalo, New York, Gift of Seymour H. Knox, 1964.

2.124 GEORGES SEURAT, *Seated Model*, 1887. Oil on board, 9½ × 6ins (24 × 15.2cm). The Louvre, Paris.

physically painted.

Another demonstration of the power of complementaries is given in Larry Poons' *Orange Crush* (**2.123**), which juxtaposes orange and blue. If you stare at it long enough, you will begin to see ghost colors glowing and flashing around each of the blue circles, and bright orange circles that are not physically there will appear as afterimages scattered through the orange ground.

Because color sensations do interact with each other, some artists and color theorists have tried to mix colors optically rather than physically. The Post-Impressionist painter Georges Seurat studied the science of color perception in depth and created a technique called POINTILLISM. Using dots of primary and secondary colors in close juxtaposition, he coaxed the eye to mix other colors from them, as in his *Seated Model* (**2.124**). Seen from a distance, the dots tend to blend into colors other than those of the

dots, such as flesh tones and their shadows. The effect suggests scintillating lights, rather than flat pigments.

A remarkable and effective contemporary approach to optical mixtures of colors has been developed by Arthur Hoener. Working with the interactions among colors and the ground against which they are shown, he is able to create optical color mixtures in the areas between colored figures. In his unique color theory, called SYNERGISTIC COLOR MIXING, the primaries are orange, green, and violet. Violet and green mix optically to form blue, orange and green are mixed to produce yellow, and violet and orange mix to form red. Although these combinations are quite different from those of the traditional Newtonian color wheel shown in Figure 2.100, they do work surprisingly well. In Hoener's painting *Tenuous* (**2.125**), the "yellow" wedge you see is actually made from orange and green, and the "red"

2.125 ARTHUR HOENER, *Tenuous*, 1974. Acrylic on canvas, 23½ × 23½ins (59.7cm × 59.7cm). Collection of Mr and Mrs Walter Tower, Newton MA.

wedge is made from violet and orange. These color effects are difficult to reproduce, however, because color printing devices tend to be fooled by them, as is the human eye.

2.126 FRANK STELLA, *Katsura*, 1979. Oil and epoxy on aluminum, wire mesh, 115 × 92 × 30ins (292 × 234 × 76cm) irregular. The Museum of Modern Art, New York, Mr and Mrs Victor Ganz, Mr and Mrs Donald H. Peters, and Mr and Mrs Charles Zadok Funds.

Limited and open palette

We leave the complex subject of color with a final measure of ways that artists use color: the range of colors used in a single work of art. An artist who works with an OPEN PALETTE draws from the full range of colors, as Frank Stella does in *Katsura* (**2.126**). His color choices seem completely unrestrained, in a composition held together by repetition of shapes such as French curves and other drafting tools. At the other extreme is the very LIMITED PALETTE used by Picasso in his *A Woman in White* (**2.127**). The painting is quite rich in color, however, despite the immediate impression of white. The hues Picasso uses are primarily reds and blues, in values so light that they approach white. In general, there is an obvious difference in emotional impact between the two approaches. A more open palette tends to be busy and exciting, especially when colors are used at full saturation. A more limited palette creates a far more subdued, tranquil emotional atmosphere. This is generally true even if those colors are red (2.112).

2.127 PABLO PICASSO, *A Woman in White*, 1923. Oil on canvas, 39 × 30½ins (99 × 77.5cm). The Metropolitan Museum of Art, New York, Rogers Fund 1951.

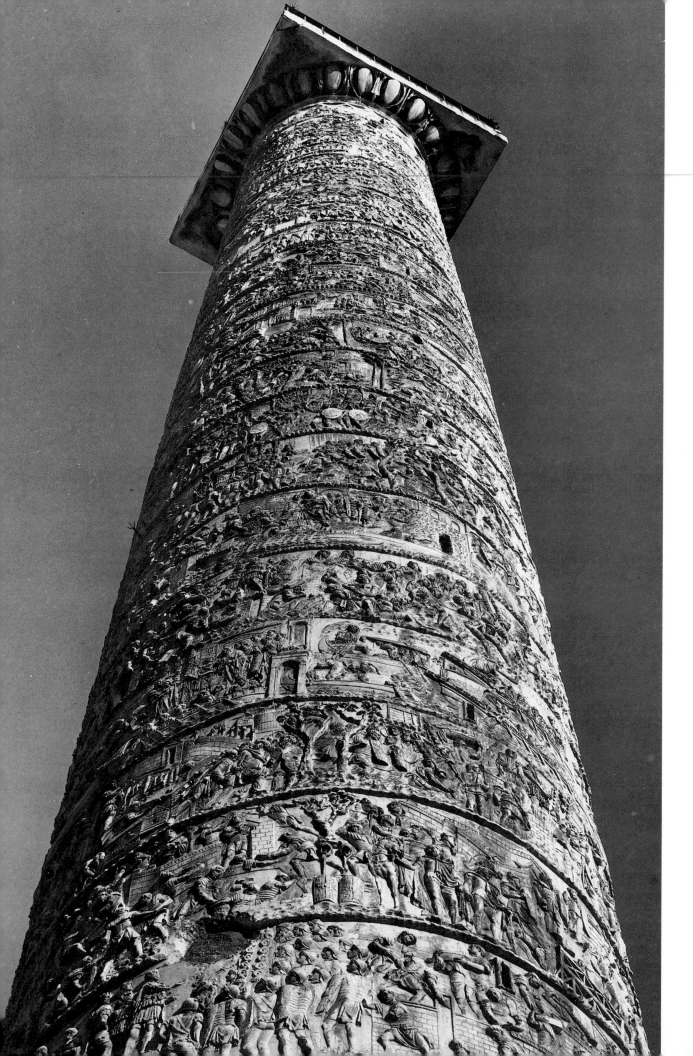

TIME

Thus far we have been exploring visual elements that exist in space: line, form and shape, texture, value and light, and color. But art exists in time as well as space, and time can be considered an element in itself. Ways in which artists work with time include manipulations of viewing time, actual movement, the illusion of movement, capturing a moment in time, using time as the subject of a work of art, and bringing attention to change through time.

Viewing time

A certain amount of time is required for the viewing of any work of art. But some works call on us to spend a long time with them. One way of doing so is to get us to walk all the way around a three-dimensional piece. The Roman *Column of Trajan* (**2.128**) does more than that: It lures us to walk around the column again and again, reading the story of Trajan's campaigns to expand the Roman Empire across the Danube. The low relief narrative is carved in marble as a 625-foot-long (190m) spiraling band that gets broader near the top to improve its visibility. Reading the 150 separate events thus chronicled, working out who and where the figures are and what they are doing, is time-consuming but was presumably possible for those who were familiar with the stories.

Whereas the sculptor of Trajan's Column asks us to walk around the outside of his work, the designers of the *Fort Worth Water Garden* (**2.129**) entice us to spend time walking not only around the perimeter of the artificial falls but also down through them to the pool at their center. The broad stepped slabs provide varying surfaces over which the patterns of the water change as it descends. The water is finally channeled into torrents as it gathers from the whole area and plunges into the pool. Many of us are fascinated by the patterns of moving water and will happily spend time beyond mind watching them change.

2.128 Column of Trajan, Rome, AD 113. Marble, 125ft (38m) high.

2.129 PHILIP JOHNSON and JOHN BURGEE, Water Garden, Fort Worth, Texas, 1974.

2.130 BRIDGET RILEY, *Crest*, 1964. Emulsion on board, 65½ × 65½ins (166.4 × 166.4cm). Private Collection.

An entirely different kind of viewing time is demanded by works of Op Art, whose reliance on the distortions introduced by visual fatigue requires that we look at them for a long time in order to experience their effects. In works that juxtapose bright complementary colors, effects such as vibrating edges and color halos appear as the retina tires of the contrast. In black and white Op Art, such as Bridget Riley's *Crest* (**2.130**), one's perception of mere black and white lines lasts only briefly. If you stare at it a bit longer, allowing the image to weave its hypnotic spell, continually changing optical phenomena will occur, including movement, wavy moiré patterns, and perhaps even the appearance of brilliant colors. Try focusing and unfocusing your eyes, shifting the ways you look at it, to see how many different effects you can experience.

Actual movement

Rather than requiring movement on the part of the viewer, some three-dimensional works move through time themselves. They are often called KINETIC SCULPTURE. Famous examples are the MOBILES of Alexander Calder—constructions suspended by a system of wires so that their parts circle around the central point when pushed or moved by air currents. This aspect of the movement of a mobile such as *Lobster Trap and Fish Tail* (2.131) is partly predictable, but intriguing as we watch the different parts passing in front of us. More surprising are the unpredictable ways that the individually suspended parts turn around each other and on their own axes. Spatial relationships among the shapes will change continually, as long as the mobile is in motion.

Many toys are made with movable parts. At any

2.131 ALEXANDER CALDER, *Lobster Trap and Fish Tail*, 1939. Hanging mobile, painted steel wire and sheet aluminum, 102 × 114ins (260 × 290cm) variable. The Museum of Modern Art, New York.

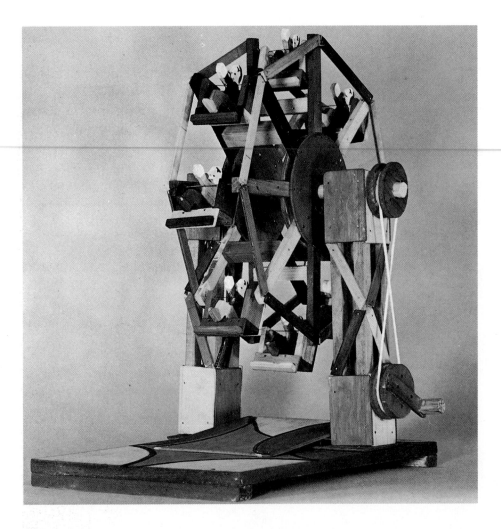

2.132 FELIPE GOMEZ and his children, *Wheel of Fortune*, c.1965. Wood and wire construction painted with aniline colors, 10 × 15⅝ins (25.4 × 39.7cm), riders 3 ins (7.6cm) tall. Oaxaca City, Mexico.

2.133 MARCEL DUCHAMP, *Nude Descending a Staircase #2*, 1912. Oil on canvas, 58 × 35ins (147 × 89cm). Philadelphia Museum of Art, Louise and Walter Arensberg Collection.

age, we get a special pleasure from being able to make a toy move the way our mind thinks it will. Our natural impulse on seeing the Mexican folk art ferris wheel (**2.132**) is to turn the crank and thus make the wheel go around. By the way we turn the crank, we can make it go forward or backward, setting the little chairs swinging from their wires. These things are obvious even before we get involved; making them happen brings a sense of satisfied expectations. To set a great Calder mobile in motion, on the other hand, is to invite the unknown.

Illusion of movement

In two-dimensional works, movement obviously cannot happen in real time. It can only be suggested. How to do so was an intellectual and artistic challenge to the French artist Marcel Duchamp. He chose the device of showing a single figure in a sequence of motions, rather like stop-action photographs, for his famous and controversial *Nude Descending a Staircase* (**2.133**). Some scientists today feel that this is actually the way time moves: by little jerks, a series of barely different frames, rather than a continually changing flow. So far we have no way of knowing which model of time is true. But when Duchamp painted *Nude Descending*, the European artists who called themselves "Futurists" were insisting that modern art should reflect modern life, which is fast, fragmented, and in constant change. In their *Futurist Manifesto* of 1910, they asserted,

The gesture which we would reproduce on canvas shall no longer be a fixed *moment* in universal dynamism. It shall simply be the *dynamic sensation* itself. Indeed, all things move, all things run, all things are rapidly changing. A profile is never motionless before our eyes, but it constantly appears and disappears. On account of the persistency of an image upon the retina, moving objects constantly multiply themselves; their form changes like rapid vibrations, in their mad career. Thus a running horse has not four legs, but twenty, and their movements are triangular.[8]

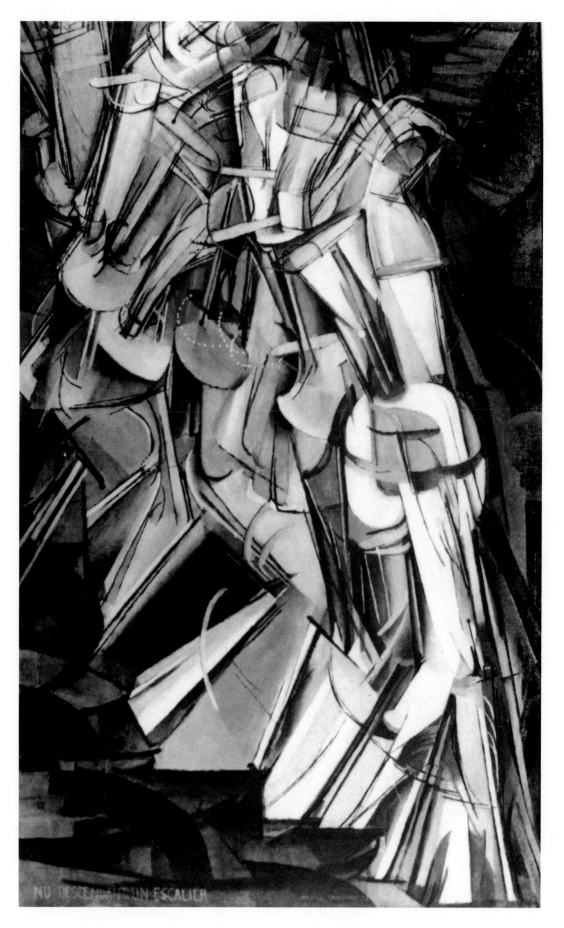

2.133

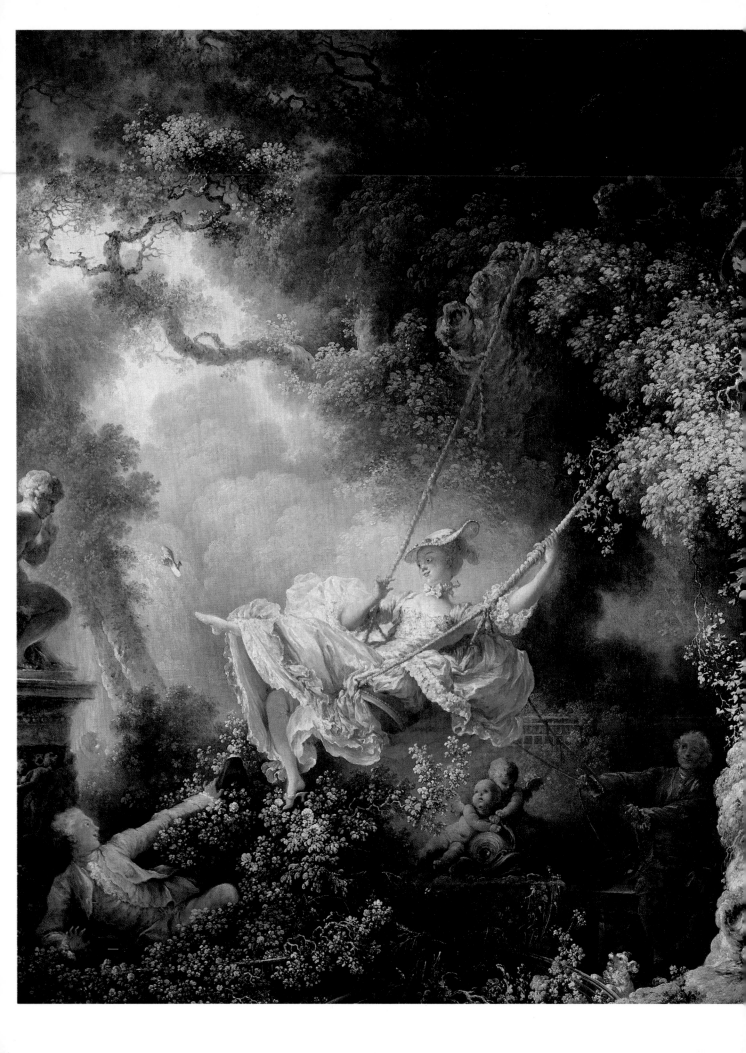

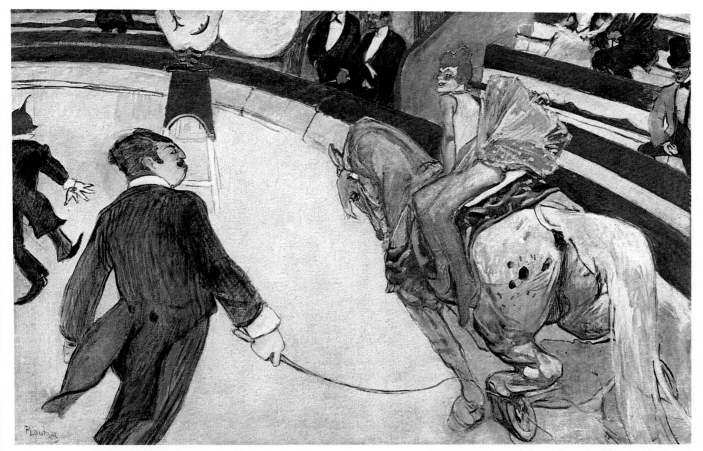

2.135 HENRI DE TOULOUSE-LAUTREC, *Cirque Fernando: The Ringmaster*, 1888. Oil on canvas, 39⅜ × 63⅜ins (100 × 161cm). The Art Institute of Chicago.

The captured moment

Although it is difficult to represent the passage of time in a single two-dimensional image, some images clearly refer to motion by capturing a moment of it in time. In Fragonard's *The Swing* (**2.134**), we see a young woman being swung by an obliging but naive old cleric at the behest of her hidden admirer, whose gaze she teasingly acknowledges by kicking off her shoe toward him. The sensuous swirling of her clothes, the dynamic positions of her limbs, and the curve of the ropes create a great sense of continuing motion in a fleeting, erotic moment.

With the invention of photography, some artists began selecting and framing their views of life as if seen through the lens of a camera. As we saw in

2.134 JEAN HONORÉ FRAGONARD, *The Swing*, 1766. Oil on canvas, 32 × 35ins (83 × 66cm). The Wallace Collection, London.

discussing point of view, Degas did so to bring us into the intimacy of the ballet theatre (2.52). Considerably influenced by Degas, Toulouse-Lautrec used a photographic cropped effect to create a sense of motion in his *Cirque Fernando: The Ringmaster* (**2.135**). We see only what we could see if we were in the ring to the ringmaster's right, watching the horse almost from behind as it gallops around. We could not see much above the dancer's head without raising our glance, so the top of a clown standing on a stool is out of our sight, as is the left side of the clown to the left. Toulouse-Lautrec makes it clear that we are following the horse visually through time, of which only one moment is shown, and he gives the horse a large open area into which to move, increasing the impression of its movement.

In the early days of action photography, cameras were capable of capturing moving forms at speeds of up to 1/2500 of a second (in the case of the single-lens camera brought out in 1899 by Guido Sigriste). But

167

2.136 JACQUES HENRI LARTIGUE, *Grand Prix of the Automobile Club of France*, 1912. Photograph.

they used a FOCAL PLANE SHUTTER, which was a curtain with a slit that travels across in front of the film to expose it. If the subject is moving rapidly or the camera is being turned to follow the action, the image will be distorted in ways that give the impression of great speed, as in Lartigue's photograph of the Grand Prix (**2.136**). Unlike the Fragonard (2.134) and the Toulouse-Lautrec (2.135), this image does not show the area ahead of the action. This truncated space visually increases the sense of speed: the automobile is moving so fast that it has almost disappeared before the moment could be captured on film.

Not all captured moments deal with movement. Some references to moving time center on the ephemeral and precious nature of the present moment, which will never recur in exactly the same way. Juan Gonzales's exquisite pencil drawing *Sara's Garden* (**2.137**) shows us a fleeting glimpse of tiny dewdrops along fragile threads seemingly strung like cables to hold up lilies whose blossoms are at their peak. The "cables" are imaginary, as are the "pearls" at their junctions, according to the artist, who used them to break up the space and suggest poetic allusions in the mind of the viewer. The work is executed so realistically that we can sense the fragility of the moment, fully expecting that the slightest wind will break the gossamer threads, and the lilies will wither and die in the natural cycle of life. But here, captured, is the beauty of the moment.

2.137 JUAN GONZALES, *Sara's Garden*, 1977. Graphite on paper, 22 × 18ins (56 × 46cm). Nancy Hoffman Gallery, New York.

2.138 THE LIMBOURG BROTHERS, *October*, from *Les Très Riches Heures du Duc de Berry*, 1413–16. Illumination, 8½ × 5½ins (21.6 × 14cm). Musée Condé, Chantilly, France.

2.139 GENTILE DA FABRIANO, *The Adoration of the Magi*, 1423. Tempera on wood panel, 119 × 111ins (302 × 282cm). Galleria degli Uffizi, Florence.

Time as the subject

Yet another way in which artists work with time is to make it the central subject of their piece. In uncertain times, such as the Hundred Years' War in France, artworks that bespeak the orderly, predictable passage of time have a special significance. During that war, the three Limbourg brothers created for the Duke of Berry a remarkable Book of Hours—a private devotional book giving the Catholic prayers for each part of the day, from Matins to Compline, plus other liturgical duties and calendars for local feast days. Each month has a detailed miniature painting of what the peasants or aristocracy should be doing during the month. For October, shown here (**2.138**), the peasants are planting winter wheat. Above the scene are notations and symbols of the zodiac signs for the month—with images of Libra and Scorpio —and the reassurance that the chariot of the sun will be making its yearly rounds.

In addition to our desire for life's certainties as time inevitably brings changes, we also like to be told stories about events happening *through* time. Works that tell a story using pictures rather than words are often called NARRATIVE works. Many were used to teach the illiterate the traditions of church or state, such as Tintoretto's *The Finding of the Body of St Mark* (2.51); some are simply to entertain, such as

2.140 CHRISTINE OATMAN, *Icicle Circle and Fire*, 1973. Lake Tahoe, California. Ice needles and fire on a frozen lake.

Fragonard's *The Swing* (2.134).

While these paintings summarize a whole story in one image, others show progressive frames of action occurring through time, rather like a cartoon strip. In Gentile da Fabriano's *The Adoration of the Magi* (**2.139**) we see beneath the primary painting small scenes of the birth of Jesus, the flight to Egypt, and the visit of the Magi in a contemporary setting, with depictions of the trip of the Magi to Bethlehem above culminating in the crowd spilling into the canvas for the moment in which the Three Kings actually kneel in adoration before the Christ child.

Change through time

All works of art themselves change through time. Usually they gradually deteriorate, some so slowly that the change is barely noticeable. But some are purposely fragile, so that witnessing their decay is part of the art experience itself. The life of Christine Oatman's *Icicle Circle and Fire* (**2.140**) is obviously brief, as the fire melts the icicles, but how intense and dramatic is the celebration of the changing moment!

CHAPTER THREE
ORGANIZING PRINCIPLES OF DESIGN

Consciously or intuitively, most artists use some way of holding their compositions together visually. Although some contemporary art intentionally evokes a sense of tension and fragmentation, one or more guiding principles that satisfy the mind's longing for order can nevertheless be discerned in most successful works of art.

3.1 NATHALIE DU PASQUIER, Fabric, 1985. Silk. Manufactured by Memphis/Tino Cosmo, Italy.

The visual elements examined in Chapter 2 are manipulated by artists to form compositions that have a certain coherence, or UNITY. If these elements work well, they contribute to a whole that is greater than the sum of the parts. In trying to determine what holds an effective work together, theorists have distinguished a number of principles that seem to be involved. They include repetition, variety or contrast, rhythm, balance, compositional unity, emphasis, economy, and proportion. Another principle that artists use, but that theorists generally overlook, is the relationship of a work to its environment.

Not all of these principles are emphasized in a single work. And certain artists use them more intuitively than intellectually, using nonlinear thinking while sketching, planning, and manipulating design elements – adding a bit here, taking out something there, moving things around—until everything feels right. Nevertheless, the principles give us a basis for understanding the form of certain compositions. Often these formal considerations help to express the content of the work and can best be understood when the content as well as the form is taken into account.

REPETITION

One of the basic ways that artists have unified their designs is to repeat a single design element, be it a kind of line, shape, form, texture, value, or color. As the viewer's eye travels from one part to another, it sees the similarities, and the brain, preferring order to chaos, readily groups them as like objects. Nathalie du Pasquier of the Milan-based Memphis design group presents imaginary animals as cut-out shapes tumbling across her fabric design (**3.1**). The turning of the same amusing shape to many different positions makes the design lively and interesting, while its repetition holds the design together in the viewer's perception.

In three-dimensional work, repetition of a single design element can have powerful effect. *Backs* (**3.2**), by Polish fiber artist Magdalena Abakanowicz, has a disturbing emotional impact on viewers, not only because of the headless, limbless quality of the hunched-over, hollowed-out torsos, but also because there are so many of them. The artist explained: "I needed 80 to make my statement. At first I made six, but then I saw I must have 80 of them—to show a crowd, a tribe, or a herd, like animals."[1] She leaves their interpretation to viewers, preferring universal to specific references, but they clearly reflect human oppression, as experienced by one who grew up in a war-ravaged, enemy-occupied country.

The repeated figures in Abakanowicz's *Backs* and du Pasquier's fabric seem to stand alone, despite their

3.2 MAGDALENA ABAKANOWICZ, *Backs*, 1978–81. Eighty sculptures of burlap and resin molded from plaster casts, over life size.

3.3 JOSÉ CLEMENTE OROZCO, *Zapatistas*, 1931. Oil on canvas, 45 × 55ins (114.3 × 139.7cm). The Museum of Modern Art, New York.

similarity. By contrast, in José Clemente Orozco's *Zapatistas* (**3.3**), the similar figures in the peasant army merge into a unified whole. As shown in the diagram (**3.4**), our eye picks out the diagonals of the standing figures and their hats as beats in a single flowing movement to the left, with bayonets as counterthrusts pointing to the drum-like repeated beats of the large hats above. We can see that even if one revolutionary falls, the mass of the others still moves inexorably forward.

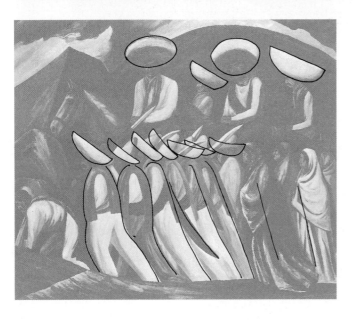

3.4 Repeated figures in *Zapatistas.*

3.5 HENRY WILSON, Wallpaper, 1898.

3.6 PAUL SCHULZE, *New York, New York*, 1984. Solid crystal column, 17 × 3¾ins (43.2 × 9.5cm). Steuben Glass, New York.

Many paintings use repetitions of some design quality to unify complex compositions. In *Mont Sainte-Victoire seen from Les Lauves* (2.29), for example, Cézanne uses the repetition of similar brush-strokes to help tie the work together. If you page through the illustrations in this book, you will find many more examples—some obvious, some quite subtle.

In purely decorative works, such as fabric and wallpaper designs, repetition of design elements is often used to build up an all-over PATTERN, a series of images that are repeated in an orderly way. When a whole wall is papered in Henry Wilson's wallpaper (**3.5**), one sees a pattern of interlocking stylized trees with flowers both separating and unifying them.

VARIETY

The companion of repetition is VARIETY: change rather than sameness through space and time. Variety often takes the form of subtle variations on the same theme: Du Pasquier's animals (3.1) vary in position, each of Abakanowicz's backs is slightly different (3.2), and in *New York, New York* (**3.6**), we see skyscrapers of differing height and form. To create what is actually a visual illusion, Steuben Glass craftsman Paul Schulze has shaped the outside of clear glass in such a way that refracted light appears in its interior in these elegant patterns, which change as one moves around the piece.

Another way in which variety is expressed is through TRANSITIONS, or gradual changes from one state to another. For example, one color may gradually blend into another, a line may change in character, or a form may dissolve into unfilled space. Helen Frankenthaler's woodcut *Essence Mulberry* (**3.7**) presents a beautiful transition from mulberry to a gray that echoes the gray of the ground. She also works with variety in the form of CONTRAST—an abrupt change. Here the gradual vertical color change of the upper portion is played against the sudden horizontal of gold on the bottom. Frankenthaler is also working with contrasts in scale and shape, between the hard-edged geometry of the large golden rectangle and the soft-edged amorphous shapes above.

3.7 HELEN FRANKENTHALER, *Essence Mulberry*, 1977. Woocut, edition of 46, 40 × 18½ins (101.6 × 46.9cm).

Contrast is often used to enhance our appreciation of both things being compared. The gold and the mulberry hues are so different that each brings out the other's richness by contrast. In a Balega mask (**3.8**) the rough, random fibers of the beard accentuate the smooth, fast lines of the head. The Church of Taivallahti, excavated as an underground space within living rock in Helsinki (**3.9**), calls us to appreciate both the organic roughness of the stone and the elegant refinement of the organ pipes, the earthiness of the walls and the light of the sky brought in beneath the great copper dome. Through a continuing series of contrasts, the stone church wakes up our perceptions and sharpens our awareness of each visual sensation.

Although it might seem logical that highly contrasting passages in a work would disorganize it, detracting from its unity, often the opposite is true. The roughness of the Balega mask beard keeps referring us to the smoothness of the face, tying the two together visually like an egg in a nest. In any work that makes us look from one passage to another and back, it is that act of comparing on the part of the viewer that is the unifying factor.

Even if parts seem diametrically opposed to each other, they can be unified in the viewer's mind as two ends of the same continuum. Opposites have a certain unity, completing each other like black and white, night and day, masculine and feminine. It seems that the Austrian Expressionist painter Egon Schiele was working with this kind of complementarity in his *Portrait of Gerta Schiele* (**3.10**). He has intentionally painted the figure very flat, as though arms, legs, torso, clothes, whatever she is sitting on, and the ground below all exist as interlocking elements on the same plane. These flat parts compose a flat dark area that seems locked into the space to each side. Because the dark figure touches both top and bottom of the canvas, space seems to lie next to rather than surround it. We can read the painting as light shape, dark shape, light shape, contrasting but interlinked areas across a two-dimensional field.

Artists may also use contrast to create a certain visual tension that adds excitement to a work. There is a fine point where things fight with or pull away from each other as far as they possibly can without

3.8 Balega Mask, Africa. Wood with pigment and fiber, 8ins (20.3cm) high. Private Collection.

3.9 TIMO and TUOMO SUOMALAINEN, Interior of Taivallahti Church, Helsinki.

3.10 EGON SCHIELE, *Portrait of Gerta Schiele*, 1909. Oil, silver and gold-bronze paint, and pencil on canvas, 55 × 55¼ins (139.7 × 140.3cm). The Museum of Modern Art, New York. Purchase and partial gift of Ronald Lauder.

3.11 JACOPO TINTORETTO, *Leda and the Swan*, c.1570–75. Oil on canvas, 63¾ × 85¾ins (162 × 218cm). Galleria degli Uffizi, Florence.

3.12 Compositional arcs in *Leda and the Swan*.

destroying the unity of the composition. Tintoretto seems to have found this point in his *Finding of the Body of St Mark* (2.51) and also in *Leda and the Swan* (**3.11**). As diagrammed in Figure **3.12**, Leda and the observer form strong arcs actively pulling away from each other and twisting through space, accentuating Leda's movement toward her lover Zeus, who has appeared in the form of a swan. Tintoretto worked out his compositions by posing small wax figures in boxes, as if on a stage. He then translated the three-dimensional scene to two dimensions by drawing the figures on a grid placed across the stage and then

183

3.13 *Apsara*, Northern Wei Dynasty, China, early 6th century. Gray limestone, 25ins (63.5cm) wide. Victoria and Albert Museum, London.

enlarging them from this grid to the scale of the painting. Not only has he depicted the figures as pulling away from each other; each of the bodies is also twisted in a flowing serpentine movement called *serpentinata* in Italian, an exaggeration of the CONTRAPPOSTO figure-posing used in High Renaissance art. First developed by classical Greek sculptors, the technique involves twisting areas of the body in counterpoised opposition to each other. The twisting movement adds to the dramatic effect. Tintoretto was one of the so-called Mannerist painters, who exaggerated gestures for their theatrical impact.

RHYTHM

A third organizing principle found in many works is RHYTHM. Repetition and variety in design elements create patterns that are analogous to rhythms in music, from the predictable drumbeats of a marching band to the swirling rhythms of romantic symphonies to the offbeat intricacies of jazz timing. The same element—such as a line, form, or color—may be repeated visually through space, or groupings may be repeated so that the eye picks out recurring patterns, such as small-large-medium, small-large-medium. Such patterns, which may be easily perceived or complex and subtle, create repeated visual accents with spaces between them, like upbeats and downbeats, or waves and troughs. The *apsara*, or divine water nymph, shown in Figure **3.13** in fact appears to be part of the flowing rhythm of the ocean, and of the song being played on the instrument. There is a continued repetition of upswept lines, and within these arcs secondary melodies repeat the theme with variations. These melodies within melodies are particularly visible on the right side of the piece, where wavy lines dance within the upward arcs. The nymph's body, too, is turning rhythmically in space, with face frontal, hips turned sideways, and feet so turned that we see the soles. Even the fingers are treated rhythmically, like notes in counted measures.

Rhythm in a work satisfies the desire for order, for it brings a familiar sense of the pulsing of life. In the *apsara*, the pulsing is playful and free, but ordered nonetheless. In the *Last Supper* altarpiece by the medieval artist Ugolino di Nerio (**3.14**), the rhythm formed by the repetition of the circles of the haloed heads of the disciples is as regular as drumbeats. This easily-perceived regularity is broken by the wider space separating Christ from the others, the grieving position of John the beloved, and the absence of a halo around the head of Judas. These dramatic elements are like crossbeats to the rhythms of the rest of the painting, another being produced by the alternating placement of reds.

Rhythms may flow continuously through time, without the measured pauses seen in Ugolino's *Last Supper*. As we noted in examining the Thonet rocking chair (2.15), its lines flow rhythmically through long curves, never stopping fully except at the delicate ends of the "tendrils." For the most part, the only changes we "hear" in the visual music of the chair are shifts in volume and speed, with slight crescendos through the center of the curves and slowing decrescendos as the lines change direction.

In freely-stroked works, each line reflects the rhythm of the breath and movements of the artist. The Levha calligraphy by Sami Efendi (2.1) is created with single brush movements, precisely controlled for a free-flowing effect. The calligrapher cannot lift pen or brush before completing a stroke, for its subtly varying width depends on the movement and angle of the writing implement. Traditional Chinese and Japanese painters were trained to use the whole arm to create brushstrokes. They practiced brush movements for years to develop the control and flexibility needed to create free-flowing lines that were also even and continuous. The wrist was used only in drawing very delicate lines.

The rhythm of certain works is like orchestral music, a complex interweaving of voices. Cézanne's *Pistachio Tree in the Courtyard of Château Noir* (**3.16**) could be seen as a composition whose contrasting rhythms flow through time, like different movements of the same symphony. The first movement, in this interpretation, would be the heavy, austere blocks at the base of the composition, the second would be the transition area through the middle where colors and forms are shifting, and the third would be the lively free lines of the trees above.

3.14 UGOLINO DI NERIO, *Last Supper*, c.1322. Tempera and gold on wood, 13½ × 20¼ins (34.3 × 51.4cm). The Metropolitan Museum of Art, New York, Robert Lehman Collection, 1975.

BALANCE

A fourth design principle is BALANCE—the distribution of apparent visual weights so that they seem to offset one another. We subconsciously assign VISUAL WEIGHT to parts of a work, and we tend to want them to be distributed through the work in such a way that they seem to balance each other. The sense of forms held in balance against the pull of gravity is psychologically pleasing; imbalances may give us an unsettled feeling, a reaction that is not usually the artist's desired effect. Reading horizontally across a piece, the balancing of visual weights is like a seesaw. As diagrammed in Figure **3.15**, this kind of balancing of equal forces around a central point or axis is called SYMMETRICAL or FORMAL BALANCE. An example of strictly formal balance is the chest from the Haida

3.15 Symmetrical horizontal balance.

3.16 PAUL CÉZANNE, *Pistachio Tree in the Courtyard of Château Noir*, c.1900. Watercolor over pencil sketch, 21¼ × 16⅞ins (54 × 43cm). The Art Institute of Chicago.

culture of Queen Charlotte Island off the northwest North American coast (**3.17**). If an imaginary vertical axis were drawn right through the center of the piece, the two halves of the central figure and the geometric animal motifs extending to the sides would be exact mirror images balancing each other. If a horizontal line were drawn through the center of the piece from left to right, the upper and lower halves would also consist of symmetrically balanced, though not identical, visual components.

Symmetrical balance can occur even if images on each side of the vertical axis are not exactly the same. In William Blake's dramatic painting of *The Last Judgement* (**3.18**), those who have erred are descending to the flames of hell on the right side, balanced by those blissfully ascending to the throne of God on the left side. The fact that the right side of the painting is darker than the left adds to the visionary drama. Although the value difference would imbalance the work otherwise, it is balanced by the symmetrical circular motion of the figures, as if radiating outward from the point between the two central beings blowing horns, and by the strong vertical axis created by the patterns of the figures rising through the center. The continuing movement of the figures reflects Blake's view that our fortunes are ever-shifting and that those who have sinned are not eternally damned.

3.18 WILLIAM BLAKE, *The Last Judgement*, 1808. Tempera, 19⅞ × 15¾ins (47.5 × 38cm). Petworth House, Sussex.

3.17 Chest for clothes and jewelry of the Haida tribe, of Queen Charlotte Island of Northwest Coast of North America, 19th century. Wood inlaid with shells and animal tusks. The British Museum, London.

3.19 Asymmetrical horizontal balance.

When the weights of dissimilar areas counterbalance each other, the result is called ASYMMETRICAL or INFORMAL BALANCE. Expressed as a simple diagram (**3.19**), a large light-colored area might be balanced by a small dark-colored area, with the fulcrum off-center. Dark colors generally seem heavier than light ones, busily detailed areas heavier than unfilled ones, bright colors heavier than dull ones, large shapes heavier than small shapes, and objects far from the center heavier than those near the center.

Consider Thomas Gainsborough's *Mr and Mrs*

Andrews (**3.20**). The painting is obviously asymmetrical, for both important figures are on the left side, with nothing but their lands to the right. The balancing point is established by the vertical thrust of the tree, well to the left of center. The pair carries considerable visual weight because they are visually interesting and detailed human figures, because they are looking at us and holding our attention, because they and the tree trunk are the largest and closest objects in the composition, and because their clothes are the brightest colors in the painting. The breadth of the fields to the right is not a wasted area in the composition, for Gainsborough needed a great expanse of less detailed space to balance his strong figures. Note that the fields recede into deep space. To a certain extent, Gainsborough is setting up a balance that extends into—as well as across—the picture plane. And those fields serve a purpose in the content as well as the form of the painting: They demonstrate the wealth of this couple, whose lands seem to stretch as far as the eye can see.

3.20 THOMAS GAINSBOROUGH, *Mr and Mrs Andrews*, c.1749. Oil on canvas, 27½ × 47ins (69.8 × 119.4cm). The National Gallery, London.

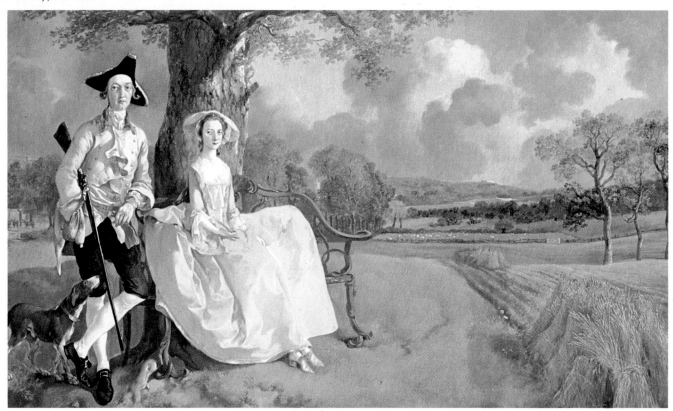

3.21 JOHN VAN ALSTINE, *Los Arcos*, 1985. Granite and steel, 84 × 108 × 48ins (213 × 274 × 122cm). George Ciscle Gallery, Baltimore, MA.

Sometimes artists violate the principle of balance intentionally to create tension in their works. John van Alstine's *Los Arcos* (**3.21**) holds our attention because we automatically assume—and worry—that it is about to topple over. Poised on a single point to the right and slanting away from the vertical, the steel arc seems to defy the stabilizing influence of the granite mass to the left. While visual balance satisfies our sense of order, apparent imbalance may excite our curiosity.

3.22 PIETRO VANUCCI, called PERUGINO, *The Crucifixion with Saints*, c.1485. Oil, transferred from wood to canvas, middle panel 39⅞ × 22¼ins (101.3 × 56.5cm), side panels 37½ × 12ins (95.2 × 30.5cm). The National Gallery of Art, Washington D.C., Andrew W. Mellon Collection.

3.23 Double triangle composition.

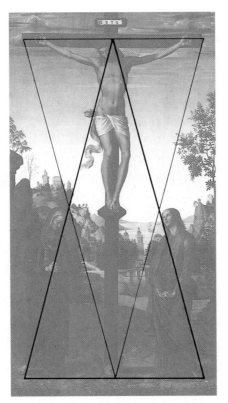

3.24 Double triangle composition in *The Crucifixion with Saints.*

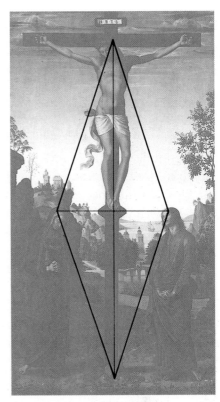

3.25 Implied triangles in *The Crucifixion with Saints.*

COMPOSITIONAL UNITY

Artists can also hold compositions together by creating strong attachments between elements within the work. They may physically touch each other, like the cut-out shapes forming Matisse's abstract *Snail* collage (2.30). They may be held together by the energy of opposition, like the magnetism of opposing arcs in Tintoretto's *Leda and the Swan* (3.11). Or the artist may have arranged the lines of the work—both actual and implied—in such a way that they lead the viewer's eye from one area to another, visually tying the work together.

A common formula for unifying compositional lines is the implied triangle. Standing on its base, a triangle is a highly stable shape. Christian sacred art has often used the solidity of a double triangle pattern, with a strong primary triangle counterbalanced and filled out by a weaker inverted secondary triangle, as in Figure **3.23**. The central panel of Perugino's *Crucifixion with Saints* altarpiece (**3.22**) illustrates a complex series of these compositional

triangles. As shown in Figure **3.24**, the major triangle is crowned by the head of Christ and bounded on its lower corners by the pointed feet of the mourners. A secondary inverted triangle is formed by the horizontal of the cross and implied lines joining it from the diagonal stakes pointing upward at the base of the cross.

Another set of triangles is created by the eyelines among the figures, as diagrammed in Figure **3.25**. Jesus's head is inclined down toward Mary, whose downcast eyes lead us to a diagonal stake, which points us up to the face of John, whose gaze is directed up to Jesus's face. This circuit completes and reinitiates a diamond pattern that is divided into two triangles across the middle by the horizon. We can also read our way round and round each of these triangles. For instance, in the lower one, we read from Mary's gaze down to one stake, up through the other to John's head, and then across along the horizon back to Mary's face. Even the folds in the saints' robes contribute to the triangular patterns. Perugino carefully leads us through the composition, bringing us back again and again to the major figures and thus tying them together both in form and in emotional

content. The balance and compositional unity of the work are entirely appropriate for an altarpiece forming the focal point of a symmetrically planned church. But it is not rigid. Notice, for instance, the off-center arrangement of the lake and hills in the background, placing John's head against water and sky and Mary's against rock. This interesting asymmetry is possible because the composition is so well unified by the triangular patterns in the foreground.

In later works, compositional unity is often achieved by less formulaic means. Renoir's Impressionist painting *The Boating Party* (**3.26**) uses a series of devices to unify the many individual figures. The first is the subject matter: These people are relaxing together at a pleasure garden overlooking the Seine. They are unified into small groups because we see them talking to and looking at each other. The friends having lunch together in the foreground

are not in conversation with each other—Aline Charigot, who was to become Renoir's wife, is paying more attention to her dog—but they are held together by being at the same table. The man standing and bending toward the table at the right brings the groups in the background into relationship with those seated at the table. The canopy over the whole group pulls them together visually, as does the bracketing of the figures by the two boatmen. Placed strategically at the right and left margins of the canvas, they stand out from the others because of their large size and matching athletic clothes. Their gazes cross the canvas, encompassing the whole space.

Three-dimensional works are often unified by compositional lines as well, though they cannot be fully appreciated in a two-dimensional photograph from a single point of view. The sculptors of the

3.26 PIERRE AUGUSTE RENOIR, *The Boating Party*, 1881. Oil on canvas, 51 × 68ins (130 × 173cm). Phillips Collection, Washington DC.

3.27 Three-dimensional compositional lines in the *Laocoön*.

3.28 HAGESANDRUS, ATHENODORUS, and POLYDORUS, *Laocoön*, 1st century AD. Marble, 96ins (244cm) high. The Vatican Museums, Rome.

Hellenistic marble *Laocoön* group (**3.28**) wrapped a continuing series of lines around the anguished figures of Laocoön and his sons. Most obvious are the lines of the sea serpents winding through the group. They were said to have sprung out of the sea to attack and strangle Laocoön, a Trojan priest, and his sons for defying Apollo or for warning that the Greeks' Trojan horse was a ruse. In addition to the serpents' horrifying way of connecting the figures, the lines of the three straining humans form a continuing series of related curves, as suggested two-dimensionally in Figure **3.27**. They are further tied together by the eyelines from the sons to the father.

EMPHASIS

A further organizing principle in many compositions is that of EMPHASIS—the predominance of one area or element in a design. By its size, position, color, shape, texture, or surroundings, one part of a work may be isolated for special attention, giving a focus or dramatic climax to the work.

When awareness is drawn to a single place, it is called the FOCAL POINT of the composition. In Leonardo da Vinci's *The Last Supper* (**3.29**), Christ is clearly the central focus of the work. The most obvious device used to emphasize him is his placement

195

3.29 LEONARDO DA VINCI, *The Last Supper*, c.1495–98. Mural painting, 15ft 1⅛ins × 28ft 10½ins (4.6 × 8.6m). Refectory, Monastery of Santa Maria delle Grazie, Milan.

3.30 Perspective composition in *The Last Supper*.

at the exact center of the painting. Leonardo has formally lined up the figures along one side of the table, opening the space in front of them so that they all face the audience, as it were, rather than using the arrangement favored by Ugolino (3.14). On this stage, Christ's central position is emphasized by the perspective lines, which all come to a point in or behind his head, as shown in Figure **3.30**. Many of the disciples enforce this movement toward the center by looking at Christ. Even those who are turning away

from him to talk among themselves of his tragic announcement point to him with their hands. Finally, Christ's head is framed within the central window at the back of the room and by the arch over it.

Sacred architecture often develops a single focal point to center worshippers' attention on the forms used to represent divinity. In the small chapel (**3.31**) reconstructed at the Cloisters in New York from twelfth-century sources, the altar is clearly the focal point, with its candles, marble ciborium (canopy), and statue of the Madonna and child. In addition to being the most visually interesting area of this simple chapel, the altar is emphasized by the domed arch in the architecture, the windows to either side that highlight the area, the contrasting value of the curtain behind the statue, and the raised platform on which the altar rests. These devices also symbolize the sacredness of the spiritual, elevating it above the mundane.

Not all works of art have a focal point. In a wallpaper or fabric pattern, the same design motif may be

3.31 Chapel, from the church of Notre Dame du Bourg, Longon, Bordeaux, after 1126. Marble ciborium from the church of San Stefano, near Finao Romano, Rome, 12th century. The Metropolitan Museum of Art, New York, Cloisters Collection.

repeated again and again with equal emphasis, scattering the attention in the interest of creating an overall effect. If the repeating unit has a particularly strong visual element, it may appear as accents within the larger pattern. Many pieces of sculpture also lack a single focal point, for the intention may be to lead the viewer to examine the work from all angles, unlike two-dimensional images in which many elements must be unified across a single plane. Sometimes the entire sculpture becomes a focal point, as it were. Imagine how Brancusi's *Bird in Space* (1.11)

would look if it were displayed by itself in a darkened room with a single spotlight gleaming off its polished bronze surface. In most museum settings, works are shown in the midst of many others rather than being emphasized by isolation in a dramatic setting. Altarpieces, for example, were originally intended as the focal points of symmetrical churches. Much of their emotional impact is lost when they are hung on the walls of museums, flanked by other pieces to which they are visually unrelated, and seen under uniform lighting.

ECONOMY

The principle called ECONOMY OF MEANS refers to the ability of some artists to pare away all extraneous details, presenting only the minimum of information needed by the viewer. Economy is a hallmark of some contemporary design, and also of artists influenced by Zen Buddhism. In his portrait of the poet Li Po (**3.32**), Liang K'ai captured the man's spiritual essence as well as his voluminous form with a few quick brushstrokes. This was considered inspired art, possible only when the artist was in direct communion with the Absolute. Nevertheless, to develop the technique of the "spontaneous" brushstroke took many years of practice.

3.32 LIANG K'AI, *The Poet Li Po*, 13th century. Ink on paper, 42⅞ × 13ins (78 × 33cm). Tokyo National Museum.

3.33 Vase (*Ching-te-chen* ware). Ch'ing Dynasty, China, probably K'ang-hsi period, 1662–1722. Porcelain, *sang de boeuf* glaze, 7⅞ins (20cm) high. The Metropolitan Museum of Art, New York, Bequest of Mary Clark Thompson, 1924.

Economy is not limited to figurative art that suggests real forms by using a minimum of clues. The principle can also be applied to nonobjective art. In contrast to the decorative approach of those who paint marble sculptures or cast saltcellars in the forms of the gods (1.46), it is possible to create objects of great beauty by severely limiting the design elements used. The elegant porcelain vase from Ch'ing Dynasty China (3.33) eschews any ornamentation in order to focus attention on the gracefulness of the form and the subtle crackles and color changes in the oxblood glaze. The intensity of the red gets our attention, but in its simplicity, the vase becomes an object for quiet contemplation.

Isamu Noguchi, whose spare aesthetic is apparent in his marble sculptures (2.105) and his point-balancing cube (1.36), speaks of the difficulties of reducing art to the minimum:

> The absence of anything is very beautiful to me. That is to say, emptiness is very beautiful to me. And to desecrate that emptiness with anything takes nerve. So you might say, well, I'm not a lover of art. But I am, you know. I'm always in a quandary. Too much is not good. Too much of anything is not good. With my attitude, it makes it rather difficult to do anything at all. Nevertheless, I'm rather prolific.[2]

As in the Bauhaus dictum, "Less is more," it is possible to suggest very complex forms or ideas with very few visual clues. Graphic designers are challenged to do so when they are commissioned to create logos. A successful LOGO is a highly refined image that bespeaks the nature of an entire group or corporation with an absolute minimum of marks. The logo Peter Good designed for the Hartford Whalers hockey team (3.34) immediately suggests the tail of a sounding whale, completed by a fluid "W" for the Whalers and a figure-ground reversed "H" for Hartford implied in the unfilled white space. Open to the surrounding space, the "H" has a dynamic flowing quality through the upper portion, with squared-off legs giving strength to the base. If you look very closely at the outer corners of the feet of the "H" you can see LIGHT WELLS there—tiny outward swells that counter the eye's tendency to round off the corners. The light wells actually make the lines of the "H" look straighter. The light pouring in through the

3.34 PETER GOOD, Logo for the Hartford Whalers Hockey Club, 1979.

opening seems to collect in these corners, creating vibrant effects and perhaps even colors in the eyes of some viewers. In what is actually only two simplified filled areas, this economic logo gives us the initials of the town and team, suggests the derivation of the Whalers name, and gives the impression of liveliness, strength, and speed.

PROPORTION

A further principle in composing artworks is that all parts should be in pleasing proportion to each other. From our experiences in the three-dimensional world, we have a learned sense of "correct" size relationships. In representations of the human figure, we expect the head, feet, arms, and fingers to be a certain size in relationship to the rest of the body. These expectations have been institutionalized in certain schools of art. In the art of China and Japan, for instance, one set of conventions for drawing the human figure was to make the standing body seven times the height of the head, the seated body three times the height of the head, the head itself twice the size of the open palm, and so on. These same schools taught proper proportions for representing on a panel the illusion of the vastness of landscapes, called *Shan-Shui*, or "mountain-water" pictures in Chinese. According to one convention of proportions, if a mountain were shown ten feet high, a tree

3.35 The Golden Rectangle.

should be one foot high, a house a tenth of a foot high, and a human the size of a pea.

In addition to these artistic conventions about proportion in figurative art, there have been theories that we have an innate abstract sense of ideal proportion. The Greeks formulated this idea of mathematical perfection as the GOLDEN RECTANGLE: one in which the short side is to the longer side as the long side is to the sum of the two sides. This ratio works out to approximately 1 to 1.618, as shown in Figure

3.35. It is a now-familiar shape, for its proportions of length to height have been used for centuries as an approximate format for paintings.

Although the Greeks worked out the Golden Rectangle as a mathematical formula, they also recognized that our visual perception is not flawless and that it is influenced by our mental assumptions. Ictinus and Callicrates, the architects of the Parthenon (**3.36**), therefore used an astonishing series of "optical refinements" in the proportions of the building to make it appear perfectly regular and rectangular to the human eye. Exact measurement of the Parthenon has revealed many apparently intentional deviations from regularity and rectangularity. Because the Greeks recognized that our visual apparatus perceives vertical lines as sloping and horizontal lines as sagging in the center, they corrected for these human errors in perception. The platform and steps actually curve upward. So does the ENTABLATURE (the horizontal element above the columns), though to a lesser degree, presumably because it was farther from the viewer's eye. The columns and entablature also slope inward slightly to prevent their appearing to slope outward. At the corners, the columns are thickened slightly to counteract the optical thinning effect

3.36 ICTINUS and CALLICRATES, The Parthenon, Athens, 447–438 BC.

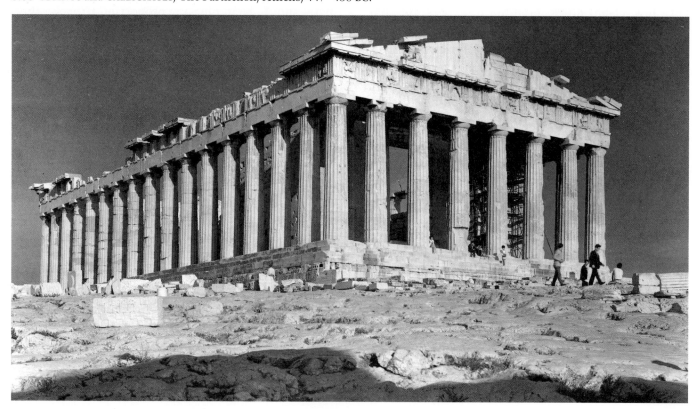

3.37 TIMOTHY BRIGDEN, Chalice, late 18th or early 19th century. Pewter, 8⅞ins (22.5cm) high. The Metropolitan Museum of Art, New York, Gift of Joseph France, 1943.

of their being silhouetted against the sky. The form of the columns bulges out by two-thirds of an inch (1.7cm) part way up to accommodate the human assumption that the columns will be slightly compressed by the weight they appear to bear (a subtle principle called ENTASIS), and the illusion of regular spacing among the columns is created by having their spacing actually differ. The result is what we perceive as the most perfectly proportioned building ever created.

Artists who are able to create satisfying proportions may thus be working with the actual visual "feel" of objects rather than mathematical precision. The lovely chalice by Timothy Brigden (**3.37**) is divided into three areas that are approximately—but not exactly—the same size: the cup, stem, and base. The base is actually slightly shorter in height than the cup and stem, but with its outward flare it would appear awkward if it were any higher. Brigden has

also forsaken exact regularity in the area just below the bottom of the cup, making it straighter than the curves of the rest of the stem. It serves as a transition from the straighter lines of the cup to the undulations of the stem. If it had a more rounded curve, there would be "too many" curves. As is, the chalice appears just right to the human eye.

Mathematical precision in proportions can actually be found in nature. The seeds in a sunflower head, the florets in a daisy, and the chambers in a nautilus shell (**3.38**) grow in spiraling increasing patterns in the mathematical relationship called a *Fibonacci series*. The ratio of the size of one unit to that of the following unit is 0.618... (an infinite, irrational number); the size of any unit divided by the size of the preceding one is 1.618..., the Greeks' GOLDEN SECTION, on which the Golden Rectangle is based. These relationships seem so naturally harmonious that they appear often in art, even when the proportions are not worked out mathematically, as in the gradually diminishing scale of the spirit figures in the New Guinea men's house (**3.39**).

There are also proportional relationships that are entirely intuitive, based totally on the individual's innate sense of aesthetics. An extreme example is the perfection of the Zen rock garden in Ryoanji Temple (**3.40**). The relationships of sand (raked in lines to represent the sea) to rocks (representing moun-

3.38 Diagrammatic section of a Nautilus shell.

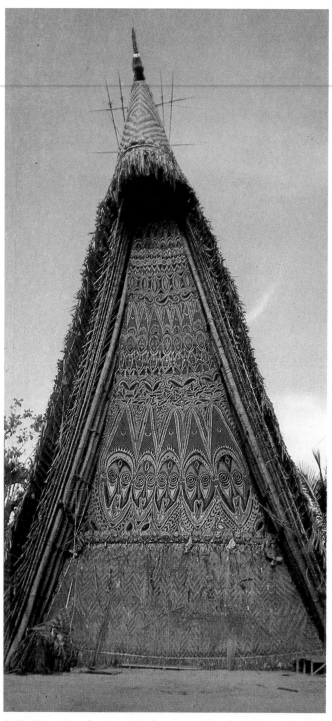

3.39 *Haus Tambaran* at Kinbanggwa, North Abelam, Papua New Guinea.

tainous islands, like the islands of Japan), rock to rock within each grouping, and rock group to rock group are the result of a meditative attunement to the perfection of the universe, rather than obedience to any human system of perfection.

RELATIONSHIP TO THE ENVIRONMENT

A final principle with which artists must often work is the relationship of a piece to its intended environment. When we see art on the pages of a book or on the walls of a museum, we cannot grasp this dimension, for it can only be appreciated in the midst of the living setting for a work of art.

To appreciate the relationship of St Peter's Church (**3.41**) to its midtown Manhattan setting, one must imagine the great height of the skyscrapers all about, the passing traffic, and the driven attitude of the pedestrians on the Lexington Avenue sidewalk. Under the shadow of the huge Citicorp tower, amid the power plays of banks and publishing houses and the wealth showcased at the Waldorf Astoria and the Racquet and Tennis Club, the tiny church raises its rose-gray granite angularity to the heavens, suggesting a haven of peace in the midst of the fast life.

Artists must work within the limitations and features of whatever settings their commissions involve. When Michelangelo was commissioned to fresco the ceiling of the Sistine Chapel in Rome (**3.42**), he faced a vast curving surface broken by triangular arches over each window. He also had to create images that would read well to people standing 70 feet (21m) below on the floor. Fresco is a very demanding medium even on a flat vertical surface, and Michelangelo considered himself a sculptor rather than a painter. What he created under these extraordinarily difficult conditions is one of the world's greatest works of art. He conceived the ceiling as an illusionary continuation of the architectural details of the building, within which over three hundred figures tell the Christian story of the human race. The crown of the vault contains the story of

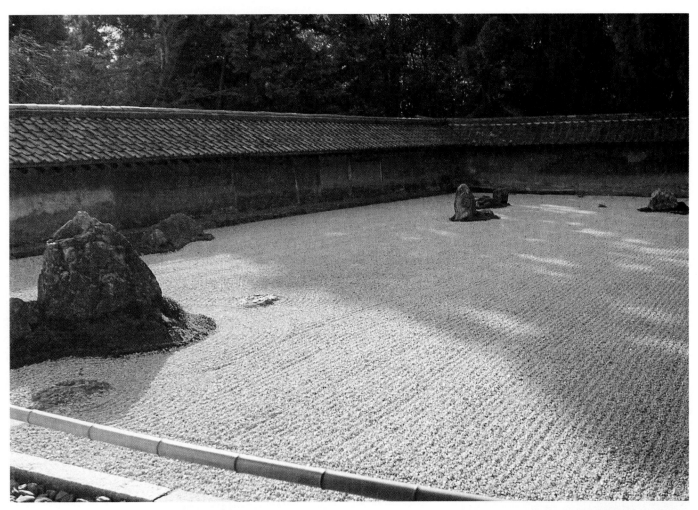

3.40 Rock Garden of
Ryoanji Temple, Kyoto,
Japan.

3.41 HUGH STUBBINS
ASSOCIATES, St Peter's
Church, New York, 1977.
Photo © Peter
Aaron/ESTO.

Genesis, beginning over the altar with God's separating of the darkness and the light. He treated the curving areas where the vault begins as thrones for those who prophesied the coming of Christ, with the architectural triangles between them housing the ancestors of Christ. Between these concave triangles he painted columns and stone ribs that seems to support the upward curve of the ceiling.

Architect Frank Lloyd Wright's *Fallingwater* (**3.43**) is as brilliant in its own way in accommodating itself to the existing features of a natural setting as Michelangelo's monumental Sistine Chapel ceiling was in working within a humanly-created building. Preserving and capitalizing on the beauty of the waterfall, Wright cantilevered the decks of the house right out over it. The horizontal lines of the building mirror the slabs of rock below, echoing their pattern of linear, light-struck mass punctuated by deeply shadowed recesses. Structurally and visually daring, *Fallingwater* satisfies both our appreciation of unifying order in design and also our excitement with that which transcends the expected and ordinary.

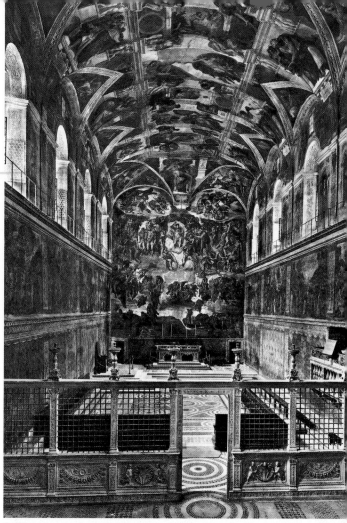

3.42 MICHELANGELO BUONARROTI, Frescos in the Sistine Chapel, Rome. Ceiling 1508–12, *The Last Judgment* wall 1534–41.

3.43 FRANK LLOYD WRIGHT, Kaufmann House (*Fallingwater*), 1936–39. Bear Run, Pennsylvania.

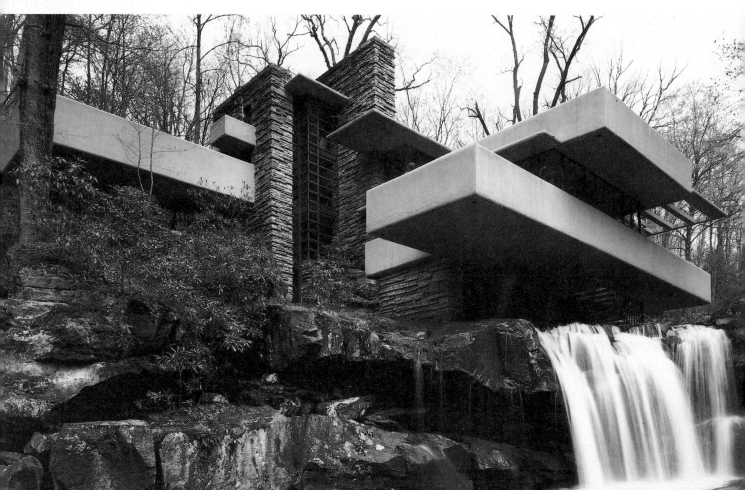

CHAPTER FOUR
TWO-DIMENSIONAL MEDIA AND METHODS

Since humans first approached their cave walls to scratch and paint images of the animals they hunted and spirits they sensed, flat surfaces have lured us to record our impressions of life. Across the millennia, we have appropriated everything from plaster walls to television screens for this purpose.

Appreciating the technical aspect of art requires knowing what to look for. Each MEDIUM—a term we use in its broad sense as the material with which the artist works, such as watercolor, oil paint, or stone—and the methods by which it is used have unique characteristics that can be seen in certain works, though some artists use their medium so skillfully that they transcend its limitations and can make it do anything they choose. In this chapter we will examine many forms of two-dimensional art, ranging from drawing and painting to movies, video, and computer graphics, exploring not only their typical uses but also their great versatility.

DRAWING

Drawing is perhaps the most direct of all the arts. The marks the artist lays down in a drawing reflect the movements and skillfulness of the arm and hand.

4.1 AUBREY BEARDSLEY, Cover design for *The Forty Thieves*, 1879. Pen and black ink, brush, and black chalk, 9⁷/₁₆ × 7¹³/₁₆ins (24 × 19.7cm). Fogg Art Museum, Harvard University, Cambridge MA, Grenville L. Winthrop Bequest.

This aspect is somewhat different from the visual quality of the lines themselves. Aubrey Beardsley's Ali Baba (**4.1**) is composed of elegant flowing lines, but to get this free-flowing effect with pen and ink took tremendous manual control on Beardsley's part. Even the letters are elegantly controlled drawn lines.

Drawings are often created as illustrations, such as Beardsley's illustration for the book *The Forty Thieves*. Techniques of book printing are easily adapted to reproduction of drawn lines, and they resemble and complement the lines of letter forms, as in the Ali Baba cover.

Another way in which artists have often used drawing is in studying natural forms in preparation for rendering them in another medium. Artists do not typically paint or sculpt a human figure, for example, by starting at the head and working down, filling in all the details as they go along. Rather, they first analyze the general form, the underlying structure and relationships between parts. They study the figure in terms of volume, values, proportions, lines, and the dynamics of gestures. What they see they may then draw in a preliminary series of sketches —thinking on paper, as it were. Before painting the Sistine Chapel ceiling (3.42), Michelangelo made numerous drawings to work out the musculature and gestures of the figures. The sketch page shown here (**4.2**) includes his working out of the famous arm of the Lord that we see infusing Adam with life in the celebrated *Creation of Adam* portion of the ceiling. Michelangelo's technique in these drawings is alternately free and "sketchy," and tighter and more refined, with God's arm modeled in considerable detail.

A third way in which drawings may be used is in presentations, as models for future works. Claes Oldenburg's proposed colossal clothespin monument drawing (**4.3**) was a tongue-in-cheek entry in a competition for a Chicago memorial, 45 years after the fact, although he did actually erect a similar clothespin in Philadelphia in 1976. Such presentation drawings are now considered collectable works of art in their own right. Christo often sells his drawings of proposed earthworks to help finance his huge projects, such as *Running Fence* (2.7).

In today's broad aesthetic, all three of these kinds

4.2 MICHELANGELO BUONARROTI, Preparatory drawings for *The Creation of Adam*, Sistine Chapel ceiling, 1511. Red chalk over black chalk, 8⅜ × 11ins (21.3 × 27.9cm). Teylers Museum, Haarlem, The Netherlands.

of drawings—illustrations, sketches, and presentation drawings—are appreciated and hung as works of art. Many artists also create finished drawings as ends in themselves. The many media now at their disposal are explored in the following sections. Those described are not an exhaustive list; some contemporary artists are drawing with new media such as felttip pens. Neither are these categories absolute. Chalks, crayons, charcoal, and pastels are quite similar, and pastel work is often classified as painting rather than drawing because it involves laying down masses of color rather than lines.

Note that most of the illustrations of drawings are of relatively recent works, for the medium on which most drawing is done—paper—has only been readily available since the early 1500s. At that time, increasing urbanization concentrated the population, and the manufacture of less expensive yard goods coupled with growing affluence led people to throw away clothes as they were worn, outgrown, or out of style. Rag collectors moved through the cities buying the used fabric and selling it to paper manufacturers, enabling paper to be produced in greater quantities than in the past and bringing its price down. Today the best artist's papers are still made with rag; less expensive papers, made from woodpulp, yellow and deteriorate with time and don't hold up well under repeated working.

4.3 CLAES OLDENBURG, *Late Submission to the Chicago Tribune Architectural Competition of 1922: Clothespin (Version Two)*, 1967. Pencil, crayon, and watercolor, 22 × 23¼ins (55.9 × 60.3cm). Des Moines Art Center, Gift of Gardener Cowles by exchange and partial gift of Charles Cowles, New York 1972.

4.4 JEAN BAPTISTE CAMILLE COROT, *Città Castellana*, 1826. Graphite pencil on beige paper, 12¼ × 15⅜ins (31 × 39cm). The Louvre, Paris.

Graphite pencil

The pencils commonly used by artists are quite similar to those used as writing tools. They are simply thin rods of GRAPHITE—a soft form of carbon whose value ranges from silver-gray to black—encased in wood or some other material as a holder. Though now commonplace, the graphite (or "lead") pencil was not widely used in drawing until the end of the eighteenth century, when techniques for varying the hardness of graphite were developed. The hardest grades of graphite produce the palest, finest lines; the softer grades tend to produce darker, broader lines and to

glide more smoothly across the paper. A lighter touch with a soft pencil can also be used to create paler values.

Artists may use many grades of graphite or varying techniques with a few grades to create a range of values in a single drawing. In Corot's *Città Castellana* (**4.4**), soft grades of graphite have been used to create very black filled-in areas. For lighter gray values, Corot has used parallel lines of hatching. And on the right side of the drawing, he has used the side rather than the point of a pencil to lay down broad areas of graphite, which are then rubbed for an overall gray tone. These value graduations create contrasts

that remind us of the continual variations between darks and lights in a deciduous forest. Corot has used a visual shorthand for trees, leaves, stream, and rocks, but gives enough information for us readily to perceive the representational scene.

Whereas graphite is laid down in quite a free fashion in Corot's drawing, it is used with great precision in Stuart Caswell's *Chain Link Disaster* (**4.5**). Whether real or imaginary, this view of mangled sections of chain link fencing is photorealistic in its precisely described values and interwoven, overlaid lines. Pencil drawings are more typically used as quick studies; this kind of tight rendering is extremely time-consuming.

Silverpoint

The advent of the graphite pencil greatly lessened the use of SILVERPOINT, which had been popular in the fifteenth and sixteenth centuries. Silverpoint drawings are made with hard, finely-pointed rods of silver in a holder. The paper is first coated with some medium such as opaque white pigment or rabbitskin glue with bone dust to prepare a rather abrasive surface that will scrape off and hold minute grains of the metal. The lines made as the silverpoint tool is run across this prepared ground are silver at first but soon oxidize to a darker, duller color with a special light-reflecting quality. Copper, gold, and lead have also been used in the same way. Jan van Eyck's *Portrait of Cardinal Albergati* (**4.6**) illustrates the uniformity characteristic of silverpoint lines; note that shadows and textures are built up using parallel lines.

Charcoal

In contrast to the tight, thin lines produced by silverpoint, CHARCOAL is a medium that moves very freely across the paper, depositing broad, soft lines. Charcoal is made of charred wood or vine in sticks of varying width and hardness. The marks it makes are easily smudged. Though this possibility is often exploited by artists in toning an area, charcoal drawings are coated with a fixative when finished to prevent further accidental smudging.

4.5 STUART CASWELL, *Chain Link Disaster*, 1972. Pencil on paper, 22 × 28ins (55.9 × 71.1cm). Minnesota Museum of Art, St Paul.

4.6 JAN VAN EYCK, *Portrait of Cardinal Albergati*, c.1431. Silverpoint on grayish-white prepared paper, 8¼ × 7ins (21 × 18cm). Kupferstichkabinett, Staatliche Kunstsammlungen, Dresden.

Käthe Kollwitz's uses of charcoal in her *Self-Portrait with a Pencil* (**4.7**) demonstrate the great versatility of the medium. She has given a faint tone to the paper with a slight deposit of charcoal. The charcoal has also been used sideways with a light touch to create broad strokes across the chest. Laid down this way, the charcoal dust sits on the surface of the paper, allowing the grainy texture of the paper itself to show through. The side of a soft piece of charcoal has been worked into the paper with great strength along the arm, creating lines of a darker value whose boldness bespeaks the creative energy of the artist at work. The tip of the charcoal has been used to create lines describing the artist's features.

And Kollwitz has used the tip of a harder, finer piece of charcoal to complete the upper contour of her head.

Because charcoal is such a soft and free medium, the tendency is to use it in a quick way, as Kollwitz has done. The spontaneity of the act of drawing is revealed and celebrated in this very natural use of the medium. But it is also possible to use charcoal in a more controlled manner. Richard Lytle's charcoal study, *Norfolk* (**4.8**), is a rare example of a very refined charcoal drawing in which the paper is left totally white in places. Whereas many charcoal drawings use only a range of mid-values, Lytle creates very rich blacks whose juxtaposition with true white makes

4.7 KÄTHE KOLLWITZ, *Self-Portrait with a Pencil*, 1933. Charcoal, 18¾ × 24⅞ins (48 × 63cm). The National Gallery of Art, Washington DC, Rosenwald Collection.

4.8 RICHARD LYTLE, *Norfolk*, 1976. Charcoal, 22½ × 30ins (57.1 × 76.2cm). Collection of the Artist.

them sing. He comments,

> Most people use charcoal since it is a very forgiving medium. You can rub it off, in contrast to the immutability of ink. But I use charcoal with a mentality that was evolved through my work with ink. The imagery in this piece is slow in revealing itself, suggesting a bit of mystery, with the dark areas worked densely to a pure velvet black and the floating white areas developing volumes.[1]

Chalk

CHALK is a naturally-occurring deposit of calcium carbonate and varying minerals, built up from fossil seashells. Powdered, mixed with a binder and compressed into sticks, it has long been used as a soft drawing medium. Renaissance, Baroque and Rococo artists used white, red, and black chalks to work up and down the value scale on a tinted surface which served as a mid-tone. This technique is beautifully illustrated by the cartoon for *The Virgin and Child with St Anne and St John the Baptist* (**4.9**) by Leonardo da Vinci. A CARTOON was a full-sized drawing done as a model for a painting. The lines from the cartoon were transferred to canvas or wall by pressing charcoal dust through holes pricked in the major lines of the cartoon. But this cartoon is so striking in its own right that it is displayed by itself in a special dark room of the National Gallery in London, with lighting designed to keep the paper from deteriorating. To indicate volumes rounding in space, Leonardo has used black chalk lines to separate the figures from the tone of the paper and then used dark tones within the figures to indicate areas receding from the viewer

in space. Areas that are to be seen as closest are lightened with white chalk. Notice how much flatter the areas that were not yet worked out—such as the upraised hand and the feet—appear without this use of values. Leonardo's very subtle value gradations were called SFUMATO, Italian for the smoky appearance that softens the lines of the contours and gives a mysterious hazy atmosphere to the image. He achieved the same effect in his paintings, such as *The Virgin of the Rocks* (6.19).

Pastel

PASTEL is a chalky stick made of powdered pigment plus filler bound with a small amount of gum or resin. When rubbed onto a rough-textured paper with enough "tooth" to hold the particles, it deposits masses of color. Pastel drawings are very fragile until treated with a fixative; if they are shaken before they are fixed, some of the powder will fall off. But an overabundance of fixative will deaden or spot the drawing; the only way to assure the permanence of a pastel is to seal it under glass.

The word "pastel" is commonly associated with pale tones, and pale pastels are well suited for creating light and romantic images. However, in the hands of Degas, pastels became a brilliant medium, like paints, but with their own special powdery effect. *After the Bath* (**4.10**) is one of his many major works in pastel. Because pastels are so soft, most artists smudge and blend them on the paper; Degas handles them as lines of color that reveal the act of drawing. He was able to lay one coat of pigment on top of another without their blending, using a special fixative between layers. The formula for the fixative has since been lost, and it is now difficult to build up layers with pastels using contemporary fixatives without dulling the brightness of the colors. In

4.9 LEONARDO DA VINCI, *The Virgin and Child with St Anne and St John the Baptist*, 1510. Black chalk heightened with white on paper, 55¾ × 41ins (141.5 × 104.6cm). The National Gallery, London.

4.10 EDGAR DEGAS, *After the Bath*, c.1895–98. Pastel on paper, 27½ × 27½ins (70 × 70cm). Musée d'Orsay, Paris.

addition to his special fixative, Degas used pastels made with a high ratio of pigment to filler, juxtaposed at maximum strength so they intensify each other's brilliance.

Crayon

Several media carry the name "crayon." CONTÉ CRAYON, named after the person who invented it in the eighteenth century, is a fine-textured grease-free stick made of powdered graphite and clay to which red ocher, soot, or blackstone has been added to give it a red, black, or brown color. Children's crayons are made of pigmented wax. Oil-based crayons come in

4.11 HENRI DE TOULOUSE-LAUTREC, *Équestrienne*, 1899. Crayon, 19¼ × 12⅜ins (48.9 × 31.4cm). Museum of Art, Rhode Island School of Design, Providence.

4.12 PABLO PICASSO, *Three Female Nudes Dancing*, 1923. Pen and ink, 13⅞ × 10⅜ins (35.2 × 26.3cm). National Gallery of Canada.

brighter colors than wax crayons and can be blended on the paper, rather like oil paints. Lithographic crayons are made of grease for use in lithographic printing, but have been adopted for drawing by contemporary artists who like the pleasing way they glide across the paper. Each has its unique qualities, but crayons in general tend to skip quickly across paper. This quickness—and the humor it brings out in the artist—is apparent in Toulouse-Lautrec's *Équestrienne* (**4.11**). To see how differently the mass of the horse is described when the artist is using drawn lines rather than painted masses of color, compare this crayon drawing with Toulouse-Lautrec's oil painting of a similar subject shown in Figure 2.135.

4.13 HYMAN BLOOM, *Fish Skeletons*, c.1956. White ink on maroon paper, 16¾ × 22¾ins (42.5 × 57.8cm). Collection of Mr and Mrs Ralph Werman.

Pen and ink

While the drawing media discussed so far are all DRY MEDIA, it is also possible to draw lines with a LIQUID MEDIUM: usually ink. Today's drawing inks are made of pigment particles, shellac, and water. In traditional China, Japan, and Europe during the Middle Ages and Renaissance, ink was made from ground lampblack mixed into a weak glue. Ink is usually applied with pens made of steel, quills, reeds, or bamboo. Depending on the shape of its point, a pen may produce either lines of uniform width or lines that vary in width according to the direction and pressure of the pen.

Pen and ink drawings are difficult to execute, for the point of the pen may catch on the surface of the paper and splatter ink unpredictably. Today's technical pens can move more easily across the paper, like fine ballpoints, but it is still difficult to create so free-flowing a line as Picasso has used in his *Three Female Nudes Dancing* (**4.12**). If you follow the lines, you will see areas where the ink came out in spurts rather than a continuous flow, but the lines keep moving with utter assurance.

Whereas most ink drawings are dark lines on a white or toned surface, Hyman Bloom creates the texture and form of fish skeletons (**4.13**) by working in white ink against maroon paper. By varying the amount of white laid down in an area, Bloom creates a range of values that gives an in-and-out spatial quality to this image that borders on both realism and fantasy.

Ink can also be thinned and brushed on as a WASH.

4.14

In Claude Lorraine's *Campagna Landscape* (**4.14**), brown ink has been watered down and used to fill in varying brown tones, without overpowering the darker penned lines used to describe the trees and rocks. The tower, however, is described by a darker wash accented by drawn marks, and the distant hills are suggested by a very thin wash alone that almost blends into the light value of the sky.

Brush and ink

The final step into liquid media that can still be classified as a "drawing" is the application of ink with a brush without any penned marks. Developed to a fine art by Oriental schools, this technique is used in a near-abstract manner by Rembrandt in his sketch of a sleeping girl (**4.15**). The action of making each wet stroke is clearly evident, including passages where the ink on the brush was spent and the white of the paper began to show through. Above the girl's head an area of the background is suggested with a brushed wash. Note the attention to the placement of the figure on the ground, a consideration that is particularly important when large areas of the ground are left unfilled and will be perceived as flat shapes in themselves. The wash tends to contradict such an interpretation, softening and pushing the largely unworked area back in space.

4.14 CLAUDE GELLÉE, called CLAUDE LORRAINE, *Campagna Landscape*, 1660. Pen and bister with wash, 12⅝ × 8½ins (30.4 × 21.6cm). The British Museum, London.

4.15 REMBRANDT VAN RIJN, *Sleeping Girl*, c.1660–69. Brush drawing in brown ink and wash, 9⅝ × 8ins (24.5 × 20.3cm). The British Museum, London.

4.16 ROBERT RAUSCHENBERG, *Canto XXI*, 1959–60. Combine drawing for Dante's *Inferno*. Gouache, collage, graphite, red pencil, and wash, 14½ × 11½ins (37 × 29cm). The Museum of Modern Art, New York.

Experimental media

There is no limit to the tools artists could use to draw with and surfaces to draw on: anything that will make a mark and anything that can be marked on. As definitions of art broaden, some artists are exploring unique territories. One of those whose imagination crosses all boundaries is Robert Rauschenberg. He mixes traditional and nontraditional media with great zest. His "combine drawing" for Dante's *Inferno* (**4.16**) includes gouache and collage (both of which are usually classified as painting techniques) with washes and graphite and red pencil drawings and rubbed transfers.

Another new drawing medium that is unlike anything ever done before is COMPUTER GRAPHICS. Rather than holding a pencil or brush in hand and making strokes, the artist creates a computer program that will instruct a pen plotter to draw lines. For example, a very simple BASIC program that tells a plotter to draw 25 random lines in color looks like this:

```
10  HGR: FOR Z = 1 TO 25: H1 = RND (1) •270:V1=RND(1)•190
20  H2 = RND(1)•270:V2=RND(1)•190: HCOLOR=INT(RND(1)•8)
30  M = (V2−V1)/(H2−H1):PRINT M:HPLOT H,V
40  NEXT H: NEXT Z
```

These instructions establish a series of points on X and Y axes that when connected form lines. Very complex figures, such as architectural models, can be thus described, rotated for viewing from all sides, blown up or reduced in scale. Although early computer drawings were quite uniform and visually predictable, computer artist and engineer Harold Cohen has created a computer that he can program to draw surprisingly nonmathematical lines, reminiscent of a child's drawings (**4.17**).

4.17 Drawing produced by AARON, a computer built and programmed by Harold Cohen, 1983.

4.18 AGNOLO BRONZINO, *Portrait of a Young Man*, c.1550. Oil on wood panel, 37⅝ × 29½ins (95.7 × 74.9cm). The Metropolitan Museum of Art, New York, H. O. Havemeyer Collection.

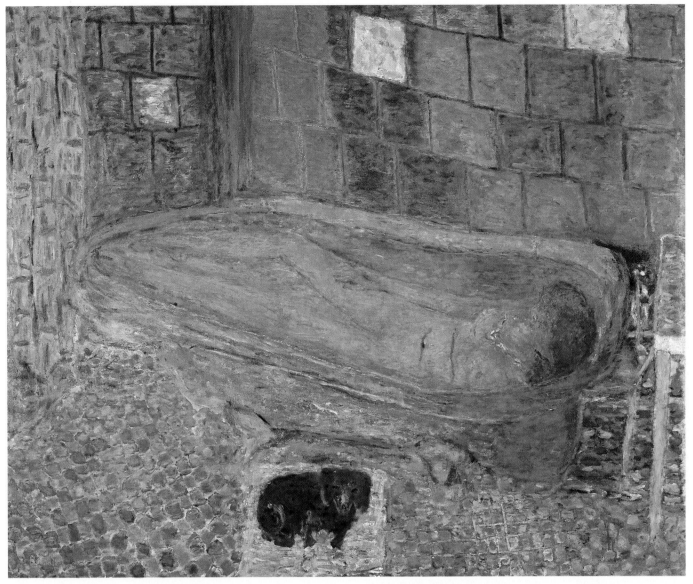

4.19 PIERRE BONNARD, *Nude in a Bathtub*, 1941–46. Oil on canvas, 48 × 59½ins (121.9 × 151.1cm). The Carnegie Museum of Art, Pittsburgh, The Sarah Mellon Scarfe Family.

PAINTING

Painting is the process of coating a surface with color, usually with a brush or palette knife. Over the years, many different technical solutions have been devised to allow the spreading of colored PIGMENTS (particles of color) across a surface. In general, however, painting is made possible by suspension of pigments in a liquid MEDIUM, a vehicle for binding together the pigment grains and making them adhere to a surface.

The surface on which the paint (pigment plus medium) is spread is called the SUPPORT. Through time, varying media have been developed to improve properties such as ease in working, drying time, permanence, or brilliance. Each form of painting thus evolved—often referred to as MEDIA, in reference to the varying vehicles that distinguish them—has its own strengths and difficulties. Most are still in current use, though sometimes only by a few artists who are willing to tolerate the technical difficulties for the sake of the special effects possible.

Approaches to painting have changed as well. In general, the older approach was to plan carefully and execute a painting in stages, beginning with drawing studies of the forms to be represented. Once the drawing satisfied the artist, it was transferred to a support and the forms were developed in a series of stages. In this INDIRECT method, used for works such as Bronzino's *Portrait of a Young Man* (**4.18**), perfection in technique was a painstaking matter but was capable of representing subtleties such as the textures of wood and fur and the translucent appearance of skin. Such effects involved a staged process of sketching, UNDERPAINTING to define the major forms and values, and then a series of OVERPAINTINGS to tint and describe the forms.

Another approach—the DIRECT method—is to paint imagery directly on the support without staged underlayers. This approach may allow the paint—and the painter—to reveal their presence. Oil paint, for instance, has a lush, creamy quality. Van Gogh laid down his paint with heavy IMPASTO strokes that reflect the spontaneity of his gestures. His paintings (such as *The Park of the Asylum*, Figure 1.30) have appreciably three-dimensional surface textures. Oil paints now available also carry sensually rich colors. In Pierre Bonnard's *Nude in a Bathtub* (**4.19**), the model's body is almost obscured by the way the dabs of paint juxtapose varied colors, breaking up the outlines of the forms. The colors are playful, sensual delights rather than reports of actual local colors; the shapes they "describe" are flattened, abstracted.

Direct painting, as practiced by contemporary artists, does not necessarily call attention to the texture of the paint or the activities of the painter, however, and may not even be used to describe forms. Certain nonobjective painters in the twentieth century have worked on UNSIZED canvases (that is, canvases that are not treated with a glue solution to hold the paint on their surface and keep oils from rotting the canvas) so that the paint would be absorbed, with no noticeable surface texture and no trace of the artist's hand. Their works, such as James Brooks' *Anteor* (**4.21**), are created with an appreciation for the essential quality of pigment as pure, flat color.

4.20 *Young Woman with a Gold Pectoral*, Egypto-Romano (Coptic) c.AD 100. Encaustic, 16½ × 9½ins (42 × 24cm). The Louvre, Paris.

Encaustic

A very early method of painting that was used by the Greeks, Romans, and early Christians in Egypt, ENCAUSTIC involves the mixing of pigments with wax. The wax must be kept hot as it is applied, to keep it liquid. Knowledge of the technique used to make such luminous works as *Young Woman with a Gold Pectoral* (**4.20**) was lost for many centuries, though temptingly described by writers such as Pliny. Leonardo da Vinci, ever the experimenter, may have tried to revive the process in 1503, but his attempts failed. Encaustic has been reintroduced but little used in this century.

4.21 JAMES BROOKS, *Anteor*, 1981. Acrylic on canvas, 60 × 60ins (152.4 × 152.4cm). Collection Exxon Corporation.

Fresco

The FRESCO technique was developed by the ancient Mediterranean civilizations, refined to a supreme art by the Italian Renaissance painters, and used with great vigor by twentieth-century Mexican muralists.

The word "fresco" means "fresh" in Italian, for fresco paintings must be created quickly and spontaneously, with little room for error. They are wall paintings in which pigments in a water base are painted onto freshly applied plaster. The immediacy of this method is apparent in the lively feeling of the figures

225

4.22 AMBROGIO LORENZETTI, *Allegory of Peace*, 1339, detail. Fresco. Palazzo Pubblico, Siena.

4.23 Layers in a fresco.　1 Masonry wall　2 Underlayers of plaster　3 Cartoon of image　4 Fresh *intonaco* 5 Previously completed portion.

in Ambrogio Lorenzetti's *Allegory of Peace* (**4.22**). As indicated in Figure **4.23**, which is a reconstruction of the progress of Lorenzetti's fresco, the wall is first given several layers of plaster. Once these layers are dry, the cartoon of the intended image may be traced or freely sketched onto the wall. The final layer of plaster, the INTONACO, is applied over this sketch in small sections, only enough for one day's work at a time, and a portion of the desired image is painted onto its damp surface. The paint immediately bonds to the plaster, and once it is dry it is as permanent as the plaster of the wall. Over the centuries, chunks of the plaster may fall away, as in *Allegory of Peace*, but fresco is by and large a very permanent method of painting.

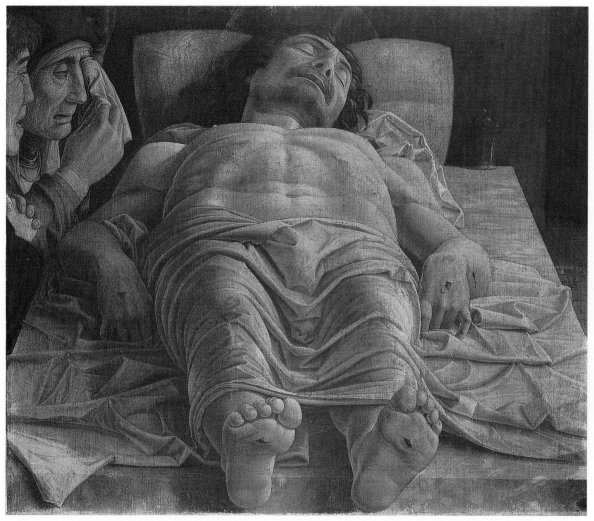

4.24 ANDREA MANTEGNA, *Dead Christ*, after 1466. Tempera on canvas, 26¾ × 31⅞ins (66.8 × 81cm). Pinacoteca di Brera, Milan.

Tempera

Another old and very demanding painting technique involves the mixing in water of pigments with water-soluble egg yolk or some other glutinous material. The resulting TEMPERA paint dries very quickly to a matt finish that will not crack, as can be seen in Andrea Mantegna's *Dead Christ* (**4.24**). Unlike later paints, tempera colors will not blend or spread well. The artist must lay down tiny individual brush-strokes side by side, hatching or cross-hatching to cover an area with pigment. The painting of the final surface follows lengthy preparation procedures.

As diagrammed in Figure **4.25**, a simplified detail of Ugolino's tempera painting of the Last Supper (3.14),

4.25 Layers in a tempera painting. 1 Wood panel
2 Gesso and perhaps linen reinforcement 3 Underdrawing
4 Gold leaf 5 Underpainting 6 Final tempera layers.

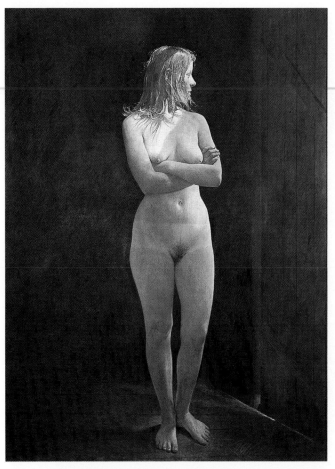

4.26 ANDREW WYETH, *The Virgin*, 1969. Tempera on canvas, 46 × 36ins (116.8 × 91.4cm). Brandywine River Museum, Chadds Ford, Pennsylvania.

painting guilds of the Middle Ages worked out a system of underpainting flesh passages with *terre verte* (green earth). In the final layers of the painting, the flesh areas are covered with pink pigment; the bits of green that show through make the complementary reds of the skin seem more vibrant. A faintly greenish cast that persists can often be seen in the finished work.

It is so difficult to create lively, fresh paintings with tempera that most artists eventually switched to oil paints. But a few contemporary artists still use this old medium quite skillfully, most notably Andrew Wyeth (**4.26**).

Oil

Tempera is a LEAN MEDIUM—a uniform thin film. By contrast, paint that uses oil as a binder for pigment is called FAT. It can be piled up in thick globs and dries very slowly, allowing the artist to blend colors right on the canvas. The use of oil paints by artists began about five hundred years ago, flowering brilliantly in the work of Jan van Eyck. As is apparent in van Eyck's *The Madonna of Chancellor Rolin* (**4.27**), oils opened great vistas to painters. Now they could simulate textures, portray the effects of light and shadow, model three-dimensional forms, add tiny bits of colors as highlights, and work from the darkest to the lightest tones without losing the brilliance of the pigments.

Another characteristic of traditional oil paintings is their luminosity. The flesh of Correggio's *Danae* (**4.28**) actually seems to glow. Even the shadows glow with life. These striking effects were the result of underpainting and then overpainting with layers of GLAZES (films of pigment suspended in a transparent medium) to build up color tints and details of form. A very light passage, such as Danae's body, might be thickly underpainted with white and then glazed with skin tones; a dark passage such as the shadows of the room might be underpainted with brown and then glazed with thin layers of a darker gold-brown.

Oil paint is itself luscious and can become part of the visual focus of a work. Hans Hofmann's *Rhapsody* (**4.29**) is a celebration of the sheer vitality and flexibility of the medium. Color passages are built

the support used—wood or canvas—is first coated with GESSO. This is a fine white substance that gives the panel a smooth, brilliant eggshell finish that accepts paint readily and has enough "tooth" to allow control of the brush. After the gesso dries, the cartoon of the drawing is scratched onto it. These scratched outlines can sometimes be seen beneath the paint in the finished work. If there are to be gold areas in the work, they are covered with a light coating of red gilder's clay, BURNISHED (rubbed) to a gloss. Extremely thin leaves of gold are applied over the gilder's clay in layers, each of which is also burnished. As the gold leaf wears off, patches of the red gilder's clay underneath may show through.

Then comes UNDERPAINTING. Most areas are first underpainted with a base tone of their local colors. But to keep flesh tones from appearing too flat, the

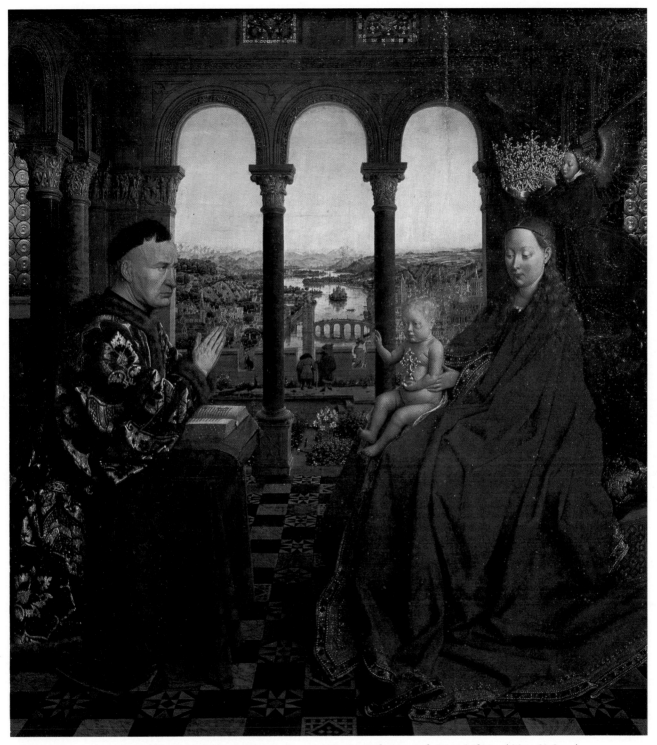

4.27 JAN VAN EYCK, *The Madonna of Chancellor Rolin*, c.1433–34. Oil on panel, 26 × 24⅜ins (66 × 61.9cm). The Louvre, Paris.

4.28 ANTONIO CORREGGIO, *Danae*, c.1532. Oil on canvas, 64½ × 29ins (163.5 × 74cm). Galleria Borghese, Rome.

one atop the other, by SCUMBLING (putting one layer of paint on top of another in such a way that some of the undercolor shows through) and heavy IMPASTO strokes that leave such a thick deposit of the medium that the strokes of brush or palette knife are recorded as an actual texture on the surface. When layered wet, oil colors can be blended; if the underneath hue is to be kept as is, it is allowed to dry before the next layer is applied.

Highly saturated hues in prepared tubes of paint were a nineteenth-century innovation. Earlier oil paintings were built on a more subdued palette created from natural pigments, ground and mixed with oil by apprentices who devoted years to learning how to formulate paint.

Watercolor

An extremely fluid and transparent medium—WATERCOLOR—is created when pigments are bound with a water-soluble medium such as gum, thinned with varying amounts of water, and applied wet to dampened paper. The white of the paper is usually allowed to shine through the thinned pigment in some areas. Whereas the white usually appears as the background against which images have been worked, Richard Lytle brings the white into the foreground as

4.29 HANS HOFMANN, *Rhapsody*, 1965. 84¼ × 60½ins (63.5 × 153.7cm). The Metropolitan Museum, New York, Gift of Renate Hofmann, 1975.

4.30 RICHARD LYTLE, *Spring Thaw on Goose Pond*, 1986. Watercolor, 30 × 41½ins (76.2 × 105.4cm).

the color of flower petals in his *Spring Thaw on Goose Pond* (**4.30**). Note how well watercolor adapts itself to portraying the transparency of water and sky here, with one tone blurring into another.

Watercolor is a very runny medium, so hard to control that Lytle's tight rendering is exceptional. Watercolor cannot be corrected and reworked, unlike oil paint, so the artist is committed to each stroke, which must be made quickly, before the paper dries. This necessity becomes a virtue in the hands of artists like Turner, whose *A Whale Aground* (**4.31**) uses the medium's liquid freedom of gesture and transparent airiness to the fullest. The heaviness of the whale is barely suggested by the shadowed area in this powerful and free abstraction.

Gouache

In contrast to the transparency of watercolor, GOUACHE is an opaque medium. It, too, is water-soluble, but in this case it is bound with gum arabic and mixed with Chinese white pigment. Despite its opacity, it cannot be piled up like oil paints, for the gum arabic will not prevent it from cracking if heavily built up. Some artists use gouache passages to strengthen their watercolors; some paintings referred to as "gouache" are actually watercolors painted over an opaque white ground.

In Bill Martin's *Abalone Shells* (**4.32**), a tour de force of gouache painting, the opaque gouache gives the shells a convincing solidity. Although gouache dries so quickly that blending adjacent colors is difficult, Martin has juxtaposed soft-edged areas of varying hues to create striking pearlescent illusions.

4.31 JOSEPH MALLORD WILLIAM TURNER, *Looking out to Sea: A Whale Aground*, 1845. Pencil and watercolor on paper, 9⅜ × 13¼ins (23.8 × 33.5cm). The Tate Gallery, London.

4.32 BILL MARTIN, *Abalone Shells*, 1982. Gouache, 11⅞ × 15¾ins (30.2 × 40cm).

4.33 CHARLES CLOSE, *Frank*, 1968–69. Acrylic on canvas, 84 × 108ins (213 × 274cm). The Minneapolis Institute of Arts.

Synthetics

Several decades ago, SYNTHETIC MEDIA created chemically rather than derived from natural substances were introduced as part of the artist's tool kit. The form most used today—called ACRYLIC EMULSION, or ACRYLICS—is a water-based medium that can be used straight from the tube with techniques similar to those of oil paints, thinned and blown out as a fine spray through an AIRBRUSH, or thinned right down to the consistency of watercolor. Acrylics dry quickly, and for this reason are preferred by some artists to oils. This property not only allows the artist to complete a painting quickly, but also makes it possible to create special effects, such as painting hard-edged shapes by laying a line of masking tape over previous-

ly painted, already dried areas. Very bright, pure colors can be formulated with synthetics; without the pigment, the medium itself would dry clearer than glass. Acrylics are also permanent and fade-proof; in theory, even if the support rots away, the acrylic paint won't. Its molecular structure is similar to that of the superglues, so it has tremendous bonding power and can be used on many different grounds. Not all artists have switched from slow-drying oils to acrylics, however, for acrylics have a different feel and optical quality and are less easy to blend on the canvas.

Airbrushing with acrylics can be used to create very even gradations in value. As used by some fantasy illustrators and commercial artists, these transitions are flawless rather than more realistically

irregular. But by precisely controlling the gradations, Chuck Close is able to create photorealistic human heads of monumental proportions, such as his *Frank* (**4.33**), which is nine feet (2.75m) tall. Close begins with a photograph which he blows up and transfers to the canvas by a grid system and then recreates in minute detail, complete with facial blemishes and slightly fuzzy areas where the close-up photograph was out of focus.

Helen Frankenthaler's *Flood* (**4.34**) demonstrates how synthetic paints behave when thinned to the consistency of very fluid watercolors. The paint can get so runny that Frankenthaler often works with her canvases on the floor rather than on an easel. Unlike watercolors, acrylics can be painted in layers, allowing the preservation of the hue of an underlayer rather than the blending that occurs when two watercolor hues are laid on top of each other wet.

4.34 HELEN FRANKENTHALER, *Flood*, 1967. Synthetic polymer on canvas, 126 × 140ins (315 × 356cm). Whitney Museum of American Art, New York, Gift of the Friends of the Whitney Museum of American Art.

4.35 PAUL ZELANSKI, *Connecticut Remembered*, 1986. Collage, 8 × 10ins (20.3 × 25.4cm).

Collage

A relatively new art form, introduced in 1912 by Picasso, is COLLAGE. Though technically classified with paintings, a collage does not necessarily involve the application of paint to a surface. Rather, it is built up two-dimensionally, or as a relief, by selecting and gluing to a surface varying flat materials, such as the colored papers, leaf, and Polish stamp in *Connecticut Remembered* (**4.35**). For the artist, it is exciting to collect materials that are interesting in themselves —such as old documents and drawings—and then combine them into an effective whole. Having ready-made areas of colors, textures, and shapes that can be physically moved around allows a very experimental approach to design. For the viewer, the excitement comes first in responding to the work as a whole and then in trying to figure out the original identity of its parts.

Mixed media

Art forms no longer fit neatly into the traditional categories. We live in a period of great experimentation with all media, and some artists are introducing media and art forms that have never existed before. Often media are mixed, crossing all previous boundaries. One example of this creative ferment is Jennifer Bartlett's *White House* (**4.36**). Here the beach house of the painting is also brought off the canvas into three-dimensional space as a model, complete with picket fence. Should this work be called a painting? (Bartlett has been primarily known for her serial paintings on a single theme.) Should it be considered a sculpture? An environment? As distinctions break down, the important consideration is how the artist approached the piece. In this case, the most compelling and interesting part of the work is the huge painting; the house and fence add another spatial dimension to the painting, emphasizing its dramatically unusual point of view by contrast with the ordinariness of physical house and fence.

4.36 JENNIFER BARTLETT, *White House*, 1985. Mixed media. Paula Cooper Gallery, New York.

4.37 *The Battle of Issus*, 2nd to 1st century BC. Mosaic, 8ft 11ins × 16ft 9½ins (272 × 513cm). Museo Archeologico Nazionale, Naples.

4.38 Detail of Alexander from *The Battle of Issus*.

MOSAIC

An ancient and long-lived technique for creating two-dimensional imagery, MOSAIC is composed of small pieces of colored ceramic tile, glass, pebbles, marble, or wood. These are usually imbedded in cement along the surface of a wall, floor, or ceiling of a building. The subtleties possible with this process are illustrated by *The Battle of Issus* (**4.37**), an impressive Roman mosaic that was buried by the eruption of Vesuvius in AD 79 and not unearthed until the eighteenth century. The image is a lively depiction of Alexander the Great's defeat of the Persians (Alexander is bare-headed at left, with the Persian King Darius in retreat in his chariot). Its vigorous realism seems all the more surprising when we recognize that the colors are composed of small TESSERAE, cubes of natural stone that can more readily be distinguished in the detail (**4.38**). The hues are limited to black, white, yellow, and red, but stones of vary-

4.39 LLUÍS DOMÈNECH I MONTANER, Balcony of the Palace of Catalan Music (*Palau de la Música Catalana*), Barcelona.

ing values in each hue have been used to suggest spatial modeling and to provide details for the forms.

Mosaics were common in the early civilizations of Sumeria, Greece, and Rome and were used to decorate early Christian and Byzantine churches until the fourteenth century, when the cheaper medium of fresco was introduced. But the technique has not been lost. Visionary architect Lluís Domènech i Montaner used it lavishly and playfully in the decoration of architectural structures such as pillars in his Palau de la Música Catalana in Barcelona (**4.39**). An exhilarating feast for the senses, the building borrows from the Byzantine, Moorish, and Gothic styles of Catalonia's past. The architect's exuberant use of the mosaics on the pillars almost negates their function. Pillars are usually convincingly solid visual evidence that they are holding up heavy structures. We don't expect them to appear so flowery and airy as these do. Here the tiles are much larger than in the Roman mosaic and no attempt is made to hide their identity as individual cubes.

4.40 ANTONIO DEL POLLAIUOLO, *Battle of the Ten Nude Men*, c.1460. Engraving, 15⅛ × 23¼ins (38.4 × 59cm). The Metropolitan Museum, New York, Purchase 1917, Joseph Pulitzer Bequest.

4.42 Detail of *Battle of the Ten Nude Men*

PRINTMAKING

PRINTS—images made by transference of ink from a worked surface onto a piece of paper, usually in multiples—were originally used as illustrations in books and other kinds of printed matter. Books, in turn, were largely dependent on the appearance of inexpensive, readily available paper. Aside from hand-illustrated, one-of-a-kind treasures (such as the Duc de Berry's Book of Hours, shown in Figure 2.138), books were illustrated with images printed from durable blocks of wood, metal plates, or stones worked by hand. Even after photo-mechanical methods of reproduction removed this need for prints, the printmaking arts continued to be practiced, for prints became valued as artworks in themselves. Now artists can print a limited edition of an image and sell each one as an original.

Processes used for the creation of transferable images allow great variety in artistic styles. Some prints are similar to tightly rendered representational drawings. Antonio del Pollaiuolo's influential *Battle of the Ten Nude Men* (**4.40**) is a highly skilled example of this approach. All of the muscular human forms and foliage in this line engraving are built up through a series of small lines, as shown in the detail view (**4.42**). The painstaking effort involved in making such a work is not immediately evident because

of the great vigor of the image as a whole. Pollaiuolo's skillfulness as an engraver apparently derived from his training as a goldsmith, but his genius in conceiving this dramatic composition of opposing lines far transcends mere manual skill.

A far freer approach to the block is apparent in Hokusai's *Southerly Wind and Fine Weather* (**4.41**), one of his famous views of Mt Fuji series. With stylized simplification of natural cloud and tree forms into flat shapes and a limited palette of hues, it creates an atmosphere all its own that expresses the respect of the Japanese people for their most-loved mountain. The color woodcut print was highly developed in Japan as a way of illustrating popular

4.43 MARY FRANK, *Untitled*, 1977. Monotype on two sheets, printed in color, 32½ × 23¾ins (82.6 × 60.3cm). The Museum of Modern Art, New York, Mrs E. B. Parkinson Fund.

4.41 HOKUSAI, *Southerly Wind and Fine Weather*, late 1820s. Woodblock print, 10 × 14¾ins (25.5 × 37.5cm). The British Museum, London.

picture books. Hokusai, one of the greatest of the practitioners of the art, created tens of thousands of such prints, each of which was reproduced in multiples and usually sold very cheaply. These mass-produced UKIYO-E woodcut prints were not considered fine art until pages from one of Hokusai's illustrated books turned up in Paris in 1856 as packing material for a shipment of valued porcelains.

Printmaking has usually been defined as a method for creating multiple identical copies of an image by repeatedly inking and printing a worked plate. An alternative introduced in the seventeenth century is MONOTYPE, a printmaking process in which the artist paints an image directly onto a sheet of metal or glass with printer's ink or paint and then presses paper onto it to transfer the image. Some ink or paint may be left on the surface, as a ghost of the image which can then be re-inked and reprinted. Each time the image may change slightly, so no two monotype prints will be exactly alike. And the fact that the artist is printing and improvising freely, perhaps even wiping off areas with turpentine and adding something else, rather than scratching fixed lines, gives the monotype an entirely different quality from other prints, as is evident in Mary Frank's soft and fresh rendering of an amaryllis in bloom (**4.43**).

Another departure from traditional definitions of printmaking is the possibility of making an image that is transferred without any ink. Covers of some books are BLIND EMBOSSED, pressed against an un-inked cut plate of metal to create an image that can only be seen when it is turned against the light to bring out the shadows in its indentations. The same process has been used by Jack Youngerman to create the inkless intaglio prints in his *White Portfolio*, one of which is shown in Figure 4.54. Here the visual interest lies in the subtly different values seen in the white paper as it has been shaped by being pressed into the contours of a deeply-cut, uninked printing plate.

There are many ways of preparing a plate to be printed. Most can be grouped into four major categories: relief, intaglio, planographic, and stencil. Each is explored below.

Relief processes

In a RELIEF technique, a block of wood, metal, linoleum, or even found object is carved so that lines and areas to be printed are raised above areas that will stay blank. A simplified diagram of the process is shown in Figure **4.44**.

The classic relief process is the WOODCUT. Typically, a drawing of the intended image is created on or transferred to a smooth block of a softish wood—though some artists develop the image directly on the block, as they cut it. Everything that is to remain as an inked line or area is left intact; all other wood near the surface is carved away with a knife along the edges of lines. Gouges are used to remove large areas of wood. All cut-away areas will be shallower and will not pick up ink when it is applied to the surface with a roller. After the woodblock is inked, a sheet of paper is pressed onto it in such a way that it picks up, in reverse, the inked image.

Traditional European woodcuts used intricate lines of HATCHING and even CROSS-HATCHING to build up tones and textures, rather like ink drawings. Although it is much more difficult and indirect to carve wood away from lines than to draw them, this approach to the medium was handled with superb technical and aesthetic proficiency by Albrecht Dürer. Although Dürer was personally skillful at woodcutting, like many artists of the period he often prepared only the drawing, delegating the actual cutting of the block to some of the finest artisans of the time. Dürer's *St Christopher* (**4.45**) illustrates the range of tones and flowing lines these collaborators were able to coax out of the stiff, flat wood. Some

4.44 Schematic section of a relief printing block.

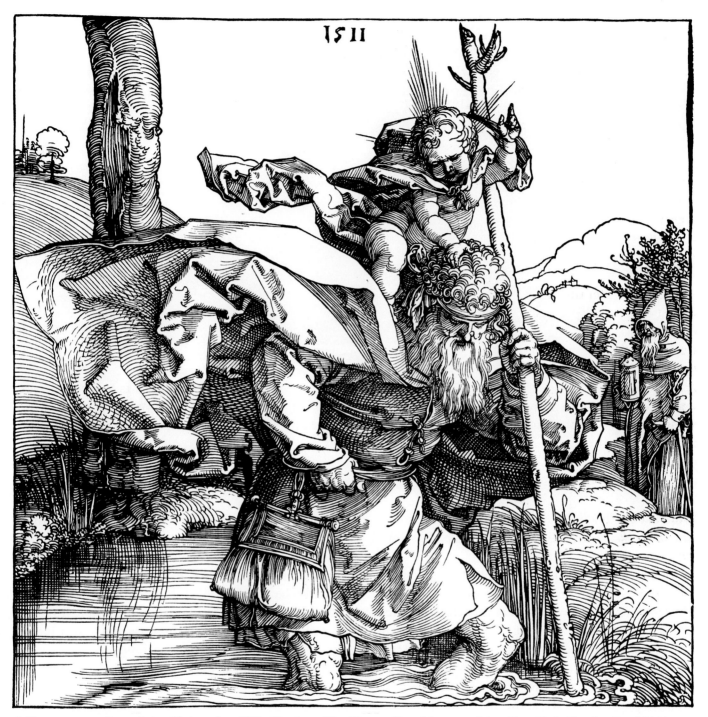

4.45 ALBRECHT DÜRER, *Saint Christopher*, 1511. Woodcut. The Metropolitan Museum of Art, New York, Fletcher Fund 1919.

4.46 ANTONIO FRASCONI, *Portrait of Woody Guthrie*, 1972. Woodcut, 23½ × 38¾ins (59.7 × 98.4cm). From Antonio Frasconi, *Frasconi – Against the Grain*, Macmillan Publishing New York, 1972.

were used as book illustrations; others were sold as single sheets so cheaply that the middle class could afford to buy them.

Although the woodiness of the block is well hidden in Dürer's work, some contemporary artists have chosen to reveal the character of the wood. Different kinds of wood have very different grain patterns, which appear as lines in the printed areas. Wood from the beech tree and fruit trees—such as cherry, apple, or pear—is uniformly hard and even-grained. These woods are often used when the artist wants to create fine details that will stand up to hundreds of printings of the block and to avoid obvious grain lines. Certain species of pine, on the other hand, have wood that varies considerably in softness and hardness from one ring to another, producing strong grain lines that the artist may choose to exaggerate in order to create visual textures in the print. The grain may be heightened by scraping a wire brush across it so that it will

be sure to print. In Antonio Frasconi's *Portrait of Woody Guthrie* (**4.46**), the woody quality is a quiet visual pun that accentuates the rough-cut, homespun character of the folk guitarist. The grain—which can clearly be seen running horizontally through the work—is also used to indicate tones and textures, in a rather serendipitous fashion. Whites with bits of grain printed through them become optically grayer.

Woodcuts can also be executed in colors, as in Joseph Raffael's *Matthew's Lily* (**4.47**), in which the image is composed of twenty-eight colors. The traditional way of adding extra colors—developed to a precise art by the Japanese *ukiyo-e* printmakers—is to cut a series of precisely matched blocks, each having only the area to be printed in a certain color raised as a printing surface. To match the blocks, a master or "key" block with the essential details is first cut and inked, and numerous reference prints are made from it. Areas that are to be printed in different

colors are then indicated on these prints. These guides are glued face-down onto new blocks, one for each color, and everything except the intended colored areas is cut away. At the corners, beyond the edges of the print, registration guides are also cut to help in precise placement of the paper used for the final printing of the entire image. After all the blocks are cut, the same piece of paper is printed by each of the blocks, usually working from lighter to darker tones. The ink is somewhat transparent, and where two colors overlap they will blend. Interestingly,

although Germany and Japan had little contact with each other until the mid-nineteenth century, their artists had devised very similar ways of printing color woodcuts from a series of blocks. The chief difference in the result was the more delicate values of the Japanese prints, which were made with water-soluble rather than oil-based inks. As an alternative to the use of separate blocks, some woodcuts were hand-tinted, one-by-one.

When the end-grain rather than a lengthwise slab of wood is cut, the process is called WOOD ENGRAV-

4.47 JOSEPH RAFFAEL, *Matthew's Lily*, 1984. 28-color woodcut, edition of 50, 32 × 37ins (81.28 × 94cm).

ING. The cross-section of a tree trunk is less likely to splinter than a lengthwise plank and can be incised directly with burins and gravers. The lines cut by these tools become areas that do not print, and are therefore white in the print. In the wood engraving of Winslow Homer's painting of a Civil War sharpshooter (**4.48**) made for the magazine *Harper's Weekly*, it is apparent that the soldier's body, his canteen, and the tree are conceived as white lines cut out of dark areas.

The art of wood engraving is historically associated with Thomas Bewick, an English artist whose wood engravings prompted adoption of the technique as the method of choice in printing illustrations for books and newspapers until it was replaced by photographic methods at the end of the nineteenth century. When illustrations were needed quickly for new stories, a team of wood engravers who had been trained to use the same style were given different parts of an image to cut, and then their blocks were bolted together and printed as a unit. The engraved blocks could be clamped into place at the same height as type and the two printed together to make illustrated texts. The gradations of tone in Bewick's works such as *The Chillingham Bull* (**4.49**) result from slight differences in height in different areas of the block so that they would receive varying degrees of pressure when being printed, varying the amount of ink transferred.

In the twentieth century, linoleum blocks have been added to the printmaker's options. Linoleum cuts, commonly referred to as LINOCUTS, lack the directional character of woodgrain. Lines can be cut equally smoothly and uniformly in any direction, and

4.48 After WINSLOW HOMER, *The Army of the Potomac: A Sharpshooter on Picket Duty*, 1862. Wood engraving, 13¾ × 20⅛ins (35 × 51cm). The Butler Institute of American Art, Youngstown, Ohio.

4.49 THOMAS BEWICK, *The Chillingham Bull*, 1789. Wood engraving, 5½ × 7¾ins (14 × 19.7cm). Victoria and Albert Museum, London.

uncut areas can print in a strong solid black, as in Stephen Alcorn's *Don Juan* (**4.50**). When lines are made directly with a gouge, rather than being what is left after the surrounding wood is carved away, the image is often conceived as white lines within a black area, rather than vice versa. Lines tend to be free-flowing and bold, reflecting the speed of the direct cuts. Although linoleum is easy to cut, it is also somewhat crumbly and cannot be used for ultra-fine lines.

Linocuts have been eschewed by some serious artists because of their association with children's art, but using the medium well is actually quite difficult. Stephen Alcorn, who also works in other printmaking and painting media, explains:

> I was attracted to linoleum by the uncompromising discipline it requires. It is not a flexible medium. Whatever tonal gradations, ornamentation, and pattern appear in the finished print have to be deliberately invented, in contrast to media such as charcoal or lithography, where the artist can hide a lack of structure in the drawing by creating facile atmospheric effects, or oils, where the possibilities for creating subtleties with transparent glazes are endless. Linoleum is a bold and healthy medium. It requires vigor, decisiveness, and solidity in drawing. And to experiment to find ways to enrich the initially barren uncut surface, to make it come to life, is very exciting.[2]

4.50 STEPHEN ALCORN, *Don Juan*, 1984. Linocut, 12⅞ × 10ins (33 × 25.2cm). From *The Bibliophile's Calendar* 1986, Meriden-Stinehour Press

4.52 LUCAS CRANACH THE YOUNGER, *Portrait of a Woman*, 1564. Oil on wood, 32⅝ × 25⅛ins (83 × 64cm). Kunsthistorisches Museum, Vienna.

4.51 PABLO PICASSO, *Bust of a Woman after Cranach the Younger*, 1958. Color linocut, 25¼ × 21⅛ins (64.1 × 53.7cm).

Some prints have historically been used as a means of reproducing works of art originally executed in other media, such as the wood engraving of Winslow Homer's painting (4.48). Picasso plays with this method in his color linocut *Bust of a Woman after Cranach the Younger* (**4.51**). It is loosely derived from Cranach's sixteenth-century painting, *Portrait of a Woman* (**4.52**). Note that the linocut image is the mirror opposite of the painting; Picasso apparently worked it with the same orientation as the painting, but when the sheet was pulled off the inked block, the image was reversed. Picasso's linocut version is also obviously much more direct and playful. For the multiple colors of his linocuts he developed the REDUCTION PRINT method of continually cutting away areas on a single block, inking the surface a different color at each stage rather than cutting a series of registered blocks.

Intaglio processes

The second major category of printmaking methods is INTAGLIO, a term derived from the Italian word for engraving. As shown in Figure **4.53**, it is the exact opposite of relief techniques. In intaglio prints, the image is cut into the surface of a plate. These depressed lines are printed by applying thin ink to the plate with dabbers that force the ink into all the grooves. The plate is then wiped so that no ink remains on the surface, and a sheet of dampened paper is pressed onto the plate so that it picks up the ink that remains in the sunken areas. For special tonal effects or softening of the lines, the plate may first be rubbed lightly with a piece of gauze or muslin, lifting small amounts of ink from the incisions. This technique, most often associated with etchings, is called RETROUSSAGE.

On an intaglio print, the paper beneath the lines is slightly raised because it has been pressed very firmly and uniformly into the grooves to avoid missing any part of the image. A strong roller press—traditionally hand-operated but now mechanized—is therefore used for intaglio prints, in contrast with the lighter pressure exerted by the screw press or hand-rubbing used to transfer ink from block to paper for relief prints. The faint sculpting of the paper as it is pressed in a damp state into the plate is exaggerated to sculpt the subtle forms seen in Jack Youngerman's inkless intaglio (**4.54**). A heavy paper with pliable fibers, such as handmade Japanese paper, is usually used for such deeply sculpted forms to reduce the risk of tearing.

The earliest intaglio process developed was LINE ENGRAVING. In this relatively direct method, the image is drawn on a plate of metal. Copper was generally

4.53 Schematic section of an intaglio printing plate.

used from the sixteenth century until the nineteenth century, when steel was chosen for its ability to hold an image sharply for a greater number of printed copies. Steel, however, was much harder to engrave than copper, so a method of applying a steel facing to already-engraved copper plates was developed in the late 1850s. A BURIN is used to cut the lines. This is a bevelled steel rod with a sharpened point and a wooden handle. A similar tool is used for wood engraving, which is a relief process. Because line engraving is an intaglio process, the ink is forced into the v-shaped grooves cut by the burin, and these become the printed lines.

Line engravings, like wood engravings, were traditionally used for illustrations and reproductions of works of art before photography took over this function. The translation of an image from one medium to another is never precisely accurate. In the steel engraving (**4.55**) of Turner's oil painting *Snow Storm: Steamboat off a Harbor's Mouth* (**4.56**), the engraver has skillfully created a complete range of values from black to white, with many mid-tones, by engraving a tremendous number of tiny lines that vary in width, length, and proximity to other lines, as shown in the enlarged detail of waves (**4.57**). Every area of the engraving is executed with great skill. But even though the values and shapes are similar in the reproduction and the original, the two versions differ tremendously in attitude. The engraving is necessarily conceived in terms of precise lines; the painting is a swirling mass of free-moving brushstrokes, depicting the wild and ever-changing elements as almost obliterating the identity of the steamboat. Another obvious difference, of course, is that the painting is executed in color, whereas line engraving is traditionally a black-and-white medium.

A second major intaglio technique is ETCHING. A copper, zinc, or steel plate is coated with a waxy, acid-resistant substance called a RESIST. The design is drawn through this coating with an etching needle, baring the surface of the metal. The plate is then bathed in an acid solution that bites grooves into the metal in the areas where the needle has cut through the resist. These grooves are then inked and printed as in engravings. Because the waxy resist offers much less resistance to the etching needle than a metal

4.54 JACK YOUNGERMAN, Inkless intaglio from *White Portfolio*, 1972. 36 × 27ins (91.4 × 68.6cm).

4.55 After JOSEPH MALLORD WILLIAM TURNER, *Snow Storm*. Steel engraving, 1891. The British Museum, London.

4.56 JOSEPH MALLORD WILLIAM TURNER, *Snow Storm: Steamboat off a Harbor's Mouth*, 1842. Oil on canvas, 36 × 48ins (91.5 × 122cm). The Tate Gallery, London.

4.57 Detail of engraving of *Snow Storm.*

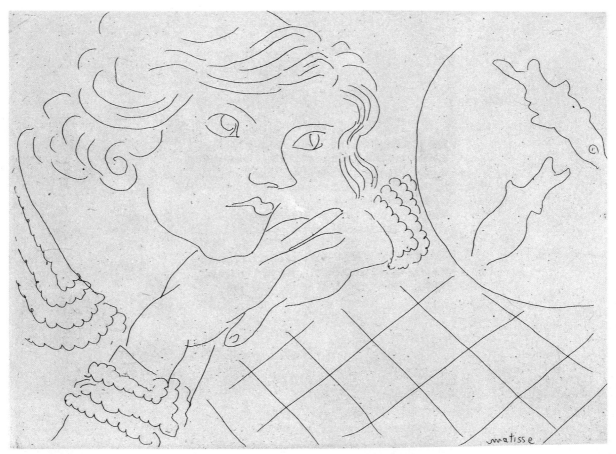

4.58 HENRI MATISSE, *Girl Before Aquarium*, 1929. Etching, printed in black on *chine collé* paper laid on white wove, 5 × 7½ins (12.7 × 19cm). The Museum of Modern Art, New York.

plate does to a burin, the lines in an etching can be quite freely drawn, as they are in Matisse's *Girl Before Aquarium* (**4.58**).

Another unique characteristic of etchings is the possibility of varying tones by withdrawing the plate from the acid bath, "stopping out" certain areas with varnish to keep them from being etched any deeper (and therefore printing darker) and then returning the plate to the bath for rebiting of the unstopped areas. If printed individually, each stage is called a STATE. Rembrandt, whose etchings helped to establish the process as a major art form, printed five states of his *Three Crosses*, of which three are illustrated here (**4.59–61**). The second state is printed on VELLUM, a fine parchment made of animal skin, rather than paper. The vellum blurs the lines, giving a softer,

more paint-like quality to the composition. The fourth state reveals a tremendous amount of reworking. As the states proceed, the work becomes more abstract, with the masses milling below the crosses receding into the shadows (**4.62–4**).

In addition to being stopped out and rebitten, etching plates may also be touched up directly with a DRYPOINT tool—a sharp-pointed, perhaps even diamond-tipped device for scratching lines directly into a copper plate. In an etching, touching up with drypoint techniques eliminates the need for reapplying the resist in order to make changes and is a way to work more value and textural variations into the basic design. The long, dark, parallel lines in the later stages of Rembrandt's crucifixion etchings were obviously added after the original plate was cut.

4.59 REMBRANDT VAN RIJN, *The Three Crosses*, 1653, State II. Drypoint and burin etching, on vellum, 15⅛ × 17¾ins (38.4 × 45cm). The Metropolitan Museum of Art, Gift of Felix M. Warburg and his family.

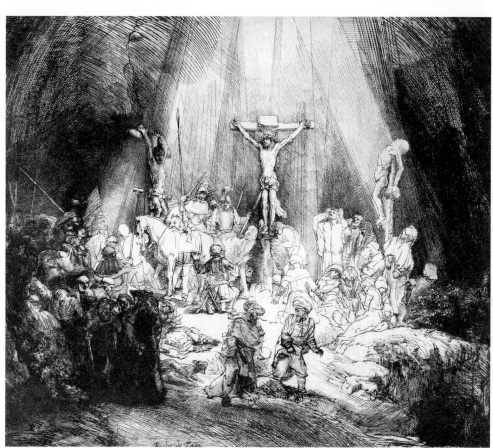

4.60 REMBRANDT VAN RIJN, *The Three Crosses*, 1653, State III. Drypoint and burin etching, 15⅛ × 17¾ins (38.4 × 45cm). The British Museum, London.

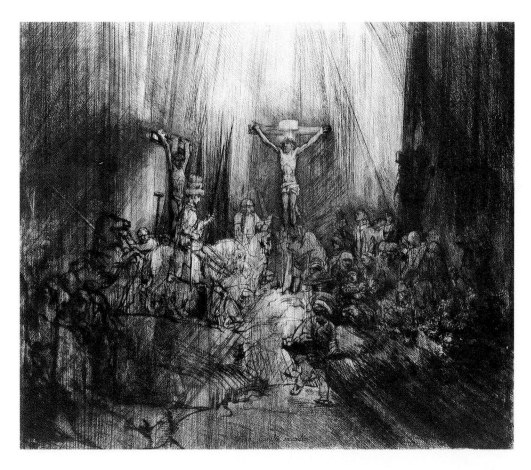

4.61 REMBRANDT VAN RIJN, *The Three Crosses*, 1653, State IV. Drypoint and burin etching, 15⅛ × 17¾ins (38.4 × 45cm). The British Museum, London.

4.62, **4.63**, **4.64** Details of States II, III, and IV of *The Three Crosses*.

255

4.65 MARY CASSATT, *The Caress*, 1891. Drypoint, 7^{11}/$_{16}$ × 5¾ins (20 × 15cm). The Metropolitan Museum of Art, New York, Gift of Arthur Sachs, 1916.

Drypoint cutting can also be used by itself to scratch lines into a blank copper plate. When inked and printed, the plate yields what is called a DRY-POINT PRINT. Mary Cassatt's *The Caress* (**4.65**) is a lovely example of the directness and sensitivity of this process. The darkness of lines is directly determined by the depth to which they are cut. Drypoints also have a characteristically soft and furry line quality. This softening of the line is created by the burr of metal pushed up by the drypoint tool. The burr tends to hold ink when the plate is wiped. Because the burr does not hold up under repeated prints, editions of

drypoints are usually small.

A fourth method of intaglio printing is called MEZZOTINT. In this process, the copper plate is first scored with a rocking device, creating a burr across the whole surface. The burr is then smoothed and scraped to varying degrees to create variations in tone and texture. The lightest tones will appear in areas that are smoothed the most. Gradations from very dark to white are possible, and the print will have a rich velvet visual texture, as in Prince Rupert's *The Standard Bearer* (**4.66**).

Another intaglio printing method is called AQUA-

4.66 PRINCE RUPERT, *The Standard Bearer*, 1658. Mezzotint. The Metropolitan Museum of Art, New York, Harris Brisbane Fund, 1933.

TINT. Like mezzotints, aquatints are capable of creating toned areas rather than the lines to which line engraving, etching, and drypoint are limited. The aquatint process is like etching tones instead of lines. Transparent areas of ink that resemble a wash drawing are created by allowing acid to penetrate a porous covering of powdered resin. Where the surface of the copper or zinc plate is not protected by the resin particles, the acid etches pits in the metal, producing the grainy tones characteristic of aquatints, as in Anne Sobol-Wejmen's *Boyka Fable* (**4.67**).

In the traditional aquatint method, the whole surface is first dusted with the resin and then variations in tone are created by repeatedly stopping out areas with varnish to vary the degree to which the acid bites into the plate. Linear details are usually added using line engraving or drypoint. A version of this process that allows more spontaneous, direct work on the plate is called SUGAR AQUATINT. In this method, the composition is painted onto the resin-coated plate with a sugar solution. The plate is then varnished and immersed in water. The water swells the sugar, which bursts the varnish in the painted areas and exposes the metal there. When the plate is

257

bathed in acid, the previously painted areas will have the grainy aquatint texture, while the varnished areas will remain white.

Planographic processes

The major PLANOGRAPHIC or "surface" process of printmaking is LITHOGRAPHY. In lithography, prints are made from a perfectly flat surface rather than one that is raised (as in relief methods) or incised (as in intaglio). Invented in the late eighteenth century, the method is based on the observation that grease and water will not mix. A design is drawn on a slab of fine-grained limestone (or a metal or plastic plate) with a greasy substance, such as a litho crayon made of wax, soap, and lampblack. The stone is chemically treated to fix the grease and make the open areas more porous, and then it is dampened. When oily lithographic ink is spread across the surface, it is repelled by the wet areas but sticks to the greasy areas.

Lithography can easily reproduce both lines and tones. The dark areas in the prints pulled from a lithographic plate can be very lush, as they are in Redon's *The Light of Day* (**4.68**), in contrast to darks that must be built up by lines. Artists find it a very free way to work, and one that mirrors the gestures of their drawings exactly. A great number of prints can be pulled from a single stone or plate, so modern versions of the process are widely used for commercial printing of everything from cigar labels to books. In OFFSET LITHOGRAPHY, the process used to print this book and most others today, illustrations are converted to systems of dots that give the effect of different tones. The dot patterns are created by photographing the image through a screen of crossed lines. You can see the dots if you examine one of the black-and-white illustrations in this book with a magnifying glass. Screened illustrations and typeset text are then transferred photochemically to plates for printing. Ink is picked up—"offset"—from the cylindrical plates onto a rubber roller and thence transferred to paper so that the final image is the same way around as that on the plate, rather than reversed, as in most art printing processes.

In both original works of art and commercial print-

4.67 ANNE SOBOL-WEJMEN, *Boyka Fable*, 1979. Aquatint, 9¼ × 11½ins (23.5 × 29.2cm). Collection: Annette Zelanski.

4.68 ODILON REDON, *The Light of Day*, from *Dreams*, 1891. Lithograph, 8¼ × 6⅛ins (21 × 15.5cm). Bibliothèque Nationale, Paris.

4.69 JAMES ROSENQUIST, *Iris Lake*, 1975. Nine-color lithograph, 36 × 52ins (91.4 × 132cm).

4.70 JOSEF ALBERS, from the *Mitered Squares* portfolio, 1975. Screenprint, edition of 36, 19 × 19ins (48.2 × 48.2cm).

ing processes, lithography can also be adapted to multiply colored images. In prints that originate as lithographs, such as James Rosenquist's nine-color *Iris Lake* (**4.69**), a separate plate is made for each color. Each plate is marked so that it can be carefully aligned to match the others during printing. In commercial reproduction of colored images created by other processes, such as those in color in this book, *color separations* are done on a computerized *color scanner*. It reads a *transparency*—a flexible transparent photograph of the work—to translate the colors into mixtures of the four colors that will be used to print it on a *four-color press*: yellow, magenta (red), cyan (blue), and black. Each color is printed from a separate plate; the pages of this book that have color illustrations have received four precisely registered printings.

Stencil processes

The fourth major printmaking process is stenciling—masking out areas that are not to be printed. The form of stenciling now most often used both by fine artists and commercial printers is the SILK SCREEN or SERIGRAPH. A fine silk or synthetic fiber screen stretched across a wooden frame is masked in places by a cut paper or plastic stencil or by lacquer, glue, or lithographic crayon. When ink is brushed across the screen with a squeegee, it passes through the un-masked areas to be deposited on the paper or other surface to be printed below. A multi-colored image can be created by use of successive screens with different colors and different masked areas. The typical effect is a series of flat opaque colored areas, as in Josef Albers' print from his portfolio *Mitered Squares* (**4.70**). Precise registration by his printer, Ken Tyler, makes the edges as sharp as a hard-edged painting, with no unintentional gaps or overlapping between colors. Graduated tones are also possible in a silkscreen print, through use of a photographic emul-

4.71 RICHARD CLAUDE ZIEMANN, *Edge of the Forest*, 1975. Etching and engraving, 20 × 24ins (51 × 61cm). The Brooklyn Museum, New York.

4.72 LARRY RIVERS, *French Money*, 1965. Silkscreen printed in colors with plexiglas collage, edition of 125, 32 × 30ins (81 × 76cm).

sion on the screen. Paints used may be transparent or opaque. Colors can blend into each other through a *split fountain* technique, in which different paints are placed at different ends of the squeegee and blended where they overlap as they are pushed across the screen.

Mixed media

Although we have examined the major printmaking processes separately, in practice they are often mixed with each other. Richard Ziemann has used both etching and engraving in his *Edge of the Forest* (**4.71**) for a combination of sharper engraved and softer etched lines, to create varying textural and tonal effects. Relief, intaglio, planographic, and stencil plates can be alternately printed on the same surface. In today's wide-open experimentation, some artists are even combining printmaking with other media. In *French Money* (**4.72**), Larry Rivers silkscreened images onto a rigid sheet of clear acrylic and also cemented acrylic shapes to the surface, like a transparent collage.

GRAPHIC DESIGN

In addition to drawing, painting, mosaic, and print-making, another major area of two-dimensional design is GRAPHIC DESIGN. The term "graphic designer" is a rather new label in the history of art. It is applied primarily to those who design two-dimensional images for commercial purposes, from advertisements, packaging, and corporate images to the pages of books. Their challenge is to catch the eye of an already optically saturated public, conveying information in a memorable way.

Graphic designers must have their fingers on the ever-changing public pulse, staying one step ahead of shifting tastes and interests. This does not necessarily mean that effective designs are always futuristic. For a logo for New York's Russian Tea Room (**4.73**), Milton Glaser has combined contemporary honed-down hard-edged lines with a more lyrical, nostalgic invented type style that is reminiscent of the Cyrillic alphabet. The image does not suggest today's Soviet Union; it bespeaks the wealth of Czarist Russia. The gradually thinning lines around the border and the implied lines that run outward from the center on the corners give the center shape and letter forms greater impact by making them appear to project toward the viewer in space.

In line with the current public mood, many designers are packaging food in ways that make it appear more "natural." To market a new pasta sauce as if it were home-made from an old family recipe using all-natural ingredients, Duffy Design Group suggested bottling the sauce in traditional canning jars, complete with raised measurement marks along the side. The labels they designed for the jars (**4.74**)

4.74 CHARLES SPENCER ANDERSON designer/illustrator, Duffy Design Group, Packaging for Prince Foods' Classico pasta sauce range.

have the rustic appearance of hand-cut, hand-tinted woodcuts, adding to the home-made image. Through words and imagery, the designers develop a certain feeling toward the product in the attitude of the consumer.

Graphic design is usually aimed directly at consumers, though there is often an art director and a marketing team between the designer and the end user. But its blatant commercialism has not kept some graphic design from being treated as fine art. Some is created by recognized artists who have distinguished themselves in other media, such as Toulouse-Lautrec, whose lithographed posters for dance-halls and cabarets (**4.75**) raised the poster to an art form. They were so admired by collectors that they were stolen as fast as they were put up.

4.73 MILTON GLASER, Logo for the Russian Tea Room, from Milton Glaser, *Graphic Design*, The Overlook Press, Woodstock NY, 1983.

The poster, like most graphic design, was initially conceived as an ephemeral piece to be thrown away once its commercial purpose was finished. But posters are often so visually compelling that someone saves—or buys—them and hangs them as one would a painting. They have become a relatively inexpensive way to bring art into one's home. Whereas a few decades ago, those who couldn't afford original works of art hung reproductions of them in their homes, many people now display museum posters advertising shows by favorite artists. David Lance Goines specializes in creating and printing posters whose primary function is to be seen as art; their actual commercial application is an excuse for elegant design, such as Goines' nine-color poster (**4.76**) for an exhibit of—what else?—posters. Goines has

4.76 DAVID LANCE GOINES, Poster, *The Poster*, 1974. Nine-color offset lithograph, 12¼ × 24ins (31.1 × 60.9cm).

4.75 HENRI DE TOULOUSE-LAUTREC, Poster, *Aristide Bruant dans son Cabaret*, 1893. Color lithograph, 54½ × 39ins (138 × 99cm). The Metropolitan Museum of Art, New York, Harris Brisbane Dick Fund, 1932.

his own offset press and is highly skilled in its use. He prints a specified number for each client, plus several hundred more that are sold through a gallery. But even though his posters are widely collected as art, when Goines was asked to comment on the difference between commercial and fine art, he replied, in part,

> The fine artist must please only himself and one other person, that is, the buyer of the already completed work of

art. . . . The commercial artist has more restrictions put on him, and must please himself, the client and the Great God Public, or he's out of business. . . . Generally speaking, the commercial artist has a whole lot of other people's money, hopes, dreams and aspirations riding on his efforts, and can under no circumstances produce any "art for art's sake," or he will quickly find himself out on the street. . . . A commercial artist is in the class of skilled laborer (although most designers and commercial artists no doubt think of themselves as white collar workers, and wear neckties). . . . Someone like Milton Glaser is very highly skilled, and the measure of that is in the effectiveness, rapidity, cleverness and economy with which he executes a client's task. Fine art is not like that.[3]

Typography

The two major ingredients of graphic design are letters and images. Typography is the art of designing, sizing, and combining letter forms on a printed page. The choices the graphic designer must make are subtle and complex. Hundreds of TYPEFACES that can be used for printing the Roman alphabet have been developed over the years. Most can be grouped into two large categories: SERIF and SANS SERIF typefaces. A serif is a fine line that finishes the larger "stroke" used to make a letter form. Originally used in the classical Roman alphabet on which modern letters are based, serifs tend to lead our eye through a word, tying it together visually, as well as giving elegant calligraphic flourishes to the individual letterforms. Most books, including this one, are printed in one of many serif typefaces. Many modern typefaces eliminate the serifs, however, for a more contemporary look. These sans serif ("without serif") type styles are often chosen when an upbeat, forward-looking message is desired. Figure **4.77** illustrates the general

4.78 ALBRECHT DÜRER, page from *Underweisung der Messung*, 1525. Victoria and Albert Museum, London.

difference between these two categories: Baskerville is a serif typeface originally designed in the eighteenth century by John Baskerville, while Gill Sans is a twentieth-century sans serif typeface often used on

4.77 Baskerville (above) and Gill Sans (below) typefaces.

Aabcdefghijklmnopqrstuvwxyz
ABCDEFGHIJKLMNOPQRSTUVWXYZ
Aabcdefghijklmnopqrstuvwxyz
ABCDEFGHIJKLMNOPQRSTUVWXYZ

Douglas C. McMurtrie:
We use the letters
of our alphabet every day
with the utmost ease and unconcern,
taking them almost
as much for granted
as the air we breathe.

We do not realize that each
of these letters is at our service today
only as the result of a long
and laboriously slow process of evolution
in the age-old art
of writing.

Le plus grand chef d'œuvre
de la littérature
n'est jamais qu'un alphabet
en desordre. Jean Cocteau

Das größte
ist das Alphabet,
denn alle Weisheit steckt darin.
Aber nur der erkennt den Sinn, der's recht
zusammenzusetzen
versteht.
Emanuel Geibel

Ἀρχὴ μεγίστη τοῦ βίου
τὰ γράμματα.

Für Philip Hofer in Cambridge, geschrieben von Hermann Zapf, Frankfurt am Main 1959

4.79 HERMANN ZAPF, Alphabet with quotations, 1959. Ink. Mr and Mrs Philip Hofer Collection, The Houghton Library, Harvard University.

modern English signs. Eric Gill based its proportions and shapes on the classic Roman letter forms, but made the rules for their creation so simple that even the least skilled signwriter could follow them perfectly.

When a typeface is designed, each letter is carefully constructed, with attention to the balance between stressed (thicker) and unstressed (thinner) portions. Albrecht Dürer, influential in so many of the visual arts, published in 1525 *Underweisung der Messung mit dem Zirckel und Richtscheyt* ("A Course in the Art of Measurement with Compass and Ruler"). This book included instructions for applying geometric principles to the construction of letterforms. In the page shown in Figure **4.78** Dürer relates each letter to a square, with a ratio of ten to one between the height and width of the letter strokes. Not only are his letters lovely; the page as a whole is beautifully designed, with pleasing contrast between the scale of the text type and the display type, and enough white space around the printed text to allow it to breathe.

Typesetting has largely been turned over to computerized photocomposition processes rather than handsetting of metal type. But the art of the beautifully designed letter and page is being maintained by aficionados of fine printing. Hermann Zapf has designed over 50 typefaces adapted to twentieth-century technologies, but he maintains a poetic sense of the aesthetics of typography, as is evident in the alphabet sampler done in his own calligraphic hand (**4.79**).

In addition to having unique characteristics if examined closely, each typeface creates a slightly different value when printed in blocks on a page. In Herb Lubalin's cover (**4.80**) for the typographic newsletter *U&lc* (Upper and Lower Case), each article in the right column is summarized in a different typeface, revealing noticeable differences in blackness and grayness. Lubalin, a highly resourceful graphic designer who often creates his own typefaces to make images of words and letters, has managed to integrate

4.80 HERB LUBALIN, cover for *U&lc*, 1974. Reprinted with permission from *U&lc* magazine, International Journal of Typographics published by the International Typeface Corporation.

59 different units of varying typefaces, 7 illustrations, and 16 rules (lines) into a page that works well as a whole.

Illustration

The other major ingredient in graphic design is illustration. Any kind of image may be used, from photographs to woodcuts. The style of illustration and typography must be harmonious. To illustrate Chaucer's *Canterbury Tales*, William Morris created a special Gothic typeface, surrounded it with intricate borders, inset woodcuts of drawings by Edward Burne-Jones, and embellished the whole with large illuminated capital letters, as shown in one of the 556 pages of the monumental book (**4.81**). In its brief life from 1891 to 1898, Morris's Kelmscott Press created 18,000 copies of 53 books, all hand-crafted. Their quality and lavish decoration revived interest in fine printing as an art form, at the same time that commercial printing was becoming increasingly mechanized. Morris, who also designed wallpaper, furniture, stained glass, interiors, and industrial products, had a great love for the beautiful object, carefully made of the best materials available. He wrote,

> The picture-book is not, perhaps, absolutely necessary to man's life, but it gives us such endless pleasure, and is so intimately connected with the other absolutely necessary

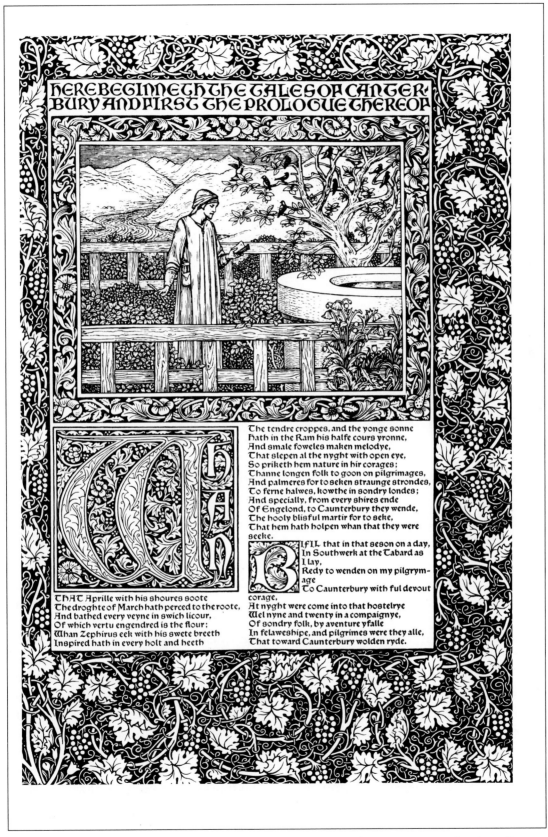

4.81 WILLIAM MORRIS and EDWARD BURNE-JONES, page from the Kelmscott Press *Works of Geoffrey Chaucer*, 1896. Victoria and Albert Museum, London.

4.82 LANCY HIDY, page from Andrew Marvell, *The Garden*, 1970. Etching and letterpress, edition of 115.

IX

How well the skilful Gardner drew
Of flow'rs and herbes this Dial new;
Where from above the milder Sun
Does through a fragrant Zodiack run;
And, as it works, th' industrious Bee
Computes its time as well as we.
How could such sweet and wholsome Hours
Be reckon'd but with herbs and flow'rs!

4.83 BARRY MOSER, *The Mad Hatter*, from The Pennyroyal Press *Alice's Adventures in Wonderland*, 1982. Wood engraving.

art of imaginative literature that it must remain one of the very worthiest things towards the production of which reasonable men should strive.[4]

Fine printing of illustrated works continues today, often with very different decorative approaches from Morris's. For example, Lance Hidy used handset italic type and a tremendous amount of unfilled white space around his delicate flower etching to present Andrew Marvell's poem, *The Garden* (**4.82**). An entirely different approach was taken by Barry Moser in his bold wood engravings and asymmetrical page layouts for *Alice's Adventures in Wonderland* (**4.83**).

The illustration takes up most of the column and even breaks out of its own rectangle, spreading toward the "gutter," or central seam of the book. The head of the Mad Hatter is opposed to the strength of the white border, metaphorically illustrating the illogical frustrations and tensions built up in the story.

Because graphic design is basically a functional art, illustrators must keep the character of what they are illustrating clearly before them. This need is especially true in advertising, where the intent is to portray the client's product as compellingly as possi-

84

they've begun asking riddles—I believe I can guess that," she added aloud.

"Do you mean that you think you can find out the answer to it?" said the March Hare.

"Exactly so," said Alice.

"Then you should say what you mean," the March Hare went on.

"I do," Alice hastily replied; "at least—at least I mean what I say—that's the same thing, you know."

4.83

4.84 GEORGE LOIS art director/copywriter, Poster for Goodman's Matzos, 1960.

ble. At one extreme, the illustration of the product may dominate the presentation, as in George Lois's subway poster for Goodman's Matzos (**4.84**). A single matzoh cracker has been blown up to the size of a rug, giving its unique surface texture tremendous visual impact. At the other extreme, an elegant and well-known product sometimes lends itself to considerable understatement, as in the refined Audi ad (**4.85**).

Looking down, as if from the point of view of the gods, we are beckoned into the car by the slightly open door and the aureole of glowing golden light. Most of the brochure cover consists of unfilled space. This extremely restrained use of color, image, and type suggests the message that the benefits of this product are so well known that they need not even be mentioned to genteel clients.

THE ELEGANT AUDI 5000S.

4.85 BARRY SHEPHERD and STEVE DITKO of SHR COMMUNICATIONS, Brochure for Audi of America, 1985.

4.86 WILLIAM HENRY FOX TALBOT, *Botanical Specimens*, 1839. Photogenic drawing. The Metropolitan Museum of Art, New York, Harris Brisbane Dick Fund, 1936.

4.87 LOUIS JACQUES MANDÉ DAGUERRE, *A Parisian Boulevard*, 1839. Daguerrotype. Bayerische Nationalmuseum, Munich.

PHOTOGRAPHY

Although photography (Greek for "writing with light") is now so much a part of our visual world that we take it for granted, it is a relatively recent invention. From the time of the Renaissance, many artists had used the *camera obscura* to draw forms and linear perspective accurately. A camera obscura was a dark room or box with light entering through a tiny hole, perhaps focused by a lens. An inverted image from the world beyond would be thrown on the opposite wall, and its outlines could be traced on paper. But it was not until the first half of the nineteenth century that several researchers working independently of each other found ways to capture this image permanently.

One of the early developers of what became photography was William Henry Fox Talbot. Longing to be able to capture images from his travels and everyday life that he did not have the skill to draw, this English scientist experimented with various techniques. One yielded what he called a *photogenic drawing*, or PHOTOGRAM, created by laying objects on paper coated with light-sensitive chemicals and then exposing it to light. The result is a negative, in which the objects appear light and the paper turns dark. In addition to his scientific resourcefulness, Fox Talbot obviously had an eye for design, as is evident in one of his early photogenic drawings (**4.86**).

At the same time that Fox Talbot was carrying on his experiments, several French researchers had been developing processes that worked along similar lines. After years of secret experimentation, Joseph Nicéphore Niépce (an inventor) and Louis Jacques Mandé Daguerre (a painter of stage sets) began collaborating to produce the process that Daguerre named DAGUERROTYPE in 1837 after Niépce's death. The public was awed by the new ability to preserve actual images in precisely accurate detail. The process was not yet perfect, of course. One problem was the lengthy time needed for exposures. Daguerre's picture of a Paris boulevard (**4.87**) makes it appear to be deserted except for a shoeshiner and his customer. This strange effect occurred because although there were other people on the streets and sidewalks, they were moving too fast for their images to be recorded.

4.88 Anonymous photographer, *Portrait of a Landowner*, India, c.1900. Painted photograph. ARCOPA (Archival Centre of Photography as an Artform), Bombay.

In the excitement over the new invention, improvements appeared quickly, including the ability to create multiple copies of a single image, based on Fox Talbot's work with the negative.

One of the exciting possibilities opened up by the invention of photography was that of having one's portrait captured for posterity. There had long been portrait painters, of course, but a perfect likeness was both rare and expensive. Many of the surviving early photographs are portraits, such as that of an Indian landowner (**4.88**). Intricately hand-painted before the advent of color photography, it is both subtly beautiful and strangely flat to Western eyes, perhaps because the apparently painted backdrop behind the sitter is not painted in accurate linear perspective (the lines on the door, for instance, all point upwards instead of converging toward a single vanishing

4.89 JULIA MARGARET CAMERON, *Iago*, 1867. Albumen print. National Museum of Photography, Film and Television, Bradford, England.

4.90 DANTE GABRIEL ROSSETTI, *Jane Morris*, 1865. Photograph. Victoria and Albert Museum, London.

4.91 DANTE GABRIEL ROSSETTI, *Rêverie*, 1868. Colored chalks, 33 × 28ins (83.8 × 71.1cm). Private Collection.

point). Even the floor seems to recede up rather than back in space, a spatial convention from traditional Mughal miniature painting.

In the hands of some photographers, the portrait photograph became an opportunity to capture an essence or atmosphere rather than a superficial likeness of a person. One of the British gentlewomen who took up the new hobby of portrait photography was Julia Margaret Cameron. Her portraits appear out of focus, for during her long exposures (three to seven minutes) her subjects may have moved, and sharpness was not her object anyway. Her *Iago* (**4.89**) illustrates the emotional and spiritual depth of her photographs. Although Iago was the villain of Shakespeare's *Othello*, we respond to this man as a complex and compelling human being, investing him with our own ideas about what he is feeling.

In addition to being enthusiastically embraced by the public as a new way of capturing images of the world, photography was adopted by many artists as a helpful tool for creating representational works in other media. As we have seen, painters such as Degas and Toulouse-Lautrec developed unusual perspectives and cropping of figures in response to the camera's-eye-view of external experience. Then, as now, some artists also used photographs as the initial study from which to develop drawings or paintings. Rather than having William Morris's wife Jane pose through long sittings, Dante Gabriel Rossetti had her photographed as he posed her (**4.90**) and then developed his chalk drawing *Rêverie* (**4.91**) from the photograph. Note that he did not imitate it slavishly; the artist's license he took is obvious when the two images are compared. Even after posing her himself, he changed her posture in the chalk drawing, creating a pleasing circular flow of light across her neck, down her right arm, up her left arm, and back to the Classical styling of her face.

Whenever a new medium appears, artists often try to increase its acceptance by making its products

4.92 EDWARD STEICHEN, *Moonrise, Mamaroneck, New York*, 1904. Platinum, cyanotype, and ferroprussiate print, 16 × 19ins (38.9 × 48.3cm). The Museum of Modern Art, New York, Gift of the Photographer.

approximate those created with earlier, familiar media. This was true in photography as well. At the turn of the century, the *pictorialist* movement in photography sought, by elaborate printing techniques, to make photographs look like paintings, emphasizing the hand of the artist at work rather than the sheer duplicating ability of the camera. Edward Steichen used layered prints created with different chemicals to create the misty atmosphere of *Moonrise, Mamaroneck* (**4.92**).

Although such painterly effects were dramatic, Steichen and Alfred Stieglitz, both leaders of the pictorialist movement, also evolved strong interest in exploring the potentials that were unique to photography. One was the ability to capture a specific moment in time. Stieglitz's *The Terminal* (**4.93**) is an ephemeral scene of a horse-drawn trolley being turned on a wintry morning. The steamy breath of the horses, the dusting of snow, and the man walking out of the picture in the background give a sense of immediacy to the image.

Willingness to abandon the search for beauty in favor of the straight *documentary* photograph made it possible for sympathetic photographers to share

what they had seen of humanity. Documentary photographers—some of them hired by the Farm Security Administration in the United States—wakened public concern for social welfare by recording the plight of the poor, from children working in mines and sweatshops to migrant workers living under wretched conditions. Dorothea Lange's photograph of a migrant mother and her children (**4.94**) was reproduced in thousands of newspapers and magazines across the country. According to Lange's field notes, this mother, who spoke to the heart of every mother, was "camped on the edge of a pea field where the crop had failed in a freeze. The tires had just been sold from the car to buy food. She was 32 years old with seven children." So effective was this memorable image in waking public sympathy and support for government welfare projects that the death of the mother decades later was publicly honored.

Sociological photo-reporting has not dwelt exclusively on scenes of human misery. Even among the poor, photographers have often captured moments of great integrity, ecstasy, or humor. Henri Cartier-Bresson specialized in images of everyday life around the world that are emotionally familiar to people from all cultures. His genius lies in his ability to

4.93 ALFRED STIEGLITZ, *The Terminal*, 1915. Photograph. Gernsheim Collection, Harry Ransom Humanities Research Center, The University of Texas at Austin.

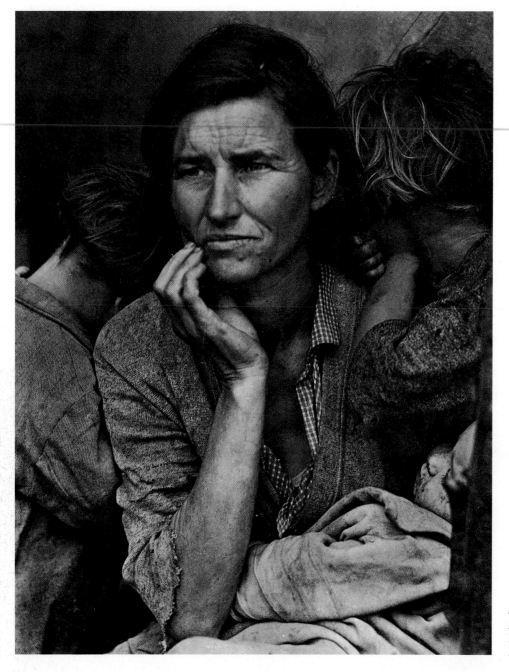

4.94 DOROTHEA LANGE, *Migrant Mother, Nipomo, California*, 1936. Photograph. The Museum of Modern Art, New York.

catch the "decisive moment" when a naturally shifting scene of unposed people clicks into place as a strong composition. In his *Sunday on the Banks of the Marne* (**4.95**), everything is placid and staid, from the calm surface of the water to the short, round forms of the well-fed torsos. The only action we sense is the business of eating, which seems to be a central theme in these people's lives.

Photographs have also been used to preserve views of the earth's natural landscape that are continually threatened by the expansion of population and industry. In the United States, the work of the great land-

scape photographers, such as Ansel Adams, has played a major role in wilderness conservation efforts. Adams was a leader in the "f/64 Group," which used a small lens opening (such as f/64) in the interests of exceptional clarity, sharpness of detail, and depth of field (sharpness of detail at all distances from the viewer), as illustrated by Adams' *Clearing Winter Storm, Yosemite National Park* (**4.96**). Such arresting images were largely the result of careful planning at the photographing stage rather than manipulation in the darkroom. Adams' full tonal range, from lush blacks, through many grays, to pure

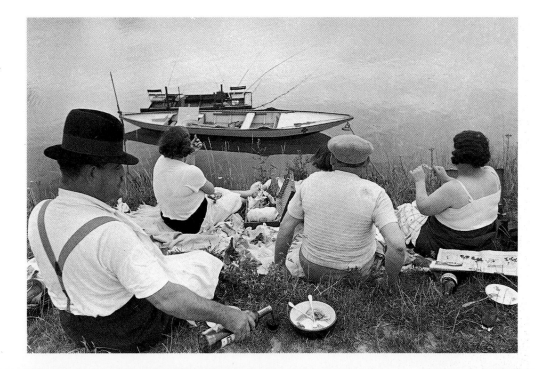

4.95 HENRI CARTIER-BRESSON, *Sunday on the Banks of the Marne*, 1939. Gelatin-silver print, 9⅛ × 13¾ins (23 × 34.9cm).

4.96 ANSEL ADAMS, *Clearing Winter Storm, Yosemite National Park*, 1944. Photograph.

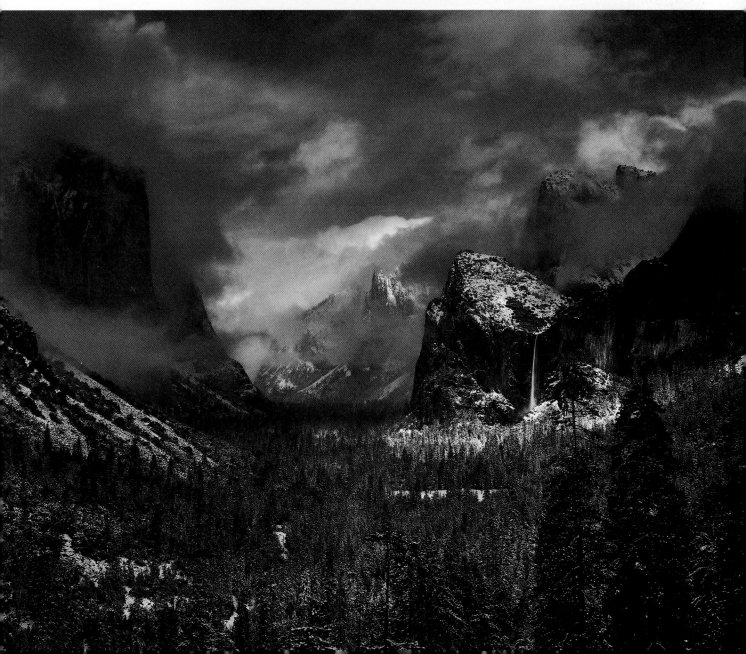

4.97 BARRIE ROKEACH, *Aerial Photograph of Suisun Marsh, Solano County, California*, 1979.
©1979 Barrie Rokeach. 1987, All Rights Reserved.

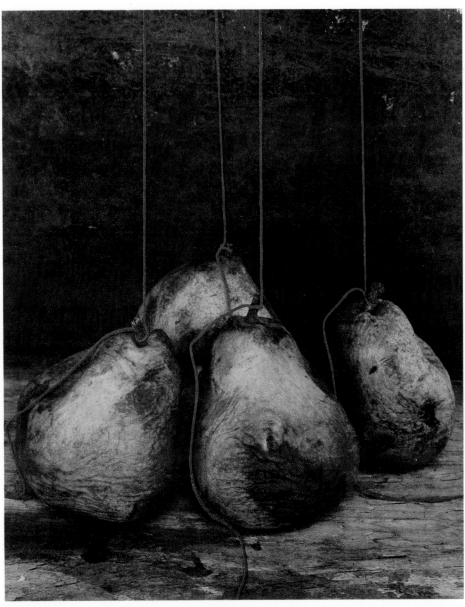

4.98 OLIVIA PARKER, *Four Pears*, 1979. Photograph.

whites, is also a hallmark of his work.

In addition to introducing armchair travelers to human and natural landscapes they had never seen, the eye of the camera has also been used to examine familiar objects in such a way that they became unexpected visual pleasures. Barrie Rokeach presents an aerial view of a marsh with a road running through it (**4.97**) as a hauntingly beautiful play of colors, very much like a nonobjective Rothko painting (1.32). Many variables can be juggled for the effect the photographer desires: lighting, type of camera and lens, point of view, exposure time, film, paper, and developing and printing options. Olivia Parker uses these options to create an unfamiliarly heightened sense of realism in her photographs of "familiar" objects. Trained as a painter, she composes her images carefully before photographing them, adding the near-fluorescent red strings to the shriveled fruits of *Four Pears* (**4.98**). Parker comments,

> Although we think of photography as more "real" than the other visual arts, it allows for transformation of objects in ways I find especially interesting. The substance of an object can be altered by removing it partway through an exposure. Light can change form and structure. Objects or figures can exist as shadows yielding only some of their information to a piece. Color can be the color of an object as we think of it, the color of light around an object or a new color caused by filtration, additional projected colored light or the peculiar way a certain film and print material see color.[5]

4.99 EDWARD WESTON, *Artichoke, Halved*, 1930. Photograph.

4.100 LOTTE JACOBI, *Photogenic #303*, not dated. Photogram, 7⅜ × 9½ins (18.7 × 24.1). The Museum of Modern Art, New York.

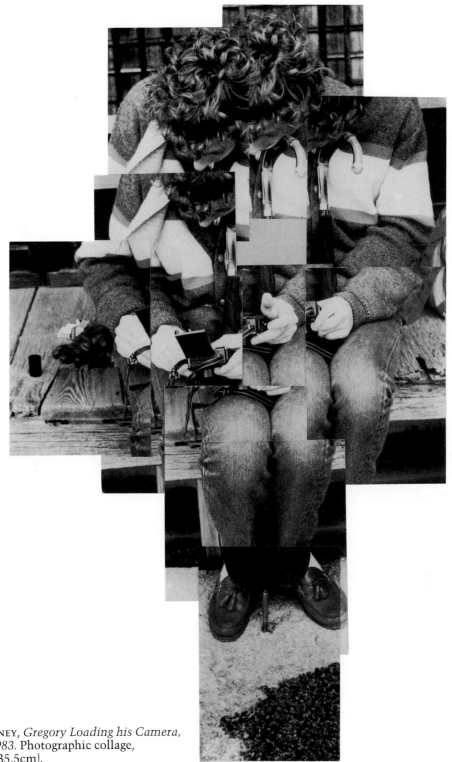

4.101 DAVID HOCKNEY, *Gregory Loading his Camera, Tokyo, February 1983*. Photographic collage, 21 × 14ins (53.3 × 35.5cm).

It is one of the wonders of photography that the camera can capture details that the eye does not perceive. Many of us have seen halved artichokes, but as photographed at close range by Edward Weston (**4.99**), this familiar object becomes a world unto itself, a sensual, evocative vision of secret recesses.

One of the most influential members of the f/64 Group, Weston used a classic large format 8 × 10 inch camera and did not enlarge his prints beyond that size, to avoid any distortion of the carefully pre-visualized image. Such photographs reveal the artist's love for the photographed object and inspire

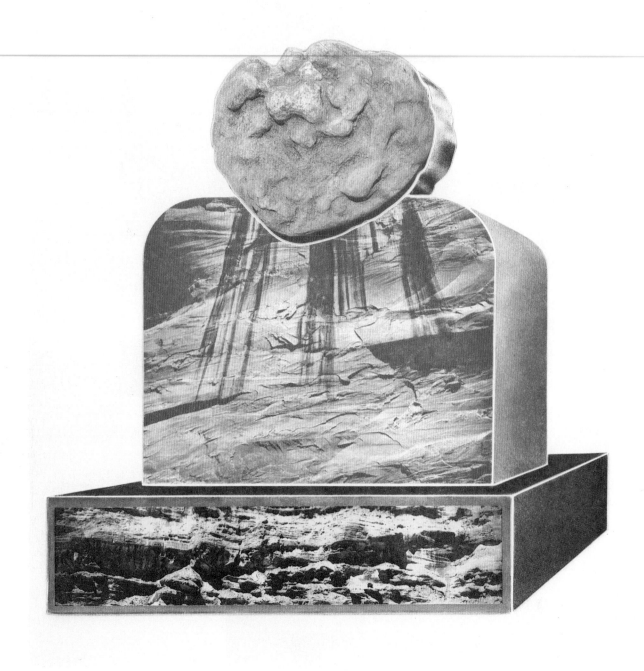

4.102 JOHN CRAIG, *Geomonument*, 1982. Photogravure etching, 26 × 22ins (66 × 65cm).

the same feeling in us.

The integrity of real objects, landscapes, and people is only one possible arena for the photograph. Film can capture effects limited only by the human imagination. In the 1950s Lotte Jacobi did a series of nonobjective works on film created in the darkroom without any camera, by using light from a flashlight masked by cellophane or paper. The effects of these "photogenics" (**4.100**) evoke associations with the unseen and mysterious rather than tangible aspects of life. David Hockney has done a series of photographic collages, in which the same image is photographed from varying perspectives and then the results cut and pasted together. The pieced images in Hockney's *Gregory Loading his Camera* (**4.101**) create a sense of process, of the event of seeing as well as of photographing unfolding through time, in a single unmoving two-dimensional framework. John Craig has combined photographic cut-outs with printmaking techniques to create the illusion of massive geological sculptures in his *Geomonument* (**4.102**).

In the midst of the exciting explorations that are stretching the boundaries of photography, some of the most elegant work being done is commissioned by businesses and research institutions. Photography is not just a fine art medium; it is also used for advertising and corporate image-building and for medical and scientific purposes, to discover how things look that cannot be seen by the human eye. In the process, images of surprising beauty are often created. Not only does the photomicrograph enlargement of computer chips for Western Electric (**4.103**) reveal the structure of the chips; it also presents them as an interesting play of lines, textures, and colors.

4.103 PHILLIP A. HARRINGTON, *Western Electric Microchip*, 1987.

MOVING MEDIA

Some of the most exciting developments in two-dimensional art are occurring in moving media—films, television, video, and computer-generated animation. All involve changes through time. Our sense of time has become far more flexible due to our familiarity with television. When viewers were first exposed to split-screen images in films—such as the simultaneous showing of a person outside a house knocking on a door and people inside the house coming to answer it—they couldn't understand what they were seeing. Now we readily grasp complex manipulations of time and space, particularly after some years of exposure to special effects.

Film

In photography a work usually consists of a single shot, but in a motion picture film a single frame is only one of a great number of consecutive shots.

Viewed individually, each is like a still photograph, as in the sequences Eadweard Muybridge shot in the nineteenth century to analyze the components of animal and human motion. To photograph the movement of a horse galloping (to answer the question of whether all four feet were ever simultaneously off the ground) or a man turning cartwheels (complete with interference from a pigeon—**4.104**), Muybridge set up a line of 12 cameras whose shutters were tripped as the subject rushed by. Putting the images side by side in a strip suggested the idea of viewing them through the whirling toy called a *zoetrope*. This was a topless drum with slits around its sides through which a series of images seemed to merge in the viewer's perception as a continuous movement. The reason for this phenomenon is the *persistence of vision*. Our perceptual apparatus retains images for about a tenth of a second after they have disappeared. In a professionally-made film, images are typically presented to us at the rate of 24 frames per second.

Once George Eastman invented flexible rolls of film, and means of projecting the images on a screen

4.104 EADWEARD MUYBRIDGE, *Headspring, a Flying Pigeon Interfering, June 26, 1885.* Victoria and Albert Museum, London.

4.105 ROBERT WIENE, *The Cabinet of Doctor Caligari*, Germany, 1919. Decla-Bioscop (Erich Pommer).

were developed, the base was laid for the use of moving pictures as an art medium: CINEMATOGRAPHY. Cinematography is broadly defined as the application of photography to moving images. As an art, it involves the technical considerations of photography—such as the control of lighting, color, camera angle, focal length, and composition for desired emotional and atmospheric effects. In addition, it involves relationships between shots and scenes, and between images and sound (which is carried on a separate track alongside the images). These choices are made by a team. In addition to the person behind the camera, the team typically includes a director, a designer, a music director, a sound mixer, and an editor.

The ability to manipulate the elements of cinematography has been used to a certain degree in all films. When these manipulations make little or no attempt at the illusion of realism, films are often termed EXPRESSIONIST. One of the most extreme examples is *The Cabinet of Dr Caligari* (**4.105**), which came out of the German Expressionist movement in the arts. Everything in the film was stylized to evoke a mood of dread, the world seen through the eyes of a madman. The sets were painted in stark black and white, with delirious diagonal lines, distorted perspectives, and strange painted shadows. The spatial wrenching was mirrored by jerky, mechanical acting, portraying

4.106 LUIS BUÑUEL and SALVADOR DALI, *Un Chien Andalou (An Andalusian Dog)*, France, 1928.

the nightmarish control of a sleepwalker's mind by the hypnotist Caligari.

The term *avant-garde* or *experimental* film has been applied to a great variety of works intended to make a philosophical or artistic statement with little regard for public taste. Some, such as *Un Chien Andalou* by Salvador Dali and Luis Buñuel, have even gone out of their way to shock. Conceived in rebellion against the art of "witty, elegant, and intellectualized Paris," as Dali wrote in his *Secret Life of Salvador Dali*, the film begins with a literal eye-opener: a close-up of a woman's eye about to be slit by a razor (**4.106**). This shot is followed by one of a cloud crossing the moon, and then a close-up of the slitting of the eye (actually that of a dead animal). It was the Russian director Sergei Eisenstein who had pioneered

this technique of MONTAGE—the splicing-together at editing stage of a variety of shots of brief duration to produce a complex visual statement. Although all the scenes in this film—which makes no visual reference to any dog—are composed of photographs of actual objects, they are as disorderly and yet as surrealistically vivid as images in dreams.

Even in more apparently realistic films, visual effects may be carefully manipulated to control the audience's response. Orson Welles's still-fresh *Citizen Kane* (**4.107**) is the portrayal of the life of a powerful press magnate. This classic work is a showcase for cameraman Gregg Toland's brilliant use of *deep focus shots* (in which the viewer's eye can travel across subjects in many different spatial planes, all in focus), symbolic camera angles (such as the tilting of

the image shown here to suggest the distorted nature of the politics in the film), *wide angle shots* that make people standing near each other seem widely separated in space, and expressionistic use of dark and light values.

In *Rashomon* (**4.108**), the famous Japanese director Akira Kurosawa's training as a painter is evident in the careful compositions of figures and the elegance with which the camera lingers over lights, shadows, textures, and visual rhythms. As in *Citizen Kane*, the enigmatic narrative proceeds by *flashbacks* to previous events, as four characters each retell the story of a woman's rape and her husband's murder in a different way, leaving the audience to draw their own conclusions.

The ability to manipulate what the viewer sees—and knows—has often been used to create sensations of suspense or surprise. Alfred Hitchcock, director and producer of thrillers such as *North by Northwest* (**4.109**), observed that to build suspense one doesn't show the bomb exploding; rather, one shows the bomb ticking below the table and the people eating above it, unawares. Hitchcock's incite-

4.107 ORSON WELLES, *Citizen Kane*, USA, 1941. RKO Pictures.

4.108 AKIRA KUROSAWA, *Rashomon*, Japan, 1951. Daiei.

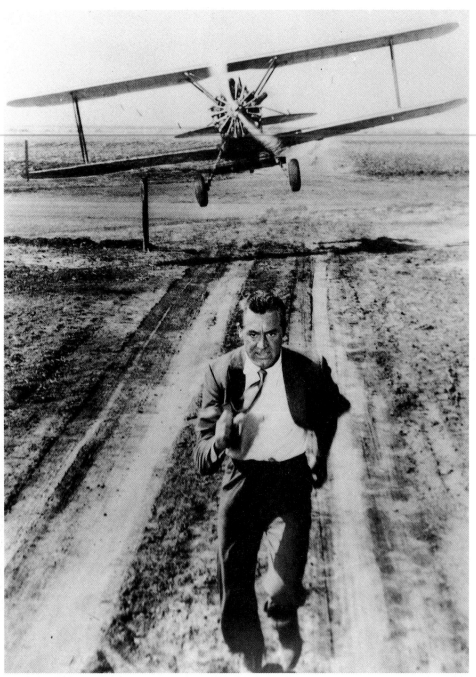

ment of tension often has a sly, knowing humour behind it. In the famous scene shown here, Cary Grant, mistaken for a spy by an enemy espionage group, is being chased across a field by a lethal crop-duster. The horror of the chase is entirely invented: It was filmed with the seemingly terrified Grant running on a sound-stage with most of the scene—including the airplane—projected from the rear onto a transparent screen behind him.

Another general approach to filmmaking is the *documentary*—a true-to-life depiction of real people, rather than actors, living their own true lives, without an imposed story line or fake shots. To create the beautiful 1922 film *Nanook of the North* (**4.110**), filmmaker Robert Flaherty lived with the vanishing native people of northern Canada for 16 months. He shared the hardships of their lives in order to record their everyday activities within a harsh natural environment. The vast arctic whiteness was a constant backdrop for the naturally unfolding narrative.

4.110 ROBERT FLAHERTY, *Nanook of the North*, USA, 1921. Revillon Frères. The Museum of Modern Art, New York, Film Stills Archive.

4.111 ANDREI TARKOVSKY, *Nostalgia*, Italy, 1982. Opera Film/Sovin Film/RAI.

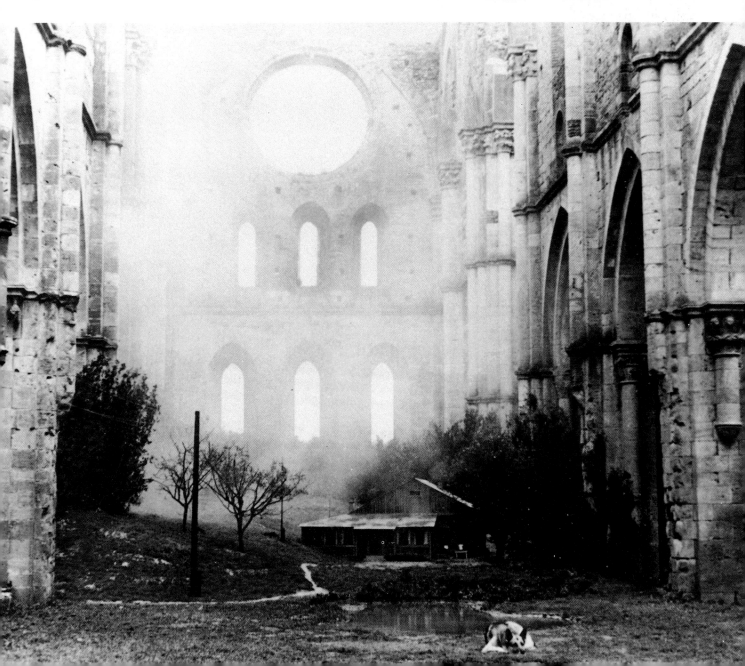

Finally, there is the film as a poetic image, mysterious and beautiful. The Russian filmmaker Andrei Tarkovsky's films, such as *Nostalgia* (**4.111**), have this quality. Tarkovsky spoke of the difficulty of staying true to the beauty of one's original inspiration when confronted by technical problems and the continual distractions of coordinating the efforts of so many people. He did not rely on editing to fix things; he specialized in *extended takes*, often incorporating entire 12-minute cans of film in the finished work. He did edit and join segments, but with keen awareness of the effect of editing on the viewer's sense of time in what is essentially a time-based art. He referred to filmmaking as "sculpting in time."

Television and video

Television—a staple of the modern age—includes both live broadcasts and playbacks of videotaped sequences. In *live television*, VIDEO (visual) and audio signals are broadcast and read as images and sound on television sets far removed from the transmitter. There is little or no editing. In general, what the camera is recording at the time is what the viewers see. This immediacy can bring the emotional impact of distant events—such as the South Vietnamese Police Chief executing a Vietcong officer (**4.112**)—right into our homes.

Television camera lenses relay the amounts of

4.112 EDDIE MOORE, *Execution of a Vietcong Officer by the South Vietnamese National Police Chief in Saigon*, 1968.

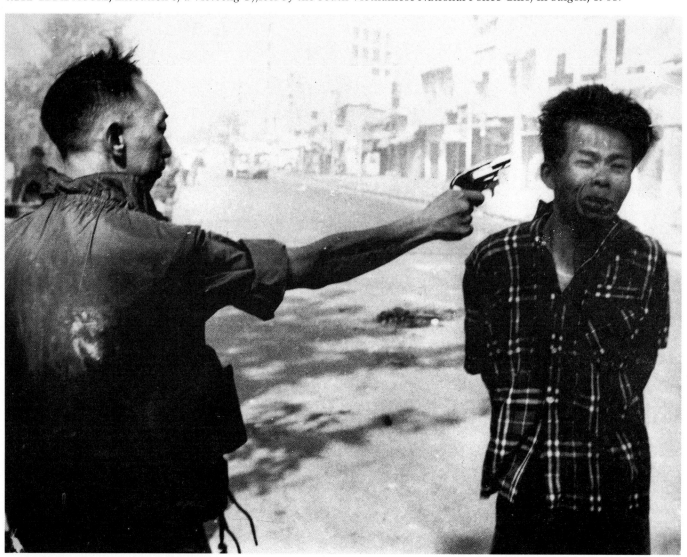

4.113 MGM RECORDS, Richie Havens performing *Here Comes the Sun*, c.1971. Televised music video.

light in a scene to a tube that translates light into electric signals. An electron scanner reads the hundreds of lines of signals so rapidly that the entire image is completely read 30 times a second. These signals, along with audio signals, are transmitted through the air by electromagnetic waves or carried by cables to television sets, where the signals are translated into the original pattern of light and sound. The persistence of human vision makes the separately transmitted signals seem to blend into continuous images.

Television signals can also be recorded on magnetic tapes, which can then be read by video and audio

heads in a receiving device. Because a permanent recording is made, it can be manipulated electronically for special effects before it is shown. Some of the most innovative video effects are being created for music videos broadcast over special music video cable television channels. Images captured by a video camera can be computer-analyzed, broken down into their components, and then visually altered in an ever-expanding variety of ways (**4.113**).

Since the 1960s, artists have also been experimenting with video as an expressive art form. Video art is collected and shown by museums, aired in performance spaces, and sometimes broadcast over

4.114 NAM JUNE PAIK, *Charlotte Moorman TV Bra for Living Sculpture*, 1969. TV sets and cello. Photo Peter Moore © 1969.

television channels. The video art of Nam June Paik makes explicit references to the medium of television, such as this shot (**4.114**) in which Charlotte Moorman wears a "bra" made of two miniature television screens whose images change in response to her cello-playing. Those who are accustomed to the rapid pace of commercial television may find some art video sequences monotonous; their appreciation requires a more flexible sense of time.

Computer video graphics

Lively experimentation is also underway in the field of computer-generated video graphics—technically known as VIDEO RASTER GRAPHICS—in which images can be generated and transformed by computer. The creators of such imagery must be computer specialists as well as artists, painting with light. Drawing on tools such as *digitizing tablets* with an electronic

4.115 WALT DISNEY PRODUCTIONS, *Tron*, 1982.

stylus, they create lines that are converted into PIXELS (mathematical points on the *x* and *y* axes of the screen, a modern equivalent of mosaic tiles). The delineated images can be electronically colored in, reduced, enlarged, rotated through space, and "photographed" from differing focal lengths, all at great speed. These capabilities lend themselves to animation effects. The first feature-length movie incorporating computer-generated animation was *Tron* (**4.115**). The rapidity of computer calculations enabled the designers not only to design fantasy machines, but also to show them in realistic and continually shifting linear perspective as "light cycles" zoomed through illusionary space.

The same technologies are increasingly used to enhance the visual excitement of television commercials. Computer graphics have also been used to create animated representations of forms in our natural world that no one has yet seen, but that can be deduced from scientific data. These are primarily created for scientific study, but some are aesthetically exciting as well. Melvin L. Prueitt, of the Los Alamos National Laboratory, where this kind of computer imagery is generated, speaks of the beauty of the unseen world:

The universe is filled with beauty, most of it unseen and unsensed. What does an intense magnetic field look like as it churns and bubbles near a neutron star? . . . The narrow spectrum of our vision, our hearing, designed to detect the coordinated motions of molecules under restricted conditions, our sense of smell allowing us to detect only a few chemical compounds in the gaseous state, and our short-range sense of touch give us only a partial view of all there is. . . . Although science discovered myriad strange phenomena, we could not see them. . . . By computer graphics we begin to see what we had suspected for some time: that the foundations of the universe are filled with niches of loveliness.[6]

As the new field of video raster graphics grows, designers are also creating dynamic invented forms that tell their own visual stories of change through time and space, from varying "camera angles." They can be programmed for credible if unfamiliar "growth" and movements, such as the seemingly three-dimensional forms based on fractal geometry (**4.117**) by Alan Norton, who is a mathematician, computer scientist, and artist. Computer paintings such as David Em's *Zotz'* (**4.116**) use the power of the computer to manipulate colors, textures, and forms to create images that are totally unconstrained by the laws of the known physical universe.

As engineers discover the beauties of unseen or

295

4.116 DAVID EM, *Zotz'*, 1985. Computer graphic.

4.117 ALAN NORTON, *Computer-Generated Fractal Three-Dimensional Image*, 1985. Computer graphic.

invented forms based on mathematical formulae, new questions arise: Is this a new art form that does not require artistic sensibilities? Will the ease of creating symmetrical, brightly colored images by computer, increasingly used to enliven television commercials, change public tastes in art? Will we witness the same kind of shift in aesthetics as occurred when the van Eycks popularized oil paint? The field is too new for sure prophecies, but the mere fact that such questions can be asked is an indication of the potentially revolutionary nature of this new medium.

CHAPTER FIVE
THREE-DIMENSIONAL MEDIA AND METHODS

In our daily lives we are surrounded by works of three-dimensional art. Our clothes, buildings, gardens, cars, and functional objects all bear the designer's stamp, with varying artistic success, as do sculptural works whose main purpose is the aesthetic experience.

The three-dimensional media are not isolated on our walls and television screens. Instead, they exist in our three-dimensional world either as art objects or as our very surroundings. Our exploration of three-dimensional art begins with the fine art of sculpture and then surveys the many applied three-dimensional arts: crafts, industrial design, clothing design, architecture, interior design, environmental design, and designs for the performing arts. These applied disciplines are increasingly the province of designers trained in aesthetics as well as functionality, bringing exciting visual stimulation to contemporary life.

SCULPTURE

There are four traditional ways of creating sculptures: carving hard materials, modeling soft materials, casting molten materials that will harden, and assembling materials that can be joined. Two other methods that fall somewhat outside these categories are shaping the earth into environmental works and creating sculptures that move through time and space.

Carving

In the SUBTRACTIVE process of carving, the sculptor cuts away material from an existing piece of some hard material, such as wood, stone, or ivory. Often the original form of the material is totally altered in the process, but in the thirteenth-century carved wood figure of a saint (**5.1**), the base of the log that originally surrounded the form is still visible at the foot of the piece. Tools from hammer and chisel to chainsaw can be used to "liberate" the form conceived in the block. Sculptors may begin with drawings and a small clay model, or MAQUETTE, of the intended work but continually take clues from the wood itself as the form emerges. Wood is a highly personal medium, warm and organic to the touch, rhythmic in its unfolding growth patterns, and requiring respect for the natural direction of its grain. If wood is protected from weathering and insects, it can be very long-lived. Beautifully carved wood reliefs

5.1 GERMAN RHENISH SCHOOL, *St James the Less*, 1260–80. Walnut or fruitwood, 77ins (196cm) high. The Metropolitan Museum of Art, New York, Fletcher Fund, 1928.

over 4000 years old survive from ancient Egypt.

In the subtractive process of carving away, taking away too much is disastrous. To keep track of where they are in the block, sculptors may draw the outline of the intended piece on it and first remove any excess material that clearly lies outside of the outline, perhaps with a hand saw. A medium-sized gouge struck by a mallet may then be used to start working in toward the final form, with the block held in a vise. After this *roughing out* process approximates the desired final form, smaller gouges may be used to create fine details. For the finest of these, the gouge may be hand-driven rather than struck with a mallet. This is done across the grain in shallow strokes to avoid lifting fibers of areas that are to remain positive in the final piece. The sculptor continually reads and works the piece in the round, often referring to elevations previously drawn of the desired appearance from many sides. Finer details are often sketched on the wood itself as the form emerges. A number of tools are used to give the piece a smooth finish, including a scraper with a beveled cutting edge that is drawn across the surface. It shaves off a thin layer of wood, clears the pores of the wood, reveals the grain, and compresses the fibers to make the surface glossy. If desired, the gloss is enhanced with a wax polish.

Although stone offers much more resistance to the sculptor's chisel than does wood, its permanence, colors, and textures have long been prized for creating subtractive sculptures. Sometimes the original surface texture of the stone is retained. The twentieth-century *Head of a Woman* by Modigliani (**5.2**) is carved directly into a limestone block, celebrating its stony texture with a deliberately "primitive" technique. Some traditional marble sculptures have been carved mechanically, often by hired artisans, by transferring measurements from a maquette to a block of stone, but such a process is not responsive to the uniqueness of the individual block. The sculptor may live with a block of stone for a long time, allowing it to "speak" its own nature before approaching it with a preconceived image.

This respect for the stone may be evident even in sculptures carved and polished to resemble non-stone textures, such as the soft flesh of the *Venus de Milo* (2.73). All kinds of stone—from the roughest

5.2 AMEDEO MODIGLIANI, *Head of a Woman*, c.1910. Limestone, 25¾ins (65.4cm) high. The National Gallery of Art, Washington D.C., Chester Dale Collection.

limestone to the finest marble—can be polished to a high sheen, enhancing the stone's color, sealing the surface, and erasing the tool marks. After the lengthy process of carving the form, polishing the surface

5.3 AHMAD SHAH, Carving on the Friday Mosque, Ahmadabad, India, 1411–42.

entails another series of steps. These may include smoothing with a flat chisel, filing remaining rough areas with a file or carborundum stone, sanding with wet sandpaper or an abrasive sanding screen, and rubbing with a polishing agent that seals the surface and makes it glisten. As these steps are taken, previously hidden colors and deeper tones will often appear, but so also may weaknesses in the design, requiring some reshaping of the piece.

A slow and patient art, stone carving is sometimes made even more time-consuming by ornateness of design, such as the elaborate window traceries in the Friday Mosque (**5.3**). The Chinese vase of jade (**5.4**) is painstakingly carved from a single block of the extremely hard semi-precious stone. Jade is so hard and brittle that artists may grind it with a power diamond-tipped bur rather than cut it with hammered chisels, claws, points, and files.

Modeling

At the other extreme from carving hard stone is MODELING—the hand-shaping of soft, malleable materials. Some are so soft, in fact, that they cannot support their own weight and must be built over an ARMATURE, a simple skeleton of harder material, such as wood or wire. *Plaster* is typically built up over an armature by strips of fabric that have been dipped in wet plaster of Paris. The final layer is plaster alone, spread over dampened underlying layers with the hands or hand tools such as knife or spatula. Details —such as the modeling of the hair on Houdon's *Bust of a Young Girl* (**5.5**)—are then worked with a blade.

The use of *clay*—a fine-grained natural deposit— as a modeling medium was common in many ancient civilizations. Worked moist, it can be used to create quite fine details and then be fired to a hard, permanent state. It has more structural integrity than wet plaster, so it will hold slight projections, such as the petals of Robert Arneson's leathery parody of the soft

5.4 Magnolia vase, c.1900. Jadeite, 10½ins (27cm) high.

5.5 JEAN-ANTOINE HOUDON, *Bust of a Young Girl*, c.1779–80. Plaster, 19½ins (49.5cm) high. The Metropolitan Museum of Art, New York, Bequest of Bertha H. Busell, 1941.

5.7 EDGAR DEGAS, *Horse Galloping on Right Foot*, c.1881. Bronze cast of wax model, 11⅞ins (30cm) high. The Metropolitan Museum of Art, New York, Bequest of Mrs H. O. Havemeyer, 1929.

fineness we associate with roses (**5.6**).

Wax is very easily shaped and reshaped when warm. It was used by the ancient Greeks for toy dolls and small religious statues and by the Romans to make death masks. But wax is vulnerable to melting when the weather is hot. It is therefore more often used to capture the fresh immediacy of hand-shaping and then cast in some more permanent material, such as the bronze cast of Degas's wax model of a galloping horse (**5.7**). The dabs of wax Degas pressed on to build up the form are clearly preserved in the cast.

5.6 ROBERT ARNESON, *Rose*, 1966. Ceramic, 19½ × 12ins (49.5 × 30.5cm).

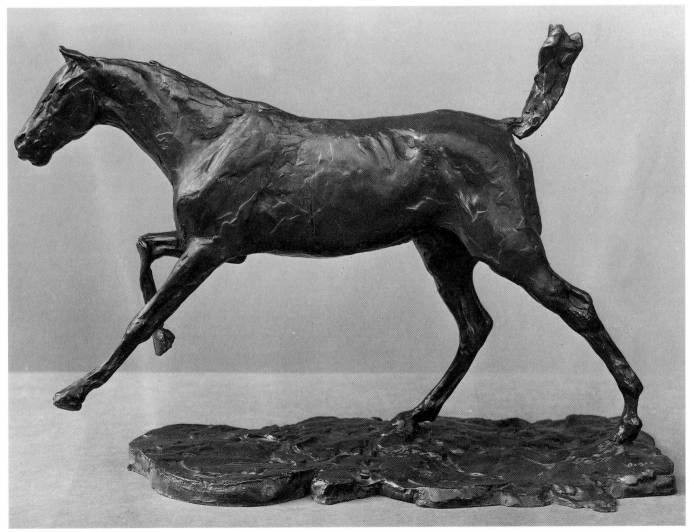

5.7

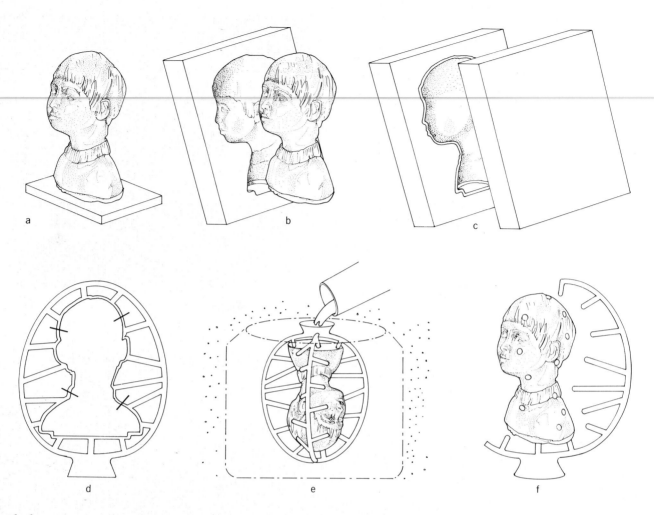

5.8 The lost-wax casting process.

Casting

In CASTING, easily-shaped materials are used to create a negative mold into which a molten material such as bronze or plastic is poured and then allowed to harden. When the mold is removed, anything that was concave in the mold is convex in the cast form, and vice versa. If the mold is salvageable, multiple copies can be made of the same form.

This process, for which the Bronze Age was named, was refined by the ancient Greeks. They developed the LOST-WAX process illustrated in Figure **5.8**, which is still in use at contemporary foundries. A positive model (a) is used to make a negative mold (b), which is then coated with wax (c). The wax shell is filled with a core of some material such as plaster or clay (d). The

mold is removed and metal rods are driven through the wax into the clay to hold the layers in place, as shown in Figure **5.9**. Wax vents that will allow the metal to be poured in and the gases to escape are fitted around the piece. This assembly is then coated with plaster—called the INVESTMENT—and buried in sand (e). The investment and sand are unharmed when this assembly is heated, but the wax melts. It is drained off, leaving an opening between the core and the investment that is filled with molten bronze. When it has hardened, the extraneous investment, tubes, and core are removed (f) and the halves of the cast are reassembled. What remains is a perfect hollow replica in bronze of the original pattern. Solid casting of large pieces does not work well, and hollowness economizes on bronze and weight. Even cast hollow,

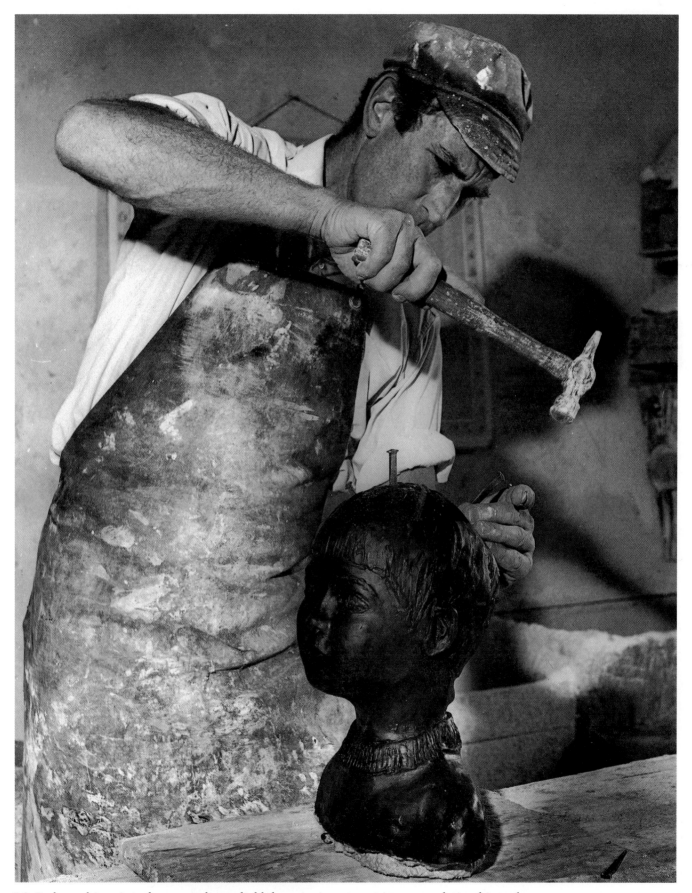

5.9 Rods are driven into the wax replica to hold the outer investment in proper relationship to the core.

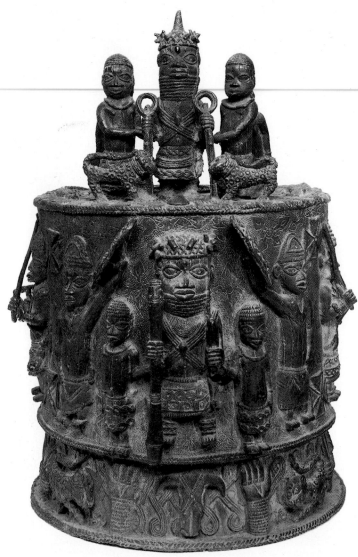

5.10 Altar of the Hand, Benin, Nigeria, 1550–1680. Bronze, 17½ins (44.4cm) high. The British Museum, London.

bronze is quite strong enough to support the open, extended forms of arms and legs.

Despite their complexity, casting processes are capable of reproducing very fine details. In the fifteenth- to eighteenth-century kingdom of Benin in western Africa, intricate bronze castings such as the *Altar of the Hand* (**5.10**), which celebrated the divine king (the figure whose large head symbolizes his intelligence and power), were made by highly skilled members of a respected professional guild under the direction of the king. While the Altar of the Hand is quite stylized, casts are also capable of reproducing

very naturalistic detail, such as the anatomical and psychological accuracy of the Greco-Roman *Seated Boxer* (**5.11**). His musculature is superbly defined, and yet this is not an heroic, idealized portraiture. In the boxer's hunched, tired posture, broken nose, scarred body, and sidelong glance we can read a very human story, perhaps involving exhaustion, defeat, battered pride, or introspection about the emptiness of victory.

Assembling

Another approach to sculpture is to fashion or collect pieces of varying materials and then somehow attach

5.11 APOLLONIUS, *Seated Boxer*, c.50 BC. Bronze, 50ins (127cm) high. Museo Nazionale Romano, Rome.

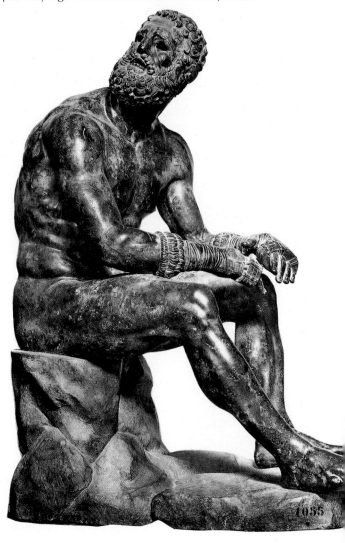

them to each other to form an aesthetically unified whole. Some works are assembled from FOUND OBJECTS, such as the book, pins, razor blade, scissors, table knife, foil, glass, and plastic rod in Lucas Samaras's *Book 4* (2.66). The reliquary figure from Gabon (5.13), which was placed atop bones from a family's most celebrated ancestors, combines carved wooden legs, worked metal upper body and head, and what appear to be ivory eyes. The piece is unified visually by making the metal part the focal point. Our attention is drawn not so much by the variations in materials but by the variations in the ways the metal has been worked.

Louise Nevelson assembles large frontal sculptures of bits of turned wood, encased in a series of boxes. In her *Black Crescent* (5.12), fragments are unified visually by the repetition of the box forms and the uniform black paint. Within this coherent framework, we are invited to explore the differences in form between the wood turnings and the varying ways they relate to each other.

In addition to unifying an assembled work visually,

5.13 Reliquary figure of the Kota tribe, Gabon. Wood, brass, and ivory, 16⅝ins (42.2cm) high. The Metropolitan Museum of Art, New York, The Michael C. Rockefeller Collection of Primitive Art, Gift of Nelson A. Rockefeller, 1979.

5.12 LOUISE NEVELSON, *Black Crescent*, 1971. Black painted wood, 48 boxes, 133½ × 86 × 11ins (339 × 218 × 27.9cm), base 12ins (30.5cm) high. The Metropolitan Museum of Art, New York, Gift of Albert and Vera List, 1972.

5.14 WILLIAM KING, *Collegium*, 1984. Cast and plate aluminum, 32ft (8.1m) high. Installation at the University of Houston, Texas, 1984.

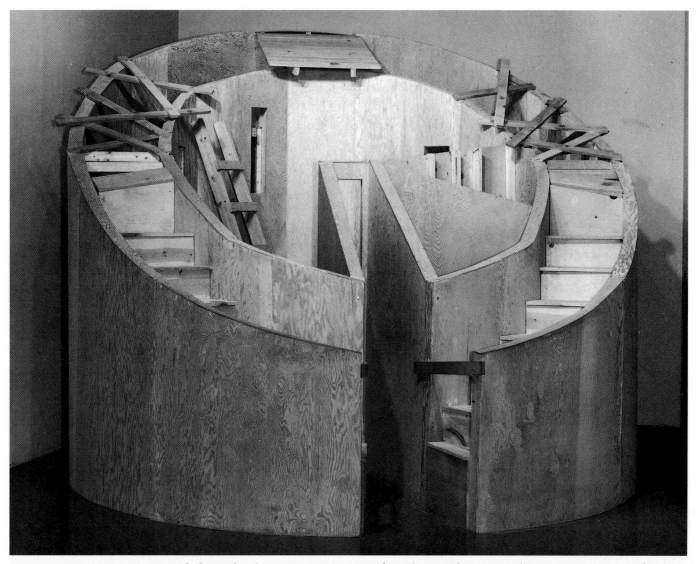

5.15 ALICE AYCOCK, *Project Entitled "Studies for a Town"*, 1977. Wood, 119½ × 139¾ × 145ins (304 × 350 × 369cm). The Museum of Modern Art, New York, Gift of the Louis and Bessie Adler Foundation Inc.

the artist must deal with the mechanical problems of physically joining the pieces so that they will not fall apart. Metal may be welded or bolted; a wooden piece may be held together with glue, nails, and screws. Nevelson has chosen to hide these joining techniques, whereas William King openly reveals the bolts uniting the sheets of aluminum in *Collegium* (**5.14**). In fact, the bolt heads are presented as part of the design interest in these tall-walking college figures.

When an assembled piece seems to lack structural or aesthetic unity, the effect may be intentional. The emotional focus of Alice Aycock's work is often

a feeling of frustration and rejection. Her *Project Entitled "Studies for a Town"* (**5.15**) offers steps that are barred, a narrow hall that leads only to a wall, a ladder that would carry one only to an empty space, narrow windows too high to see through, a platform that cannot be reached from anywhere. In this incomplete town there is no shelter. The barriers are obviously the work of human hands, for boards are visibly nailed askew over every possible point of entry—or escape. The effect is psychologically evocative, turning rejected viewers inward to question whether this abortive architecture reflects how life feels to them, and why.

Earthworks

Rather than sculpting materials taken from the earth, some artists have used the earth's surface itself as their medium. Their tools become those of the earthmover, from shovels to bulldozers, perhaps with the addition of structurally reinforcing materials, such as the concrete framing Michael Heizer used to strengthen the earth mound of his *City Complex One* (2.25). Often these earth sculptures are artistic ends in themselves, but in some cases they serve an ecological as well as aesthetic function. Robert Morris's *Earthwork at Johnson Pit #30* (**5.16**) outside Seattle is a land reclamation project in which an abandoned gravel pit has been recontoured both to create visually interesting lines and to impede erosion.

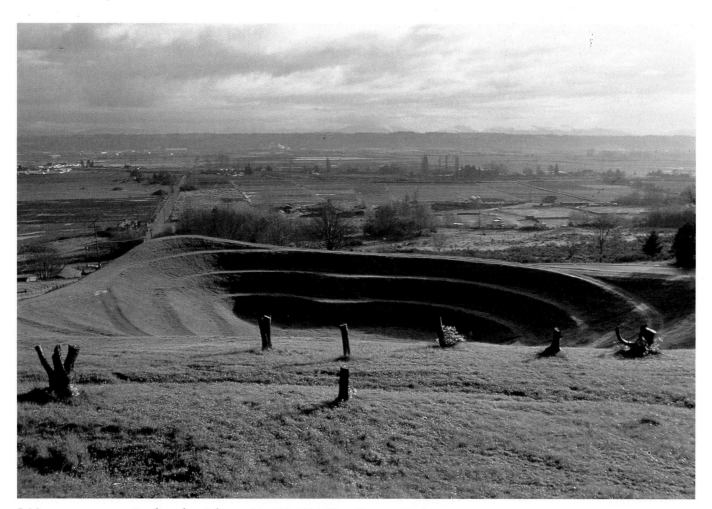

5.16 ROBERT MORRIS, *Earthwork at Johnson Pit #30*, 1984. King County, Washington.

5.17 JEAN TINGUELY, *Meta-Matic No. 9*, 1959. Motorized kinetic sculpture, 35½ins (90.1cm) high. The Museum of Fine Arts, Houston, Texas, Purchased from funds by Dominique and John de Mevil.

Kinetic sculpture

Anything that will move can be used to create KINETIC sculpture. Kinetic sculpture is not a basic technique, in the same sense that carving, modeling, casting, and assembling are sculptural techniques. But the requirements of making something movable warrant separate consideration. Pieces may have wind-up devices, motors, or be designed to use natural energies. Alexander Calder harnessed the energy of air currents or viewers' hands to propel his mobiles, such as *Lobster Trap and Fish Tail* (2.131). In the age of the mechanical contraption, the Swiss-born artist Jean Tinguely has invented absurd machines to perform artlike activities. The motor-driven arms of *Meta-Matic No. 9* (**5.17**) clamor like a kitchen appliance as they draw a small picture with colored pens. The product of this playful rattling busyness is a random drawing whose expressionistic quality is reflected in the form of the machine itself.

CRAFTS

The appreciation of fine handmade objects is undergoing a rapid renaissance today. This trend may be a reaction to our highly industrialized surroundings, a reassertion of the value of what is made by human hands. Many craftspeople make no attempt to hide their tracks, for the sense of the individual at work may be more highly prized than machinelike perfection and sameness. Even though some craft objects are created in multiples on a semi-production basis, they may still reflect the human touch.

In general, crafts also tend to celebrate the materials from which they are made. One senses that the wood, clay, or fiber has been chosen and worked lovingly. This appreciation for natural colors and textures is contagious. To fill one's home with handcrafted functional items is to turn everyday activities—such as eating and storing food—into sensual experiences of beauty. We feel that these objects have been made slowly, with care, and they can evoke the same unhurried appreciation in us.

The major craft media are clay, metal, wood, glass, and fibers. All have been in use since antiquity, and many of the traditional methods are still employed. At the same time, many craft artists are experimenting with new techniques, materials, and approaches, sometimes to the point of using craft techniques to create nonfunctional works of art.

Clay

The ancient craft of making objects from clay is called CERAMICS. Clays are found across the globe, but only those clays that are easily shaped and capable of being hardened by heat without cracking or warping are suitable for ceramics. Sometimes several different kinds of clay are mixed to form a *clay body* that has a combination of desirable properties. The most common clay bodies are EARTHENWARE (porous clays such as terra cotta), STONEWARE (clays that become impermeable when fired at high temperatures), and PORCELAIN (a very smooth-textured clay, translucent when fired, and with an extremely smooth, glossy surface).

Clay can be worked by freeform hand modeling, as in pinching a small pot out of a lump of clay. Three traditional methods of building up clay into larger walled vessels have been in use for thousands of years. SLAB BUILDING (**5.18**), used for straightsided pieces, involves rolling out flat sheets of clay for sides and bottom. The joints are sealed with a rope of clay or with *slip*, a slurry of clay and water.

In COIL BUILDING (**5.19**), the potter rolls out ropes of clay and curls them in spiraling layers on top of a base, welding the bottom layer to the base and joining the coils to each other. Scraping and patting of the outside may be used to obliterate the in-and-out coil structure. To build up a tall pot, the lower area must be allowed to dry and harden somewhat so that it will support the upper layers. For a narrow-necked piece, the upper layers are gradually diminished and then perhaps pulled out again. The potter must work all around the piece if it is to be uniformly rounded, so it may be placed on a hand-turned base.

The American Indians, who used the coil method or molds for their pottery, were one of the few pottery-making peoples not to use the third major method: WHEEL-THROWING (**5.20**). The potter's wheel, found in the ruins of ancient Greece, China, and other early civilizations, is a flat disk attached by a shaft to a large flywheel. This lower wheel is kicked by the potter or driven by a motor to make the upper wheel turn. The continual turning of the wheel allows the potter to literally pull the pot upward, symmetrically. After *wedging* (repeatedly slamming

5.18 Slab building.

5.19 Coil building.

5.20 Wheel-throwing.

the clay onto a hard surface, cutting and folding it, and throwing it again, to remove air pockets and create an even consistency), the clay is centered on the wheel with the hands while the wheel is being rapidly turned. Working with both moistened hands, the potter then shapes the inside and outside of the pot at the same time by finger pressure applied in just the right places as the wheel is rotating. For a symmetrical form with walls of even thickness, the potter's hands must be disciplined to apply perfectly even pressure. After any of these building techniques —slab, coil, or wheel-throwing—the pot is typically GLAZED (painted with a material that turns glassy when heated) and FIRED (baked in a kiln or an open fire) for permanence and water resistance.

Facility with such techniques allowed ancient artisans to create vessels that were as beautiful as they were functional. The elegantly proportioned wheel-thrown amphora from Athens (**5.21**) is of the type used to hold the prize of sacred olive oil for the winners of the Panathenic festivals. The foot runners, whose lines carry the eye around the width of the jar, were painted in black and white onto a ground of slip which turned red-orange when fired.

Some contemporary potters have eschewed elaborate ornamentation to bring out the beauty of the

natural clays and earth-toned glazes. Karen Karnes' pots (**5.22**) are noted for their simple strength of form and the subtle glazes that emphasize rather than hide the grainy texture of the stoneware.

Another contemporary direction is the use of ceramic techniques for artistic expression rather than the creation of functional pieces. Richard and Sandra Farrell's porcelain plates with abstract, painterly glazes (**5.23**) could be used as dinnerware, but it is more likely that they will usually be kept hanging on their fabric panel as handsome works of art.

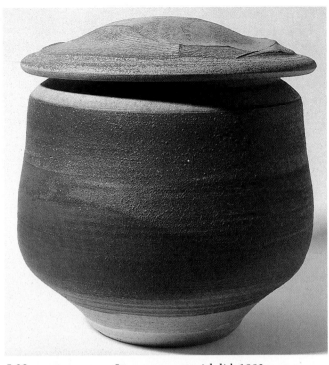

5.21 Attributed to EUPHILETOS painter, Black-figured prize amphora, Athens, c.530 BC. 24½ins (62.2cm) high. The Metropolitan Museum of Art, New York, Rogers Fund, 1914.

5.22 KAREN KARNES, Stoneware pot with lid, 1982.

5.23 RICHARD and SANDRA FARRELL, Three plates, 1982. Porcelain, glaze overlay, each 11ins (27.9cm) square.

Metal

Like clays, many metals are quite amenable to being shaped. Those used for handcrafted objects have included copper, brass, nickel, pewter, iron, and the precious metals gold, silver, and platinum. They vary in MALLEABILITY (the capacity for being shaped by physical pressure, such as hammering), DUCTILITY (the ability to be drawn out into wire), and hardness. Gold is the most ductile and malleable and is of course prized for its untarnishing color and luster. It is often drawn into wires and shaped into jewelry;

Benvenuto Cellini's masterpiece, the saltcellar for Francis I (1.46), is made of gold and further ornamented with ENAMEL, a glasslike, jewel-toned coating that can be fused to metal by heating.

At the opposite extreme, iron and steel (an alloy of iron and other materials) are the hardest of the common metals and among the least malleable. But they are somewhat ductile and when heated are malleable enough to be FORGED (hammered over an anvil), stretched, and twisted into forms such as Joseph Brandom's kitchen utensils and rack (5.24). These combine the sought-after feeling of old-fashioned

5.24 JOSEPH L. BRANDOM, Utensils and Rack, 1982. Stainless steel, rack 39ins (99cm) long.

POUSSÉ (hammering punches against a sheet of metal from the back to create a low-relief pattern). Individually worked pieces of iron can be riveted, screwed, bolted, brazed, or torch welded together, but purists prefer the traditional hammered weld, with pieces heated to the point that they will fuse.

Metal can even be coaxed into hollow vessel forms by *raising* (hammering a flat sheet over a stake to raise the sides and work them inward). Douglas Steakley's raised copper vessels (**5.26**) have been purposely textured with marks of punch and hammer to accentuate their handcrafted appearance and add subtle textural interest to their asymmetrically curving surfaces.

5.25 SZABÓ, Clock, c.1924. Wrought iron.

5.26 DOUGLAS STEAKLEY, Raised vessels. Copper, left 8ins (20cm) high, right 5ins (13cm) high.

blacksmithing technology with a light, clean contemporary design. Note that some of the hammering marks are retained, for the desired handcrafted appearance. If a metalsmith chooses to erase all hammer marks, bulges, and wrinkles from a piece, it can be PLANISHED smooth with a flattening hammer. As metal is worked, it may also need to be continually ANNEALED, or heated to make it more malleable, because many metals harden when they are hammered.

Iron that is worked in a heated state with hand tools is called WROUGHT IRON, in contrast to *cast iron*, in which molten iron is poured into molds. Szabó's extraordinarily crafted wrought iron clock (**5.25**)—a product of the early twentieth-century rebirth of art metalwork in France—achieves the delicate filigree usually seen only in jewelry fashioned from fine wires. Such decorative details may be created by drawing out, hammering over varied forming stakes, punching, splitting, bending, incising, or RE-

5.27 "Sea Dog" table, mid 16th century, based on designs by JEAN JACQUES DU CERCEAU. Walnut. Hardwick Hall, Derbyshire.

Wood

Because trees grow in most parts of the world, and because wood is sturdy and fairly easily shaped by saw, chisel, lathe, file, and sanding devices, it has been pressed into service by artisans of most cultures. Its warmth to the touch, smoothness when sanded and polished, rich natural colors, and lively growth patterns give it a highly sensual appeal. It has been used to fashion everything from picture frames and furniture to kitchen utensils, toys, and musical instruments. Many handcrafted wooden objects are now valued as collectors' items, from jewelry boxes with ebony inlays to folk art pieces made of soft woods such as pine and spruce. These soft woods are not necessarily the easiest to work, for they may

splinter. Medium-hard woods include birch, butter-nut, cherry, pear, and apple; the durable, fine-grained hardwoods include walnut, oak, maple, hickory, teak, ebony, and rosewood.

Wood can be worked into extremely ornate forms, such as the sixteenth-century walnut "sea dog" table (**5.27**) in the Withdrawing Room of Hardwick Hall in England. It may have been a royal gift to Hardwick Hall's original owner, Elizabeth, Countess of Shrewsbury. This extreme elaboration of a table's function is based on the designs of Jean Jacques Androuet Du Cerceau, French designer of architecture and fantastic ornamentation.

Some contemporary crafters of wood take a much simpler approach to the medium, allowing it to express the more natural linear qualities of trunk and

branch. The large refectory table (**5.29**) designed by Fred Baier and Chris Rose for limited production by Professional Woodworkers has the lithe grace of a bridge. The curve of the oak slab transforms its heaviness into a dynamic lightness, accentuated by the growing and diminishing lengths of the many cross-members. Although trees grow in relatively straight lines, their wood can be bent into curves when steamed, as in the slab here and the bentwood Thonet chair shown earlier (2.15).

Those who use milled lumber—such as the uniform boards and poles from which the refectory table is built—typically look for clear wood, with no cracks or knots where branches grew out of the main trunk. But some woodworkers purposely seek out and emphasize "defects" in wood for their design interest. BURLS—woody hemispherical knobs that grow on the trunks of certain trees—have curling linear patterns that are often used to advantage in VENEERS (thin overlays of fine woods placed over other woods) and in handcrafted bowls. The art of Mark Lindquist's wood bowl (**5.28**) is less a matter of imposing a design on it than of careful selection of the burl and respectful minimal working to bring out the natural beauty of its sinuous curves.

5.28 MARK LINDQUIST, *Toutes Uncommon Bowl*, 1980. Spalted yellow birch burl, 32ins (81.2cm) long. Collection: Duncan and Mary McGowan.

5.29 FRED BAIER and CHRIS ROSE, Refectory Table, 1985. Oak, 276ins (700cm) long. Professional Woodworkers Ltd., U.K.

5.30 HARVEY LITTLETON, Vase, 1963. Hand blown clear glass, 9¾ × 7½ × 4⅞ins (24.8 × 19 × 12.4cm). The Museum of Modern Art, New York, Greta Daniel Design Fund.

Glass

For all its fragile transparent beauty, glass is made by the surprisingly simple process of melting sand with lime and soda. The technique has been in use for at least 3500 years for creating luxury versions of everyday functional objects.

One of the most common ways of making glass vessels is to scoop up a glob of molten glass with a long metal blowpipe and blow it into a bubble while shaping its form with hand tools. The liquidity of the glass before it hardens is captured in Harvey Littleton's freely blown and draped glass vase (**5.30**).

Glass can also be cast. The lost wax ("cire perdue") process produces one-of-a-kind pieces. René Lalique, one of the great names in glass design, began his studies of the possibilities of glass with the lost wax casting process. Pieces such as his glass vase shown in Figure **5.31** are prized by collectors not only for their subtle design and the beauty of the glass but also because they retain the human touch: the thumbprints of the modeler, which can be seen in the flowers. Lalique soon abandoned these unique handcrafted pieces and turned to mass production of beautifully designed glass tableware, vases, bottles, boxes, jewelry, lamps, and panels for luxury cars, trains, and ocean liners.

In the Steuben glass works, LEAD CRYSTAL glass (in which up to a third of the formula is lead oxide) is handblown and hand engraved (**5.32**) in precise designs such as the *Swan Bowl* (**5.33**). Such collectors' items are not the product of a single artisan. The Swan Bowl was designed by a sculptor/inventor and a ceramist, blown by a master gaffer, trimmed by a cutter who also drew the design on the surface with crayon, and engraved by a master engraver. The engraving alone took almost two hundred hours.

In addition to blown and cast vessels, glass is also blown or poured into sheets to make two- or three-dimensional works that both admit and transform light, as in lamp shades or cathedral windows. ANTIQUE GLASS, prized for its metal oxide brilliance and its "imperfections" such as bubbles and warps, is blown by a glassblower as a cylinder, cut lengthwise, and heated until it lies flat. For STAINED GLASS, chemical colorants are heated with the base glass in a kiln

5.31 RENÉ LALIQUE, Glass vase, c.1905–10. Cast glass, 6ins (15.2cm) high. Private collection, Miami.

5.32 Ladislav Havlik engraving *Swan Bowl.*

until they fuse. OPALESCENT GLASS, developed by Louis Tiffany and John La Farge, incorporates soda ash for opacity; the glassmaker swirls bright color oxides through the molten glass as it is poured out into a sheet. To create designs of different colors, pieces of stained glass are cut and then joined by means of soldered lead channeling, copper foil, glue, or heat fusing.

5.33 PETER ALDRIDGE and JANE OSBORN-SMITH, designers, and LADISLAV HAVLIK, engraver, *Swan Bowl*, 1985. Engraved crystal glass, 8ins × 9ins (20.3 × 22.8cm). Steuben Glass, New York.

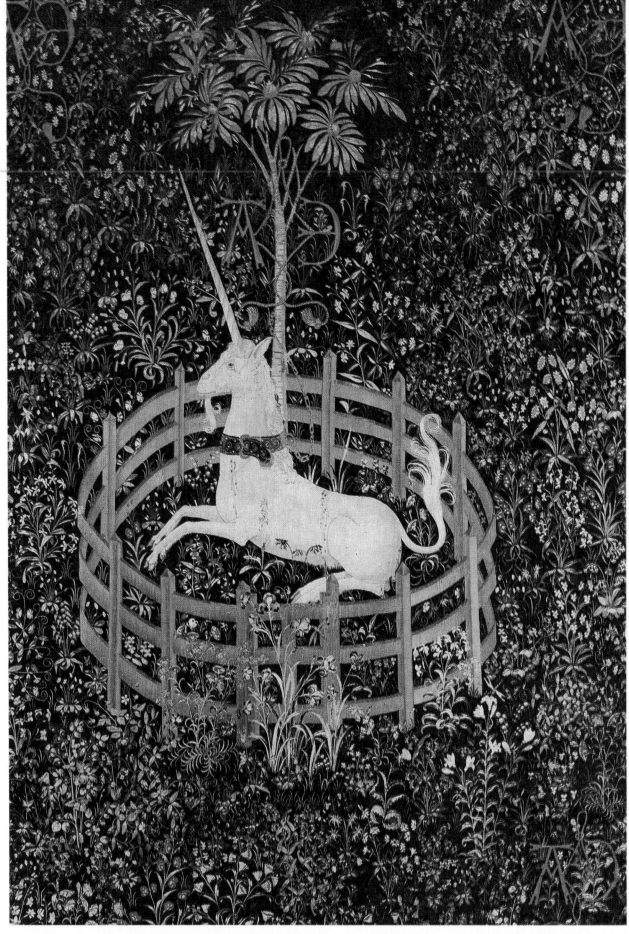

5.34 *The Unicorn in Captivity*, from the *Unicorn Tapestries*, c.1500. Silk and wool, silver and silver-gilt threads, 145 × 99ins (368.3 × 251.4cm). The Metropolitan Museum of Art, New York, The Cloisters Collection, Gift of John D. Rockefeller Jr, 1937.

5.35 Carpet from Tabriz, Iran, Safavid period, 16th century. Wool pile on cotton and silk, 26ft 6ins × 13ft 7ins (8.07 × 4.14m). The Metropolitan Museum of Art, New York, Gift of Samuel H. Kress Foundation, 1946.

5.36 ELIZABETH BUSCH working on *Maine Coast Video*, 1984. Quilt with painted panels.

Fibers

Another ancient craft that is presently undergoing a great resurgence of interest is *fiber art*. This broad category includes everything made of threadlike materials, usually woven or tied into larger wholes. Many of these works are conceived with the functional purpose of maintaining warmth, such as the TAPESTRIES created in many ancient cultures. In Gothic Europe, tapestries were designed to take the chill off the cold masonry walls of castles and cathed-

rals during medieval Europe's mini-Ice Age. In these heavy handwoven textiles, pictures were woven directly into the fabric. A cartoon of the desired image was drawn on the *warp*, the lengthwise threads strung on the loom. As the crosswise *weft* threads of varied colors were woven loosely over and under the warp and then pressed downward, complicated pictures emerged, as in the lovely Unicorn tapestries, of which the last is shown in Figure **5.34**. In the courtly medieval world, these time-consuming works were far more expensive than paintings.

5.37 CAROL HART, Splint Baskets. White and black ash, hickory, and white oak.

5.38 NORMA MINKOWITZ, *Epicenter*, 1984. Fiber, acrylic, colored pencil, and shellac, 11 × 8 × 6½ins (27.9 × 20.3 × 16.51cm).

Another prized fiber art is the weaving of Oriental rugs in the Near and Far East (**5.35**). Despite their intricate beauty, the original Persian rugs were used by nomadic peoples to cover the sand within their tents and to wrap their possessions when traveling. They were nonetheless treasured family possessions, and in the sixteenth century, Europeans began collecting them as works of art. In everyday use, they can last a hundred years, and the older sun-mellowed ones are much sought-after. The highest quality rugs are made from the wool of sheep grazed at high altitudes. The wool is knotted at densities ranging from 60 to 600 knots per square inch.

In addition to carrying on the traditional fiber arts, contemporary artists are also experimenting with nonfunctional "paintings" and sculptures of fibers ranging from cloth and yarns to wire gauze, hog gut, and vines. Quilting, traditionally a way of sewing fabric scraps into durable blankets, is a medium for abstract painterly wall hangings in the hands of painter Elizabeth Busch. She is shown assembling

Maine Coast Video (**5.36**). It incorporates satins, painted canvas panels, and beads with yarns sewn across diagonally in exaggerated quilting stitches. And the traditional idea of making baskets from pliable materials, exemplified by Carol Hart's meticulous basketforms (**5.37**), have been borrowed by fiber artist Norma Minkowitz to create vessel forms that are not intended to hold anything. Minkowitz's *Epicenter* (**5.38**) is crocheted from fibers, delicately colored with pencils, and stiffened with shellac to stand up in forms suggesting the dynamic forces in the center of the earth.

INDUSTRIAL DESIGN

In contrast to the unique nature of each handcrafted item, the products of INDUSTRIAL DESIGN are massproduced. In the past, this feature was often equated with dreary functionality in appearance. But contemporary designers are taking a new look at the familiar

5.39 JOSIAH WEDGWOOD, Teapot Design No.146, c.1785. Black basalt, modern. The Wedgwood Museum, Stoke-on-Trent.

5.40 LELLA and MASSIMO VIGNELLI and DAVID LAW, Dinner set, 1984. Stoneware, large plate 10¾ins (27.3cm) diameter. Manufactured by Sasaki Crystal, Japan.

5.41 ANTTI NURMESNIEMI, *Antti Telephone*, 1985. Manufactured by Fujitsu, Japan.

goods used in homes and offices, from furniture and toasters to computers. The result in many cases is a marriage of function and the aesthetics of color, surface texture, line, space, and form.

A few older designs still in production—such as the classic Wedgwood teapot (**5.39**)—show that good design from the past is still appreciated. But new design houses are flourishing in many countries, some of which provide governmental support for their designers as national resources. Today's industrial designers lend their imagination, sense of aesthetics, and awareness of contemporary tastes and technologies to a wide variety of commercial endeavors. For example, Vignelli Associates has offices in New York, Paris, and Milan and provides many firms with designs for graphics, consumer products, furniture, and interiors. Owners Lella and Massimo Vignelli, in conjunction with David Law—a designer of two-dimensional graphics, packaging, exhibits,

furniture, products, interiors, and environmental works—designed the handsome dinnerware shown in Figure **5.40**. They gave great attention to the subtly pebbled "organic" texture of the dishes, the dramatic contrast between the black expanses and the wide white beveled edges, and the sensuously rounded profile of the teapot. Like the Wedgwood teapot, it is functional as well as pleasing to the eye, with an easy-to-grasp open handle, good balance in the hand, and a practical spout for pouring hot liquid.

Objects such as the desk telephone used to be treated as businesslike scientific instruments. Consumer interest in design and the breakup of telecommunications company monopolies on access and equipment have changed all that. One of the many new options available to consumers is appropriately called the *Antti Telephone* (**5.41**), ostensibly named for its Finnish designer Antti Nurmesniemi. With its pleasantly touchable buttons, bold colors, and slim

5.42 BOEING 747, 1969. Manufactured by the Boeing Corporation, Seattle.

curves, it is everything the old dial telephones were not: playful, sensuous, fun to use, light in the hand. It has the streamlined smoothness we tend to equate with efficiency and speed, as though it were designed to fly.

Integrity in design often grows directly out of careful and imaginative attention to making objects that work well. The sensuous wide-bodied curves of the Boeing 747 (**5.42**) directly reflect its function as an efficient, cost-effective way to move hundreds of people through the air. The interior is designed to hold as many bodies as a minimum of comfort allows; the exterior is based on considerations such

as minimizing wind drag and wind sheer and maximizing the lift on the wings.

ERGONOMICS, the new science of designing for efficient and comfortable interaction between a product and the human body, attempts to cut down on awkwardness and fatigue in common home and workplace tasks. One offshoot of this new trend is designs that allow physically handicapped people to be as independent as possible. The cutting board (**5.43**) that Maria Benktzon and Sven-Eric Juhlin designed for manually handicapped people turns the unwieldy act of bread slicing into a simple sawing maneuver adaptable for either right- or left-handed

people. The new approach works so well that the piece has been happily adopted by more able-bodied consumers as well.

In addition to product design, designers are being hired to turn their creative and artistic skills to the packaging of products. The appealing rounded contours and protective plastic caps of *Pic and Nic* (**5.44**), small scissors and paper knife, are emphasized by their placement against black foam packing, viewed through clear acetate. The objects and foam backing are carefully composed into a figure-ground relationship in which the shapes of the generous unfilled areas complement the shapes of the tools.

Contemporary mass production of furniture is headed in many directions at once, from the utterly whimsical to the geometric, no-space-wasted func-

5.43 MARIA BENKTZON and SVEN-ERIC JUHLIN, Kitchen knife and cutting board, 1974. Plastic and steel, knife 13⅜ins (34cm) long. Produced by Gustavsberg for Ergonomi Design Group, Stockholm.

tionality of Stefan Wewerka's *Cella* units (**5.45**): create-your-own interior architecture for urban dwellers in small quarters. In a minimum of horizontal space, these units fit together to provide bookshelves, chest of drawers, couch, desk, storage space, and even a tiny vertical "kitchen."

Many contemporary products are the result of technological innovations in materials and industrial processes. Paradoxically, some aspects of high technology make it possible to mass-produce the look of the old and handcrafted. For example, the development of miniature low-voltage halogen lights has allowed designers to eliminate the fuss of wires and fittings in a lamp and to use relatively flammable materials near the light source. Hiroshi Morishima's table lamp (**5.46**) has a gentle handcrafted look, with the light glowing through the soft, random texture of handmade Japanese paper.

5.44 *Pic and Nic*, 1985. Scissors and paperknife set, stainless steel with plastic caps, scissors 3ins (7.8cm) long. Manufactured by Plus Co. Ltd., Japan.

5.45 STEFAN WEWERKA, *Cella*, 1983. Natural and lacquered woods and stainless steel. Manufactured by Tecta Möbel, Germany.

5.46 HIROSHI MORISHIMA. *Wagami Andon*, 1985. Lamp encircled in a cone of Japanese handmade paper, 29½ × 21½ins (75 × 55cm). Manufactured by Time Space Art Inc., Japan.

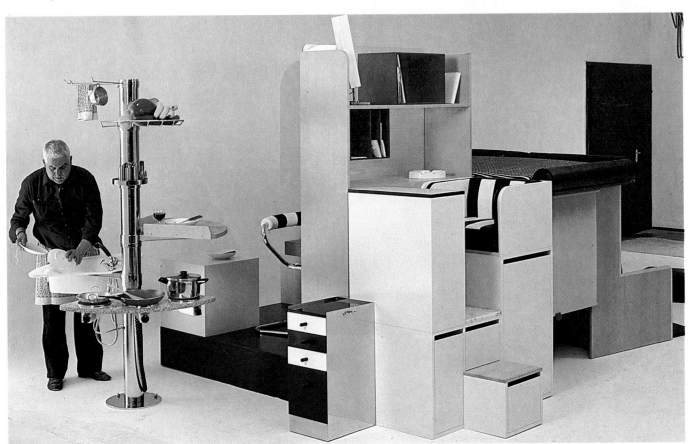

5.47, 5.48, 5.49 SEBASTIAN LECLERC, Costumes of working class, middle class, and aristocratic women, late 17th century. Engravings. Victoria and Albert Museum, London.

CLOTHING DESIGN

Those who design clothes sculpt in fibers, with the human body as a supporting armature. In addition to their aesthetic qualities, our clothes carry symbolic connotations that transcend the sheer function of protecting our bodies from the weather. Naked, we are all much the same. Clothed, we make symbolic statements about our wealth, status, lifestyle, sex role, personality, and taste.

The art of dressing often connotes class rank. As suggested by the seventeenth-century drawings of female dress (**5.47, 5.48, 5.49**) in different classes of French society, three women may present entirely different social images based on their clothing. The working classes usually dress for convenience—here, simple sturdy fabrics, a deep-pocketed apron for carrying things and protecting areas likely to be soiled, a skirt length allowing free movement, comfortable sleeves that can be rolled out of the way, hair cover-ing that helped one to balance a jug. Farther up the social scale, wealth and leisure were demonstrated by surpluses of luxuriant fabric and a more ornamental than functional approach to design.

In addition to demonstrating that the wearer was not involved in manual work, fashions for women have at times turned them into visual display cases. As indicated in the engraving by Voisard (**5.50**), high-born French women of the 1770s were almost immobilized by immense side-paniers, tight-waisted corsets, frilly sleeves, and towering hats and hairstyles that took hours to put together and required that one move very carefully, if at all. Even to be carried in a sedan chair, women so dressed had to kneel on the floor to make room for the height of their headdresses. The hairstyles took so long to construct that they were maintained for a month or two, with the aid of lard and whiting. Sleeping with them was as

5.50 VOISARD after DESRAIS, *A Lady of Fashion*, c.1770. Colored engraving.

334

5.50

5.51 After HANS HOLBEIN THE YOUNGER, *Henry VIII*, 1537. Oil on canvas, 92 × 53ins (234 × 135cm). Walker Art Gallery, Liverpool.

5.52 Costumes for KISS, 1986 tour.

hazardous as it was uncomfortable, for mice liked to nibble on them; the solution, a mouse-resistant nightcap, added to the great weight of the concoction.

As well as being calculated to impress others with one's wealth and position, fashions have been used to accentuate one's gender image. To look more desirably feminine, women of some periods and cultures have stuffed themselves into breast-lifting devices and then worn deeply cut gowns to reveal the rounded forms of their pushed-up flesh. Visual attention is drawn to areas with sexual associations, but to make them more desirable they are concealed. Males, too, may dress in ways that flaunt and exaggerate their masculine traits, such as the immense padded shoulders, decorated codpiece, and barely covered legs of Henry VIII's costume (**5.51**). Not only do the artificially broad shoulders emphasize his masculinity; they also bespeak the great political

power of the monarch. To a certain extent, such displays were considered *noblesse oblige*; subjects wanted to be proud of their royal families. But Henry VIII obviously enjoyed dazzling audiences with his splendid dress. At his coronation, he wore an ermine-trimmed robe of crimson velvet and a doublet studded with rubies, pearls, diamonds, and emeralds.

Flamboyance in male attire was rare in Western societies during the middle of this century, with the conservative business suit widely accepted as a uniform. But the love of gorgeous softly draped fabrics and light-catching surfaces has returned in some quarters, most visibly in the concert costumes of popular music groups such as KISS (**5.52**), whose stage outfits juxtapose a great variety of lush colors and textures.

As we become more liberated from traditional social role expectations, we are freer to dress as in-

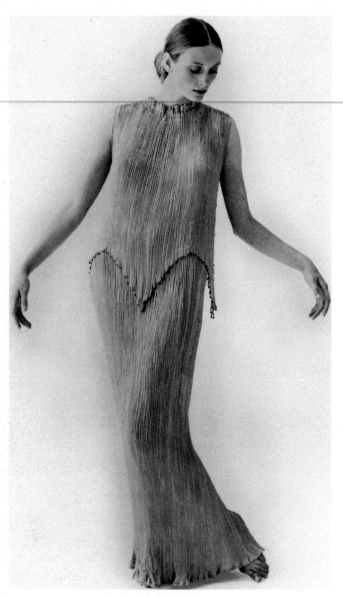

5.53 MARIO FORTUNY, *Delphos* dress, c.1912. Silk.

dividuals. Early in the twentieth century, women's emancipation from stricter Victorian standards opened the way for greater freedom in their clothing. The *Delphos* dress of pleated silk by Fortuny (**5.53**) allowed the natural curves of the body to show, without exaggeration or coyness. Its graceful lines —still in demand—were inspired by the draped garments of classical Greece. The pleats travel well and are in fact best maintained by twisting the dress into a knot.

As in the other arts, the world of contemporary high fashion is a mélange of different styles. Its variety is personified by the exuberantly unconventional output of Japanese designer Issey Miyake. His garments range from marvelously loose and flowing pieces that allow and encourage free movement of the body to the open basketwork "coat" (**5.54**). Its cane framework resembles samurai armor, revealing and contrasting with the sensuality of the body. Even Miyake's fabrics are his own invention. To support his broad credo—"Anything can be clothing"—he takes his inspiration for fabrics from everyday images: "leaves, trees, bark, sky, air. Anything. A noodle." Miyake drapes the fabrics over himself to see what they will do. He says,

> Fabric is like the grain in wood. You can't go against it. I close my eyes and let the fabric tell me what to do.

Ever pushing at the boundaries established for fashion by social convention and lack of imagination, Miyake observes that the Japanese word for clothing —*fuku*—also means happiness: "People ask me what I do. . . . I say I make happiness."[1] The wearer of such a garment must have something of the same blithe spirit, a sense of independence and self-confidence. Designed for lithe and sensual movement, the clothes only "work" on a person who moves freely within them.

Some garments—such as those by Issey Miyake —are considered wearable art by collectors. High-quality Chinese and Japanese kimonos are hung as paintings, even though they are also very comfortably functional with their deep-cut arms and loose fit. Indeed, kimono designers old and new have approached this traditional garment as a broad surface for two-dimensional art, such as the intricate

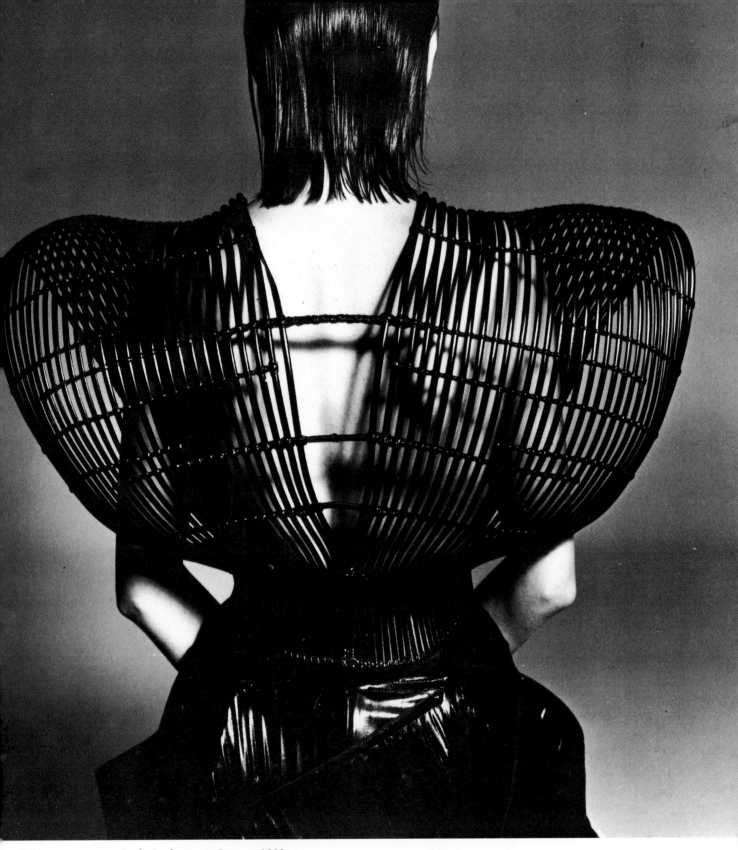

5.54 ISSEY MIYAKE, *Body Sculpture in Rattan*, 1982.

embroidered patterns of silk and gold threads worked across the Chinese woman's coat (**5.56**).

In some cultures elaborate handmade garments are among a family's treasures passed down from one generation to the next and worn on special ceremonial occasions. There are also some contemporary attempts to maintain or revive the old labor-intensive costume-making arts as symbols of one's cultural heritage. Cheryl Samuel visited museums from Leningrad to Toronto to study the eleven remaining old-style Kotlean robes woven 200 years ago by natives of the northwest coast of North America, in order to produce a twelfth one (**5.55**). She found that the people had used their basketweaving techniques to twine the robes, working each row from left to right and knotting the weft strands into a fringe on both sides. After each of the concentric geometric patterns was completed, the black weft yarns were left hanging as tassels. When a dancer wearing one of these robes moves, the whole garment sways with the body, and the motion of the dance is accentuated by the swinging of the tassels.

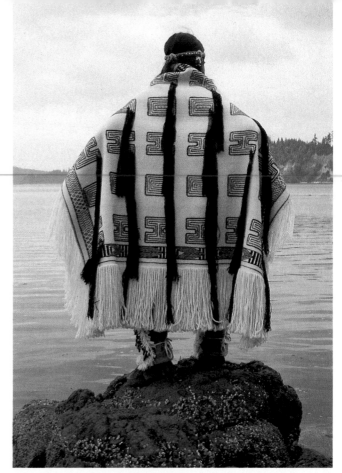

5.55 CHERYL SAMUEL, Kotlean robe, 1986. Handwoven wool. (From Evan Adams and Cheryl Samuel, *The Raven's Tail*, University of British Columbia Press, 1987.)

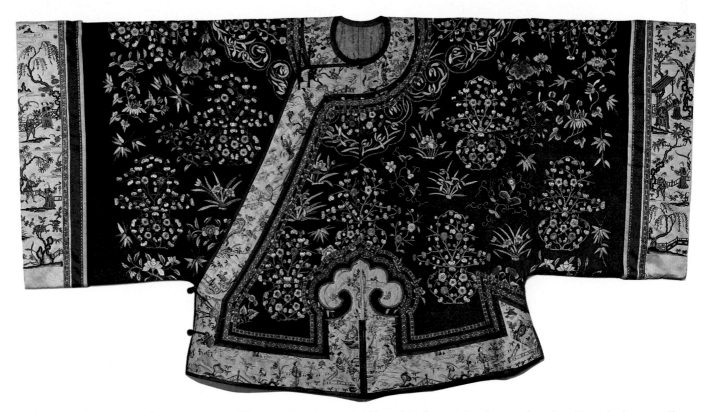

5.56 Woman's coat, North or Northwest China, c.1850–1900. Wool broadcloth, satin borders, embroidered in polychrome silks and gilt threads, 29½ins (75cm) long. The Metropolitan Museum of Art, New York, Gift of Dorothy A. Gordon and Virginia A. White, in memory of Madge Ashley, 1973.

ARCHITECTURE

For comfort in living, we humans have always sought some kind of shelter from the elements. Not only have we clothed our bodies; we have also tried to create miniature environments that are warmer or cooler than our natural setting and that will provide shelter from the elements for ourselves and our possessions. Where climate is warm and possessions minimal, as in aboriginal Australia, a simple bark shelter from the rain will do (**5.57**). But in most cultures, there has been a desire to create larger and more permanent structures. Those designed for group assemblies—such as places of worship, houses of government, and commercial institutions—have required more elaborate technologies in order to stretch roofs over larger interior spaces and protect structures from wind, snow loads, earthquakes, and the like. Some historic solutions in Western architecture are diagrammed in Figure **5.58**.

One of the simplest and most common structural forms is the POST AND LINTEL. The lintel, or horizontal member supporting the roof, is subject to the downward pressure of gravity, and lintels made of stone or wood will break if they span too wide an opening. The lintel could be stretched when the great tensile strength of steel was introduced, either as a reinforcing mesh for prestressed concrete or as the skeleton of a steel frame building.

Before iron and steel frameworks were introduced in the nineteenth century, architects had developed other ingenious ways of spanning broad interior spaces. Many were based on the observation that an

5.57 Australian aboriginal bark shelter.

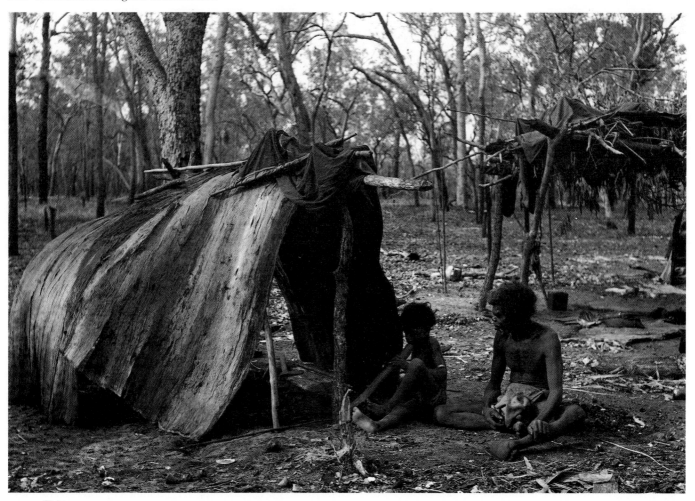

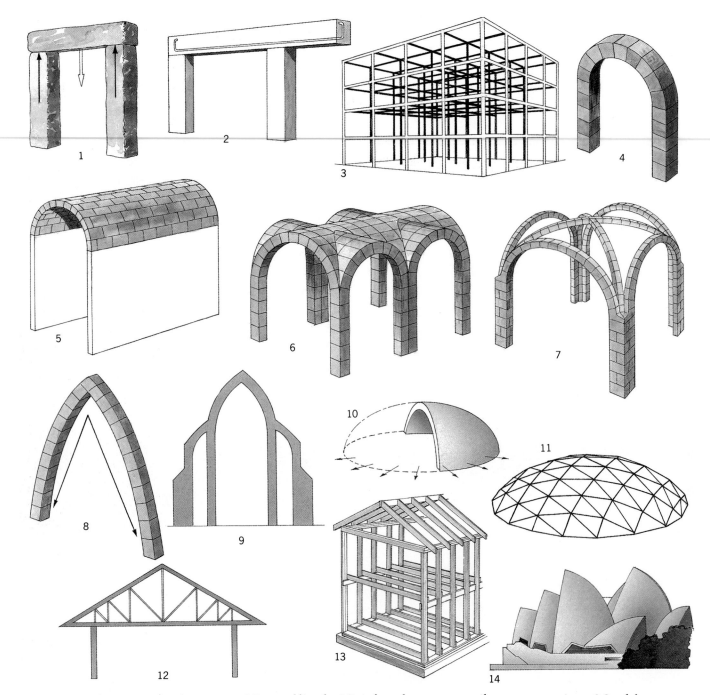

5.58 Structural systems in architecture. 1 Post and lintel 2 Reinforced concrete cantilever construction 3 Steel-frame construction 4 Round arch 5 Barrel vault 6 Groin vault 7 Ribbed cross vault 8 Pointed arch 9 Flying buttress 10 Dome 11 Geodesic dome 12 Trusses 13 Balloon construction 14 Reinforced concrete freeform construction

arched roof would transfer weight to the supporting walls rather than sagging in the middle. Carefully cut stones were fitted into BARREL VAULTS based on the ROUND ARCH, GROIN VAULTS made of intersecting barrel vaults, and POINTED ARCHES whose width at the base could be varied. Gothic architects had also perfected systems of RIBBED VAULTING that carried most of the weight of an arch, allowing lighter mate-

rials to be used for the areas between. Because vaults and arches transferred pressure not just downward but also outward, the supporting structure, if it was not to be massive, had to be itself supported, sometimes by elaborate systems of exterior FLYING BUTTRESSES.

Other approaches have been developed through time for roofing large interior spaces. One is to turn

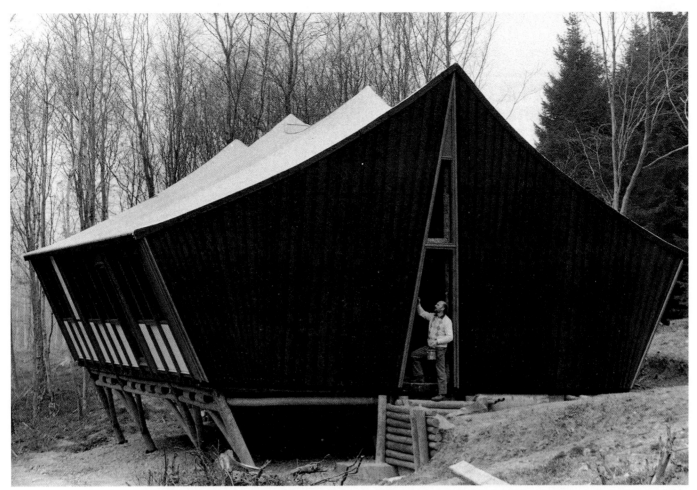

5.59 JOHN MAKEPEACE, *Prototype Building*, 1985. Hooke Park Forest, Beaminster, Dorset.

the roof or an entire structure into a great dome, such as Buckminster Fuller's GEODESIC DOME. Polyhedrons of lightweight materials can form skeletal frameworks with a high ratio of strength to weight. Added to post and lintel construction, TRUSSES can be used to support roofs with the strength of the triangle. In wooden buildings, BALLOON FRAME construction of slender 2-inch boards was introduced in the mid-nineteenth century as a light and easily constructed alternative to heavy timbers. Reinforced concrete can be used to create freeform structures and cantilevered structures in which only one end of a horizontal member is supported.

Experimentation with all building methods continues today. At the same time that new high-tech materials and methods are being examined, some builders are re-examining the potential of peasant structures and readily available materials. For example, British furniture designer John Makepeace has demonstrated that the thin round poles usually regarded as waste *thinnings* in a managed forest, cut out to let other trees grow bigger, can themselves be used to build "matchstick houses" (**5.59**). The slim poles are used like ropes taking tension at their ends, with joints of glues originally designed for space travel. Makepeace calculates that the thinnings wasted in England alone could be used to build 30,000 houses a year.

The strength of varying construction methods is only one consideration in architecture. The Roman architect Vitruvius observed in the first century BC that the basic principles of good architecture are convenience, beauty, and strength. As we will see, architecture also carries symbolic meanings.

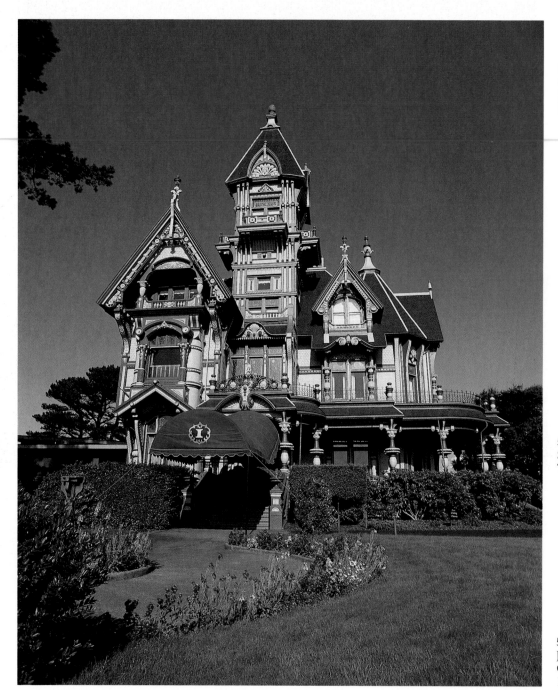

5.60 JOSEPH NEWSOM, Carson House, San Francisco, 1884–86. Photo by Bob von Normann.

5.61 HORACE WALPOLE, Strawberry Hill, Twickenham, 1749–77.

5.62 PHILIP JOHNSON, Johnson House, New Canaan, Connecticut, 1949.

Individual homes

Like our clothes, our homes transcend structural and functional considerations. Much domestic architecture bespeaks ideas of aesthetic beauty and symbolic statements about the lifestyle and status of the inhabitants, in addition to the attitudes of the period and the mindset of the architect. Joseph Newsom's Carson House in California (**5.60**) is an exuberant exaggeration of the Victorian gingerbread style. Most of the exterior ornamentation is like the elaborate frosting on a wedding cake, added for the sheer pleasure of decoration. Somewhat less ornamental but overwhelmingly imposing in scale and extravagance is Horace Walpole's home at Twickenham (**5.61**). He renovated it to look like a Gothic castle, complete with turrets, towers, and battlements, and furnished it with chivalric armor and the like, for the fun of make-believe. A romantic love of the past is often reflected in our homes, many

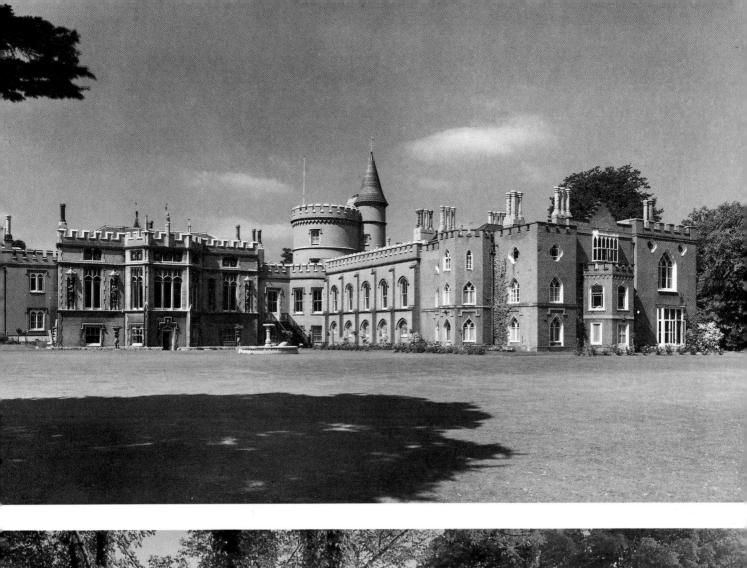

5.63 VALENTINO AGNOLI, Agnoli House, California, 1968–69. Exterior detail.

of which are modeled on earlier styles.

Different paths can be taken by those who have a special affection for the land on which they build. In 1949, architect Philip Johnson built himself a house with glass walls (**5.62**). The structure and walls of the house are almost invisible; what one sees from within and without are the surrounding trees and vegetation, the pond with fantasy pavilion below, and the valley in the distance. Most of us use opaque walls and curtained windows to insure our treasured privacy; Johnson's personal life is shielded from the curious by a high dry stone wall along the road.

Consciousness of the ecological costs of energy has prompted development of many energy-efficient housing features. In cold climates, passive sun-collecting designs may have thick insulation and windows concentrated on sunny sides. Some have also dug their homes into hillsides, using the earth itself for insulation from temperature extremes. The related back-to-the-land movement has also invigorated loving use of organic materials, such as the carefully crafted woods of Val Agnoli's into-the-hill house (5.63). To be surrounded by the textures and colors of natural wood and stone, revealed rather than hidden behind other materials, is for some a return to a sense of connectedness with the earth.

Multiple dwelling units

As our cultures become increasingly urbanized and as construction and energy costs rise, the single family house surrounded by land is a luxury that some cannot choose. In privacy-loving Western societies that do not have a tradition of communal living, the challenge is to create humane and personal surroundings for many people living separately under the same roof. One of the most delightful solutions to this situation ever devised is Casa Milá in Barcelona (5.64), designed by the extraordinarily inventive Antoni Gaudí. Eschewing the straight lines and right angles of most contemporary urban architecture,

5.64 ANTONI GAUDÍ, Casa Milá, Barcelona, 1907.

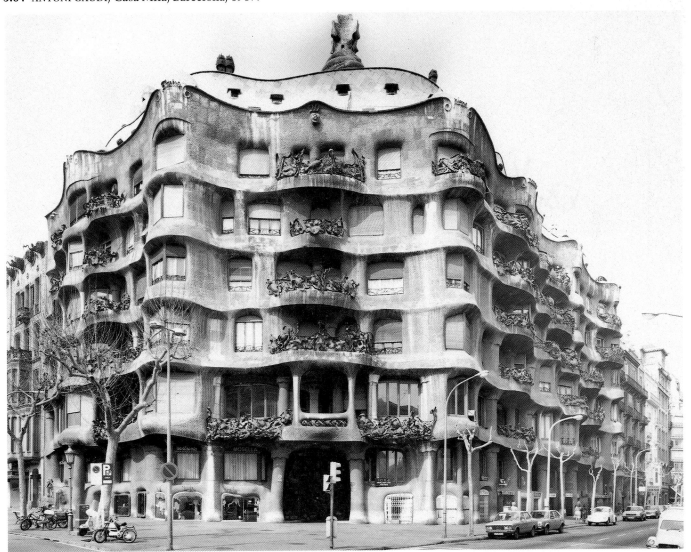

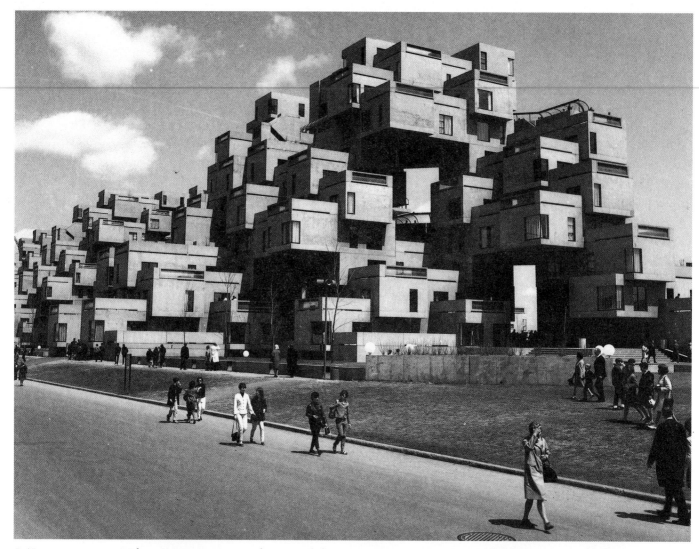

5.65 MOSHE SAFDIE, Habitat, Expo 67, Montreal. 354 modular construction units, pre-cast in concrete with metal reinforcements.

Gaudí created a lyrically expressive building that flows in and out through space. Even the roof, chimneys, walls, and ceilings undulate like liquid images in a fantasy world—yet Gaudí coaxed these forms out of layers of cut stone.

An utterly different vision of the future of massed urban dwellings was created by Moshe Safdie in *Habitat* (**5.65**). Erected in Montreal for the 1967 Expo, it demonstrated the feasibility of *modular* building. Identical 70-ton units, each theoretically a complete apartment, were prefabricated and then lifted by a crane to be joined in varying configurations, breaking the monotony of repetition by introducing elements of variety and choice.

Sacred architecture

In most cultures, the devout have created special buildings that express and inspire their devotion to the divine. To work on such projects is itself an act of devotion. In Western architecture, this effort reached a peak in the High Gothic cathedrals, such as the one at Chartres (**5.66**). Its soaring, open interior leads the eye and the spirit rapidly upward into the vastness; openings for windows were filled with stained glass images, many of them celebrating the Virgin Mary. The tunic she is said to have worn when giving birth to the Christ child is the cathedral's most sacred relic. The uplifting effect of being inside the cathe-

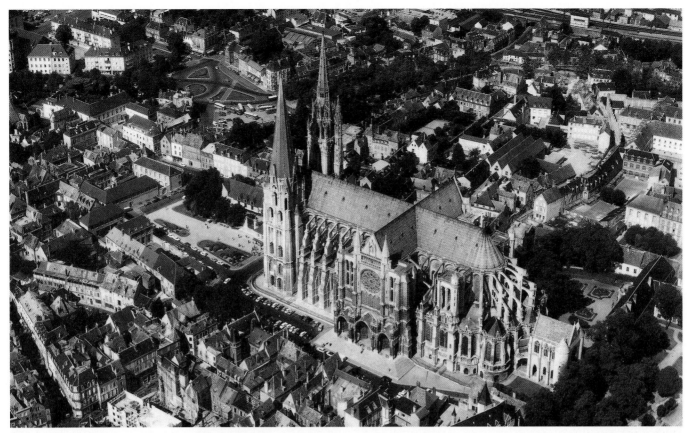

5.66 Chartres Cathedral, France, begun 1194.

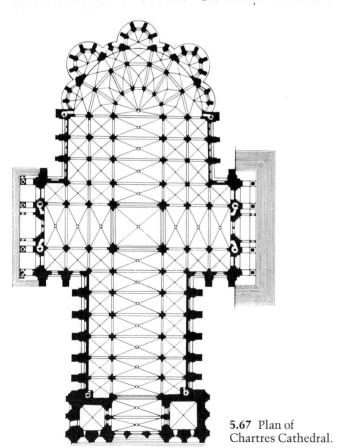

5.67 Plan of
Chartres Cathedral.

5.68 EUGÈNE VIOLLET-LE-DUC,
Drawing of a Gothic cathedral.

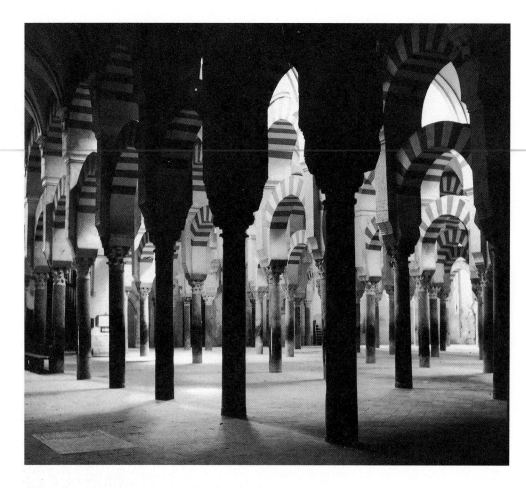

5.69 Interior of the Great Mosque, Cordoba, Spain, c.AD 961–976.

dral, so very different from one's everyday environment beyond its walls, was made possible by the ribbed vaults (which appear as elongated crossed lines along the NAVE, or central hall, in the plan shown in Figure **5.67**), flying buttresses (which can be seen surrounding the APSE, or rounded end of the cathedral, in the aerial photograph), and the pointed arches that line the sides of the nave. The extraordinary verticality of the interior of such a High Gothic cathedral is apparent in the ill-fated Cathedral of Beauvais (1.50). The outside of Gothic cathedrals was meant to have a pointing-to-the-heavens vertical effect as well. The intention was to have towering spires on every corner, as in Viollet-le-Duc's drawing (**5.68**), but all Gothic building projects eventually ran out of money, and none was able to complete more than three spires. Nevertheless, these hand-built structures laid out in the form of a cross were by far the largest buildings of their times, dominating the skyline as well as the sacred life of an area and drawing pilgrims from far away.

In contrast to the vertical thrust of Christian struc-

tures toward a God who was watching over humans from above, Islamic sacred architecture tends to spread into a boundless horizontal vastness, reflecting the concept that God is everywhere, an unseen presence within and beyond all physical realities. In the Great Mosque of Cordoba (**5.69**), the roof can hardly be seen above the forest of 514 columns topped with double arches. There are no images of saints or of God in material form, for such depictions were forbidden by the Prophet Mohammed. God's presence is everywhere rather than confined to any special place, time, or being, so ornamentation is absent in some mosques and confined to abstract geometrical and floral designs in others. The emptiness can open the way for a spiritual experience of the ubiquitous presence of the divine.

While the Gothic cathedrals and the Islamic mosques created sacred interior spaces cut off from the outside world, the *Wayfarers' Chapel* designed by the firm of Lloyd Wright (**5.70**) is entirely open to its natural surroundings. In this case, the setting is truly inspirational, for the church is sited on a cliff over-

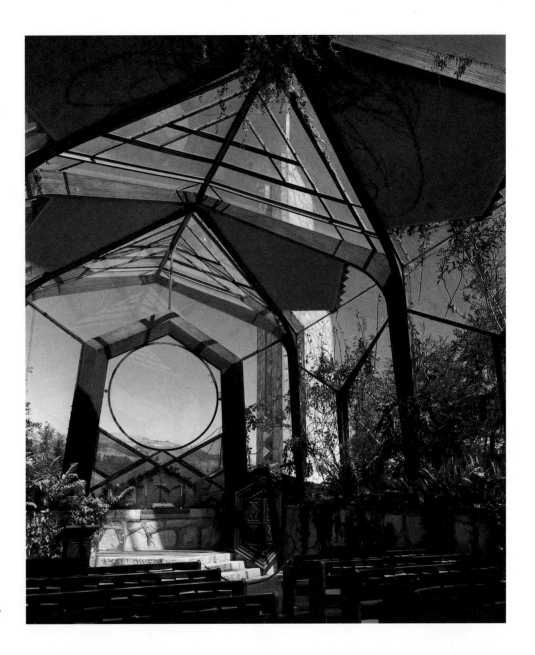

5.70 LLOYD WRIGHT, Wayfarers' Chapel, Palos Verdes, California, 1951.

looking the Pacific Ocean. The structure reflects a philosophy of direct mystical communion between the material and spiritual realms. It also reflects the organic architecture of Frank Lloyd Wright, with its simple redwood beams supporting glass and tile. Imagine the effect of worshipping in this open sanctuary during a storm! Wright's extensive use of plate glass is a relatively new trend in architecture. In 1955, he wrote,

> This resource is new and a "super-material" in modern life only because it holds such amazing means for awakened sensibilities. It amounts to a new qualification of life in itself. If known in ancient times glass would then and there have abolished the ancient architecture we know, and completely. . . . By means of glass, then, open reaches of the ground may enter into the building and the building interior may reach out and associate with these vistas of the ground. . . . Perhaps more important than all beside, it is by way of glass that sunlit space as a reality becomes the most useful servant of the human spirit. Free living in air and sunlight aid cleanliness of form and idea.[2]

Another symbolic expression of the nature of the divine is seen in Gottfried Böhm's church and quarters for pilgrims at Neviges (**5.71**). Böhm, a sculptor who was also trained as an engineer, sculpted sandblasted concrete into an asymmetrical 114-foot- (35m) high mountain. It impresses one with a show of massive strength, but yet there is also something light, free, and wild about this architectural statement. The angular strength of the mountainous

5.71 GOTTFRIED BÖHM, Church and quarters for pilgrims at Neviges, 1964.

5.72 The Dharmaraja Rath and other rock-cut temples, Mahabalipuram, India, AD 625–674.

5.73 Angkor Wat, Kampuchea, early 12th century.

church is accentuated by its contrast with the curving Gaudíesque quality of the pilgrims' quarters. Böhm, whose work received the Pritzker Architecture Prize in 1986—an honor akin to the Nobel Prize—has devoted half of his building projects to religious architecture.

In the Hindu spiritual tradition, all forms spring from the all-pervading radiant ether. To carve a temple out of living rock, such as the temples at Mahabalipuram (**5.72**), was a divinely inspired act that parallels the process by which material substance is created from ether. Realities are multiple, each one successively more tangible, like the broadening tiers into which this granite monolith has been sculpted. The stone has a visibly lively quality, expressing its infusion with the divine.

In some times and places, religious architecture has been inspired by secular as well as sacred motives. In the Khmer Kingdom of what is now Kampuchea, the people alternately embraced both Hinduism and Buddhism, with rulers proclaiming themselves divine god-kings in either tradition. On the vast plain of Angkor, kings built temples to glorify themselves, assure their divine rank, and inspire awe in their subjects. The largest of these is Angkor Wat (**5.73**), a carved stone monument 200 feet (60m) high at the center. This complex of pyramids and passageways was surrounded by a moat almost 2½ miles (4km) around. Long and beautiful bas-reliefs of the Hindu Vishnu, Krishna, and Rama myths grace the gallery that surrounds the central spires. As an illustration of the rich ornamentation that abounds on all surfaces, there are 1700 figures of celestial *apsaras* alone in the bas-reliefs. Despite the fact that the temples of Angkor are one of the world's great architectural treasures, the significance attached to them waned after the thirteenth century. The jungle had reclaimed the area until a twentieth-century restoration project revealed the structures once again. Then in 1972 archaeologists and maintenance crews were forced out by war and political upheaval, and it is reported that the remorseless vegetation has once again begun to overrun the vast complex.

Public buildings

Not only religious architecture but also secular public buildings make symbolic statements. These are often subtle and perhaps even unconscious, for today's pluralistic, materialistic cultures have few publicly agreed-upon beliefs.

In downtown urban areas, scope for the architect's imagination is often limited by severe space restrictions. With real estate extremely expensive, the only economically feasible direction to expand is upward. This direction has become possible only through the development of steel and concrete frameworks capable of supporting tremendous loads. With these frameworks, walls become non-load-bearing curtains and can be made entirely of glass. Interiors also become broad-spanned open spaces within which partitioning can be arranged and moved about according to shifting interior needs rather than the necessity for supporting what lies above.

In the INTERNATIONAL STYLE which evolved on several continents after World War I, the steel and concrete framework was mated with an austere approach to design. Buildings were constructed along purely functional lines, with largely glass exterior walls, flat roofs, a lack of ornamentation except for horizontal bands defining floors, and symmetrical modular grids. The visual effect of these structures is that of space-filled volume rather than the solid mass associated with earlier architectural forms. Symbolically, they bespeak the impersonal triumph of technology, the future as it was then envisioned. Mies van der Rohe and Philip Johnson's *Seagram Building* (**5.74**) in New York is a classic example of this now-familiar style and perhaps its most successful product, with its perfect proportions. A large open area has been left beyond the sidewalk for a broad walkway and fountains, allowing a sense of spaciousness and graciousness in the midst of the crowded urban scene. Many large cities now require that skyscrapers be set back from the sidewalk to allow sun to penetrate into the canyons between tall buildings. And it turns out that there is a limit to the economy of building vertically. While cities vie for the distinction of having the world's tallest skyscraper, rents in these buildings are very high and it has been esti-

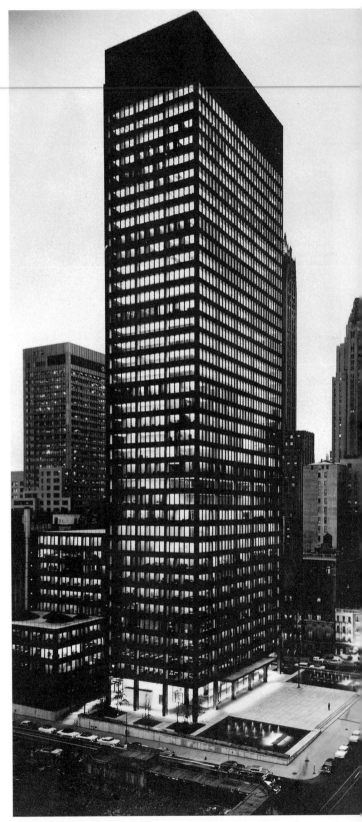

5.74 LUDGWIG MIES VAN DER ROHE and PHILIP JOHNSON, Seagram Building, New York, 1956–58.

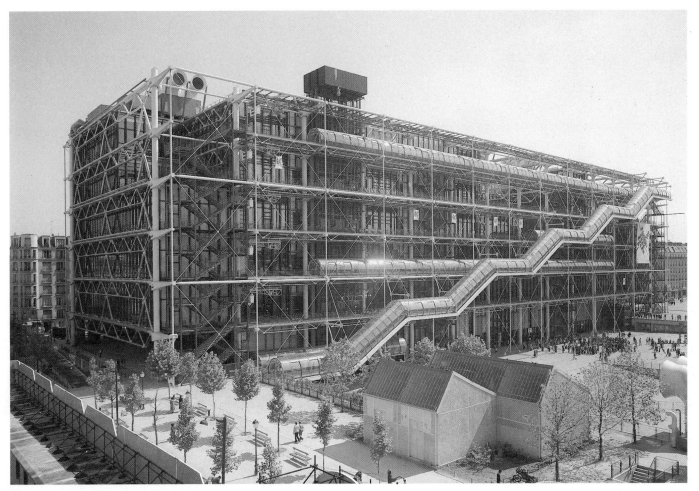

5.75 RENZO PIANO and RICHARD ROGERS, Pompidou Center, Paris, 1971–78.

mated that building a 150-story tower is twice as expensive as building three 50-story towers.

Money is not the only consideration limiting the proliferation of International Style skyscrapers. After the Second World War, reaction set in against the purely functional glass boxes of the International Style. In what is now called POST-MODERN architecture, buildings tend to be more expressive and individual and, some say, less élitist. There is no one look that defines them all. Some are sensual and decorative, some refer back to historical styles, some are lively and playful. An extreme example of the willingness to create an architecture for the people rather than the architectural critics is the *Pompidou Center* in Paris (**5.75**) designed by Renzo Piano and Richard Rogers. Designed to house a modern art museum, a public library, exhibition space, and an

audio-visual center, it is conceived as an upbeat public gathering place rather than an austere cultural center. Rogers explains its oil refinery appearance: "We wanted it to be fun and easy to read,"[3] so he and Piano put its mechanical services and functional supports on the outside and color coded them: water pipes were painted green, electrical ducts yellow, and air conditioning pipes blue. To carry people from one floor to another, they also put the elevator on the outside—a large glass caterpillar that slinks its way up the building and offers a superb view across Paris. Although some critics have condemned the ugliness and high cost of heating and cooling this building turned inside-out, it is indeed popular with the people. Some 30,000 Parisians and tourists visit it every day, more than go to the Eiffel Tower and Louvre put together. Bistros and boutiques have

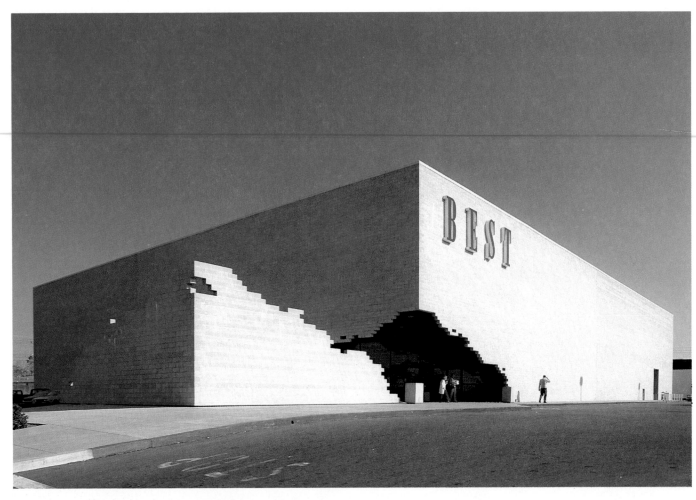

5.76 SITE, Notch Project, Sacramento, California, 1976–77.

5.77 Suq al-Ainau, Barat region of the Yemen Arab Republic.

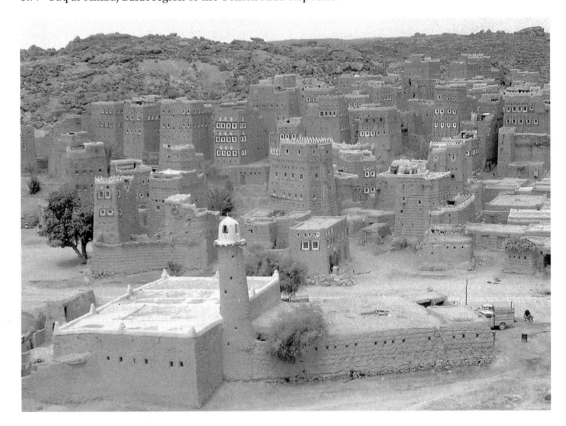

sprung up around it, and pretzel sellers, fire eaters, and chamber quartets abound in the plaza outside the center.

While the Pompidou Center brings structure out into the open, taking away the mystique of high-tech construction methods, the *Notch Showroom* (**5.76**) contradicts traditional architectural expectations by playfully destroying its own apparent structure. To lure shoppers to the Best Products discount store, the SITE architects built a structure that would stand quite adequately without one corner, and then built a mock corner for the building that rolls out to form an entrance. This jagged excision is a favorite tourist attraction, and crowds gather daily to watch the opening and closing of the notch, which seals the building outside business hours. After the tedium of boxy shopping centers, the Notch building makes the

symbolic statement that shopping can be fun, just as the Pompidou Center celebrates the idea that art can be fun.

The architecture of towns

On a broader scale, individual buildings are often perceived together as a distinctive whole. In North Yemen, the market-town of Suq al-Ainau (**5.77**) is visually unified by use of the same material—packed mud—in its multi-storied buildings. From a distance, they look like children's building blocks in comparison with the higher hills rising behind. In the southern Italian peninsula, the traditional Apulian houses (**5.79**) all have the same unusual *trulli* roofs made of roughcut stones of decreasing size. So closely clustered are these beehive forms that it is difficult to

5.78 The Dallas skyline.

5.79 Trulli houses, Apulia, Italy.

tell where one home ends and another begins. Even in contemporary cities where buildings display a multitude of styles, in a distant view of the skyline the individual forms merge into a whole that bespeaks the character of the city. In Dallas, for instance, an exuberant spirit of growth, change, and wealth is reflected in an array of new tall buildings by world-class architects (**5.78**). Although they are as different as the Reunion Tower (the ball on a stick at center right) and the Marriott Hotel to the left, whose stepped form intentionally mimics the skyline itself, seen as a group they are like an exciting nonobjective sculpture in glass and light.

INTERIOR DESIGN

Once a permanent building is in place, there is the issue of selecting and organizing its contents—furniture, fabrics, art objects, functional objects, and personal possessions. In some cases, functionality of furnishings is the prime consideration. The Reading Room of the British Library (**5.80**) is a businesslike arrangement of lighted reading tables fanning out like spokes from the central hub—shelves of reference volumes and an information desk. Chairs are upright, with no arms. All space is dedicated to task-solving equipment, with aisles left for convenient traffic flow. This is obviously not a place designed for comfort or conversation, but it efficiently carries out the function of providing reading spaces for a great number of people, with the elegance of a truly functional design.

By contrast, in our homes we tend to try to surround ourselves with things we consider beautiful or interesting, and furnishings designed to make our lives more comfortable. An extreme example of the opulent extremes to which this endeavor has been taken is the bedroom from Palazzo Sagredo in Venice

(**5.81**), now preserved *in toto* in the Metropolitan Museum of Art in New York. The bedroom belonged to Zaccaria Sagredo, a major patron of the Venetian artists of the Late Baroque period. Every surface is richly ornamented, from the painting on the ceiling and the stucco cherubs to the magnificent brocade covering the bed and its headboard. The reds and golds increase the impression of sumptuous, almost royal wealth. The room has the appearance of a stage setting, with the bed raised on a platform, enclosed by an archway, and theatrically lit brighter than the space in front allotted for the "audience."

At the other extreme, in the Japanese tradition one's home is not used as a place to display material abundance, though it may be a setting for appreciating the beauty of a few carefully selected possessions. The main parlor in a Kyoto merchant's home (**5.82**), lovingly restored along traditional lines by the son who grew up there, is almost entirely bare of furnishings. The simple cushions and table are low to the *tatami*-covered floor, and all other possessions are stored out of sight, with the exception of the single painting within the TOKONOMA alcove out of camera range to the left. This spare aesthetic turns a relatively small space into a quietly spacious sanctu-

5.80 The Reading Room, The British Library, London, 1826–47.

5.81 Bedroom from the Palazzo Sagredo, Venice, c.1718. Wood, stucco, marble, glass, 13ft (4m) high. Painted ceiling by Gaspare Diziani, *Dawn*, c.1755–60. The Metropolitan Museum of Art, New York, Rogers Fund 1906.

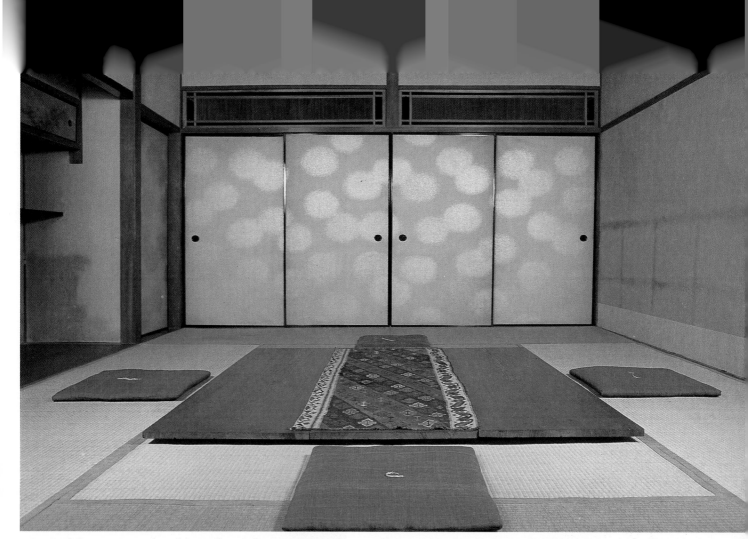

5.82 *Zashiki* or main parlor of a merchant's house, Kyoto, Japan.

ary, a haven from the busyness and crowds of the streets. In the absence of visual noise, inhabitants can develop a heightened awareness of and appreciation for the exquisite experiences of the moment. Instead of being submerged in a symphony, in this space one listens keenly to single notes—the scent of a flower, the texture of a cup, the sound of a voice. Kojiro Yoshida, the son, named his family's treasured home *Mumeisha*: "the hall for casting light on the unnamable things of the present."

Rather than planning our interiors as period pieces or philosophical statements, most of us fill our living spaces with the things we like and use. The results may be as eclectic as the study of Italian playwright, poet, and novelist Gabriele d'Annunzio (**5.83**), who

5.83 The Study of Gabriele d'Annunzio, c.1900–20, Italy.

lived from 1863 to 1938. In addition to the sensuous pleasures of beautiful leather-bound books and writing case, the study incorporates favored objects from periods ranging from Classical and Byzantine times to his own times. The clutter of treasured photographs, books, and art objects give the sense of a man who had surrounded himself with tangible reminders of his love for life.

Some of us deliberately decorate our living spaces to help us forget the world outside their walls. In the deserts of Saudi Arabia, the nomadic Bedouins have for centuries used wool and goat's hair tents for shelter from sun, rain, wind, and cold. These shelters are of necessity temporary and portable, for the people must be ready to move their herds and their belongings quickly to areas that have just received rainfall. But to create under these circumstances a gracious environment that belies the barrenness outside, the people use beautiful and valuable rugs and blankets to cover the floors and walls (**5.84**).

By contrast, when our surroundings are aesthetically and psychologically pleasing, we may invite them into our homes. Perhaps the most striking example of a house built around a natural environment is Frank Lloyd Wright's *Fallingwater* (3.43), built for the Kaufmann family. Not only is the house interwoven with the flow of the stream called Bear Run, but also the boulder on which the living room is built has been allowed to remain in place, extending almost seven feet (2m) into the room and rising up to ten inches (25cm) above the floor (**5.85**). Flagstone paving has been carefully fitted about it, waxed, and sealed, but the boulder retains its natural dry texture, as if rising above the waters of a stream. Wright had planned to sheer the boulder down to floor level; it was the owner, Edgar J. Kaufmann, who asked that it be allowed to keep its own character. Kaufmann's son, Edgar, Jr., apprenticed himself to Wright and had a special appreciation for the results of the collaboration between his father and the renowned architect, and between humans and nature:

> When Wright came to the site he appreciated the powerful sound of the falls, the vitality of the young forest, the dramatic rock ledges and boulders; these were elements to be interwoven with the serenely soaring spaces of his structure. But Wright's insight penetrated more deeply. He

5.84 Bedouin tent, Saudi Arabia, c.1970.

understood that people were creatures of nature, hence an architecture which conformed to nature would conform to what was basic in people. For example, although all of Fallingwater is opened by broad bands of windows, people inside are sheltered as in a deep cave, secure in the sense of hill behind them. Their attention is directed toward the outside by low ceilings; no lordly hall sets the tone but, instead, the luminous textures of the woodland, rhythmically enframed. . . . People are cosseted into relaxing, into exploring the enjoyment of a life refreshed in nature.[4]

Business environments may be carefully calculated to give a favorable impression to potential

5.85 FRANK LLOYD WRIGHT, Living room fireplace of the Kaufmann House (*Fallingwater*), Bear Run, Pennsylvania, 1936.

clients as well as employees and to facilitate and symbolize the division of labor. In the renovation of a former shopping mall as the corporate offices of Canberra Industries, a specialized electronics firm, the wide-open expanses were divided by movable partitions into a variety of workspaces. An open plan of mini-offices with low walls that allowed co-workers easy access to each other was used for most clerical and managerial employees, with a few private offices around the edges for corporate officers and conference spaces. Shown in Figure **5.86** is a low-ceilinged area used as a waiting "room" for visitors, backed by the president's receptionist and the offices of the president and senior administrators. Modern nonobjective works of art on the walls announce that this is a forward-looking company with good taste. Subdued lighting over the couches and an area rug set them off from the brightly-lit business areas beyond, without isolating them from view of the flow of business activity.

5.86 GLENN GREGG, architect, VIRGINIA LINBURG, interior designer, VIRGINIA McKERNAN, art consulting design, Executive Offices, Canberra Industries, Meriden, Connecticut, 1984.

ENVIRONMENTAL DESIGN

Beyond our homes and public buildings, we humans have also longed to shape our immediate outdoor environment. Traces of gardens have been found in the ruins of the earliest civilizations. In arid countries, water and lush plantings have been especially prized. On the Indian plains, for example, few wildflowers can survive the fierce sun, but cultivated gardens were mentioned in early Buddhist and Hindu texts. During the great Mughal period of the sixteenth and seventeenth centuries, the emperors had magnificent formal gardens built around their mountain retreats in Kashmir. One of the most beautiful, Nishat Bagh (**5.87**), was built by Asaf Khan, Prime

Minister to the emperor Jahangir and brother of his wife. When the emperor saw its lovely green terraces, the sparkling play of water over its stone water-ladders, and its views of the lakes and mountains beyond, he strongly recommended that Asaf Khan give it to him. Asaf Khan demurred, and the emperor in anger cut off the irrigation supply, without which the garden was deprived of much of its soul-soothing beauty. The water was eventually restored, and the garden is today a serenely refreshing oasis open to the public.

From ancient times, societies have also made arrangements for public gathering spaces. In urban

5.87 Nishat Bagh, India. View from the pavilion along the main axis of the garden, early 17th century.

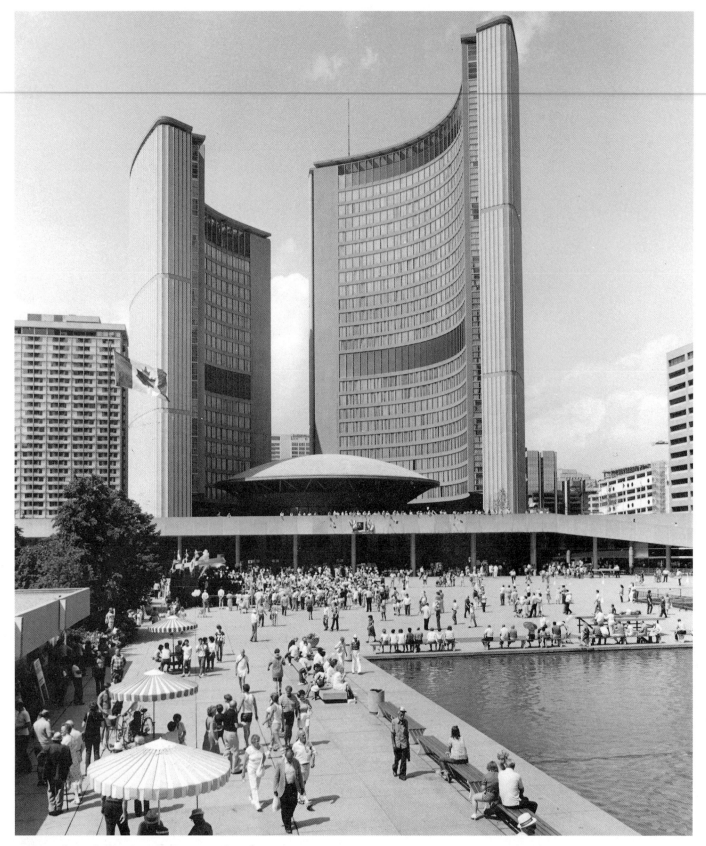

5.88 Nathan Phillips Square, Toronto, Canada.

design can be measured by whether people choose to congregate there. By this criterion, Nathan Phillips Square (**5.88**) in Toronto is overwhelmingly successful. Beyond the embrace of the twin towers of City Hall, a multi-level public space is booked every day with entertainers, from rock concerts to drum majorettes performing their routines, and the area is always thronged with people.

Municipalities have also made provisions for their occupants to benefit from natural settings without having to leave the city, by creating city parks. Some are extensive green belts; some are tiny areas with plantings and benches. In the heart of mid-town Manhattan, the Greenacre Foundation used the space between two buildings for a "vest-pocket" park featuring an artificial waterfall, tables and chairs, and shady trees (**5.90**). To step off the street into the ambiance of this place is a psychological and aesthetic respite from the high-pressure atmosphere of commercial New York. The sound of the waterfall drowns out street noises and its cooling spray adds to the soothing quality of the park.

Where water is plentiful, as it is in Rome, it is

5.89 GIANLORENZO BERNINI, Piazza of St Peter's, Rome. Plan.

5.90 HIDEO SASAKI, Greenacre Park, New York, 1979.

areas, plazas and public squares offer a different pace from linear sidewalks crammed with busy people going places. In seventeenth-century Rome, a need was felt for a great open public space to accommodate crowds approaching St Peter's, the monumental central structure of the Roman Catholic Church. The desired piazza (**5.89**) was designed by Gianlorenzo Bernini, who in addition to being a great painter and sculptor (see Figure 1.34) was also an architect. He planned a huge oval area open at one end and embraced by enormous Tuscan columns lined up to form two giant colonnades, like the arms of the Church welcoming the people. The project was so expensive that it almost bankrupted the Vatican.

Contemporary urban space planning often allows open areas between buildings. The success of their

5.91 Water Organ, Villa d'Este, Tivoli, near Rome, c.1550.

5.92 VICTOR HENDERSON and TERRY SCHOONHOVEN, known as THE LOS ANGELES FINE ARTS SQUAD, *Isle of California*, 1972. Enamel mural, 42 × 65ft (13 × 20m). Los Angeles.

sometimes used with even greater abandon. An entire river was diverted to feed the Water Organ of the Villa d'Este (**5.91**). This usage is entirely nonfunctional; it is a dynamic environmental sculpture in which water is the medium.

At the grassroots level, some groups are bringing life to the walls of ghettos and otherwise unappetizing cityscapes by painting MURALS. Some are celebrations of ethnic pride; others are humorous illusions, such as *Isle of California* (**5.92**). It was painted after a minor earthquake by the Los Angeles Fine Arts Squad as a teasing, surrealistically three-dimensional

takeoff on Californians' greatest fear: the freeways collapsing into the ocean.

On a broader scale, many people now feel a need to protect the beauty and environmental functions of the natural environment. Lawrence Halprin's sketch for *Sea Ranch* (**5.93**), a planned community on the California coast, sets up a series of restrictions that keep houses and roads hidden from view. In landscape design, he specifies use of native materials, forbidding attempts to create artificial grassy lawns, in the interests of preserving the original character of the dramatic setting. These are moral judgments

SEA RANCH

Handwritten annotations in sketch:

keep houses back from ridge face so only silhouette can be seen

no houses in flat above road

roads up draws.

Riding trails

no roads up face

new group plantings

houses at edge only where they cannot be seen by others

Planting restrictions for Sea Ranch
1. No lawns - ground covers only. ice plant, ceanothus etc.
2. Trees only natives or naturalized ie: Monterey cypress
3. Shrubs - natives ie: toyon, sweet bay, rhamnus.

Architectural restrictions..
These are harder to establish
1. Stable of arch'ts ? - no review
2. Materials ?
3. submissions ; to arch. commission

5.93 LAWRENCE HALPRIN, *Environmental Specifications for Sea Ranch*, 1963. Notebook sketch.

about how what we do to the environment affects the quality of our lives, as well as the ecological characteristics of the land. Applied to urban planning, the idealism of environmental design has led to such enlightened, humane projects as John Oldham's Narrows Interchange in Perth, Australia (**5.94**). It provides 40 acres of park space for pedestrians and a scenic view for those driving on the highways that intersect at this point, separated from the pedestrian areas of the park by over- and underpasses.

In trying to deduce some general aesthetic principles common to all those cities around the world that are invigorating or pleasant rather than disagreeable,

Lawrence Halprin came to the conclusion that good city planning—or happenstance—respects both the old and the new and provides a creative, vibrant environment for the multiplicities of human activities:

The provocative city results from many different kinds of interrelated activities where people have an opportunity to participate in elegant, carefully designed art and spontaneous, non-designed elements juxtaposed into what might be called a folk idiom, a series of unplanned relationships ... those chance occurrences and happenings which are so vital to be aware of—the strange and beautiful which no fixed, preconceived order can produce. A city is a complex series of events.[5]

5.94 JOHN OLDHAM, Landscape design for the Narrows Interchange, Perth, Western Australia.

VISUAL ASPECTS OF THE PERFORMING ARTS

While environmental designers use plants, water, earth, stone, paving materials, and screening devices to create pleasant settings for our daily lives, designers connected with the performing arts create artificial settings for make-believe. In the ancient Greek theatre, actors initially performed from a flat space at the foot of a hill, with the audience seated on the hillside. There was no scenery. This simple way of separating the imaginary space of the performance from the real space of the audience was later formal-

5.95 Reconstruction drawing of the Hellenistic theatre at Ephesus.

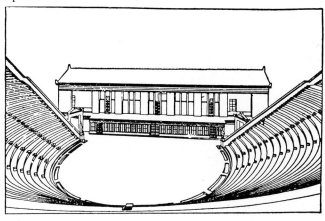

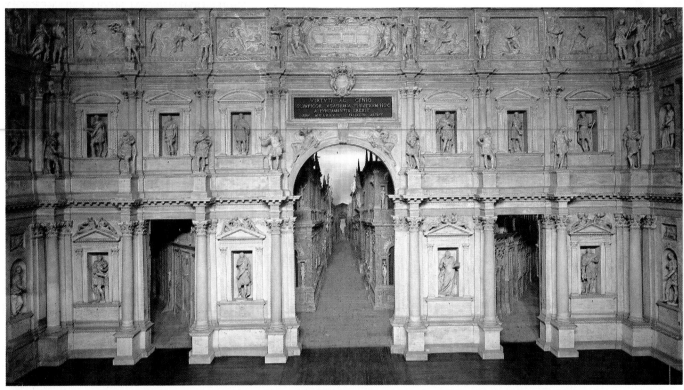

5.96 ANDREA PALLADIO and VINCENZO SCAMOZZI, Teatro Olimpico, Vicenza, Italy, 1580–84. Interior.

5.97 MING CHO LEE, set design for *Dog Lady* by Milcha Sanchez-Scott, Intar Theatre, New York, 1984. Costumes by Connie Singer, lights by Anne Militello.

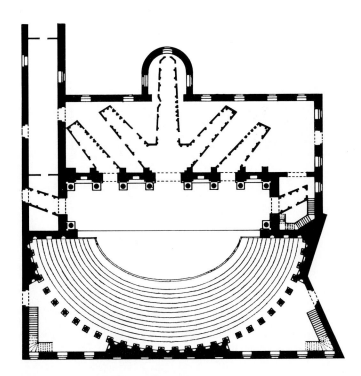

5.98 Plan of the Teatro Olimpico.

ized with tiered seating rising up a hillside in a semi-circle around a wooden platform (5.95). Actors entered and exited from a small building called a SKENE, from which we get the words "scene" and PROSCENIUM (in front of the *skene*).

To enhance the illusionary setting for theatrical performances, the area designated as a stage became more elaborate, with fabricated scenery designed to give the illusion of deep space. The chief way of creating this spatial illusion was the use of FORCED PERSPECTIVE, an exaggeration of the speed at which parallel lines converge toward a vanishing point. Shortly after perspective drawings were adopted by Renaissance artists, the device was transferred to the stage. At the *Teatro Olimpico*, designed by Andrea Palladio, completed by his pupil Vincenzo Scamozzi in 1585 and still standing today, three elaborate arches opened onto illusionary city streets with their floors raked upwards and rows of models of wooden houses built in forced perspective. All of this elaborate scenery, shown in a frontal view in Figure 5.96 and in plan in Figure 5.98, was intended to give the illusion of streets intersecting in a public square. Actors were confined to the acting space in front of the scenery; if they were to move up the streets, the falseness of their scale would become apparent.

Shortly after Scamozzi finished the Teatro Olim-

pico, he invented the form most familiar to us today, in which the entire stage is framed by a single PROSCENIUM ARCH. This arch is used to hide all the mechanics of the stage setting, from the tops of painted sets to light banks and pulleys that allow actors to fly. The tradition of forced perspective is still a mainstay of the set designer's trade, as indicated by the deep space of a Los Angeles barrio street Ming Cho Lee makes us perceive with his set design for *Dog Lady* (5.97). The stage itself is far shallower than what we think we see.

Another major illusionary device used in performing arts is costuming. Even when there is no stage, when performers and audience share the same space, performers may assume roles by wearing masks and costumes that hide their everyday identity. The Papuan costume shown in Figure 5.99 transformed ordinary people into spirits attending boys' initiation ceremonies. Such rituals expressed the beliefs of a

5.99 Costume of a *kaivakuku* (taboo advisor) from Waima, Papua New Guinea. Bark cloth, c.1900.

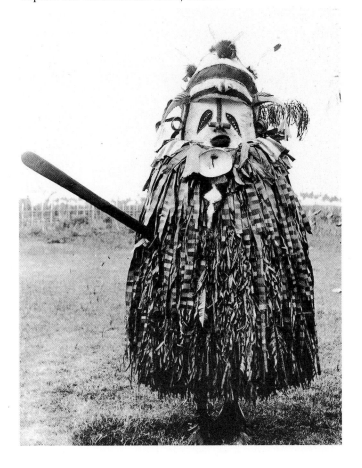

5.100 Scene from *La Bayadère*, Royal Ballet Company, London, 1978. Choreographed by Marius Petipa. Produced by Rudolf Nureyev.

5.101 ALWIN NIKOLAIS, *Sanctum*, Nikolais Dance Theatre, New York, 1976.

culture and were vital to its sense of identity and continuity.

In some performing arts, the bodies of performers are deliberately turned into design elements—elongated lines, opposing or harmonizing forms—like parts of a painting or sculpture that changes through time. This is true in classical ballet; in this scene from *La Bayadère* (**5.100**), the *corps* forms a low circle around the central characters, like a splash radiating outward from the action in the middle. Dramatic high-contrast lighting is used to make the dancers appear as points of light within a dark and otherwise empty space. In Alwin Nikolais's modern dance choreography, all reference to the body as human is deleted. Dancers in his *Sanctum* (**5.101**) move within webs of stretchy fabric, creating an eery grotto of fantasy forms. And Charles Simonds becomes both sculptor and sculpture in his performance piece *Landscape-Body-Dwelling* (**5.102**), in which he sculpts a clay landscape on his own nude body, complete with miniature dwellings for the "Little People."

The body is used as symbolic mask and gesture by Japanese *kabuki* actors. They wear highly stylized makeup over a white base, transforming their own faces into visages suggesting their roles. They offer their bodies as armatures for costumes weighing up to 50 pounds, requiring frequent adjustments by stage attendants who wear black and are therefore not considered visible. These highly trained actors, whose apprenticeships begin at the age of six or seven, assume stylized gestures, freezing momentarily like statues in melodramatic poses (**5.103**) that carry clear meaning for those familiar with *kabuki* conventions. Men play all parts; women were banned in 1629 as part of an attempt by the rulers to restrict

5.102 CHARLES SIMONDS, *Landscape-Body-Dwelling*, 1970.

the popularity of this art form.

In puppetry, all is illusion. Figures can be as fantastic as the puppeteer's imagination allows, and designed to hide the hands that move them. Many elaborate systems have been devised for remote control of marionettes and puppets, but in Frank Ballard's puppets for *The Golden Cockerel* (**5.104**), the puppeteers reveal themselves, costumed as part of the action. They keep a dead-pan expression and focus on the puppets they operate and speak for. But their presence within the illusory world of the puppets blurs the line between magic and reality, coaxing viewers to enter the world of magic themselves.

5.104 FRANK BALLARD, designer and director, *The Golden Cockerel*, 1977 performance at the University of Connecticut.

CHAPTER SIX
HISTORICAL STYLES IN WESTERN ART

Change is the one sure constant in art. Each artist's work typically evolves through stages, going as far as it can in one direction and then exploring other approaches. The same thing happens at a group level, leading over time to movements as different as High Renaissance and Pop Art.

Works of art always express something of the person who created them. They also reflect the views and artistic conventions of the society at the time. Approaches to art have often carried enough similarities among varying artists who were working at the same time, in the same place, for us to be able to categorize them as stylistic movements. These movements lasted a long time at first, since societies were isolated from each other and information passed very slowly from one to the next. Then, as commerce between areas became more common, innovations in one area were more rapidly reflected elsewhere.

Today styles come and go with such speed that the twentieth century alone has been characterized by a great number of artistic movements. Contemporary societies are also far less uniform, supporting a plurality of lifestyles and life views. When the major patrons for art were the state and church, and when the academies dictated whose work was approved and shown, their views dominated what was done. Many stylistic movements now coexist, and many artists are doing work so unique that it does not fit into any group designation.

In this chapter we will trace the chain of the major art styles from earliest times to the present. Although we have examined art from all cultures throughout this book, in this chapter we will limit our focus to the evolution of European and North American art for the sake of clarity. The art of each culture has similarly evolved through many styles, partly through internal innovations and partly through contact with other cultures. Western art has often been influenced by that of non-Western societies— Rembrandt, for instance, was a collector of Near Eastern art, and Picasso was strongly affected by African sculpture. As communications shrink our globe, techniques and approaches to art are increasingly cross-pollinating. Many of the works of Western art discussed earlier are drawn into this discussion and indicated on the Timeline on pages 380–381, to help place them in historical context.

Although our society tends to equate the passage of time with progress, some art historians feel that the art of certain periods in our past has never been surpassed. Note, too, that many of the historical groupings of artists are rather artificial constructs that were developed after the fact; others were actual groups of artists working together with a shared vision. Some of these are still called by the derogatory terms given to them by their contemporary detractors.

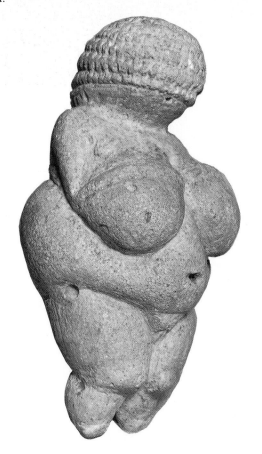

6.1 *Venus of Willendorf*, Lower Austria, c.30,000–25,000 BC. Limestone, 4½ins (11.5cm) high. Natural History Museum, Vienna.

Prehistoric Art

Very few traces remain of the lives of our earliest ancestors. We do know, however, that by 30,000 BC *Homo sapiens* was creating works we now regard as paintings and sculptures. Of the latter, the most famous is the tiny female figure found at Willendorf in Austria (**6.1**). Often referred to as the "Venus of Willendorf," she is only 4½ inches (11.5cm) tall, small enough to fit comfortably in one's hand. Archaeologists think she, like other similar figures from the same period, was probably a fertility image, judging from the exaggeration of her reproductive

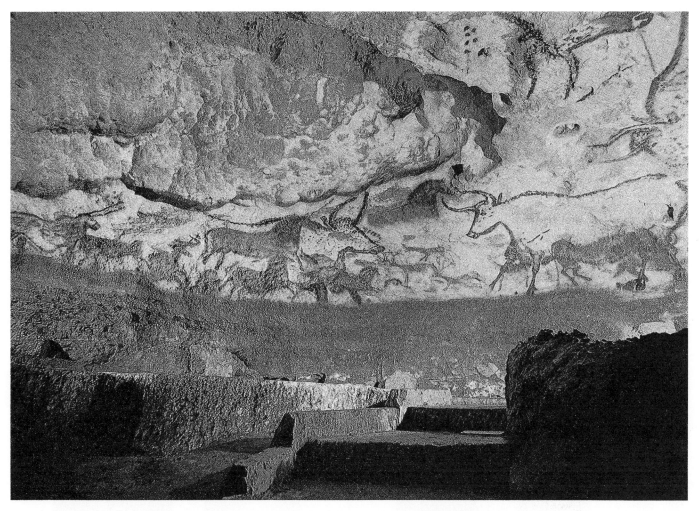

6.2 Main hall ("Hall of Bulls"), Lascaux, France, c.15,000–10,000 BC. Approximately life size.

areas, to the exclusion of facial features. Somebody carved her of limestone and painted her red, just as the people painted their bodies with red ocher.

In addition to other small, stylized stone carvings of humans and animals, early peoples incised and painted remarkably realistic animals on the roofs and walls of caves. The most famous of the cave paintings were found in Lascaux, France (**6.2**), by children exploring an extensive cave beneath an uprooted tree. There are hundreds of paintings covering a series of chambers with large figures of bulls, deer, horses, bison, and ibexes. They were apparently created by many artists over many years, using fur, feathers, moss, sticks, or fingers to outline the creatures with pigments from natural minerals. These outlines were then colored in with powders perhaps blown through

tubes of bone. Some of these cave paintings are so vividly wrought that archaeologists at first thought they were fakes, but now their authenticity has been verified, and the ones at Lascaux have been dated to about 15,000 BC.

The Lascaux caves, like others in which prehistoric paintings have been discovered, were tortuous underground water channels up to four thousand feet (1300m) long, with the painted areas far removed from the cave mouths where the people lived. They would have been very dark, illuminated only by small stone lamps, and very quiet, creating an atmosphere of other-worldly strangeness appropriate for the magical purposes for which some scholars think the paintings were created. Although we have no way of knowing for sure, it seems likely that the images

TIMELINE

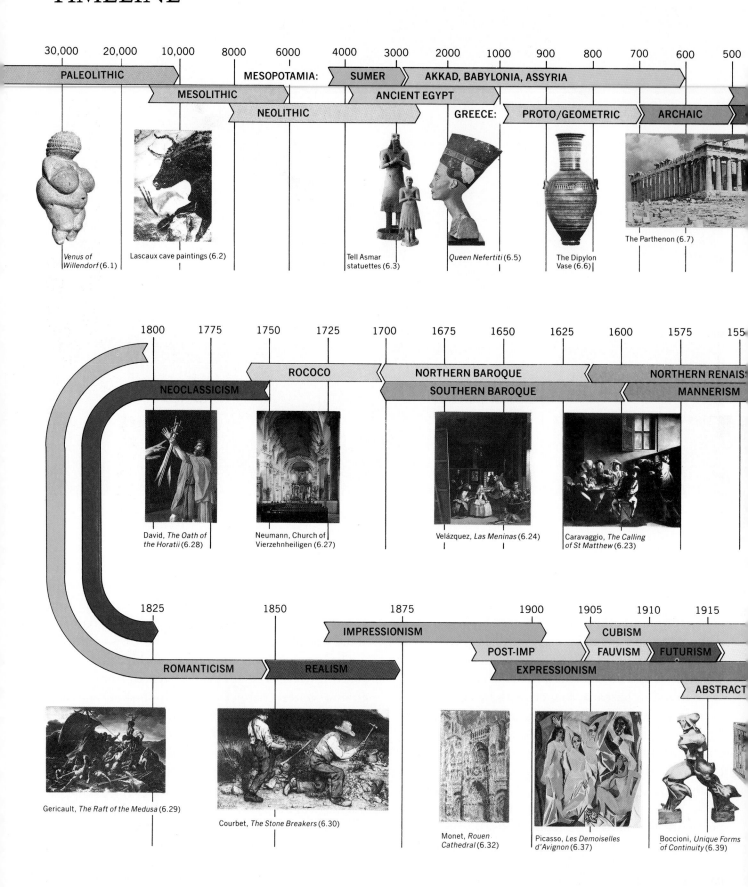

30,000 **20,000** **10,000** **8000** **6000** **4000** **3000** **2000** **1000** **900** **800** **700** **600** **500**

PALEOLITHIC

MESOPOTAMIA: SUMER AKKAD, BABYLONIA, ASSYRIA

MESOLITHIC

ANCIENT EGYPT

NEOLITHIC

GREECE: PROTO/GEOMETRIC ARCHAIC

Venus of Willendorf (6.1)

Lascaux cave paintings (6.2)

Tell Asmar statuettes (6.3)

Queen Nefertiti (6.5)

The Dipylon Vase (6.6)

The Parthenon (6.7)

1800 **1775** **1750** **1725** **1700** **1675** **1650** **1625** **1600** **1575** **155**

ROCOCO NORTHERN BAROQUE NORTHERN RENAIS

NEOCLASSICISM SOUTHERN BAROQUE MANNERISM

David, *The Oath of the Horatii* (6.28)

Neumann, Church of Vierzehnheiligen (6.27)

Velázquez, *Las Meninas* (6.24)

Caravaggio, *The Calling of St Matthew* (6.23)

1825 **1850** **1875** **1900** **1905** **1910** **1915**

IMPRESSIONISM CUBISM

POST-IMP FAUVISM FUTURISM

ROMANTICISM REALISM EXPRESSIONISM

ABSTRACT

Gericault, *The Raft of the Medusa* (6.29)

Courbet, *The Stone Breakers* (6.30)

Monet, *Rouen Cathedral* (6.32)

Picasso, *Les Demoiselles d'Avignon* (6.37)

Boccioni, *Unique Forms of Continuity* (6.39)

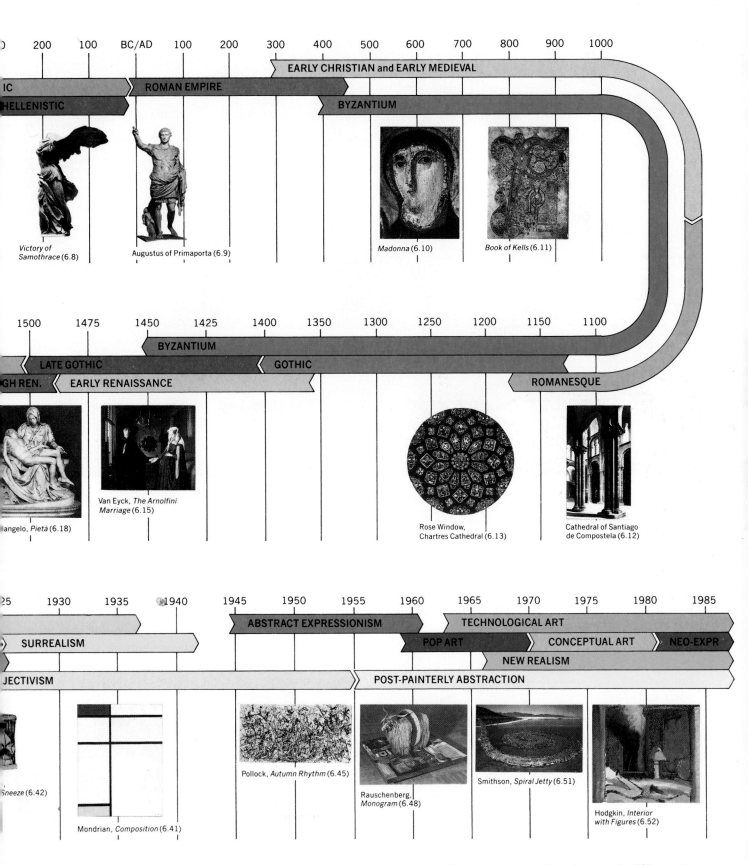

200 100 BC/AD 100 200 300 400 500 600 700 800 900 1000

EARLY CHRISTIAN and EARLY MEDIEVAL

ROMAN EMPIRE

IC

HELLENISTIC

BYZANTIUM

Victory of Samothrace (6.8)

Augustus of Primaporta (6.9)

Madonna (6.10)

Book of Kells (6.11)

1500 1475 1450 1425 1400 1350 1300 1250 1200 1150 1100

BYZANTIUM

LATE GOTHIC

GOTHIC

GH REN. EARLY RENAISSANCE

ROMANESQUE

angelo, *Pietà* (6.18)

Van Eyck, *The Arnolfini Marriage* (6.15)

Rose Window, Chartres Cathedral (6.13)

Cathedral of Santiago de Compostela (6.12)

25 1930 1935 1940 1945 1950 1955 1960 1965 1970 1975 1980 1985

ABSTRACT EXPRESSIONISM

TECHNOLOGICAL ART

SURREALISM

POP ART

CONCEPTUAL ART

NEO-EXPR

NEW REALISM

JECTIVISM

POST-PAINTERLY ABSTRACTION

Pollock, *Autumn Rhythm* (6.45)

Rauschenberg, *Monogram* (6.48)

Smithson, *Spiral Jetty* (6.51)

Hodgkin, *Interior with Figures* (6.52)

Sneeze (6.42)

Mondrian, *Composition* (6.41)

Differential timescales have been used, resulting in the relative compression of earlier periods. This apparent bias in favor of recency should be noted, although it is difficult to avoid: for if this Timeline represented all periods on the timescale used for the twentieth century, it would measure 315 feet (96 meters) in length.

381

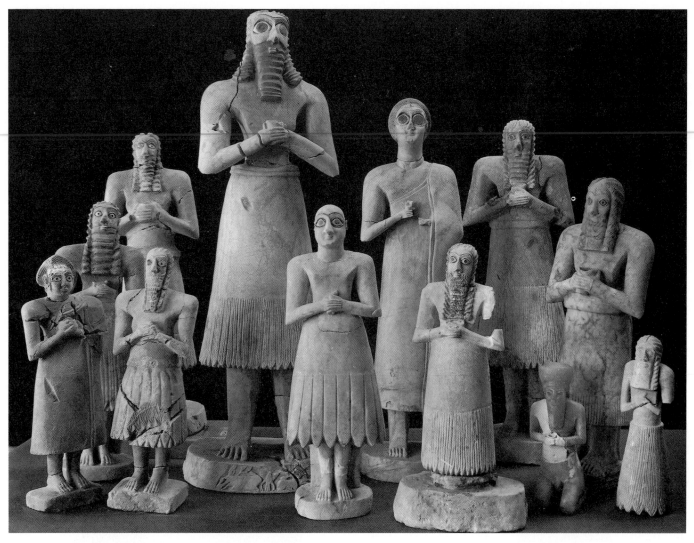

6.3 Statuettes from the Abu Temple, Tell Asmar, c.2700–2600 BC. Marble, tallest figure 30ins (76.2cm) high. The Iraq Museum, Baghdad.

were painted to insure success in the hunt, with their surprising representational accuracy a valuable aid in invoking the spirit of the animal ahead of time and ritually killing it. Those animals depicted as pregnant might have been magically encouraged to be fruitful.

Near Eastern

The earliest settled civilizations in the West were in Mesopotamia, on the plains between the Tigris and Euphrates rivers in what is now Iraq. The first of these organized urban communities were in Sumer, where each of many cities was protected by a local god or goddess, served and represented by human rulers. Much of the Sumerians' art was devoted to

ritual religious themes, such as presentations of gifts to the gods. Some of the low relief stone carvings and impressions made in clay or wax by cylindrical seals are lively and realistic. The statues placed around the inner walls in a temple devoted to Abu, god of vegetation (**6.3**), are more simply conceived as dignified, stylized cylindrical forms in an attitude of worship. The largest figure represents Abu. All are carved in rather soft gypsum marble, with painted hair and beards and inset eyes of black limestone or lapis lazuli against shells.

Egyptian

In isolation from the Mesopotamian civilization, an elaborate culture was developing in Egypt that span-

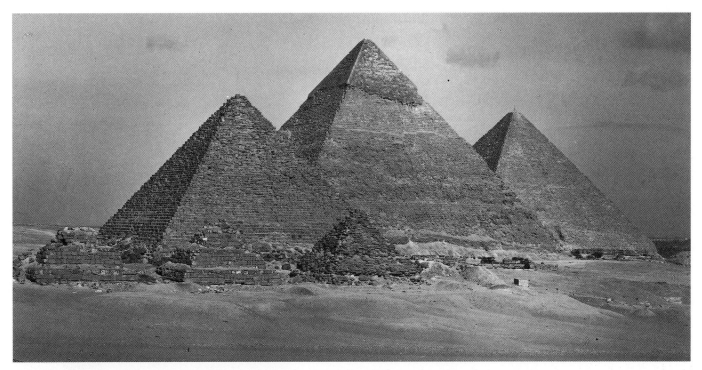

6.4 The Pyramids of Mycerinus (c.2470 BC), Chefren (c.2500 BC), and Cheops (c.2530 BC), Giza, Egypt.

ned about two thousand years. At first the arts of Egypt focused almost exclusively on the hereafter, particularly on insuring eternal life for deceased rulers. Great pyramids, such as those at Giza (**6.4**), were erected to house the mummies, statues, and belongings of kings. The pyramid form was intended as an image of the rays of the sun, a stairway on which the king could ascend to heaven. We still don't really know how these monumental structures were built, though many theories have been explored.

Egyptian paintings (see Figure 2.28) and sculptures (such as the block form of the Chancellor Senmut with Princess Nefrua as a child shown in Figure 2.20) often combined considerable artistic skill with rigid stylistic conventions. Sculptures were quite obviously rectangular; paintings of the human form usually showed the head in profile, the torso in frontal position, and the legs in profile, leading to some anatomically impossible positioning. Such conventions were not designed to please mortals; they were ways of insuring that a statue would be a suitable dwelling place for the spirit, or that a painting gave as much information as possible. But as the New Kingdom evolved, with Egypt becoming the strongest entity in the Mediterranean area and Akhenaton declaring himself the son of a single god, the god of the sun, art became somewhat more earthly and less stylized.

6.5 *Queen Nefertiti*, from Tell el-Amarna, c.1360 BC. Limestone, 19ins (48cm) high. Egyptian Museum, Berlin.

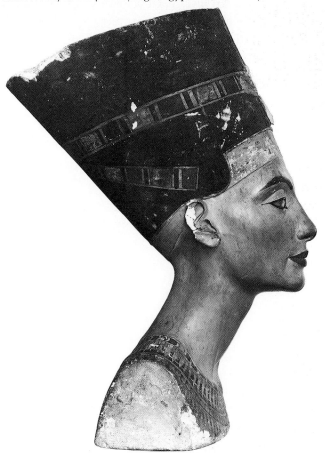

383

The elegant sculpture of Akhenaton's queen, Nefertiti (**6.5**), probably exaggerates certain features, such as the carefully balanced length of her neck. Yet beneath her painted makeup (all Egyptian statues having been initially painted), we can sense a real person. After Akhenaton's time, Egyptian art reverted back to earlier stylized conventions.

Greek

From the sixth to second centuries BC, a remarkable civilization arose in Greece which is still regarded as one of the highest models for the arts. Even before this time, potters of the GEOMETRIC period were creating two-handled amphoras and other vessels of symmetrical beauty, worked with elaborate geometric patterns. The lovely wheel-thrown *Dipylon Vase* (**6.6**), so named for the cemetery in Athens in which it was found, was of a type used to mark graves. Almost six feet (2m) high, it had to be built in separate sections which were then joined. In addition to the Greek fret pattern later used on buildings and bands of other geometrically symmetric motifs, the amphora is decorated with a frieze of mourning human figures reduced to a visual shorthand.

The Golden Age of Athens—the heart of the CLASSICAL PERIOD—lasted for only part of the fifth

6.6 The Dipylon Vase, Attic Geometric amphora, 8th century BC. 59ins (150cm) high. National Archeological Museum, Athens.

6.7 The Acropolis, Athens, 448–405 BC. View from the West.

6.8 *Victory of Samothrace*, c.190 BC. Marble, 96ins (244cm) high. The Louvre, Paris.

century BC, but its emphasis on rationality, idealized beauty of form, and avoidance of extraneous ornamentation has never been equaled. It was during this period that Pericles signaled his victory in Athens by rebuilding the Acropolis high above the city, with the *Parthenon* (**6.7** and 3.36) as its focal point. In sculpture, artists abandoned the contrived Egyptian poses for more naturalistic ones, such as the CONTRAPPOSTO attitude of the *Spear Bearer* (2.22) and the *Warrior from Riace* (1.42). Both are designed to contrast the dynamic tension of taut musculature, emphasized by the turning of the body, with an apparent air of relaxation.

After the elegant restraint of the Classical Period, the HELLENISTIC PERIOD was marked by greater emotionalism. During this period, dating from the death of Alexander the Great in 323 BC and spanning about three hundred years, the power of the Greek city-states declined but Greek culture continued to spread and was adopted by the newly dominant Romans. One of the greatest works of this period was the life-filled, wind-blown *Victory of Samothrace* (**6.8**), a marble sculpture erected by the people of the little island of Samothrace to celebrate a victory at sea. The emotional drama of her form also characterizes the Hellenistic mosaic of *The Battle of Issus* (4.37). The more natural, informal style of the Hellenistic Period can also be sensed in the warm body of the *Venus de Milo* (2.73), and its predilection for "human interest" is reflected in the late Hellenistic bronze of the *Seated Boxer* (5.11).

Roman

While the Greeks were developing a culture of ideas, the Romans were building a military empire that eventually controlled southern and western Europe and much of North Africa and the Near East. As people of varied cultural background, those living within the Roman Empire did not have a single artistic style, nor did the Romans themselves develop significantly new styles in art. In general, they copied the much-admired Greek art, to the point of using copies of Greek statues with sockets in their necks so that heads of Romans could be attached. Copies of Greek nude statues were also draped with Roman clothing, as in the statue of Augustus (**6.9**), which is thought to be based on the Greek *Spear Bearer* (2.21).

Many Roman sculptures were celebrations of the secular might of the emperors. Augustus's cuirass is covered with symbols of victory, and the equestrian statue of Marcus Aurelius (2.23) originally included the cringing figure of a captured barbarian leader beneath the horse's upraised hoof. As part of their empire-building, the Romans erected many public buildings, larger than those of Greece, on a scale facilitated by the introduction of concrete and space-spanning arches, vaults, and domes. It was the Romans who introduced nonfunctional architectural monuments, such as the Arch of Constantine (1.15) and Trajan's Column (2.128). Funerary art of the times included busts made from death masks and sarcophagi, such as the one featuring high reliefs of Dionysos and the Seasons (1.5), for honored corpses once the practice of cremation was abandoned.

Early Christian and Byzantine

In the first centuries after Christ's death, Christians were persecuted as threats to the state, so they kept what little sacred art they created secret and symbolic. Most of it consisted of burial pieces for those of the faith buried in the catacombs beneath Rome.

When the Emperor Constantine embraced Christianity in 313 as the official religion of the Roman

6.9 *Augustus of Primaporta*, c.20 BC. Marble, 80ins (203cm) high. The Vatican Museums, Rome.

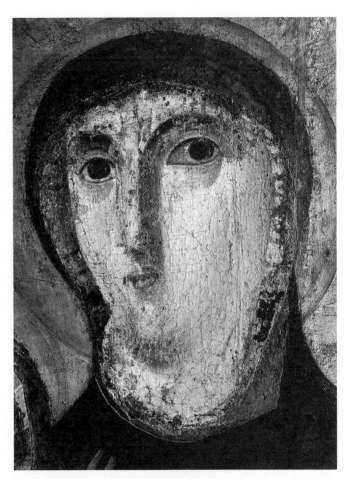

6.10 *Madonna*, 6th–7th century AD. Detail, encaustic on wood. Santa Francesca Romana, Rome.

Empire and made Constantinople its second capital, Christian art began to flower. This was particularly so in the eastern half of the Empire as barbarian groups inundated the Western Empire in the fifth century. In the eastern BYZANTINE culture, which lasted a thousand years, all art was religious and created anonymously by the devout. ICONS, inspired paintings of Christ, the Virgin Mary, and the saints, were revered for their mystical wonderworking powers. The elongation of figures was stylistically distinctive (**6.10**). Elaborate mosaics, rendered in a stylized, spiritually expressive manner, covered the ceilings and walls of churches with Christian stories. The vast domed church of Hagia Sophia (2.38), built in Constantinople by the Emperor Justinian as the greatest of all Christian churches, was so large for its structure that it had to be rebuilt and buttressed after the dome collapsed.

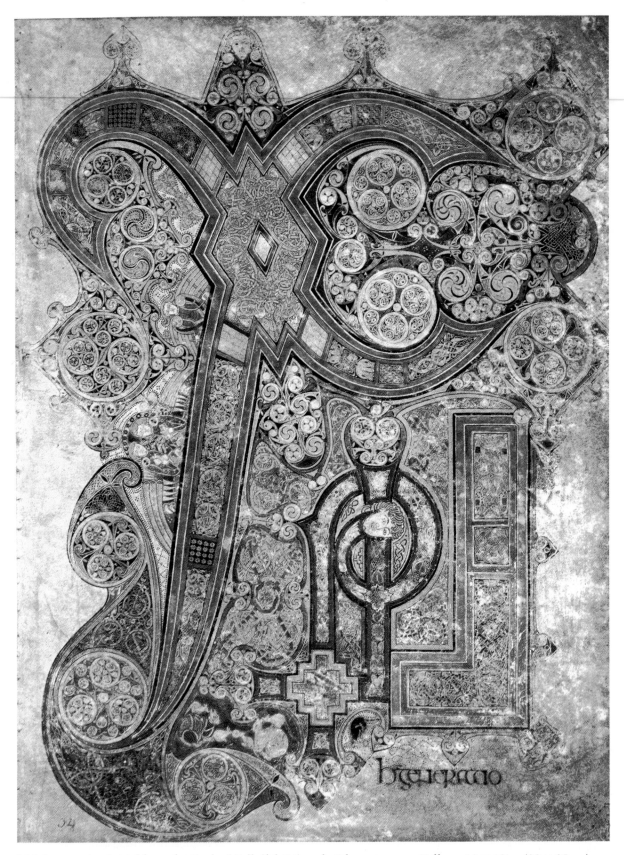

6.11 Incarnation Initial from the *Book of Kells* (fol. 34), early 9th century AD. Vellum, 13 × 10ins (33 × 25cm). Trinity College Library, Dublin.

Early Medieval

Meanwhile, Western Europe was in the throes of the Dark Ages. Learning, spirituality, and art were kept alive in the monasteries and convents. A stunningly beautiful new development under these circumstances was the appearance of elaborate illuminated manuscripts. These unique, handmade copies of sacred texts, such as the Gospels, became especially ornamental in Ireland and the northern islands of Britain, where Christian fervor was allied with ancient traditions of interlaced and spiraling spiritual motifs. In the hands of the monks of the Iona community off the coast of Scotland, capital letters became extraordinarily ornate. In the *Book of Kells*, which they created, there are over 2000 illuminated capitals used at the beginning of Gospel passages.

6.12 Cathedral of Santiago de Compostela, Spain, c.1077–1124. Interior.

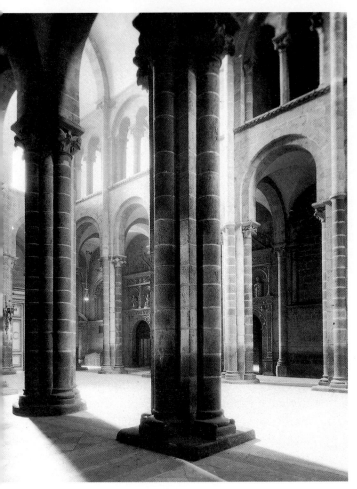

The one shown here (**6.11**) fills an entire page with intricate traceries surrounding the *Chi-Rho* monogram that begins St Matthew's story of the birth of Christ.

Romanesque

In the middle of the eleventh century, Europe entered a new period of intense creative activity centered on the Christian Church. Life was still uncertain, and the Roman culture that had once dominated the area was still widely considered the height of the arts. Nevertheless, a new, distinctive aesthetic began to emerge. It was later called ROMANESQUE because of its supposed borrowings from classical Rome, but it had its own form, expressed primarily through architecture. The great longing for churches was answered with a sacred architecture characterized by rounded arches, thick walls and columns, and relief carvings in stone (3.31). The desire for repentance inculcated by the Church led many people to undertake long pilgrimages to certain churches, most notably the Romanesque Cathedral of Santiago de Compostela in Spain (**6.12**). These heavy structures admit only indirect lighting in most areas, lending Romanesque interiors a massive, blocky, almost fortress-like atmosphere.

Gothic

In the middle of the twelfth century, European art and architecture began to undergo an even more profound change. As burgeoning cities shifted the concentration of power from feudal rural areas, spirits seemed to lift, and with them soared the ethereal vertical heights of the new GOTHIC cathedrals. This way of building had a clear beginning in the directions given by Abbot Suger for the first Gothic cathedral: that space be used to symbolize the mystery of God, that God is mystically revealed in light, and that perfect harmony between parts is the basis of beauty. The pointed arch, ribbed vault, and flying buttress allowed architects to replace the heavy appearance of Romanesque structures with more slender and vertical architectural details, such as those of Beauvais (1.50) and Chartres Cathedrals

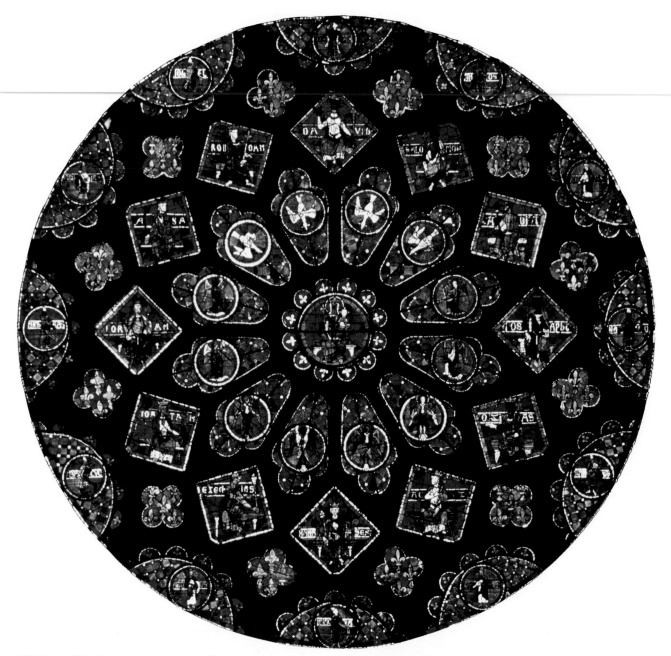

6.13 Rose Window, north transept, Chartres Cathedral, France, c.1230. Stained glass, 42ft 8ins (13m) diameter.

(5.66). The new technology also allowed much larger windows, and these were often filled with intricate stained glass designs and pictures of gemlike brilliance. They were created from cut pieces of colored glass, some of which were also painted for fine details, joined with lead strips, and reinforced with a framework of iron bands. The great rose window in Chartres Cathedral (**6.13**) is over 42 feet (13m) in diameter; it offers an illuminated view of the Virgin Mary surrounded by angels, archangels, doves representing the Gospels and the Holy Spirit, and then outer circles of figures from the Old Testament.

In painting, artists began using the two-dimensional surface as a frame within which to create the illusion of three-dimensional depth. Although it was difficult to do so in the demanding

6.14 GIOTTO, *The Lamentation*, 1305–6. Fresco, 7ft 7ins × 6ft 7½ins (2.31 × 2.02m). Arena Chapel, Padua.

medium of fresco, Giotto's *The Lamentation* (**6.14**) illustrates a revolutionary approach to the modeling of forms and the new effort to give figures an appearance of being alive and mobile, rather than frozen in static postures. These figures are also imbued with individualized human emotions, from the fierce grief of Mary to the sorrow of Mary Magdalene, to the philosophical acceptance of the two disciples to the right. Giotto was a Florentine artist whom many consider the originator of the movement that led to the Renaissance.

In contrast to Romanesque relief carvings, Gothic sculptures integrated into cathedrals were more three-dimensionally separate from their supports. They often had a humane, peaceful mien, as is evident in the countenance of the thirteenth-century German wood statue of St James the Less (5.1).

Late Gothic

Although Gothic art appeared in countries throughout Europe, it waxed and waned at different times at different places, complicating our later efforts to piece together a coherent picture of art history. In north-western Europe, an increasingly expressive and naturalistic successor to the Gothic style lived

6.15 JAN VAN EYCK, *The Marriage of Giovanni Arnolfini and Giovanna Cenami*, 1434. Oil on oak panel, 32¼ × 23½ins (81.8 × 59.7cm). The National Gallery, London.

on until about 1500. Painting was developed to new heights by artists of the Flemish school using the new medium of oil rather than tempera. The van Eyck brothers were early masters of the medium and used it to create the illusion of three-dimensional figures in deep space, with fine details and the luminous appearance possible only with skillful use of oils. Jan van Eyck's *The Marriage of Giovanni Arnolfini and Giovanna Cenami* (**6.15**) is studded with traditional symbols from the Gothic period—such as the dog indicating faithfulness in marriage, the single candle in the chandelier symbolizing Christ's sacred presence in the marriage ceremony, and the couple's shoes on the floor, reminders of God's commandment to Moses to take off his shoes when he was on holy ground. Yet the textures of metal, furs, fabrics, and wood are rendered with a realism never before achieved in any medium.

Early Renaissance in Italy

Meanwhile, in fifteenth-century Italy a major shift was underway from the metaphysics of the Middle Ages to a rebirth, or RENAISSANCE, of interest in the classical styles of ancient Greece and Rome. Classical sculptures and architecture were carefully studied for their principles of harmony and symmetry. To these were added a new understanding of perspective based on rediscovery of Euclidian geometry from classical Greece. The careful use of LINEAR PERSPECTIVE contributes to the sense of spaciousness in Fra Angelico's *Annunciation* (**6.16**), one of many frescos

6.16 FRA ANGELICO, *Annunciation*, c.1440–45. Fresco. San Marco, Florence.

6.17 LORENZO GHIBERTI, *Porta del Paradiso (Gates of Paradise)*, 1424–52. Gilt bronze, 17ft (5.2m) high. Baptistery, Florence.

he painted for a Dominican convent in Florence. A gentle and conservative monk, Fra Angelico retained many Gothic traits—such as bright pigmentation and the use of the flowery garden as a symbol of Mary's virginity—while incorporating some of the new devices such as perspective rendering and more realistic depiction of anatomy and fabric draping.

The work of the Florentine painter Sandro Botticelli, such as *The Birth of Venus* (1.44), likewise shows certain ties with Gothic traditions, such as a more two- than three-dimensional approach to figure drawing. But Botticelli's lyrical evocation of the idealized beauty of the human body and of harmonious configurations of forms is clearly innovative, with classical origins apparent in its style as well as its mythological subject matter.

The Early Renaissance also marked a rebirth of logic, though still in the service of the Church. In contrast to the devotional quality of Gothic arts, the Renaissance artist and art historian Lorenzo Ghiberti held that artists should be trained in grammar, geometry, philosophy, medicine, astronomy, perspective, history, anatomy, design theory, and arithmetic. Of his splendid gold-covered *Porta del Paradiso* ("Gates of Paradise") (**6.17**), paneled with ten scenes from the Old Testament, some incorporating scores of figures, he wrote that he "endeavored to imitate nature as much as possible, . . . with buildings drawn to the same proportions as they would appear to the eye and so true that, if you stand far off, they appear to be in relief."[1] The doors are actually modeled in low relief, but the illusion is that of very deep space.

High Renaissance in Italy

During the brief period in Italy now known as the HIGH RENAISSANCE, roughly 1490 to 1520, a number of artists centered in Rome brought forth some of the greatest art the world has ever seen. This great outpouring was freed from the stylized conventions of earlier sacred art, and informed by but not held to classical traditions. The work of Michelangelo was passionately individualistic, glorifying the divine in the individual. After hundreds of years, people are still deeply moved by Michelangelo's *Pietà* (**6.18**),

sculpted when he was only 24 years old. He regarded the human body as the prison of the soul, noble on the surface and divinely yearning within, and experienced sculpting as liberating a living form from inert stone. In addition to his anatomically and emotionally powerful sculptures, he also painted the vast Sistine Chapel ceiling (3.42), in an agonizingly awkward upward-looking position. Perhaps the extreme example of the Renaissance ideal of human freedom, Michelangelo refused to be enslaved by tradition or other people's standards, recognizing only his own divinely inspired genius and his longing for beauty as his guides.

Leonardo da Vinci applied his inventive genius to many fields, including art, and was thus the epitome of the "Renaissance man." His searching mind led him to engineering, mathematics, music, poetry, architecture, and natural science, as well as painting and sculpture. He continually studied animals, plants, human anatomy, the movement of water, and the play of light and shadow for a fuller understand-

6.18 MICHELANGELO BUONARROTI, *Pietà*, 1499. Carrara marble, 69ins (175cm) high. St Peter's, Rome.

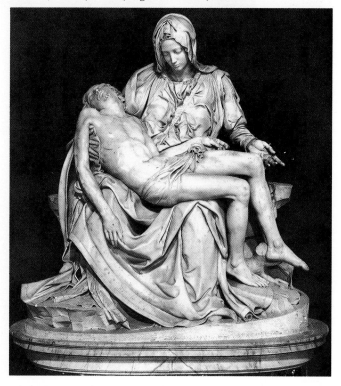

6.19 LEONARDO DA VINCI, *The Virgin of the Rocks*, c.1485. Oil on panel, 74⅝ × 47¼ins (189.5 × 120cm). The Louvre, Paris.

ing of the natural world. In art, his beautifully observed figure drawings are still consulted by artists as guides to the depiction of human anatomy. He used CHIAROSCURO effects not only to round his forms in space but also to enhance the emotional qualities of his paintings and guide the viewer's eye. In his compelling *The Virgin of the Rocks* (**6.19**), light glimmers on the flesh of the sacred figures and beckons in the mysterious distance. It was Leonardo who also developed SFUMATO modulations in oil painting to soften contours and create hazy atmospheric effects. Ever experimenting, he completed few works. His famous *Last Supper* (3.29) was done in tempera with a ground of pitch and mastic that he had invented—and which soon began to break down,

requiring a series of restorations.

The artist whose work most clearly characterizes the High Renaissance was Raphael. In contrast to Michelangelo's passion and Leonardo's inventiveness, Raphael's work emphasizes classical harmony, reason, and idealism. His *School of Athens* fresco (**6.20**) stands as a symbol of the humanistic High Renaissance appreciation of learning. The central figures are Plato and Aristotle, flanked by other ancient philosophers, mathematicians, scientists, and their students, including Pythagoras writing at the lower left and Euclid demonstrating a theorem at the lower right. This serenely balanced composition covers a 26-foot (8m) span at the Vatican Palace. Raphael further developed the triangular com-

6.20 RAPHAEL, *The School of Athens*, 1509–11. Fresco, 26 × 18ft (7.9 × 5.5m). Stanza della Segnatura, Vatican Palace, Rome.

position associated with Leonardo, and it was thereafter used extensively in depictions of the Madonna and the Holy Family.

Mannerism

In opposition to the humane balance and order of High Renaissance works such as *The School of Athens*, many Italian artists from 1525 to 1600 developed a more self-consciously sophisticated approach called MANNERISM by their detractors. Bronzino's work (4.18) is one example of the cool, sometimes almost sinister quality of elegance that some artists sought; Correggio (4.28) explored the refinements that technical perfection could lend to sensuality. A comparison of Tintoretto's version of *The Last Supper* (**6.21**) with that of Leonardo (3.29) reveals the great aesthetic distance between the Renaissance ideals of harmony and logic and the inventive theatricality of Tintoretto's Mannerism. As in his *The Finding of the Body of St Mark* (2.51) and *Leda and the Swan* (3.11), bodies turn in agitated gestures to tell a story of the infusion of the divine spirit into the bread and wine as if the narrative were being expertly enacted on a stage. In sculpture, Mannerism is most obviously exemplified by the sensuous work of Benvenuto Cellini, such as the saltcellar of Francis I (1.46).

Northern Renaissance

Beyond the Alps, the explosion of creativity in Italy at first had little effect on artists still following Late Gothic traditions, until 1500, when distinctively Northern and Protestant versions of the new trends appeared briefly and vigorously in Germany. At one extreme was the dramatic intensity of Matthias Grünewald's work, such as the *Isenheim Altarpiece*,

6.21 JACOPO TINTORETTO, *The Last Supper*, 1592–94. Oil on canvas, 12 × 18ft (4.4 × 5.5m). San Giorgio Maggiore, Venice.

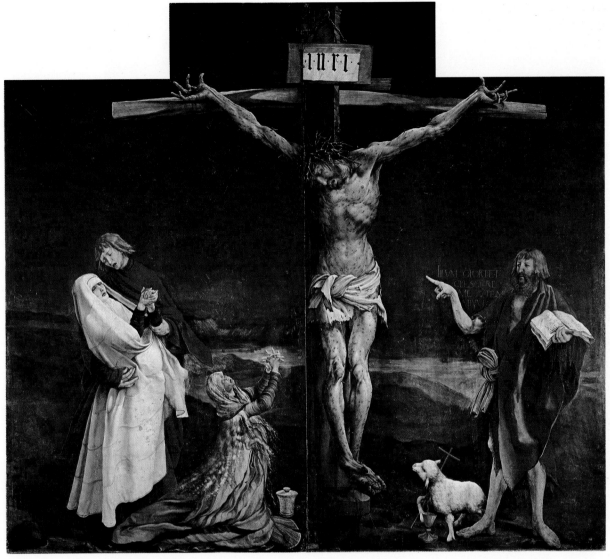

6.22 MATTHIAS GRÜNEWALD, *The Crucifixion*, central panel of *The Isenheim Altarpiece*, c.1510–15. Oil on panel, 106 × 121 ins (269 × 307 cm). Musée Unterlinden, Colmar, France.

of which the agonizing central *Crucifixion* panel is shown here (**6.22**) and the exuberant *Resurrection* panel was shown in Figure 2.111.

While only the individualistic aspects of the Italian Renaissance seem to come forth in Grünewald's work, Albrecht Dürer was so impressed by the disciplined, rational approach of the art he studied in Venice that he intentionally modeled himself as a humanistic scholar and wrote extensively to convince his compatriots of the value of Renaissance approaches to art. He was very influential because his skillful woodcuts (4.45) and engravings (1.58) were widely distributed.

Southern Baroque

Throughout Europe, the seventeenth century was a period in which the new middle class joined the Church and nobility as patrons of the arts. Art became more realistic and emotional, speaking directly to viewers in sensuous, exuberant forms. In Catholic Italy, the tempestuous Caravaggio opened this BAROQUE period with his earthy focus on real people, an entirely new concept for religious paintings. In his *Calling of St Matthew* (6.23), he dresses Matthew and his companions in contemporary clothes and has them involved in a game of chance when Christ

6.23 MICHELANGELO MERISI DA CARAVAGGIO, *The Calling of St Matthew*, 1596. Oil on canvas, 11ft 1in × 11ft 5ins (3.37 × 3.47m). S Luigi dei Francesi, Rome.

appears, recognizing his spiritual beauty in the midst of familiar everyday life rather than in a formal, idealized setting.

The same unposed, naturalistic quality appears in the works of Velázquez, even when his subjects were the Spanish royal family. His famous *Las Meninas* (**6.24**) is not a formal family portrait, but a domestic scene of the young Princess Margarita with her attendants, with the king and queen's presence seemingly reflected in a mirror at the end of the room. Is Velázquez, who has painted himself before the canvas, looking at them? Does the mirror reflect part of the canvas instead? The artist's fascination with the effects of light is evident not only in these compositional ambiguities but also in the subtle variations of

light and shadow throughout the work. Velázquez's highly skilled, suggestive brushwork led the later French Impressionists to regard him as the best of the painters of the past.

In sculpture, Bernini created ornate new forms for everything from fountains to building façades. His *The Ecstasy of St Teresa* (1.34) reflects the actively emotional quality of the Baroque period, in contrast to the cool intellectualism of Mannerism. Swirling and diagonal lines create complex circular paths through the piece, in contrast to the serenity of classical draping, and Bernini dares to give St Teresa a facial expression of supreme ecstasy whose sexual quality is hardly even ambiguous. Bernini's approach was soon copied by artists throughout Europe.

6.24 DIEGO VELÁZQUEZ, *Las Meninas (The Maids of Honor)*, 1656. Oil on canvas, 125 × 108ins (318 × 276cm). The Prado, Madrid.

6.25 PETER PAUL RUBENS, *The Assumption of the Virgin*, c.1626. Oil on panel, 49⅜ × 37⅛ins (125.4 × 94.2cm). The National Gallery of Art, Washington D.C., Samuel H. Kress Collection.

Northern Baroque

The Baroque style in northern Europe found other forms. One of its greatest exponents was Peter Paul Rubens of Antwerp. His *The Assumption of the Virgin* (**6.25**) represents plump, rounded figures in an appreciative, joyful way, with flowing movement and warm colors. This was spirituality in the flesh. His typically large, swirling paintings are quite recognizable in style, even though Rubens employed a workshop of assistants to do much of the work on his 3000 signed paintings, a common practice at the time.

In Holland, where a Protestant culture drew its

6.26 CHRISTOPHER WREN, St Paul's Cathedral, London, 1675–1710.

strength from a sober and prosperous middle class which rejected the influence of Rome, Rembrandt emerged as one of the greatest artists of all time. Influenced by the work of Rubens—as well as that of many other artists, including those of non-European cultures—he made use of Baroque devices for leading the eye through undulating three-dimensional space. Highly spiritual, he brought the psychological impact of religious themes directly through to the viewer, with subtlety and deep human understanding. His self-portraits (such as 1.60) and treatments of religious subjects, such as *The Three Crosses* (4.59 –61), are the work of one who feels life profoundly, as well as of a master of the visual arts.

In architecture, the Baroque period was characterized by grand effects and exuberant, swelling forms. This tendency was combined with a certain classical restraint by Christopher Wren in his rebuilding of St Paul's Cathedral (**6.26**) in London. He planned the structure from the bottom up, while it was under construction, and the clearly Baroque dome and towers are wedded to more classical lower levels inspired by the Italian Renaissance architect Palladio.

Rococo

In the late Baroque—or ROCOCO—period in central Europe (the first half of the eighteenth century), formal restraint was abandoned. In France, painters such as Antoine Watteau and Jean Honoré Fragonard (2.134) honored the whims of the aristocracy (led by Louis XIV, who called for a more lighthearted art) with dreamy scenes of gay and beautiful people in a natural paradise. These visions were rendered with delicate, swirling lines and pastel colors in a style considered so frilly by the French revolutionaries who overthrew the aristocracy that they dubbed it "Rococo," a frivolous concoction of shells. Today the Rococo style is considered to have rather more substance—an intentional freeing of art from academic rules of composition in favor of exuberant, dancing lines and gentle coloring.

Architecture also became unabashedly ornate and fantastic. The most extraordinary of the German Rococo churches is Balthasar Neumann's pilgrimage

church of Vierzehnheiligen (**6.27**). Everything seems to be in constant motion. There are few straight lines; curling motifs developed in France swirl endlessly, and the ceiling is treated to create a floating illusion of boundless space. The gaiety expressed here is a far cry from the heavy, still atmosphere of Romanesque churches or the soaring, vertical thrusts of the Gothic cathedrals—yet all are conducive to certain kinds of spiritual experiences and appropriate for their times.

Neoclassicism

In the swings of action and reaction that increasingly characterized art history, the late eighteenth century brought another return to the aesthetics of ancient Greece and Rome. As a reaction to Baroque and particularly Rococo styles and as an expression of the Enlightenment, artists like Jean-Antoine Houdon sought a quiet, informal dignity (5.5). Archaeologists' discoveries of classical cities such as Pompeii gave architects models to follow in their return to noble, restrained buildings. Winckelmann's highly influential *Thoughts on the Imitation of Greek Works of Art* (1755) held that "The only way to become great . . . is by imitation of the ancients . . . [Art] should aim at noble simplicity and calm grandeur."[2]

NEOCLASSICAL painters tried to recreate the style of classical sculptures, since little was known of ancient painting. Using his art to encourage a revolutionary patriotism and stoicism, Jacques-Louis David recreated a story of heroic self-sacrifice from Republican Rome in his *The Oath of the Horatii* (**6.28**). Its severity, clarity, and economy of means are clear departures from the works of the recent past.

6.28 JACQUES-LOUIS DAVID, *The Oath of the Horatii*, 1784–85. Oil on canvas, c.14 × 11ft (4.3 × 3.7m). The Louvre, Paris.

6.27 BALTHASAR NEUMANN, Church of Vierzehnheiligen, near Staffelstein, Germany, 1743–72.

Romanticism

Throughout the history of Western art certain artists have focused more on emotion and imagination than on the logic and harmony of classicism. This perennial tendency surfaced in the ROMANTIC movement in the early decades of the nineteenth century, when it coexisted with Neoclassicism, championed by Ingres (2.27, 2.72). In contrast to the austere Neoclassical attempts to be impersonal, Romantic artists openly expressed their own feelings. In their landscape paintings, newly elevated to a position as significant as figure paintings, they portrayed the natural world as an extension of their own sensibilities, which ranged from the peacefulness of John Constable's rural scenes to the turbulence of Turner's seascapes (4.31). Turner discovered the emotional impact of pure color and pushed it to the point where it almost becomes the subject matter.

Théodore Gericault's *Raft of the Medusa* (**6.29**) illustrates the emphasis on sensation and passion in content and dynamism in composition that characterized the French version of Romanticism. The huge painting depicts the 13-day ordeal of the few passengers who survived the sinking of a government ship. They were left adrift on a crude raft by the captain and crew, who took the only lifeboats. Emotions of despair, suffering, and hope are built into a strong double-triangle composition charged with energy.

The mystical prints and paintings of William Blake (3.18) carried something of the passionate emotional content of the Romantic movement, although Blake had his own unique visionary agenda. In architecture, Romanticism was expressed largely through nostalgia for Gothic structures, as evidenced in Viollet-le-Duc's drawings (5.68).

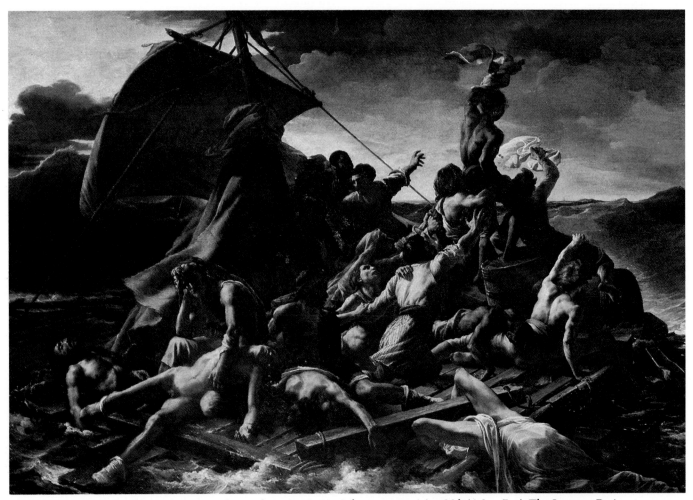

6.29 THÉODORE GERICAULT, *The Raft of the Medusa*, 1818–19. Oil on canvas, 16 × 23ft (4.9 × 7m). The Louvre, Paris.

6.30 GUSTAVE COURBET, *The Stone Breakers*, 1849. Oil on canvas, 63 × 102ins (160 × 259cm). Formerly Gemäldegalerie, Dresden (destroyed 1945).

Realism

At odds with the idealized content of both Neoclassicism and Romanticism (for instance, Gericault's survivors are not gaunt and covered with sores), another approach to art began to appear as a recognizable movement in France from about 1850 to 1875. Honoré Daumier (1.27) may be seen as a forerunner; but it was the work and theories of Gustave Courbet that led this rebellion against the "grand manner." In paintings such as *The Stone Breakers* (**6.30**), Courbet sought to present real people without artifice rather than idealized or heroic scenes drawn from the artist's imagination. It was his choice of subject matter—everyday contemporary life—as much as his attempt to portray it truthfully that represented a sharp break with the past. Courbet eschewed historical, mythological, or abstract subjects ("Show me an angel and I'll paint one"), insisting on painting only what he could see, exactly as he saw it, without artistic conventions. In his "Open Letter to a Group of Prospective Students" (1861), Courbet gave a clear definition of REALISM:

> Painting is essentially a *concrete* art, and can consist only of the representation of things both *real* and *existing*. . . . Imagination in art consists in finding the most complete expression for an existing thing, but never in imagining or creating this object itself. . . . Beauty as given by nature is superior to all the conventions of the artist.[3]

Impressionism

Realism was not considered good art by the academic juries who controlled most of the purchasing of art in France. They also rejected the work of Édouard Manet, whose *Déjeuner sur l'Herbe* (**6.31**) shocked even those who visited the counter-exhibit held in 1863 by many angry artists whose work had been refused by the official Salon. Manet used a classical composition borrowed, in heavy disguise, from Raphael, but in such a manner that we cannot figure out its meaning. In a complex way, he was denying the use of paintings to teach or arouse emotions;

paintings, he asserted, can exist for the sheer beauty of colors, light, patterns, and the brushstrokes on the surface of the canvas.

Manet's NATURALISM was closely followed by a group of artists who were dubbed IMPRESSIONISTS. Some of them rejected not only story-telling and meaning but even realistic depiction of objects, seeking instead to capture the ephemeral impressions of light reflecting off surfaces under different atmospheric conditions. If anything, their dabs of unblended colors broke down images into montages of light, as in Monet's *Rouen Cathedral* (**6.32**). Whereas Realists often worked from photographs of everyday scenes, these Impressionists painted outside in order to observe and record the effects of natural lighting.

Others who are often grouped with the Impressionists—such as Degas (2.52, 4.10)—tried to capture fleeting action or transient moments rather than focusing solely on the changing effect of light. Renoir (3.26) is also grouped with the Impressionists, but the style of his later works—luminous but blended use of color to describe lush, three-dimensional forms—varied considerably from the increasingly abstract

6.33 PAUL CÉZANNE, *Still-Life with Apples*, 1895–98. Oil on canvas, 27 × 36½ins (68.6 × 92.7cm). The Museum of Modern Art, New York, Lillie P. Bliss Collection.

brushstrokes of Monet. Renoir wrote,

> I had wrung impressionism dry, and I finally came to the conclusion that I knew neither how to paint nor how to draw. . . . Light plays too great a part outdoors; you have no time to work out the composition; you can't see what you are doing. . . . If the painter works directly from nature, he ultimately looks for nothing but momentary effects; he does not try to compose, and soon he gets monotonous.[4]

Post-Impressionism

In some art historians' ways of categorizing styles, the late works of Degas and Renoir are included in a group of paintings known as POST-IMPRESSIONIST. In a narrower definition of this style, however, the major Post-Impressionists were Cézanne, Seurat, van Gogh, and Gauguin. What unites them is their move-

ment beyond what they conceived as the limitations of Impressionism and their highly personal explorations of the art of painting. Van Gogh (1.30) distorted lines and forms to express essence; Gauguin (1.61) intentionally rejected a "civilized" style. In Cézanne, by contrast, there was a return to careful composition in an intense search for artistic perfection. But Cézanne did not return to the past; rather, he was perhaps the pioneering figure in modern painting. Rejecting both the messiness of Impressionism and the conventions of linear perspective used since the Renaissance to give the illusion of form and space, Cézanne tried to reinvent two-dimensional art from scratch. He built up spatial layers, geometric forms, and rhythms with colors, lines, and shapes alone (see 2.29 and 3.16), with careful attention to orderly relationships between forms across the picture plane.

409

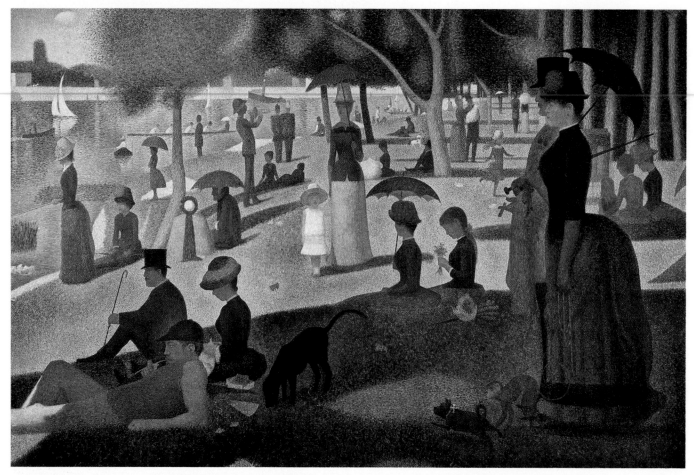

6.34 GEORGES SEURAT, *A Sunday Afternoon on the Island of La Grande Jatte*, 1884–86. Oil on canvas, 81 × 120⅜ (205.7 × 305.7cm). The Art Institute of Chicago, Helen Birch Bartlett Memorial Collection.

Even in his clearly representational works, such as *Still-Life with Apples* (**6.33**), he concentrated on meeting aesthetic goals such as balance, intensity of color, and the *feeling* of depth, even if doing so meant distorting the outlines of objects.

Seurat's approach to painting was highly analytical. His POINTILLISTE technique of juxtaposing dots of unblended colors (to be blended optically)—as in his groundbreaking painting *A Sunday Afternoon on the Island of La Grande Jatte* (**6.34**)—is superficially similar to the unblended brushstrokes of the Impressionists. But his tiny vibrant dots of pigment are meticulously applied and calculated to define shapes rather than allow them to disintegrate under the effects of light. Under Seurat's systematic analysis, forms become precise, almost flat geometric shapes, carefully organized in space. Seurat's clearly delineated shapes and painstakingly applied dots of pigment contribute to a timeless sense of order that is in sharp contrast to the immediacy and spontaneity of Monet's paintings.

Expressionism

As artists began departing from academic standards to do their own experimenting into the nature of reality and how it could be expressed in art, some inevitably turned their attention inward. Art used as a vehicle for the portrayal of inner psychological states has been called EXPRESSIONISM. This tendency was already evident in the late works of van Gogh (1.30), for whom trees and sky writhed in sympathetic resonance with his intense inner torments. The Norwegian Edvard Munch abandoned any attempt at objective reporting of external realities in his *The Scream* (**6.35**). The terror he feels inside

6.35 EDVARD MUNCH, *The Scream*, 1893. Oil, pastel, and casein on cardboard, 36 × 29ins (91.4 × 73.6cm). National Gallery, Oslo.

becomes visible as wave upon wave of undulating colored bands, filling the environment. Prior to World War I, German artists in groups called *Die Brücke* ("The Bridge") and *Der Blaue Reiter* ("The Blue Rider") became Expressionists, usually portraying states such as anxiety or anger rather than the hopeful sweetness and materialistic complacency they perceived in French Impressionism. German Expressionism encompassed many of the arts, including filmmaking, with works such as *The Cabinet of Dr Caligari* (4.105).

Fauvism

Meanwhile in France a group of artists led by Matisse held an exhibition in 1905 of works so revolutionary that the artists were called *les Fauves* ("the wild beasts"). They had abandoned any attempt at descriptive, naturalistic use of color and, in some cases, form. Instead they used these elements of design as ends in themselves or expressions of the essence of things, freed from strict associations with the observable world. André Derain's *The Pool of London* (6.36) illustrates the use of semi-realistic forms with free choice of colors; Matisse's *The Red Studio* (2.110) uses color even more freely, with forms translated into flat shapes and painted with seemingly childlike abandon. Matisse had serious and orderly intentions, however. He rejected the "jerky surface" of Impressionist paintings, complaining,

> The splitting up of color brought the splitting up of form and contour. . . . Everything is reduced to a mere sensation of the retina, but one which destroys all tranquillity of surface and contour. Objects are differentiated only by the luminosity that is given them.[5]

By contrast, Matisse sought to create the sensations of space and form by using color purely and simply rather than in dabbed spots. Moreover, he felt that

6.36 ANDRÉ DERAIN, *The Pool of London*, 1906. Oil on canvas, 25⅞ × 39ins (65.7 × 99cm). The Tate Gallery, London.

6.37 PABLO PICASSO, *Les Demoiselles d'Avignon*, 1906–7. Oil on canvas, 8ft × 7ft 8ins (2.43 × 2.34m). The Museum of Modern Art, New York, Lillie P. Bliss Bequest.

color, like other elements of design, should serve the expressive purposes of the artist. Matisse's seminal experiments in modern art continued, but the FAUVE group disbanded after three years.

Cubism

The next significant steps in modern art were taken by Pablo Picasso and Georges Braque. Some of Picasso's early paintings, such as *The Old Guitarist* (2.109), were delicately representational. But in 1907 he abruptly switched directions. Heavily influenced by the geometric forms of Cézanne and the stylization of African sculpture, Picasso created in *Les Demoiselles d'Avignon* (**6.37**) a work considered so ugly that people tried to attack it physically when it was

first shown in the United States. What he had begun to do in this work evolved into a movement in which a subject was fragmented into geometric planes that simultaneously revealed more than one side at once, as though the artist were walking around a three-dimensional form and reporting the view from many angles. The ancient Egyptians had stylistic conventions for doing somewhat the same thing, but under the angular analysis of CUBISM, the subject sometimes becomes almost totally lost from view, as in Braque's *The Portuguese* (**6.38**).

Of this highly intellectual approach to art, Braque wrote, "The senses deform, the mind forms. Work to perfect the mind. There is no certitude but in what the mind conceives."[6] And Picasso asserted, "Nature and art, being two different things, cannot be the

413

6.38 GEORGES BRAQUE, *The Portuguese*, 1911. Oil on canvas, 45⅞ × 31⅞ins (116 × 81cm). Kunstmuseum, Basel.

same thing. Through art we express our conception of what nature is not."[7]

Futurism

In Italy, the sweeping changes of an industrializing civilization were answered by a call for revolution in the arts. In 1910 a group of artists set forth a passionate statement they called the *Manifesto of the Futurist Painters*. It contained these conclusions:

Destroy the cult of the past, the obsession with the ancients, pedantry and academic formalism. . . .
Elevate all attempts at originality, however daring, however violent. . . .
Regard art critics as useless and dangerous. . . .
Rebel against the tyranny of words: "Harmony" and "good taste". . . .
Support and glory in our day-to-day world, a world which is

6.39 UMBERTO BOCCIONI, *Unique Forms of Continuity in Space*, 1913. Bronze (cast 1931), 43⅞ × 34⅞ × 15¾ins (111 × 88.5 × 40cm). The Museum of Modern Art, New York, Lillie P. Bliss Bequest.

going to be continually and splendidly transformed by victorious Science.[8]

The principal aesthetic attempt of the FUTURISTS was to capture in art the vigor, speed, and militant pride they felt characterized modern life. In paintings, this meant portraying successive movements over time, as Duchamp had done in the "dynamic cubism" of *Nude Descending a Staircase* (2.133). In sculpture, Umberto Boccioni tried to express not form but action in works such as *Unique Forms of Continuity in Space* (**6.39**).

Abstract and Nonobjective art

In the same year that Boccioni's *Unique Forms* was completed, the Russian-born painter Vassily Kandinsky created another of the abstract paintings he had been working with for several years: *Improvisation No. 30* (**6.40**). In the intellectual ferment that followed the freeing of art from meaning, naturalistic representation, and academic aesthetic standards, Kandinsky's piece reflected the penultimate stages of movement away from art that tries to represent forms from the outer world. In Kandinsky's painting, bare references to the phenomenal world are retained only to keep art from descending to mere pattern-making; he uses colors and barely recognizable forms (here, cannons and tall buildings) to lead the viewer into a world of nonmaterial spiritual realities.

Piet Mondrian used the process of ABSTRACTION to strip natural forms to their aesthetic essence, as in his abstract paintings of trees (1.23–25). But he—as well as generations of later twentieth-century artists—soon abandoned all references to natural forms, creating purely NONOBJECTIVE art. Works such as *Composition in Blue, Yellow, and Black* (**6.41**) and *Fox Trot A* (2.9) were so different from traditional paintings that Mondrian offered many written explanations of the theories behind nonobjective art. No longer were paintings self-evident; one needed an intellectual understanding of the artist's intention. Mondrian held that because paintings are created on a flat surface, they should honor that flatness rather than trying to give it the illusion of three-dimensionality. Furthermore, line and color are the essence of art, and to be seen most clearly they should

6.40 VASSILY KANDINSKY, *Improvisation No.30*, 1913. Oil on canvas, 43¼ × 43¼ins (110 × 110cm). The Art Institute of Chicago, Arthur Jerome Eddy Memorial Collection.

6.41 PIET MONDRIAN, *Composition in Blue, Yellow, and Black*, 1936. Oil on canvas, 17 × 13ins (43.2 × 33cm). Kunstmuseum, Basel, Emannuel Hoffman Foundation.

be separated from forms to which each person brings personal associations. To display line and color nonobjectively, Mondrian chose the "universal" or "neutral" form of the rectangle.

Dada

In contrast with the sublime rationality of Mondrian's theories and paintings, a group of rebellious artists and authors in Zürich launched in 1916 an anti-rational, anti-aesthetic movement called DADA, babytalk which they claimed meant nothing. The ironically humorous, intentionally uncensored output of the group included the automatic drawings of Jean Arp (2.32) and offbeat artforms with titles such as "rubbish constructions," "rayographs," "exquisite corpses," and "ready-made objects." Marcel Duchamp's ready-made, *Why not Sneeze Rrose Sélavy* (**6.42**) is a barely-worked conglomeration of nonart objects—bird cage (complete with cuttlefish),

identical marble cubes, and a thermometer—that defies not only logical analysis but also the traditional minimal expectation that art is something physically created by the artist. The anarchistic Duchamp claimed that it is simply the act of choice that defines the artist.

Surrealism

Many of the Dadaist artists became part of the next major twentieth-century movement: SURREALISM, in which the source of images is the subconscious. Rather than abandoning forms, surrealists render them with the illogic of dreams. Based on the theories of Freud, this approach spanned the period between World Wars I and II, for the most part, though surrealistic elements had appeared throughout the history of art and still do. One of the most famous Surrealist artists is Salvador Dali, whose 1928 movie *Un Chien Andalou* (4.106) was like a bad dream in

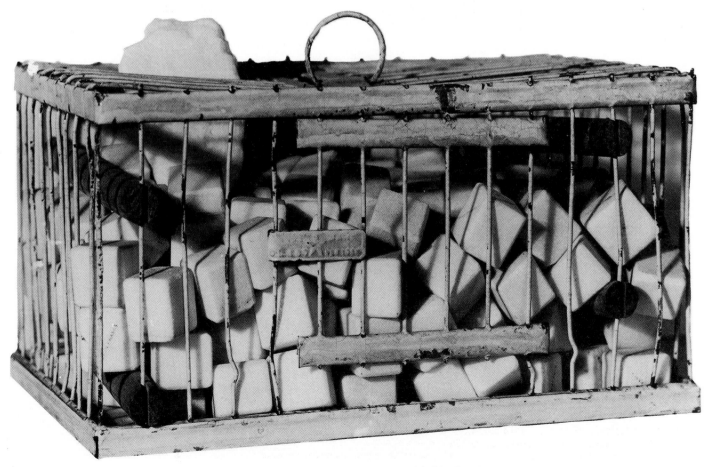

6.42 MARCEL DUCHAMP, *Why not Sneeze Rrose Sélavy*, 1921. Bird cage, marble blocks, thermometer, wood, and cuttle bone, 4¼ × 8½ × 6¼ins (11 × 22 × 16cm). Philadelphia Museum of Art, The Louise and Walter Arensberg Collection.

6.43 SALVADOR DALI, *The Persistence of Memory*, 1931. Oil on canvas, 9½ × 13ins (24.1 × 33cm). The Museum of Modern Art, New York.

6.44 ANDREW WYETH, *Christina's World*, 1948. Tempera on gesso panel, 32¼ × 47¾ins (81.9 × 121.3cm). The Museum of Modern Art, New York.

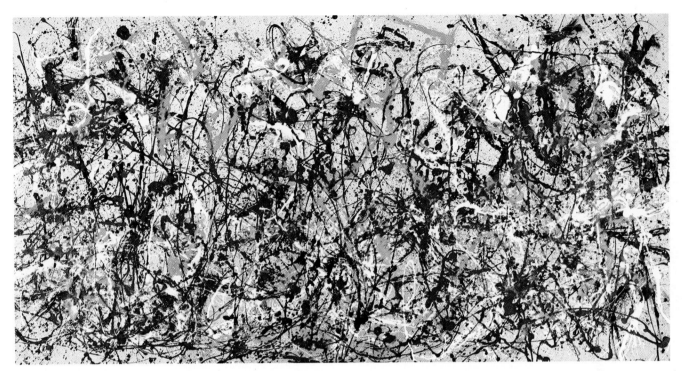

6.45 JACKSON POLLOCK, *Autumn Rhythm*, 1950. Canvas, 105 × 207ins (267 × 526cm). The Metropolitan Museum of Art, New York, George A. Hearn Fund.

itself. Expressed in a static painting rather than a time sequence, Surrealism often relies on unusual perspectives and symbols to express the apparently realistic but logically impossible contents of dreams. In Dali's *The Persistence of Memory* (**6.43**), melting watches, lightstruck cliffs, and unrecognizable forms are meticulously described, as if in a vivid hallucination.

Traditional Realism

While all these modern art styles were cropping up, many artists continued to work in a variety of traditionally realistic, representational styles. The United States particularly had an historical fondness for realistic art, and even after industrialization brought the country into the forefront of international commerce many artists retained a distinctive appreciation for naturalistic representation of life in their homeland. The emerging artform of photography was dominated in the United States by those who wanted to remain true to their subjects, as well as their medium, such as Alfred Stieglitz (4.93), Dorothea

Lange (4.94), and Ansel Adams (4.96). A number of painters who had been drawn to abstract movements in Europe returned to more realistic work, such as the perennially popular Andrew Wyeth. With meticulous tempera technique, he focuses on quietly meaningful rural scenes, such as the world of a small Maine island community as seen by a young woman with polio in *Christina's World* (**6.44**).

Abstract Expressionism

A parallel development at the opposite pole from traditional realism established New York as the leading center of modern art in the West. After World War II, the term ABSTRACT EXPRESSIONIST was applied to those of the New York school who rejected traditional painting styles and instead emphasized the spontaneously expressive gesture and all-over composition, with all areas of the canvas equally important. One of the major figures in this movement was Jackson Pollock. To create paintings such as *Autumn Rhythm* (**6.45**), Pollock engaged in what was known as ACTION PAINTING, throwing or drip-

6.46 BARNETT NEWMAN, *Vir Heroicus Sublimis*, 1950–51. Oil on canvas, 95⅓ × 202¼ins (242.2 × 513.6cm). The Museum of Modern Art, New York, Gift of Mr and Mrs Ben Heller.

ping paint with whole-body motions onto a long sheet of canvas on the floor. The frenetic, interlacing lines that he laid down have a restless energy that leads the viewer around and through, again and again, to no conclusion—perhaps an apt metaphor for the pace and meaninglessness of contemporary urban life. The subjective, "painterly" approach of expressing oneself through freely applied paint was also used by other mid-century New York artists, including Hans Hofmann (4.29), Willem de Kooning, and to a certain extent Mark Rothko (1.32), and is still present in the 1980s brushwork of James Brooks (4.21), among others.

Post-Painterly Abstraction

As the New York school evolved, many artists developed more controlled nonobjective styles that had in common the attempt to remove the evidence of their presence, allowing their work to stand by itself as a stimulus to which the viewer can react. These artists also tended to focus on color and color relationships. The *Abstract Imagists* (or Chromatic Abstractionists) typically used open, relatively flat but fluid imagery created impersonally by pouring

dyes onto unsized canvas, as in the work of Helen Frankenthaler (4.34). *Hard-edge* painters created flat, unvarying areas of pigment with immaculately sharp boundaries, sometimes with even nonobjective imagery reduced to a bare minimum. As Barnett Newman suggests by naming the hard-edged painting shown here (**6.46**) *Vir Heroicus Sublimis* ("heroic, elevated man"), such works may have a sublime, classical effect of ordered perfection and grandeur. But if you stare at his painting for a while, those fine stripes may begin to create extra optical effects that transcend the flatness of the colossal red field.

In fact, hard-edged paintings are called OP ART when they deliberately use the peculiarities of human vision to make people see things that have not actually been physically placed on the canvas. The artist steps back, allowing the experience of the work to take form in the perceptions of the viewer. Josef Albers, highly influential as a teacher as well as an artist, evoked optical color phenomena in his *Homage to the Square* series (2.112). Some Op Art even creates illusions of color, space, and movement in black and white compositions, such as Bridget Riley's *Crest* (2.130) and Victor Vasarely's *Supernovae* (**6.47**).

Pop Art

Another mid-century direction in modern art emerged in London and has encompassed some artists in the United States. This trend, called POP ART, uses objects and images from popular, commercial culture—from cartoons to beer cans—rather than the rarefied imagery of the fine arts. Some of the work is hostile toward contemporary throw-away culture; some presents it as having a rather zany aesthetic validity. As we have seen, Claes Oldenburg's monuments to the banal (such as his giant clothespin, 4.3) are humorously conceived. Some of Andy Warhol's famous pop creations, such as the well-known painting of 200 Campbell's soup cans, reflect the repetitive visual patterns of the modern marketplace—a reminder of the aesthetic realities of modern life that one can interpret as one pleases. Robert Rauschenberg mixes media with flair, combining fine art techniques such as painting and printmaking with a great variety of ready-made and partially altered bits of popular culture in ways that suggest meaning, even if one cannot be quite sure what it is. His *Monogram* (**6.48**) features a stuffed ram within a tire mounted on a base of Abstract Expressionistic paintings.

6.47 VICTOR VASARELY, *Supernovae*, 1959–61. Oil on canvas, 95½ × 60ins (242.5 × 152.4cm). The Tate Gallery, London.

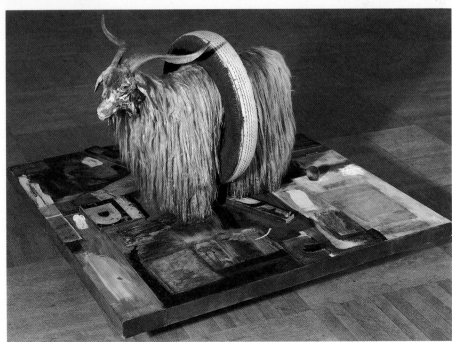

6.48 ROBERT RAUSCHENBERG, *Monogram*, 1959. Stuffed ram, automobile tire, collage, and acrylic, 48 × 72 × 72ins (122 × 183 × 183cm). Moderna Museet, Stockholm.

6.49 WILLIAM BAILEY, *Monte Migiana Still Life*, 1979. Oil on canvas, 54 × 60ins (137 × 152cm). The Pennsylvania Academy of Fine Arts.

New Realism

Alongside the nonobjective and pop trends in modern art, a number of artists have continued or returned to more realistic treatments of actual objects. Their subjects have not necessarily been traditional ones, however. Many have explored the visual facts of industrialized life—the neonlit shops, fast-food places, city streets, automobiles, depressed or overweight people. In recent years, this investigation has become *super-realistic* or PHOTOREALISTIC in the hands of artists such as Chuck Close (4.33) and Richard Estes (2.90). Some are finding beauty in close

investigations of features of the environment, such as William Beckman's *Power Lines* (1.20) and Bill Martin's *Abalone Shells* (4.32). William Bailey (**6.49**) has turned from abstraction to figurative subjects in his painting, but with sensitivities developed from modern art, rather than traditional representative paintings. Using objects painted from memory and references to the actual objects, but without physically setting up a still-life, he works with aesthetic issues such as the meanings of groupings, intervals, tensions between the flatness of the picture plane and the illusion of space, and inferences of diagonals projecting into space. Bailey says, "I wanted a paint-

ing that was silent and unfolded slowly, that offered a contemplative situation."[9]

Technological art

Although many named twentieth-century art movements have centered on painting styles, technological changes have brought changes in all the arts and have enabled the development of artforms that did not even exist in the past. In addition to new building materials and synthetic substitutes for traditional two- and three-dimensional media, industrial technologies have spilled over into art in an entirely new way. In the new arts of computer graphics (4.115,

4.116, 4.117) and laser shows (2.93), foreshadowed by the lovely light projections of Thomas Wilfred onto translucent screens (6.50), the hand of the artist at work has disappeared. Now it is a machine that directly creates the art, with the artist one step removed, building, programming, or operating the machine. Sometimes it is even the *observer* who seems to create the art, activating art-producing devices merely by being present in a certain space.

At one time, art and religion were closely linked in the West; now art and science are forming new alliances, and some very exciting contemporary art is coming out of the high-technology research laboratories, created by people whose skills and

6.50 THOMAS WILFRED, from *Lumia Suite, Opus 158*, 1963–64. Changing light composition projected against a screen, 6 × 8ft (1.8 × 2.4m). The Museum of Modern Art, New York, Mrs Simon Guggenheim Fund.

sensitivities encompass both science and art. Rapid developments in fields such as fiberoptics and communications may in the future be used to create arts that stimulate the senses in ways yet unimagined.

Installations, performance art, earthworks, conceptual art

Already the definition of art is being continually expanded: Art is whatever an artist declares to be art. Galleries and museums now display INSTALLATION PIECES, three-dimensional designed environments often set up only as temporary experiences, such as Stephen Antonakos's 24-foot-long *Green Neon from Wall to Floor* (2.92). In PERFORMANCE ART, the work consists of an artist doing something, such as Charles Simonds building a miniature brick community for the Little People on his own nude body (5.102). When performance and video art made their appearance in the 1970s, they were promoted as a way of ending the traditional emphasis on art as object, bringing art to viewers more directly as a sheer visual experience.

In EARTHWORKS it is the surface of the earth that becomes the sculptor's medium, for such massive alterations as Michael Heizer's *City Complex One* (2.25), Robert Morris's *Earthwork at Johnson Pit #30* (5.16), or Robert Smithson's *Spiral Jetty* (**6.51**). Now covered by a higher water level, Smithson's immense spiral was created in the primordial red water of Great Salt Lake to give concrete expression to the "gyrating space" he experienced at the site. And in CONCEPTUAL ART, idea is more important than form, which may be as ephemeral as Christine Oatman's *Icicle Circle and Fire* (2.140). In 1969, Sol LeWitt offered an explanation of conceptual art in his "Sentences on Conceptual Art":

> Ideas alone can be works of art; they are in a chain of development that may eventually find some form. All ideas may not be made physical. . . . If words are used and they proceed from ideas about art, then they are art and not literature.[10]

6.51 ROBERT SMITHSON, *Spiral Jetty*, 1970. Great Salt Lake, Utah. 1500 × 15ft (457 × 4.6m).

6.52 HOWARD HODGKIN, *Interior with Figures*, 1977–84. Oil on wood, 54 × 60ins (137 × 153cm). Saatchi Collection, London.

Neo-Expressionism

In the continuing replay of earlier movements, with new twists, a major current redirection in painting is called NEO-EXPRESSIONISM. Its adherents around the world are using painting to express their own emotions, as the Abstract Expressionists did, but now with figurative imagery that is distorted by those emotions. Images are often derived from the mass media, and the emotional content is typically violent or anguished, charged with energy. Howard Hodgkin's *Interior with Figures* (**6.52**) is a relatively quiet example, but even here the feelings expressed seem charged with sexual energy. Hodgkin tries to recapture the emotion of an experience through evocative objects, colors, and spatial effects. He says, "I want to include more because the more feeling and emotion you include in the painting, the more it will come out the other side to communicate with the viewer."[11]

6.53 REIKO MOCHINAGA BRANDON, *Temple Guardian "AH"*, 1982. Fiber and cotton, 5½ × 6ins (14 × 15.2cm). Honolulu Academy of Arts, Purchase from Artists of Hawaii, 1982.

The craft object

In the current redefining of the boundaries of art, one interesting direction is the merger of the fine and applied arts. Industrial design, for example, is benefiting from a sculptural approach, and handcrafts are being collected and shown as works of art. Exhibits of applied design are of great popular interest, and new museums are arising that deal in applied disciplines alone. At the same time, a number of artists trained in traditional crafts are carrying their knowledge and skills into the creation of art for art's sake. Reiko Mochinaga Brandon's *Temple Guardian "AH"* (**6.53**) is based on the guardian figures at Kyoto temples and constructed of many natural materials woven together with hand and loom techniques. Although these techniques were developed for making functional containers, Brandon turns them to aesthetic and spiritual ends: "containers for the inner spirit, prayers, messages, and my dreams and wishes."[12]

CHAPTER SEVEN
APPRECIATING ART ON ALL LEVELS

Each work of art has its own history. Conceived in abstract ideas, it gradually takes physical form. Its present aspect is only one of many possible directions it might have taken. To follow what is known of its conception and evolution enriches our multi-layered appreciation of the artist's creation.

Thus far we have looked at works of art from one perspective at a time—seeing, feeling, awareness of technical skill or design qualities, historical knowledge, or understanding of the content. When we have opportunities to see actual works of art, however, our appreciation is richest if we can bring all these levels into play. In this chapter we will take a more comprehensive look at three monumental works: a building, a painting, and a piece of sculpture.

SHAKER ROUND STONE BARN

The first of these works—the round stone barn built in 1826 by the Shaker community in Hancock, Massachusetts (**7.1**)—is not yet well known beyond the north-eastern United States. When it was built, it was designed strictly for functionality and not for its aesthetic qualities. Nevertheless, looking at it today we can recognize it as a beautiful piece of architecture.

Often it is only with hindsight that the worth of particular artists or styles is valued. In the mid-nineteenth century, tastes of the mainstream society were for highly ornamental styles; people considered the extreme simplicity of Shaker design boring and tasteless. But the Shakers cared little for the opinions or possessions of the worldly. They were a Utopian sect who intentionally withdrew from the secular material world to devote themselves to a life of the spirit. Theirs was a unique experiment, for men, women, and children lived and worked together in celibacy as brothers and sisters. Following the

7.1 Round Stone Dairy Barn, Hancock Shaker Village, Massachusetts, 1826.

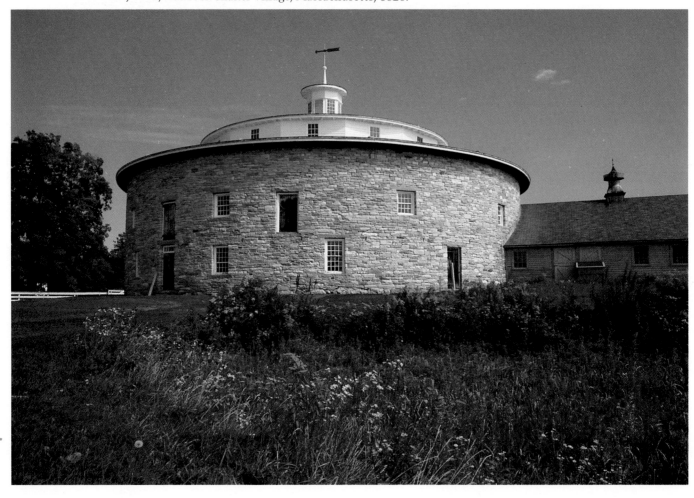

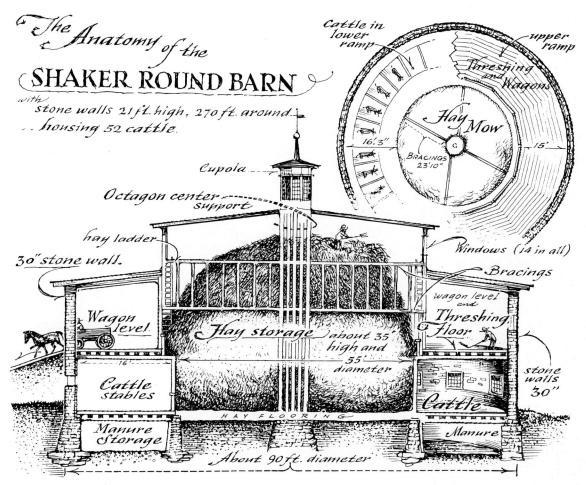

The Anatomy of the

SHAKER ROUND BARN

with stone walls 21 ft. high, 270 ft. around. housing 52 cattle.

Cattle in lower ramp

upper ramp

Threshing and Wagons

Hay Mow

16'3" 15'

BRACINGS 23'10"

Cupola

Octagon center support

hay ladder

30" stone walls.

Windows (14 in all)

Bracings

Wagon level

Hay storage — about 35' high and 55' diameter

wagon level and Threshing Floor

Cattle stables

16'

stone walls 30"

HAY FLOORING

Cattle

Manure Storage

Manure

About 90 ft. diameter

7.2 Round Stone Barn. Drawing by Eric Sloane.

dictum of their inspirational leader, Mother Ann Lee—"Put your hands to work, and your hearts to God"—they created 18 self-sufficient communities from Maine to Kentucky. In their hardworking, caring approach to meeting basic survival needs, they unselfconsciously created designs of great beauty by classical standards of harmony and proportion. Today furniture, baskets, and tools that the Shakers built are extremely valuable collectors' items.

The Shaker community in Hancock had a large herd of dairy cattle, and when the old barn burned down, Elder William Deming designed a new one that would allow many people to work at the same time without getting in each other's way (**7.2**). He based the design on a perfect circle, rather than the traditional rectangle, with room inside for eight to ten hay wagons unloading into a haymow that would hold three to four hundred tons of hay. Earth was built into a gentle ramp so that the hay wagons could enter half-way up the height of the building and

unload hay downward—easier than tossing it up—until the mow was half-full. An octagonal ventilation shaft ran up the center, ending in a cupola. Around the edges on the ground level were stanchions for 52 cows, easily fed by a person walking in a circle. At a later date, manure pits were dug beneath so that manure could be shoveled down through trapdoors behind the cows and collected for application to the fields. These pits undermined the foundations, however, resulting in cracks like the one visible in the old photograph (**7.3**). The barn was finally rebuilt in 1968 and is carefully maintained as a showpiece of ingenious functional design.

The aesthetic qualities of the barn's extreme functionality anticipated the Bauhaus principle that form should follow function. Everything the Shakers put their hands to was visually elegant, although they had no written theory of design and were guided instead by their own imaginative ergonomic solutions. Even hallways, such as the one shown from the

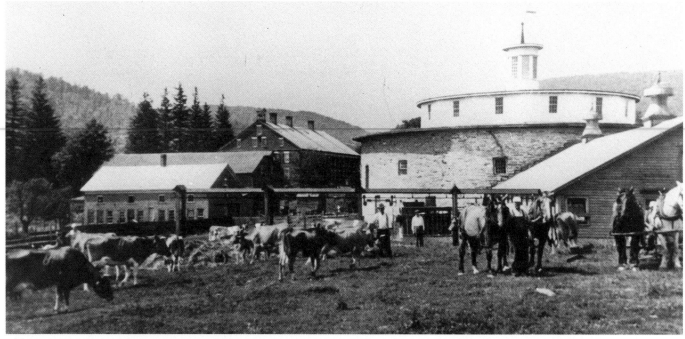

7.3 Round Stone Barn photographed in 1932.

7.4 Centre Family Dwelling, Shaker Village of Pleasant Hill, Kentucky, 1824–34. First Floor Hall.

Kentucky community (**7.4**), with pegs to hang chairs on for convenience in sweeping beneath them, were places of beauty. Materials were presented honestly. Wood was used very sympathetically and rubbed to a soft glow that is all the more noticeable from the lack of unnecessary ornamentation.

In the stone barn, stones were cut so carefully that the walls curve continually, with no bulges, while at the same time tapering in thickness from 3½ feet (106cm) at the base to 2½ feet (76cm) at the top. Stone and wood are beautifully mated, and no attempt is made to hide the structure. Structural innovations necessitated by the circular design include the splitting of the outer end of every other beam so that there is room for all of them to join at the middle but yet adequate support for the full circumference of the roof. The floor boards are likewise carefully cut in a radiating pattern. Window recesses in the deep stone walls are angled toward the interior to better spread the light. And from the outside, the great size of the barn is scaled down visually by its strongly horizontal form to fit among the other buildings. The proportions from circular stone base to 12-sided wooden third story to octagonal cupola seem just right. From any point in the Hancock community, the pale stone and white upper stories of the barn are a welcoming visual focal point.

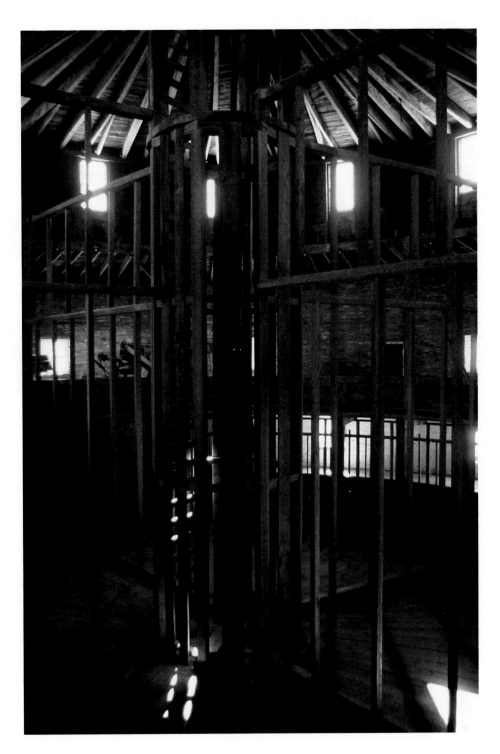

7.5 Interior of the Round Stone Barn.

And the structure does beckon one to step inside. Now, without cows and hay, the open interior is breathtaking (**7.5**). With its great central vertical thrust and the encirclement of light breaking through the deep walls, it has the atmosphere of a Gothic cathedral. People speak in hushed tones as if it were a sacred place. And perhaps it is. To the Shakers, there was no distinction between sacred and everyday.

They dedicated every moment to God, making the work of their hands as much an act of devotion as their singing and prayers. Believing firmly that all things are imbued with the spirit, Mother Ann counseled unhurried but intense awareness in every task: "Do all your work as though you had a thousand years to live, and as you would if you knew you must die tomorrow."[1]

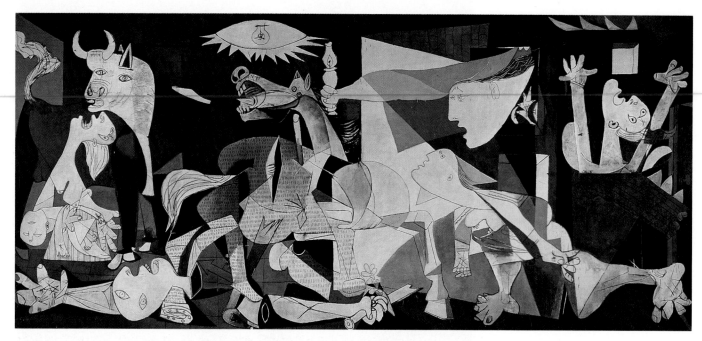

7.6 PABLO PICASSO, *Guernica*, 1937. Oil on canvas, 11ft 5½ins × 25ft 5¼ins (3.49 × 7.75m). The Prado, Madrid.

PICASSO'S *GUERNICA*

By contrast with the relative obscurity of the Shaker barn, Pablo Picasso's *Guernica* (**7.6**) is thought to be the most looked-at painting of the twentieth century. It was commissioned by the Spanish Government in Exile during the Spanish Civil War, to be displayed in the 1937 Paris International Exhibition. At Picasso's request, it was then placed in the Museum of Modern Art in New York for safekeeping until "public liberties" were reestablished in his homeland, Spain. In 1981, after Franco's fascist regime had ended, the painting was moved to the Prado in Madrid, where it is now somewhat hard to see behind security glass. It stands as a monument not only to the genius of the most prolific and influential artist of the twentieth century but also to human questioning of the sufferings caused by war.

The incident Picasso chose as his subject occurred less than a week before he began work on the painting. It was the bombing of Guernica, capital and symbolic heart of the Basque provinces. To break Basque resistance, Hitler's forces, who were supporting Franco's war against the Loyalist government,

carried out one of the world's first experiments in saturation bombing of a civilian population. They dropped over 3000 incendiary bombs over a period of three hours and machine-gunned the people as they tried to flee. The world was aghast, and Picasso had his subject. But the way in which he presented it is symbolic of all wars, all repression. It is not at all a literal representation of the actual bombing of the city or its aftermath (**7.7**). The figures are highly allegorical, and the use of blacks, whites, and grays rather than more colorful hues erase any racial or nationalistic associations. The horror of Guernica becomes the horror of all war, an epic presentation that struck home in an age that thought itself too sophisticated for sentimentality.

Despite its evocation of the chaos of surprise attack, *Guernica* is held together by its triangular compositional devices. The major triangle runs from the open palm of the dead warrior at the lower left, up to the lamp held by the woman at upper center, down to the outstretched foot of the kneeling woman on the right. A secondary triangle on the left contains the head of the bull, facing away from the disaster, and the upturned head of the wailing woman with the dead baby hanging limp in her arms. There is also a

bird on a table, with the same upward-turned imploring head as that of the mother. To the right, the outer triangle encompasses the agony of the burning woman—whose pose mirrors that of the woman with the dead baby—and the powerful questioning form of the woman thrusting a light into the scene.

Within the central triangle, there is a jumble of fragmented parts. The body of the dead warrior stretches across the base of the triangle, visually sharing the right leg with the kneeling woman. In the center is the horse with the gaping wound, whom Picasso in a rare moment of explanation identified as the spirit of the people.

The strong diagonals send the eye zipping around through the painting, searching for understandable forms and clues. We note that most of the people are women and children; this is not an heroic battle scene but the aftermath of an assault on civilians. Above all the figures is a sun or ceiling lamp or an eye—or perhaps all of these—watching, and shedding some light on the scene.

What do these images mean? Picasso generally refused to explain his symbols, insisting that viewers respond through personal, subconscious associations and emotions rather than impersonal logic:

> This bull is a bull, this horse is a horse. . . . It is necessary that the public, the spectators, see in the horse, the bull, symbols that they interpret as they understand them. These are animals. These are massacred animals. That is all, for me; let the public see what it wants to see.[2]

The painting rivets our attention and involves us by making us ask questions. It does not answer them. Is the bull, for example, a symbol of unthinking brutality, the detached and stupid presence of repression, pushing down all the human forces that are trying to rise? Is he the representative of humanity, affected by but yet isolated from what happens to each person? Is he the eternal power of Spain, reassuringly solid even in the midst of devastation? Or does he represent sheer force, power that is in itself neither good nor

7.7 The city of Guernica after bombing by Nationalist forces, 1937.

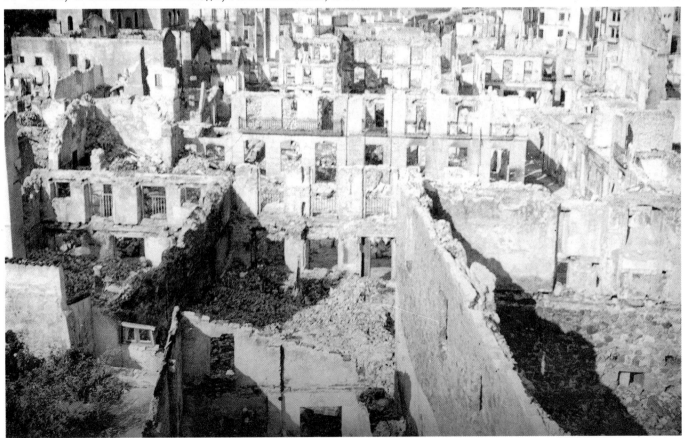

evil? The possibilities—and there are others—have intrigued viewers of the painting for decades, and whole books have been written about it.

Picasso himself approached *Guernica* with an open, extremely flexible mind, continually changing its form. Quite aware of the historic significance of his attempts, he dated the scores of sketches in which he worked out the images and composed the powerful whole of the finished painting, leaving tracks for us to follow. From the very first composition study (**7.8**), Picasso knew much of the basic structure. In this simplified visual note to himself, we can readily make out the woman with the lamp, the bull, and the horizontal shape of the dead soldier.

By the end of the first day, after five preliminary sketches, Picasso had worked out the composition study shown in Figure **7.9**. The woman with the lamp already has her distinctive cometlike shape. The fallen soldier is wearing a classical centurion's helmet; the spirit of the horse escapes through the wound in its side. At this point, the figures are fairly representational and drawn with curving lines, in contrast to their fragmented, straight-edged appearance in the final version, and there is a sense of three-dimensional space receding to the rear.

Picasso then introduced some new elements. A

7.8 PABLO PICASSO, First Composition Study for *Guernica*, 1937. Pencil on blue paper, 8¼ × 10⅝ins (21 × 26.9cm). The Prado, Madrid.

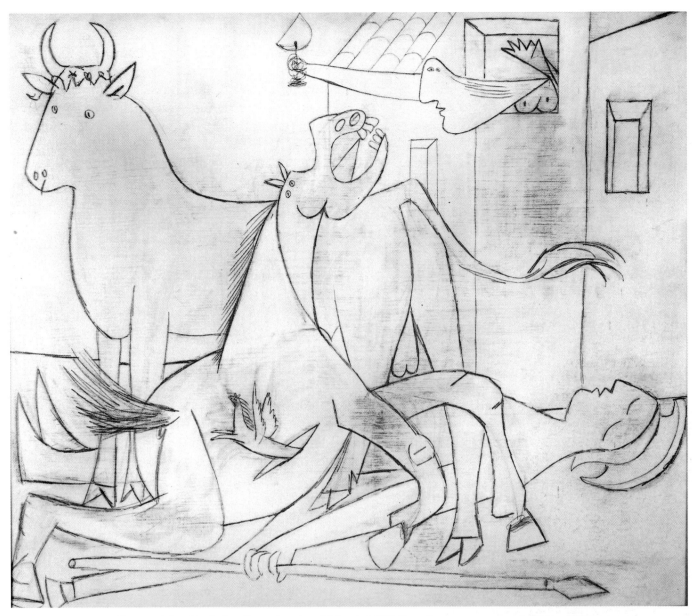

7.9 PABLO PICASSO, Composition Study for *Guernica*, dated May 1, 1937. Pencil on gesso on wood, 25½ × 21⅛ins (64.7 × 53.6cm). The Prado, Madrid.

major group he added is the mother and the dead baby (**7.10**). Throwing her head back into a reverse scream makes her plight all the more hideous. The baby's eyes seem partially aware here; its blood oozes through the mother's fingers. By the final painting, the baby's eyes are mere empty half-moons and the blood is gone, making it the most peaceful figure in the general agony of the scene. Before Picasso worked out the fully extended reverse scream posture, he had experimented with bringing the mother and baby

into the painting on bended knee at the right (**7.11**). At this point, Picasso also began to introduce the triangular shapes that play such an important role in the final composition. Three human corpses now lie on the ground, clenched fists rise heavenward, and the horse writhes into a new position.

In addition to the innovations in the sketches, Picasso continued to reassemble, add, and eliminate figures directly on the mural itself. Seven states preceding the final mural were photographed, giving us

7.10 PABLO PICASSO, Study for *Guernica, Mother with Dead Child on Ladder*, dated May 9, 1937. Pencil on white paper, 9½ × 17⅞ins (24.1 × 45.4cm). The Prado, Madrid.

further insight into the evolution of the artist's thoughts. In the second state of the painting (**7.12**), the woman with the lamp is thrust into greater prominence than before: She is larger and brought forward by the flattening out of the crowded space of the picture. The flaming woman with upraised arms has appeared to fill the space at the far right; the mother fits under the bull's head (Does he offer protection or is he holding her down?). Triangles are everywhere elaborated. Perhaps the most striking—later abandoned—aspect of this state is the hopeful, defiant fist of the dead soldier, raised with a patch of Spanish turf against a luminous sun. This dramatic gesture is reduced to a subtle sign of hope that must be discovered in the final version: the small flower in the soldier's hand. And the sun dwarfs the light brought to the situation by the woman with the lamp, who seems to have been needed from the first as a call to the world to witness what has happened.

In the final mural, all those who are suffering are imploring upwards or looking to the left, while the eyes of the centurion have swiveled around to face us, staring blankly even in death. The other eyes that face us are those of the bull—and what do we read in them? Although the bull turns away from the violence, he is clearly involved with it on some level. And so are we. No one can see this huge mural, full of larger-than-life suffering figures, without being deeply affected by it. Most people walk toward it until it fills their peripheral vision and then stop, held back by the jagged points and the pain that is more felt than seen.

Even at a distance it is impossible to grasp the whole composition at once or to resolve the meaning of the whole. Its ambiguities, even on the most basic level (for instance, is this scene inside or outside?), keep us exploring and feeling our way through the work. It is quite likely that this painting will still be studied hundreds of years from now. Showing only the effects and not "the enemy," it stands as an incredibly powerful illumination of the suffering that we humans are capable of inflicting. In this compassionate awareness lies some hope for change.

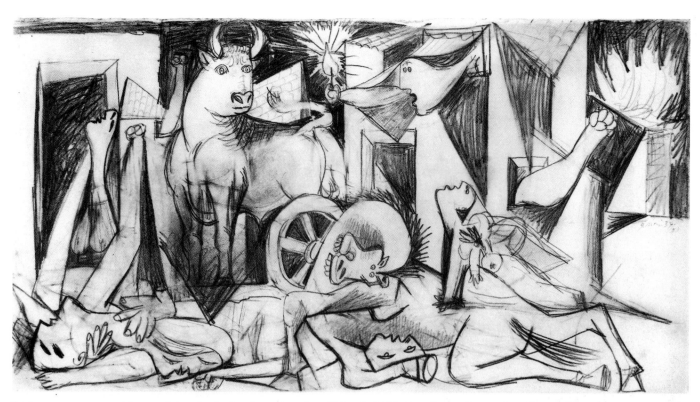

7.11 PABLO PICASSO, Composition Study for *Guernica*, dated May 9, 1937. Pencil on white paper, 9½ × 17⅞ins (24.1 × 45.4cm). The Prado, Madrid.

7.12 PABLO PICASSO, State II of *Guernica*, 1937.

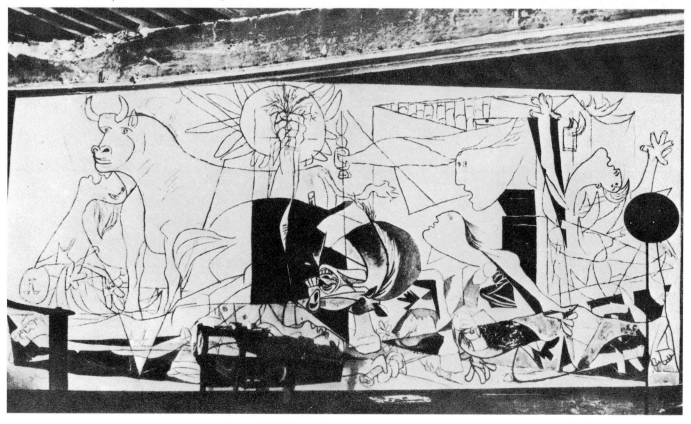

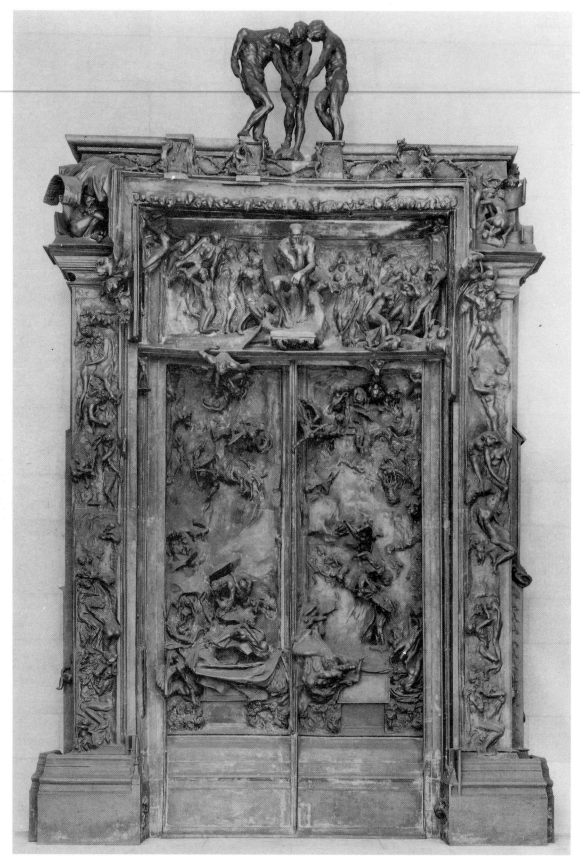

7.13

7.13 AUGUSTE RODIN, *The Gates of Hell*, 1880–1917. Bronze, 18 × 12ft (5.5 × 3.7m). Rodin Museum, Philadelphia, Gift of Jules Mastbaum.

7.14 AUGUSTE RODIN, Sketch for *The Gates of Hell*, 1880. Pencil, ink wash, and white gouache. Musée Rodin, Paris.

RODIN'S *GATES OF HELL*

What may have been the greatest sculpture of the nineteenth century was never displayed until well into the twentieth. This work—*The Gates of Hell* by Auguste Rodin (**7.13**), who reinvigorated the art of sculpture at a time when most significant work was being done in painting—occupied the artist from 1880 to 1900 but was not cast in bronze until after his death in 1917. It had been commissioned for the proposed Museum of Decorative Arts in Paris, which was never built. Rodin welcomed the opportunity to prove his stature as a skilled and imaginative sculptor after charges that his earlier life-sized sculptures were so realistic that they must have been cast from live models. His proposal for the great door was a sculptural image of *The Inferno* from Dante's *Divine Comedy*, whose allegorical account of the soul's return to God had deeply moved Rodin. He peopled his portal with nearly 200 fluidly expressive bodies, all smaller than life. Some are modeled in such low relief that they disappear into the swirling inferno;

7.15 AUGUSTE RODIN, Terra cotta study for *The Gates of Hell*. Musée Rodin, Paris.

obscured by the multitude of sensual figures.

Rodin soon abandoned any attempt at literal, compartmentalized depiction of the levels of Hell described by Dante. An early terra cotta study for the *Gates* (**7.15**) suggests its final form: a quasi-architectural framework with a cross at its center, topped by the seated figure later known as *The Thinker*. Rodin eventually executed *The Thinker* as an isolated sculpture; indeed, many of his sculptures first appeared in his preparations for the *Gates of Hell*. He worked with the malleability of clay, using live models moving freely as inspiration for gestures expressing their own inner lives. The figures and groupings thus developed were attached to a large wooden frame, on which clay was built up in relief. Plaster casts were then made of areas of the work, with the intention of using them as the basis for bronze lost-wax casts of the work. Only one of the casts that were ultimately made was done by the fine lost-wax process. Rodin actually dreamed of having the side jambs carved in marble, with the central panels cast in bronze.

Even the plaster casts themselves (**7.16**) reveal the extraordinary dynamism of Rodin's sculpture. Figures move far out and way back in space, creating areas of light and shadow that undulate continually through the piece. Extremely busy passages alternate with quieter ones, weaving another dimension into the visual rhythm of the piece. At the very top are the figures called *The Three Shades*. Like *The Thinker*, they were also cast and shown as a sculpture in themselves. They are actually the same figure cast three times and shown from three different angles. Their gestures keep directing the viewer's glance down into the turmoil below.

After absorbing an impression of the whole 18-foot (5.5m) structure, viewers are inevitably drawn in to try to decipher individual forms blended into the writhing turmoil. Among the inhabitants of Hell—which Rodin conceived as a state of mind rather than a place in the hereafter—is Count Ugolino (**7.17**). He and his sons were historical figures who had been locked in a tower to starve. There is an ambiguous suggestion in Dante's account that Ugolino ate his sons' corpses in his hunger. The horror of their torment is expressed physically, with the aristocratic

some reach out in full three-dimensionality toward the viewer. All bear witness to the profundity of Rodin's vision and his ability to use the human body to express the full drama of existence.

Historical precedents for the *Gates* included Ghiberti's Renaissance *Porta del Paradiso* (6.17), which Rodin had seen in Florence. Rodin started out with a similar concept. His first architectural sketches, such as the one shown in Figure **7.14**, divide the massive width of such a door into eight symmetrical panels. Yet even here, the organic forms they contain are starting to spill over their boundaries, until, in its final form, the straight lines of the architectural framework are mated to and in places

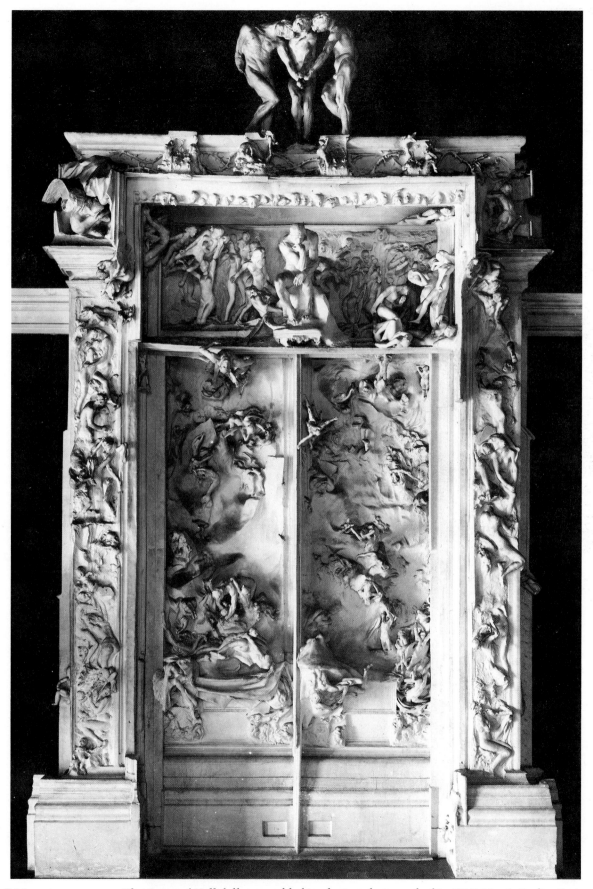

7.16 AUGUSTE RODIN, *The Gates of Hell*, fully assembled in plaster, photographed in 1917. Musée Rodin, Paris.

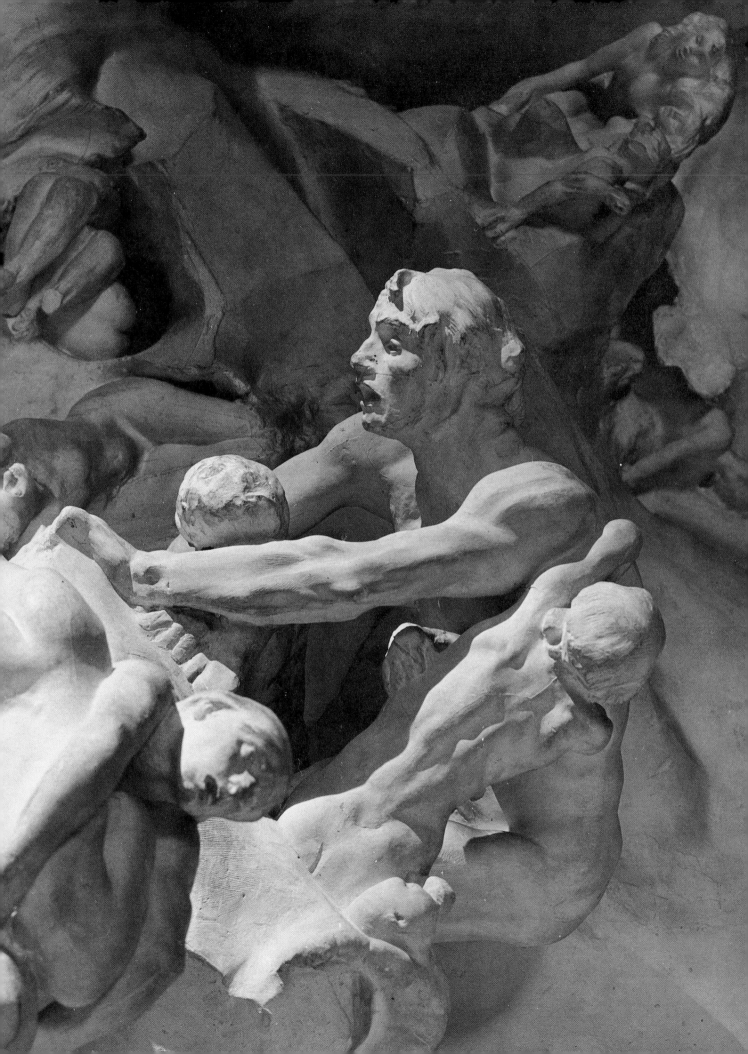

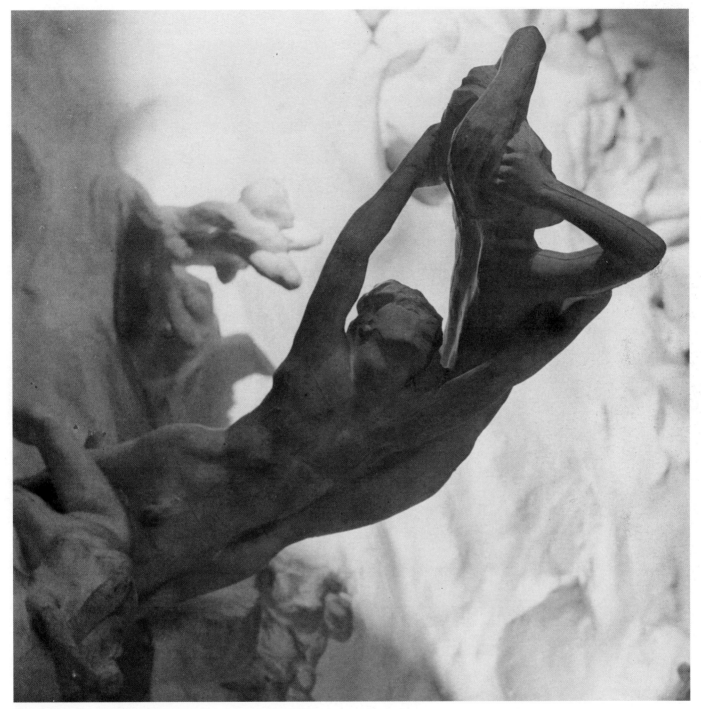

7.18 Plaster cast of *The Gates of Hell*. Detail of *Fugit Amor*.

count reduced to the crawling stance of a beast. They are placed on the left panel at the viewer's eye level, making their agony inescapable.

Below the Ugolino group are the historical figures of Francesca da Rimini and her lover Paolo, brother of the man she had married for family political reasons. Her husband, who was deformed and ugly, killed the pair when he found them out. Rodin treats their forbidden love sympathetically, if tragically, as he does that of the pair that thrusts outward from the

7.17 Plaster cast of *The Gates of Hell*. Detail of the lower section of the left door panel, with the Ugolino group and Paolo and Francesca.

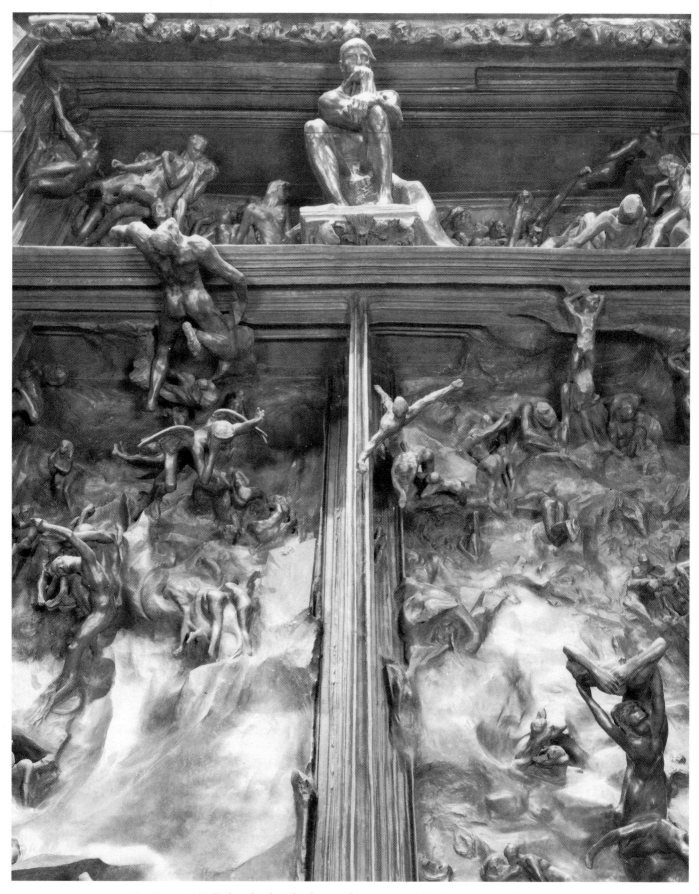

7.19 AUGUSTE RODIN, *The Gates of Hell*, detail. *The Thinker*, with portions of the door panels and tympanum. Bronze. Stanford University Museum of Art, Gift of B. Gerald Cantor Collections.

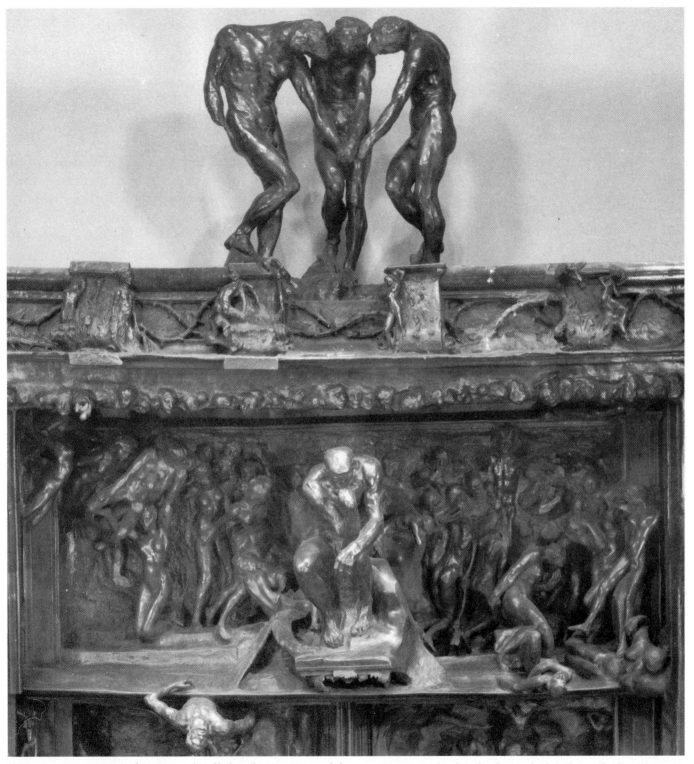

7.20 AUGUSTE RODIN, *The Gates of Hell*, detail. Front view of the tympanum, with *The Thinker* and *The Three Shades.*. Bronze. Stanford University Museum of Art, Gift of B. Gerald Cantor Collections.

right panel, called *Fugit Amor* (**7.18**) when shown as a separate sculpture. Back to back, they are among the lovers who cannot escape from the enslavement of their own passions. In Rodin's Hell, it is humanity that torments itself with its frustrated longings and inability to find peace.

The only still figure in the work is that of *The Thinker*. Many observers consider him the self-

7.21 AUGUSTE RODIN, Sketch for *The Gates of Hell* with architectural setting, c.1880–81. Pencil. Musée Rodin, Paris.

portrait of the artist—one who separates himself enough from the endless motion of human strivings to see the whole picture, wondering why. All about him bodies are struggling and climbing only to fall—even the angels (**7.19**). Within the maelstrom, some try to help and console each other; others are physically touching but isolated in their individual pain.

As observers, we stand equal to the fallen, looking upward to the barrier one would have to cross to reach the level of the Thinker. Behind him (**7.20**) are figures bespeaking seductions of the flesh and death of the body. Here, as elsewhere, different things are happening on either side of the center, breaking down the symmetry of the architectural framework and

replacing it with an undulating, organic disposition of forms in space.

To complete this epic depiction of the human condition, Rodin had intended that his sculptures of Adam and Eve be placed on either side of the *Gates*, as suggested in one of his early sketches (**7.21**). This sketch also reveals his vision of the doors as a portal at the top of a flight of stairs, framed by an arch. If this were so, if the *Gates* had actually been installed architecturally as doors, imagine what it would feel like to walk up to and then through them, as if entering the world they describe. When the *Gates* are set up with the life-sized sculptures of Adam and Eve (**7.22**), a strongly triangular composition results from the obvious reading from Adam to the Three Shades to Eve, justifying the large scale of the Shades. And to enter Hell by passing reminders of the idea of original sin—one explanation for human suffering—extends the logic of the whole.

Keenly aware of the pain of human existence, Rodin himself died in poverty, neglected by a government that accepted his works in exchange for providing him with a place to live. Heating fuel was an overlooked detail, and Rodin died from the cold, while his sculptures were housed in a heated public museum. Desperate, he asked to be allowed to stay in a room in the museum, but his request was denied by the official in charge. Friends and authorities promised coal, but did not bring it.

Despite the difficulties of his own situation and the frequent rejections of his work by more conventional minds, Rodin was passionately fond of art—and of what it reveals to us of life. His words provide a fitting conclusion to our appreciative exploration of the visual arts:

> Great works of art, which are the highest proof of human intelligence and sincerity, say all that can be said on man and on the world, and, besides, they teach that there is something more that cannot be known. . . . We [artists] are misunderstood. Lines and colors are only to us the symbols of hidden realities. Our eyes plunge beneath the surface to the meaning of things, and when afterwards we reproduce the form, we endow it with the spiritual meaning which it covers. An artist worthy of the name should express all the truth of nature, not only the exterior truth, but also, and above all, the inner truth.[3]

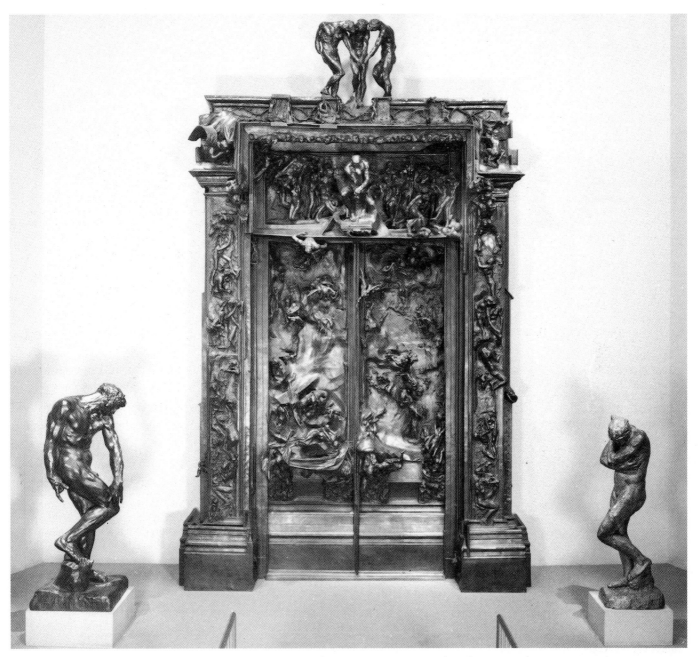

7.22 AUGUSTE RODIN, *The Gates of Hell*, with *Adam and Eve*, 1880–1917. Bronze (Coubertin Fondeur Cast No. 5), 251 × 158 × 33ins (638 × 401 × 84cm). Stanford University Museum of Art, Gift of B. Gerald Cantor Collections.

NOTES

Chapter One

1 Quoted in Margaretta K. Mitchell, *Recollections: Ten Women of Photography*, Viking Press, New York, 1979, pp. 30, 32.
2 Personal communication, March 22, 1987.
3 Quoted in Herbert Read, *A Concise History of Modern Sculpture*, Oxford University Press, New York, 1964, p. 14.
4 Conversation with Erik Satie, quoted in Carola Giedion-Welcker, *Brancusi*, Editions du Griffon, Neuchatel, Switzerland, 1959 (French edition), 31, p. 1.
5 Quoted by C. G. Guilbert, "Propos de Brancusi," *Prisme des Arts*, no. 12, 1957, p. 7, translated by Mary Pat Fisher.
6 1918 writing quoted by Eleanor S. Greenhill, *Dictionary of Art*, Laurel/Dell, New York, 1974, p. 283.
7 From Klee's Jena lecture, 1924, quoted in Will Grohmann, *Paul Klee*, Harry N. Abrams, New York, p. 367.
8 Quoted in S. Rodman, *Conversations with Artists*, New York, 1957.
9 Catalog for Russell Connor show at Grand Street Gallery, New York, November 1986.
10 Quoted in *National Geographic*, May 1985, p. 557.

Chapter Two

1 Quoted in Jonathan Fineberg, "Theater of the Real: Thoughts on Christo," *Art in America*, December, 1979, p. 96.
2 *Barbara Hepworth: A Pictorial Autobiography*, 1978 edition published by Moonraker Press, Bradford-on-Avon, Wiltshire, p. 27.
3 Letters to Émile Bernard, Aix-en-Provence, July 25, 1904 and April 15, 1904, quoted in Robert Goldwater and Marco Treves, eds., *Artists on Art*, Pantheon Books, New York, third edition, 1958, pp. 364, 363.
4 Quoted in Barbara Rose, *Claes Oldenburg*, Museum of Modern Art/New York Graphic Society, New York, 1970.
5 Personal communication, February 2, 1987.
6 Wassily Kandinsky, *Concerning the Spiritual in Art*, Dover Publications edition, New York, 1977, p. 25, translated by M. T. H. Sadler.

7 Quoted in Robert Goldwater and Marco Treves, eds., *Artists on Art*, op. cit., pp. 409–410.
8 Umberto Boccioni, Carlo Carrà, Luigi Russolo, Giacomo Balla, Gino Severini, "Futurist Painting: Technical Manifesto 1910," in Umbro Apollonio, ed., *The Documents of 20th Century Art: Futurist Manifestos*, Viking Press, New York, 1973 (English language translation copyright 1973 by Thames and Hudson Ltd., London), pp. 27–28.

Chapter Three

1 Quoted in John Dornberg, "One Way to Create Fine Art is to Take the Greatest Risks," *Smithsonian*, April 1985, p. 118.
2 Quoted in "The Courage to Desecrate Emptiness," *ARTnews*, March 1986, p. 108.

Chapter Four

1 Personal communication, October 1986.
2 Personal communication, April 25, 1987.
3 David Lance Goines, *David Lance Goines Posters*, Alphabet Press, Natick, Massachusetts, 1985.
4 William Morris, *The Ideal Book, Essays and Lectures on The Arts of the Book*, William S. Peterson, ed., University of California Press, Berkeley and Los Angeles, 1982, p. 73.
5 Quoted in Susan Weiley, "New Light on Color," *ARTnews*, October 1985, p. 88.
6 Melvin L. Prueitt, Los Alamos National Laboratory, "Scientific Applications of Computer Graphics," *The Visual Computer* 1986, vol. 2, p. 189.

Chapter Five

1 Quoted in Jack Cocks, "The Man Who's Changing Clothes," *Time*, October 21, 1985, pp. 77–78.
2 Frank Lloyd Wright, *An American Architecture*, Edgar Kaufmann, ed., Horizon Press, New York, 1955, pp. 105–106.
3 Quoted in Cathy Newman, "Pompidou Center, Rage of Paris," *National Geographic*, October 1980, p. 469.
4 Quoted in introduction to Donald Hoffman, *Frank Lloyd Wright's Fallingwater: The House and its History*, Dover Publications, New York, 1978.
5 Lawrence Halprin, *Cities*, Reinhold

Publishing Corporation, New York, 1963, p. 9.

Chapter Six

1 From the *Commentaries* of Lorenzo Ghiberti, quoted in Robert Goldwater and Marco Treves, eds., *Artists on Art*, op. cit., pp. 28–30.
2 Johann Joachim Winckelmann, *Thoughts on the Imitation of Greek Works of Art*, Dresden 1755, English translation 1765, quoted in Hugh Honour and John Fleming, *The Visual Arts: A History*, Prentice-Hall, Englewood Cliffs, New Jersey, second edition, 1986, p. 496.
3 "Open Letter to a Group of Prospective Students," Paris, 1861, quoted in Goldwater and Treves, eds., *Artists on Art*, op. cit., p. 296.
4 Conversation with Ambroise Vollard, quoted in Goldwater and Treves, op. cit., p. 322.
5 Quoted in Faber Birren, *History of Color in Painting*, Reinhold Publishing, New York, 1965, p. 332.
6 "Reflections on Painting," Paris 1917, quoted in Goldwater and Treves, op. cit., p. 422.
7 An interview with Pablo Picasso, quoted in Goldwater and Treves, op. cit., p. 417.
8 Umberto Boccioni, Carla Carrà, Luigi Russolo, Giacomo Balla, Gino Severini, "Manifesto of the Futurist Painters 1910," in Umbro Apollonio, ed., *The Documents of 20th Century Art: Futurist Manifestos*, op. cit., p. 26, translated by Robert Brain.
9 Personal communication, May 19, 1987.
10 Sol LeWitt, "Sentences on Conceptual Art," quoted in Lucy R. Lippard, *Six Years: The Dematerialization of the Art Object*, Praeger, New York, 1973, pp. 75–76.
11 Quoted in Judith Higgins, "In a Hot Country," *ARTnews*, Summer 1985, p. 65.
12 Quoted in "Portfolio," *American Craft*, October/November 1986, p. 53.

Chapter Seven

1 Quoted in Edward Deming Andrews, *The People Called Shakers: A Search for the Perfect Society*, Dover Publications, New York, 1963, p. 24.
2 Quoted in Frank D. Russell, *Picasso's Guernica*, Allanheld and Schram, Montclair, New Jersey, 1980, p. 56.
3 Auguste Rodin, *Art*, Small, Maynard and Company, Boston, 1912, pp. 181, 178, translated from the French of Paul Gsell by Mrs. Romilly Fedden.

GLOSSARY

Where a definition includes a term that is itself defined elsewhere in the Glossary, that word is printed in small capitals.

A

ABSTRACT Referring to the essence rather than the surface of an object, often by stripping away all nonessential characteristics.

ABSTRACT EXPRESSIONISM The post-World War II movement centered in New York in which paint was freely applied to a large canvas, expressing the energy and feelings of the artist *nonobjectively*, usually with no emphasized FOCAL POINT.

ACRYLIC A water-based synthetic MEDIUM for painting, also called *acrylic emulsion*.

ACTION PAINTING A style of painting, most notably practiced by Jackson Pollock, in which paint is dribbled and splashed onto the SUPPORT with broad gestural movements.

ACTUAL TEXTURE The true physical feeling of a form's surface.

ADDITIVE COLOR MIXING The combination of REFRACTED colors.

ADDITIVE SCULPTURE That which is created by a process of building up or combining materials.

AERIAL PERSPECTIVE The illusion—and illusionary device—that forms seen at a great distance are lower in VALUE contrast and less sharply defined than objects close to the viewer.

AERIAL VIEW A downward perspective on an image.

AESTHETIC Pertaining to a sense of the beautiful.

AESTHETIC DISTANCE The spatial relationship between the viewer and a work of art.

AESTHETICS Theories of what is beautiful.

AIRBRUSH A tool used for blowing a fine spray of paint onto a surface, to allow smooth gradations of VALUES and HUES.

ALLA PRIMA See DIRECT PAINTING.

ANALOGOUS COLORS Those lying near each other on the COLOR WHEEL, combined in a color scheme.

ANNEAL To heat metal to make it more malleable, to counteract the hardening typical as metal is worked.

ANTIQUE GLASS Sheets of glass that has been handblown as a cylinder, cut, and heated to flatten it; often characterized by bubbles and warps.

APPLIED ARTS Disciplines in which functional objects are created.

APSE In church architecture, the semi-circular end of the building.

AQUATINT An INTAGLIO printmaking technique, producing grainy tones rather than lines, that uses acid to penetrate areas of a metal plate that are covered by porous powdered resin.

ARMATURE An inner skeleton that supports a sculpture made of some malleable material.

ARTISAN A person who is skilled at a certain CRAFT.

ASYMMETRICAL BALANCE Distribution of dissimilar visual weights in such a way that those on either side seem to offset each other, also called *informal balance*, in contrast to SYMMETRICAL or FORMAL balance.

ATMOSPHERIC PERSPECTIVE See AERIAL PERSPECTIVE.

AXIS An imaginary straight line passing centrally and/or longitudinally through a figure, form, or composition.

B

BALANCE The distribution of apparent visual weights through a composition. See ASYMMETRICAL BALANCE.

BALLOON FRAME In architecture, a wooden framework made of many slender pieces of wood nailed together rather than heavy timbers.

BAROQUE Seventeenth-century artistic styles in Europe, characterized by swirling composition, sensuality, emotionality, and exuberant sculptural and architectural ornamentation.

BARREL VAULT A ceiling in the form of an unbroken tunnel.

BAS RELIEF See LOW RELIEF.

BINDER The material used in paint and some drawing MEDIA to bind the particles of PIGMENT together and enable them to stick to the SUPPORT.

BLIND EMBOSSING Pressing an uninked, cut plate of metal against paper to create a sculptured, uninked image.

BRACELET MODELING The use of oval lines disappearing over an edge to create the illusion of rounded form on a two-dimensional surface.

BURIN A bevelled steel rod used for cutting lines in LINE ENGRAVINGS or WOOD ENGRAVINGS.

BURL A woody circular knob on the trunk of certain trees, prized for its whorled lines in woodworking.

BURNISH Rub to a shiny finish.

BUTTRESS An external supporting structure built against a wall to counteract the thrust of an arch or vault. See FLYING BUTTRESS.

BYZANTINE Referring to art of the Byzantine period in the eastern half of the Roman Empire, from 330 AD to the mid-fifteenth century. This art was primarily religious and characterized by STYLIZED elongated human forms and rich ornamentation.

C

CALLIGRAPHY The art of fine writing.

CARTOON A full-sized drawing for a two-dimensional work, such as a

FRESCO, which is transferred to the SUPPORT at the preparatory stage.

CASTING The creation of a three-dimensional form by pouring into prepared molds a molten or liquid material that will later harden.

CERAMICS The art of making objects of clay and FIRING them in a KILN.

CHALK Naturally deposited calcium carbonate, ground to a powder and reconstituted with a BINDER for use as a drawing MEDIUM.

CHARCOAL Charred vine or wood used in sticks as a soft drawing MEDIUM.

CHIAROSCURO The depiction in two-dimensional art of the effects of light and shadow, highly developed in RENAISSANCE paintings as a means of rendering the solidity of bodies.

CHROMA See SATURATION.

CINEMATOGRAPHY The artistic and technical skills involved in creating motion pictures.

CIRE PERDUE See LOST-WAX.

CLASSICAL The art and culture of ancient Greece and Rome.

CLASSICAL PERIOD Greek art from c.500 to 323 BC, characterized by serene balance, harmony, idealized beauty, and lack of extraneous detail.

CLASSICISM Movements, periods, and impulses in Western art that prized qualities of harmony and formal restraint and claimed direct inspiration from CLASSICAL models. Traditionally contrasted with ROMANTICISM.

CLOSED FORM In sculpture, an unbroken volume with no projections or VOIDS.

COIL BUILDING A method of building a form of clay by rolling it into long ropes which are coiled in a spiraling pattern to raise the sides of the piece.

COLLAGE A two-dimensional technique in which materials are glued to a flat surface.

COLOR WHEEL Relationships among HUES expressed as a circular two-dimensional model.

COMPLEMENTARY HUES Colors lying opposite each other on a COLOR WHEEL.

COMPOSITIONAL LINE A line that leads the eye through a work, unifying figures or parts of figures.

COMPUTER GRAPHICS Various techniques of creating two-dimensional artworks by computer.

CONCEPTUAL ART Works in which idea is more important than form.

CONTÉ CRAYON A fine-textured, non-greasy stick of powdered graphite and clay with red ochre, soot, or blackstone added for color, used as a drawing tool.

CONTENT The subject matter of a work of art and the emotions, ideas, symbols, stories, or spiritual connotations it suggests. Traditionally contrasted with FORM.

CONTRAPPOSTO In figurative works, counterpoised ASYMMETRICAL BALANCE between parts of the body, with most of the weight on one leg and an S-curve in the torso, first used by CLASSICAL Greek sculptors.

CONTRAST Abrupt change, as when opposites are juxtaposed.

CONTROL To determine how an area will be seen or experienced.

COOL COLORS Those from the blue and green side of the COLOR WHEEL, thought to convey a feeling of coldness.

CRAFTS Disciplines in which functional objects are made by hand.

CROP To delete unwanted peripheral parts of a design.

CROSS-HATCHING Crossed parallel lines used to create the illusion of form on a two-dimensional surface, by suggesting shadows and rounding in space.

CUBISM An early twentieth-century art movement dominated by Picasso and Braque, distinguished by its experiments with analyzing forms into planes seen from many sides at once and by liberation of art from representational depictions.

D

DADA An anti-rational, anti-AESTHETIC art movement begun in 1916.

DAGUERROTYPE An early photographic process invented by Louis Daguerre.

DECORATIVE LINE Line that embellishes a surface.

DEFENSIVE GRID Our ability to screen out unnecessary stimuli.

DESCRIPTIVE LINE Line that tells the physical nature of an object.

DIPTYCH A work consisting of two panels side by side, traditionally hinged to be opened and closed.

DIRECTIONAL Telling the eye which way to look.

DIRECT PAINTING Application of paint directly to a SUPPORT without UNDERLAYERS, in contrast with INDIRECT PAINTING. Also called *alla prima*.

DIVISIONISM See POINTILLISM.

DRYPOINT An INTAGLIO printmaking technique, often used in combination with ETCHING, in which lines are scratched directly into the metal plate with a sharp-pointed tool.

DUCTILITY The capacity for being drawn out into wires or hammered into sheets, a varying property of metals. Gold and copper are noted for their especially high ductility.

DYNAMIC FORM A mass that appears to be in motion.

E

EARTHENWARE CERAMICS made from porous, coarse-textured clays such as terra cotta.

EARTHWORK A large-scale sculpture in which the surface of the earth is the MEDIUM.

ECONOMY Use of as few means as possible to achieve a desired visual result.

EDGE A boundary where two areas treated differently meet.

ELEMENTS OF DESIGN The basic components of the visual arts: line, shape or form, space, texture, lighting, color, and perhaps time.

EMPHASIS Predominance of one area or element in a composition.

ENAMEL A colored glassy coating heat-fused to metal.

ENCAUSTIC A painting technique in which PIGMENT is mixed with a BINDER of hot wax.

ENGRAVING An INTAGLIO printmaking technique in which lines are cut on a metal or wood printing surface with a sharp tool.

ENTABLATURE The horizontal member atop a column, supporting what lies above.

ENTASIS A slightly convex curve given to the shaft of a column to correct the illusion of concavity produced by a perfectly straight shaft.

ENVIRONMENTAL DESIGN The art of manipulating outdoor areas for practical and aesthetic purposes, from landscaping to relationships among buildings in urban settings.

ERGONOMICS The study of the mechanics and proportions of the human body, with the aim of designing products with which the body can interact efficiently and comfortably.

ETCHING An INTAGLIO printmaking technique in which lines are produced by scratching away a protective covering of wax on a copper plate, which is then bathed in acid that bites channels where the metal has been exposed.

EXPRESSIONISM An art movement, particularly strong in Germany prior to World War I, in which the artist reports inner feelings rather than outer realities.

EXPRESSIVE Giving form to emotions.

EXTERIOR CONTOUR The outside form of a three-dimensional piece.

EYELINE The implied line along which the eyes of a human figure in a work of art seem to be looking.

F

FAÇADE The front or principal elevation of a building.

FANTASY Imagery existing only in the imagination.

FAT Referring to a painting medium, such as oil, that can be piled up in thick gobs and that dries slowly.

FAUVISM An art movement of the first decade of the twentieth century, using color boldly to express the inner qualities rather than superficial appearance of things.

FIGURATIVE Referring to artworks based on images of identifiable objects.

FIGURE-GROUND RELATIONSHIP A correspondence between parts of a design in which one appears as an object with the other appearing to be the background.

FIGURE-GROUND REVERSAL A FIGURE-GROUND RELATIONSHIP in which there is intentional ambiguity between which part of a design is the figure and which part is the background.

FINE ARTS The nonfunctional art disciplines, such as painting and sculpture.

FIRE To heat CERAMICS to make them durable.

FLYING BUTTRESS A BUTTRESS in the form of strut or segmented arch that transfers thrust to an outer support.

FOCAL POINT The area of a composition to which the viewer's eye is most compellingly drawn.

FORCED PERSPECTIVE The exaggerated illusion of deep space, often employed in setmaking for theatrical performances.

FOREGROUND In two-dimensional work, the area of a composition that appears closest to the viewer.

FORESHORTENING Contraction of the length and adjustment of the contours of a figure perpendicular to the viewer. This is done to counteract the perceptual distortion of proportions of objects receding from the viewer into the distance.

FORGE To hammer heated metal over an anvil to shape it.

FORM 1. The mass or volume of a three-dimensional work or the illusion of volume in a two-dimensional work. 2. The physical aspects of a work, as opposed to its emotional and intellectual CONTENT.

FORMAL BALANCE See SYMMETRICAL BALANCE.

FOUND OBJECT An object that is presented as a work of art or a part of one, but which was not originally intended as art; also called *objet trouvé*.

FRESCO A wall painting technique in which PIGMENT in a water base is applied directly to fresh, still-damp plaster, into which it is absorbed.

FRONTAL Referring to sculpture designed to be seen only from the front.

FULL ROUND Referring to sculpture that exists in fully three-dimensional space, unattached to a backing.

FUTURISM A movement initiated in Italy in 1909 to sweep aside all artistic conventions and capture the qualities of modern industrialized life.

G

GEODESIC DOME A structural framework of small interlocking polygons forming a dome.

GEOMETRIC Having mathematically regular contours, such as a circle, square, or rectangle.

GEOMETRIC PERIOD A stylistic phase of ancient Greek art between c.800 and 700 BC characterized by abstraction of forms to geometric elements.

GESSO A fluid white coating of plaster, CHALK and SIZE used to prepare a painting surface so that it will accept paint readily and allow controlled brushstrokes.

GLAZE 1. A thinned, transparent layer of oil paint. 2. A mineral solution, applied to a CERAMIC piece, that vitrifies to a glossy and water-resistant coating when FIRED.

GOLDEN SECTION or MEAN In ancient Greek AESTHETIC theory, an ideal proportional relationship between parts, whereby the smaller is to the greater as the greater is to the whole. This ratio cannot be worked out mathematically, but is approximately 5:8, or 1:1·618.

451

GOLDEN RECTANGLE A rectangle the lengths of whose sides correspond to GOLDEN SECTION proportions. Much used as a compositional and format-establishing device in Renaissance painting.

GOTHIC A style of European art from the mid-twelfth to mid-fifteenth centuries, especially noted for its soaring vertical cathedrals, three-dimensional sculptures, and the sense of depth and emotion in two-dimensional paintings.

GOUACHE An opaque water-soluble painting MEDIUM bound with gum arabic, the lighter tones being mixed with Chinese white watercolor.

GRAPHIC DESIGN The arts involved in creating two-dimensional images for commercial purposes. Graphic designers often work with type as well as illustrations; the printed surface may range from paper to fabrics.

GRAPHITE A soft carbon used in drawing pencils.

GROIN VAULT In architecture, two intersecting, identical BARREL VAULTS.

GROUND 1. See FIGURE-GROUND RELATIONSHIP. 2. The prepared surface of the SUPPORT for a painting, onto which paint is applied.

H

HATCHING Fine, short parallel lines used in two-dimensional arts to create the effect of shadow on three-dimensional form. See also CROSS-HATCHING.

HELLENISTIC PERIOD Greek art from 323 to 100 BC or later, characterized by greater dynamism, emotional drama, and naturalism than that of the CLASSICAL PERIOD.

HIGH CONTRAST Polarization of the normal range of VALUES toward the extremes of dark and light.

HIGH RELIEF Sculpture in which figures emerge three-dimensionally from a flat surface to half or more than half of their natural depth.

HIGH RENAISSANCE The years between roughly 1490 and 1520 in Italy, productive of some of the world's

greatest art, informed by but not bound to CLASSICAL traditions.

HIGHLIGHT A spot of highest (lightest) VALUE in a work—usually white.

HUE The property of a color that enables us to locate its position in the SPECTRUM or on the COLOR WHEEL and thus label it as "red" or "blue," etc. This is determined by its wavelength.

ICON A two-dimensional depiction of a sacred figure or figures, thought to work miracles, particularly characteristic of BYZANTINE sacred art.

I

IDEALIZED Referring to art in which REPRESENTATIONAL images conform more closely to ideal AESTHETIC standards than to real life.

IMPLIED A line, shape, or form that is suggested to the eye but not actually present.

IMPASTO Thickly applied paint—mainly oil or acrylic.

IMPRESSIONISM An art movement originating in late nineteenth-century France, in which the artist attempts to capture what the eye actually sees before the brain interprets the image. This may be a surface broken by fragmented lights or an ephemeral moment in time.

INDIRECT PAINTING Using a series of layers to produce a desired final effect, in contrast with DIRECT PAINTING.

INDUSTRIAL DESIGN The art of creating functional products that also have AESTHETIC appeal.

INSTALLATION PIECE A three-dimensional designed environment set up (often temporarily) as a work of art.

INTENSITY See SATURATION.

INTAGLIO A category of printmaking processes in which the desired image is cut into the surface of a plate, which is inked and then wiped, leaving ink only in the cut channels. Dampened paper is forced against the plate, picking up the ink.

INTERIOR CONTOUR The form of the inside of a three-dimensional piece.

INTERIOR DESIGN The art of

decorating the insides of human environments.

INTERNATIONAL STYLE An architectural style, originating in Europe after World War I, characterized by rectangular forms, white walls, large windows, flat roofs, and the absence of ornament.

INTERPRETIVE COLOR Color chosen to represent an emotional atmosphere or idea rather than the visual reality of an object.

INTERPRETIVE VALUES Lights and darks used to convey an atmosphere or idea rather than a literal description of the actual VALUES of a real scene.

INTONACO In FRESCO technique, the final layer of plaster, to which paint is applied during the course of the day.

INVESTMENT A heat-resistant outer mold packed around a LOST-WAX CASTING.

K

KILN A special oven or furnace for FIRING CERAMICS.

KINETIC SCULPTURE Three-dimensional work that moves.

L

LATE GOTHIC Work produced in Europe toward the end of the GOTHIC period, characterized by increasing NATURALISM and expressiveness and by the fine details and luminosity of oil paintings.

LEAD CRYSTAL High-quality, exceptionally clear and colorless glass in which a large percentage of the formula is lead oxide.

LEAN Referring to a MEDIUM that forms a uniform thin film, such as TEMPERA, in contrast to a FAT medium.

LIMITED PALETTE Highly selective use of only a few colors.

LINE ENGRAVING A PRINT made by cutting lines into a plate of metal, forcing ink into them, and printing the cut lines.

LINEAR PERSPECTIVE The illusion of deep space in a two-dimensional work through convergence of lines

perpendicular to the PICTURE PLANE toward a VANISHING POINT in the distance.

LINOCUT A PRINT made by gouging away areas of a linoleum block that are not to be inked and printed.

LITHOGRAPHY A printmaking technique in which a flat stone or metal or plastic plate is drawn on with a greasy substance that retains ink when the wettened plate is inked for printing.

LOCAL COLOR The color usually associated with an object, as seen from nearby under normal daylight without shadows or reflections.

LOCAL VALUE The degree of light or darkness seen on an actual surface.

LOGO A graphic or typographic image that identifies a business or group.

LOST-WAX A CASTING process in which wax is used to coat the insides of molds and then melted away when the molds are assembled, leaving an empty space into which molten metal is poured; also called *cire perdue*.

LOW RELIEF Sculpture in which figures exist on almost the same PLANE as the background.

M

MALLEABILITY The capacity for being shaped by physical pressure, as in hand modeling or hammering.

MANNERISM An artistic style in Italy from approximately 1525 to 1600 in which artists developed a more subjective, emotional, theatrical approach than in the preceding HIGH RENAISSANCE period.

MAQUETTE A small model used for planning and guiding the creation of a sculpture.

MEDIUM (plural *media*) 1. The material or means of expression with which the artist works. 2. The liquid solvent, such as water or linseed oil, in which PIGMENT is suspended to make paint fluid and workable.

MEZZOTINT An INTAGLIO printmaking technique in which an overall burr is raised on the surface of the metal plate and then smoothed in

places, creating varied tones and textures.

MINIATURE A work of art done on a much smaller scale than the object being represented.

MIXED MEDIA Combined use of several different techniques—such as drawing, painting, and printmaking—in a single work of art.

MOBILE See KINETIC ART.

MODELING 1. In two-dimensional art, the depiction of three-dimensional form, usually through indications of light and shadow. 2. In sculpture, creating a form by manipulating a soft MEDIUM, such as clay.

MONOCHROMATIC Having a color scheme based on VALUES of a single HUE, perhaps with accents of another color or neutral colors.

MONOTYPE A printmaking process in which an image is painted directly onto a sheet of metal or glass and then transferred onto paper. The process can be repeated with some repainting of the plate, but this is basically a means of creating relatively few prints of an image.

MONTAGE 1. A composite two-dimensional image produced by assembling and pasting down cut or torn sections of photographs or drawings. 2. In cinematography, the composition of a sequence of short shots of related meaning.

MOSAIC Two-dimensional art created by attaching small pieces (TESSERAE) of ceramic tile, glass, pebbles, marble, or wood to a surface.

MOTIF A recurring pattern in a work of art.

MURAL A painting, usually large, done on a wall.

N

NAIVE ART That which is created by artists with no formal training.

NARRATIVE Referring to art with a storytelling quality.

NATURALISM A style of art that seeks to represent accurately and faithfully the actual appearance of things.

NAVE In church architecture, the central hall.

NEGATIVE SPACE Unfilled areas in a design.

NEOCLASSICISM The late eighteenth- and early nineteenth-century return to CLASSICAL AESTHETICS in Europe.

NEO-EXPRESSIONISM A contemporary art movement in which painting is used to express the artist's feelings, projected as distorted images from the exterior world.

NONOBJECTIVE Referring to art that does not represent any known object.

NONREPRESENTATIONAL See NONOBJECTIVE.

NORTHERN RENAISSANCE Referring to German art from c.1500, when the individualistic and rational aspects of the Italian RENAISSANCE were adopted and adapted to Northern styles.

O

OFFSET LITHOGRAPHY A commercial printmaking process in which the inking of illustrations and text is offset from the plate onto a rubber-covered cylinder that transfers them to paper so that the printed image reads the same way as the original, rather than being reversed.

OP ART Paintings that produce visual phenomena in the perception of the viewer that do not actually exist on the canvas.

OPALESCENT GLASS Opaque glass used for art objects, with color oxides swirled through it as it is poured in a molten state into sheets.

OPEN FORM In sculpture, a volume broken by projections and/or VOIDS.

OPEN PALETTE Use of an unlimited range of colors in juxtaposition.

OPTICAL COLOR MIXTURES Those in which colors are mixed in the viewer's perception rather than in physically mixed pigments.

OVERLAPPING Hiding of part of one figure by another, a device used to suggest depth in space.

OVERPAINTING The final layers in an

INDIRECT painting, such as GLAZES or SCUMBLING.

P

PASTEL A chalky stick of powdered PIGMENT, calcium carbonate filler, and BINDER, used as a drawing MEDIUM.

PATTERN An all-over design created by repetition of figures.

PERFORMANCE ART Art in which the medium of expression is the artist's own body and its coverings.

PERSPECTIVE See AERIAL PERSPECTIVE; LINEAR PERSPECTIVE.

PHOTOGRAM One of the precursors of modern photography, an image made by laying objects on light-sensitive paper and exposing it to sunlight, leaving the masked areas white while the rest of the paper turns dark.

PHOTOREALISM Art that is as REPRESENTATIONAL as a photograph, but created by other media; also called *super-realism*.

PICTURE PLANE The flat surface of a two-dimensional work, often conceived as a transparent window into three-dimensional space. See LINEAR PERSPECTIVE.

PIGMENT Powdered colored material used to give HUES to paints and inks.

PIXEL In computer graphics, one of many tiny points on the computer screen determined by intersections of *x* and *y* axes.

PLANE A flat surface.

PLANISH To hammer metal smooth.

PLANOGRAPHIC Referring to a printmaking technique in which images are transferred from a flat surface, as in LITHOGRAPHY.

POINTED ARCH An arch formed by the intersection of two curves of greater radius than that of the opening; an innovation introduced in GOTHIC architecture.

POINT OF VIEW The place from which a two-dimensional scene is reported.

POINTILLISM A technique of painting using dots of PRIMARY and SECONDARY HUES in close juxtaposition to make

them mix in the viewer's perception. Also called *Divisionism*.

POP ART A movement beginning in the mid-twentieth century that uses objects and images from the commercial culture.

PORCELAIN CERAMICS made from the finest clays, which produce an extremely smooth, glossy surface when fired.

POSITIVE SPACE Filled areas in a design, or those intended to be seen as figures.

POST AND LINTEL An architectural construction system in which upright members support horizontal members, or lintels.

POST-IMPRESSIONISM Transcendence of the perceived limitations of IMPRESSIONISM by mid-nineteenth- and early twentieth-century artists such as Cézanne, Seurat, Gauguin, and van Gogh.

POST-MODERNISM An architectural movement of the 1970s and 80s, countering the glass boxes of the INTERNATIONAL STYLE with more historically eclectic forms.

POST-PAINTERLY ABSTRACTION Various mid-twentieth-century styles of creating NONOBJECTIVE paintings that evoke certain responses in viewers, with the hand of the artist less obvious than in ABSTRACT EXPRESSIONISM.

PRIMARY COLORS The set of three basic HUES from which all other hues can be mixed; in REFRACTED colors, red, green, and blue; in REFLECTED colors, red, yellow, and blue.

PRIMARY CONTOURS The outer edges of a FORM.

PRINCIPLES OF DESIGN The organizing factors in the visual arts, including repetition, variety, CONTRAST, RHYTHM, BALANCE, compositional unity, EMPHASIS, ECONOMY, PROPORTION, and relationship to the environment.

PRINT An image made by transferring ink from a worked surface onto a surface, usually paper, and usually in multiples.

PROPORTION Size relationships of parts to each other and to the whole.

PROSCENIUM 1. The part of a stage for theatrical production that projects in front of the curtain. 2. In ancient Greek theatre, the whole of the stage.

PROSCENIUM ARCH The arch that frames the stage, hiding its mechanics.

PUTTI (singular *putto*) Chubby nude male babies often depicted in Italian art from the fifteenth century onward.

R

RAISE In metalworking, to hammer a flat sheet over a stake to bring up the sides of a vessel and work them inward.

READ To see and assign meaning to aspects of a design.

REALISM The attempt in art to capture the appearance of life as it is, as opposed to STYLIZED or ROMANTICIZED portrayals. In mid-nineteenth-century France, the artistic movement of this name concentrated on subjects from everyday, and often working-class, life.

REDUCTION PRINT A color relief print in which portions of a single block are cut away in stages, with each stage overprinted in another color, rather than creating a series of registered blocks for the various colors.

REFLECTED COLORS HUES seen when light is reflected from a PIGMENTED surface.

REFRACTED COLORS HUES seen in light.

RELIEF 1. A sculptured work in which an image is developed outward or inward from a two-dimensional surface. 2. A printmaking category in which areas that are not to be inked are carved away, leaving the image raised on the block.

RENAISSANCE A movement beginning in fifteenth-century Italy to recapture the harmony, symmetry, and rationality of CLASSICAL works, with an elaboration of LINEAR PERSPECTIVE.

REPOUSSÉ The working of a sheet of metal from the back to create designs in relief on the front.

REPRESENTATIONAL Referring to artworks that aim to present likenesses of known objects.

RESIST The waxy, acid-resistant

substance used to coat the metal plate used for ETCHING, into which the lines of the image are drawn.

RETROUSSAGE The process of wiping ink from the surface of INTAGLIO plates, leaving ink only in the grooves of ETCHED or ENGRAVED lines, allowing white areas and sharp lines in the print.

RHYTHM The visual equivalent of notes and pauses in music, created by repetition, variety, and spacing in a design.

RIBBED VAULT In architecture, a masonry ceiling in which arched diagonal ribs form a framework that is filled with lighter stone.

ROCOCO The late BAROQUE period, particularly in France, southern Germany, and Austria, characterized by extremely ornate, curvilinear forms in architectural decoration and delicacy and looseness in painting.

ROMANESQUE A style of European art from about the eleventh century to the beginning of the GOTHIC period, most notable for its architecture of rounded arches, thick walls and columns, and stone relief carvings.

ROMANTICISM The tendency to emphasize emotion and imagination rather than logic, occurring at many times in the history of Western art, including the first half of the nineteenth century. Traditionally contrasted with CLASSICISM.

ROUND ARCH An arch formed by a semicircle; an innovation introduced by Roman architecture and much used in ROMANESQUE architecture.

S

SANS SERIF Referring to a typeface that has no fine lines finishing the major strokes.

SATURATION The relative brightness or dullness of a color, also called *chroma* or *intensity*.

SCALE Relative size.

SCREEN PRINT See SILK SCREEN.

SCUMBLING In oil painting, putting one layer of opaque paint on top of another in such a way that the UNDERLAYERS partially show through.

SECONDARY COLORS Hues produced by combining two PRIMARY hues.

SECONDARY CONTOURS Forms developed across the surface of a larger form.

SERIF In typography, the fine lines used to finish the heavier main strokes of letters; also used of a typeface that has this feature.

SERIGRAPH See SILK SCREEN.

SFUMATO Softly graded tones in an oil painting, giving a hazy atmospheric effect, highly developed in the work of Leonardo da Vinci.

SHAPE A flat, defined area.

SILK SCREEN A printmaking process in which ink is pressed through a fine screen in areas that are not masked by a stencil or other material; also called *serigraph*.

SILVERPOINT A drawing MEDIUM in which a finely-pointed rod of silver encased in a holder is used to make marks on a slightly abrasive surface; the minute deposit of metal darkens by oxidation.

SIMULATED TEXTURE The illusion that an image would feel a certain way if touched, in contrast to the reality of its actual texture.

SIZE or SIZING A coating of glue or resin to make a surface such as canvas less porous so that paint will not sink into it.

SKENE In early Greek theatres, the building at the back of the performance area from which actors entered and exited, also used as a changing room and as the backdrop for the action.

SLAB BUILDING The process of building a form of clay by attaching flat shapes to each other.

SPACE The area occupied, activated, or suggested by a work of art.

SPECTRUM See VISIBLE SPECTRUM.

STAINED GLASS Art glass colored with chemical colorants heated in a kiln with the glass base.

STATE One of the stages of an ETCHING, if printed separately.

STATIC FORM A mass that appears inert.

STILL-LIFE A two-dimensional representation of a group of inanimate objects such as fruit, flowers, and vessels.

STONEWARE CERAMICS made from clays that become very hard when FIRED at high temperatures.

STYLIZED Referring to distortion of REPRESENTATIONAL images in accordance with certain artistic conventions or to emphasize certain design qualities.

SUBTRACTIVE COLOR MIXING The combination of REFLECTED colors.

SUBTRACTIVE SCULPTURE That which is created by the process of carving away material to reveal the desired FORM.

SUPER-REALISM See PHOTOREALISM.

SUPPORT The solid material base on which a two-dimensional work of art is executed, such as canvas or panel in the case of a painting.

SURREALISM Art based on dreamlike images from the subconscious, appearing as a recognized movement beginning in the 1920s.

SYMMETRICAL BALANCE Distribution of equal forces around a central point or AXIS, also called *formal balance*.

SYNERGISTIC COLOR MIXING A system of OPTICAL COLOR MIXING in which new HUES are created in the spaces between colored figures.

T

TAPESTRY A heavy, handwoven textile with pictures woven into the surface of the fabric, usually used as a wall hanging.

TEMPERA A painting MEDIUM in which PIGMENTS are mixed in water with a glutinous material such as egg yolk, usually yielding a fast-drying, matt finish that cannot be blended.

TERTIARY COLORS Hues that are a mixture of a PRIMARY and a SECONDARY HUE lying next to each other on the COLOR WHEEL.

TESSERAE (singular *tessera*) The small cubes of colored glass, CERAMIC, or stone used in MOSAICS.

TEXTURE The surface quality of a form or the illusion that it would feel a certain way if touched.

THREE-DIMENSIONAL Having length, height, and width.

THROWING See WHEEL-THROWING.

TOKONOMA In a traditional Japanese home, an alcove devoted to contemplation of a single scroll painting, perhaps accompanied by a flower arrangement.

TONAL RANGE The degree to which a work (particularly a photograph) approaches the full range of VALUES from black through grays to white.

TRIAD COLOR SCHEME The use of three HUES lying at equal distances from each other on the COLOR WHEEL.

TROMPE L'OEIL Work that "deceives the eye" into believing it sees something other than the reality of a surface, such as architectural forms on what is actually a flat wall or ceiling.

TRUSS In architecture, a framework of wood or metal beams, usually based on triangles, used to support a roof or bridge.

TWO-DIMENSIONAL Existing on a flat surface with only length and height but no depth in space.

TYPOGRAPHY The art of designing, sizing, and combining letterforms on a printed page.

U

UKIYO-E Japanese representations of everyday life, usually WOODCUT PRINTS but also paintings.

UNDERPAINTING The initial layers of paint in INDIRECT PAINTING.

UNITY Visual coherence in a work of art; also used sometimes to refer to repetition of similar motifs in a design, in contrast to VARIETY.

V

VALUE Degree of dark or light.

VALUE SCALE A graded representation of differences in VALUE.

VANISHING POINT The seen or implied spot in the distance where all lines perpendicular to the PICTURE PLANE would appear to meet if extended. In real life, a vanishing point can only be seen where one can look across a great distance; in art, if lines appear to converge rapidly to a vanishing point there will be an impression of great depth.

VARIETY Change rather than sameness in design elements.

VELLUM A fine parchment prepared from the skin of a calf, kid, or lamb.

VENEER A thin surface layer, such as a fine wood placed over other woods.

VIDEO A process of creating moving pictures by laying down images and sound as tracks on magnetic tape.

VIDEO RASTER GRAPHICS Computer-generated and -manipulated VIDEO images.

VISIBLE SPECTRUM The color frequencies that humans can see; the distribution of colors produced when white light is dispersed, e.g. by a prism. There is a continuous change in wavelength from red, the longest wavelength, to violet, the shortest.

VOID In sculpture, a hole through a work.

W

WALK-THROUGH Referring to large sculptures that the viewer can move through as well as around.

WARM COLORS Colors from the red and yellow side of the COLOR WHEEL, associated with heat.

WATERCOLOR A transparent water-soluble painting MEDIUM consisting of PIGMENTS bound with gum.

WHEEL-THROWING A method of creating forms of clay by centering a mass of clay on a circular slab and then pulling the sides up from it with the hands as this wheel is turned.

WOODCUT A PRINT made by carving away areas of a wood block and inking the remaining RELIEF surfaces.

WOOD ENGRAVING A PRINT made by cutting the end-grain of a piece of wood, capable of rendering finer lines than the lengthwise grain used for WOODCUTS.

WROUGHT IRON Iron that is shaped in a heated state with hand tools.

INDEX

CREDITS

The authors, the publishers, and John Calmann & King Ltd wish to thank the artists, museums, galleries, collectors, and other owners who have kindly allowed works to be reproduced in this book. In general, museums have supplied their own photographs; other sources, photographers, and copyright holders are listed here.